MANUAL

OF

EGYPTIAN ARCHÆOLOGY

AND

Guide to the Study of Antiquities in Egypt.

FOR THE USE OF STUDENTS AND TRAVELLERS.

BY

SIR G. MASPERO, D.C.L., Oxon.,

MEMBER OF THE INSTITUTE OF FRANCE; PROFESSOR AT THE COLLEGE DE FRANCE;
DIRECTOR-GENERAL OF THE SERVICE OF ANTIQUITIES IN EGYPT.

TRANSLATED AND ENLARGED BY
AGNES S. JOHNS.

With Three Hundred and Forty-Two Illustrations.

Copyright © 2018 Read Books Ltd.
This book is copyright and may not be
reproduced or copied in any way without
the express permission of the publisher in writing

British Library Cataloguing-in-Publication Data
A catalogue record for this book is available from
the British Library

INTRODUCTION

For the full understanding of ancient Egyptian materials some slight knowledge at least of the history of the country is necessary in order that the great antiquity of the civilization and the remote dates at which many of the materials were used may be realized. A brief historical outline therefore will be given.

The first inhabitants of the Nile valley are classified as Paleolithic and Neolithic respectively, and their age is so remote as to be quite undatable.

The Neolithic period was followed by a long interval of unknown duration termed Predynastic, which for the sake of convenience is divided into three sections, early, middle, and late. During this time the country was split up into a number of petty states, from the chaos of which gradually emerged two kingdoms, one of the North or Lower Egypt (Delta) and the other of the South or Upper Egypt. Nothing certain is known about either the separate states or the two kingdoms, beyond the fact of their existence and the practical commencement of Egyptian history dates from about 3400 B.C. when Menes, the first king of the First Dynasty, joined together the North and South

INTRODUCTION

under one rule and welded the country into the united kingdom of Egypt.

The historical period is conveniently divided into thirty Dynasties, each of which corresponds to a different royal House, analogous to the divisions of English history into the Houses of Normandy, Plantagenet, Tudor, Stuart, Hanover, and so on.

So little is known about the first two Dynasties (3400 B.C. to 2980 B.C.) that they are frequently grouped with the late Predynastic period, the whole being called Archaic. This will be done in the present book.

With the Third Dynasty began the Old Kingdom or Pyramid Age, as it is sometimes called, which lasted until the end of the Sixth Dynasty (2980 B.C. to 2475 B.C.).

The period from the Seventh Dynasty to the Tenth Dynasty inclusive (2475 B.C. to 2160 B.C.) was one of internal conflict and is very obscure.

The Eleventh and Twelfth Dynasties (2160 B.C. to 1788 B.C.) constitute the Middle Kingdom or Feudal Age, a time of great prosperity.

From the Thirteenth Dynasty to the Seventeenth Dynasty inclusive (1788 B.C. to 1580 B.C.) was a period of disorganization, about which present knowledge is very scanty, except that it included an interval of foreign domination under the Hyksos kings.

The Eighteenth Dynasty ushered in the New Kingdom or Empire, which lasted until the end of the

INTRODUCTION

Twentieth Dynasty (1580 B.C. to 1090 B.C.), during which time Egypt conquered Syria and became a great power in western Asia.

In the Twenty-first Dynasty (1090 B.C. to 945 B.C.) the Empire fell to pieces.

Of the next four Dynasties, the Twenty-second to the Twenty-fifth inclusive (945 B.C. to 663 B.C.), very little is known, except that the country was successively under the domination of the Libyans, the Ethiopians and the Assyrians.

In the Twenty-sixth Dynasty (663 B.C. to 525 B.C.) there was a revival of independence and prosperity, which was followed by the Persian conquest (525 B.C.).

The period from the Twenty-seventh Dynasty to the Thirtieth Dynasty inclusive (525 B.C. to 332 B.C.) was one of Persian domination, except for brief intervals when the Egyptians gained temporary independence.

In 332 B.C. Alexander the Great took possession of Egypt, and the Greek domination under Alexander's successors, the Ptolemies, lasted until 30 B.C.

In 30 B.C. Egypt became a Roman province, and the country remained in Roman occupation until the Arab conquest in A.D. 640.

As may be seen from the above short summary, there are several periods of Egyptian history, lasting in some cases two or three hundred years, about which very little is known, and even of the periods that are better known the information is very partial.

INTRODUCTION

With such gaps in the existing knowledge a final statement regarding the earliest or latest production or use of any material is impossible, and all that can be done is to give the dates for which the various materials have been recorded.

The knowledge of the Paleolithic and Neolithic Egyptians respectively is derived almost solely from flint and chert weapons and implements (many fashioned with a dexterity that has never been surpassed for such objects) that have been found in immense numbers in several localities in Egypt. With these, their owners could hunt, fish, and fight, but this is practically everything that is known about them, since their graves have either perished or more probably are now hidden so deeply beneath the cultivated land that they are irretrievably lost.

The Predynastic and Archaic periods are known almost entirely from the contents of graves, a large number of which have been discovered and carefully examined, and from the articles found in them a close estimate may be made of the conditions of life at the time.

For later periods the information derived from buried objects, which include a comparatively small number of written documents (papyri), is supplemented by that obtained from the remains of temples and towns and from inscriptions on the walls of the tombs and temples, in quarries, on the rocks at Aswan and elsewhere and on various monuments.

- A. Lucas,
Ancient Egyptian materials, 1926

PREFACE

"TO put this book into English, and thus to hand it on to thousands who might not otherwise have enjoyed it, has been to me a very congenial and interesting task. It would be difficult, I imagine, to point to any work of its scope and character which is better calculated to give lasting delight to all classes of readers. For the skilled archæologist, its pages contain not only new facts, but new views and new interpretations; while to those who know little, or perhaps nothing, of the subjects under discussion, it will open a fresh and fascinating field of study. It is not enough to say that a handbook of Egyptian Archæology was much needed, and that Professor Maspero has given us exactly what we required. He has done much more than this. He has given us a picturesque, vivacious, and highly original volume, as delightful as if it were not learned, and as instructive as if it were dull.

"As regards the practical side of Archæology, it ought to be unnecessary to point out that its usefulness is strictly parallel with the usefulness of public museums. To collect and exhibit objects of ancient art and industry is worse than idle if we do not also endeavour to disseminate some knowledge of the history of those arts and industries, and of the processes employed by the artists and craftsmen of the past. Archæology, no less than love, 'adds a precious seeing to the eye'; and without that gain of mental sight, the treasures of our public collections are regarded by the general visitor as mere ' curiosities '—flat and stale for the most part, and wholly unprofitable."

Thus wrote Miss Amelia B. Edwards in the preface to the first English edition of this book, published in 1887.

Since then the book has passed through other editions. Every year, almost every month, fresh material is found for the study of Egyptology and fresh light is thrown upon it by the progress of excavation, exploration, and research. Hence it follows that in the course of a few years the standard textbooks require considerable addition and modification if they

are to be of the greatest value to students, who must always start from the foremost vantage ground. Each edition in succession was therefore carefully corrected by the English editor, Miss Kate Bradbury; and Sir Gaston Maspero himself revised the work, suggesting or sanctioning any modifications or changes with his unfailing courtesy and care.

Since the last edition was issued in 1902 new material has been acquired in great abundance. Our knowledge of the earliest developments of Egyptian archæology has been consolidated and extended by further careful and prolonged study of the primitive remains that have come down to us, with results that have widened our perspective and extended our knowledge of Egyptian history. The discovery of valley temples has necessitated some changes in the chapters on tombs and temples. It has therefore been decided to retranslate the book, remodelling it where absolutely necessary, and introducing new material, but preserving its main characteristics untouched.

The claims on Sir Gaston Maspero as Director-General of the Service of Antiquities in Egypt forbade any idea of asking him to

supply the additional matter, although he has most kindly assented to the production of the new English edition.

Where any serious additions have been made, the sources of information have been indicated as far as possible in a footnote, and for references to the predynastic and Thinite periods the English editor is alone responsible. A short table of the principal epochs of Egyptian history has been added.

Many aspects of Egyptian archæology have necessarily been passed over. In a book of this size it is impossible to deal adequately with the palæography, the early relations with Nubia, and the Mediterranean peoples, nor yet with the difficult problems of the origin of the Egyptians. This work of Sir Gaston Maspero still remains the handbook of Egyptian archæology, and to render it too bulky would be to deprive it of much of its usefulness and charm.

For the new illustrations I have to thank Dr. Hogarth and Mr. Leeds for their kind assistance in procuring photographs of objects in the Ashmolean Museum; Dr. Güterbock for an excellent photograph of the Akhenaten

statue; and Dr. Flinders Petrie, the Deutsche Orient Gesellschaft, and the Egypt Exploration Fund for their courtesy in allowing me to reproduce illustrations published by them.

<div style="text-align: right;">A. S. JOHNS.</div>

CONTENTS.

PAGE

INTRODUCTION
PREFACE v
LIST OF ILLUSTRATIONS xiii
THE PRINCIPAL EPOCHS OF ANCIENT EGYPTIAN HISTORY . xxiii

CHAPTER I.

ARCHITECTURE—CIVIL AND MILITARY.

1. PRIVATE DWELLINGS 2
2. FORTRESSES 28
3. PUBLIC WORKS 41

CHAPTER II.

RELIGIOUS ARCHITECTURE.

1. MATERIALS AND PRINCIPLES OF CONSTRUCTION . . 53
2. TEMPLES 72
3. DECORATION 107

CHAPTER III.

TOMBS.

1. MASTABAS 130
2. ROYAL TOMBS AND PYRAMIDS 148
3. TOMBS OF THE THEBAN EMPIRE: THE ROCK-CUT TOMBS 169

CONTENTS.

CHAPTER IV.
PAINTING AND SCULPTURE.

PAGE.
1. DRAWING AND COMPOSITION 191
2. TECHNICAL PROCESSESS. 218
3. SCULPTURE
. 231

CHAPTER V
THE INDUSTRIAL ARTS.

1. STONE, POTTERY AND GLASS 277
2. IVORY, WOOD, LEATHER AND TEXTILES 306
3. METAL 338

XIII

LIST OF ILLUSTRATIONS.

FIG.		PAGE
1.	Bricklaying from Eighteenth Dynasty Tomb-Painting, tomb of Reckhmara	4
2.	house with vaulted floors, against the wall of the great temple of Medinet habu	7
3.	Plans of three quarters of the town of hat-hotep-Sesert.. W. M. F. Petrie	8
4.	Plan of house, Medinet habu.	9
5.	Plan of house, Medinet habu.	9
6.	Facade of a house toward the street, New Kingdom	10
7.	Plan of central court of house, Second Thebon period	10
8.	Restoration of the hall in a twelfth dynasty house W. M. F. Petrie	11
9.	Wall painting in Twelfth dynasty house. W. M. F. Petrie	12
10.	Box representing house	13
11.	Mansion with granaries from the tomb of Anna	13
12.	Portico of mansion, second Theban period	14
13.	Portico of mansion, second Theban period	14
14.	Plan of a Theban house with garden	15
15.	Perspective view of the Theban house	16
16.	Part of the palace of AT	17
17.	Perspective view of the palace of AT . .	18
18.	Frontage of house, second Theban period	19
19.	Frontage of house, second Theban period	19

LIST OF ILLUSTRATIONS.

FIG. | PAGE
20. Central pavilion of house, in form of tower, second Theban period 20
21. Ceiling pattern from behind Medinet Habû, Twentieth Dynasty 20
22. Ceiling pattern similar to one at El Bersheh, Twelfth Dynasty 20
23. Ceiling pattern from tomb of Aimadûa, Twentieth Dynasty 21
24. Wall-painting, palace of Tell el Amarna. W. M. F. Petrie 22
25. Part of painted pavement, palace of Tell el Amarna. W. M. F. Petrie 23
26. Plan of private house, Tell el Amarna. W. M. F. Petrie 24
27. Door of a house of the Old Kingdom, from the wall of a tomb of the Sixth Dynasty 26
28. Façade of a Fourth Dynasty house, from the sarcophagus of Khûfû Poskhû 27
29. Plan of second fortress of Abydos, Eleventh or Twelfth Dynasty 30
30. Walls of second fort at Abydos, restored . . . 31
31. Façade of fort, from wall-scene, Beni Hasan, Twelfth Dynasty 31
32. Plan of main gate, second fortress of Abydos . . 32
33. Plan of south-east gate, second fortress of Abydos . 32
34. Plan of gate, fortress of Kom el Ahmar . . . 33
35. Plan of the walled city at El Kab 33
36. Plan of walled city of Kom Ombo 34
37. Plan of fortress of Kummeh 35
38. Plan of fortress of Semneh 36
39. Section of the platform at A, B, of preceding plan . 37
40. Syrian fort 37
41. The town walls of Dapûr 38
42. City of Kadesh, from bas-relief, Ramesseum . . 38
43. Plan of the pavilion of Medinet Habû . . . 39
44. Elevation of pavilion, Medinet Habû 39
45. Canal and bridge of Zarû, from bas-relief, Karnak . 41
46. Cellar, with amphoræ 42
47. Granary 42
48. Plan of Pithom 43
49. Store-chambers of the Ramesseum 43

LIST OF ILLUSTRATIONS. XV

FIG.		PAGE
50.	King inaugurating public work. Carved mace head, Oxford	44
51.	Dyke at Wady Gerraweh	47
52.	Section of dyke at Wady Gerraweh	47
53.	Quarries of Silsilis	49
54.	Draught of Hathor capital in quarry of Gebel Abû Fêdah	50
55.	Bas-relief from one of the stelæ of Aahmes, at Tûrah, Eighteenth Dynasty	51
56.	Masonry in temple of Seti I. at Abydos	57
57.	Temple wall with cornice	58
58.	Niche and doorway in temple of Seti I. at Abydos	58
59.	Pavement of the portico of Osiris in temple of Seti I., Abydos	59
60.	Corbelled arch, temple of Seti I., Abydos	59
61.	Hathor pillar, Abû Simbel	60
62.	Pillar of Amenhotep III., Karnak	61
63.	Sixteen-sided pillars, Karnak	62
64.	Fluted pillar, Kalabsheh	63
65.	Polygonal Hathor-head pillar, El Kab	63
66.	Column with square die	64
67.	Column with campaniform capital, Ramesseum	64
68.	Inverted campaniform capital, Karnak	65
69.	Compound capital	66
70.	Ornate capitals, Ptolemaic	66
71.	Lotus-bud column, Beni Hasan	66
72.	Lotus-bud column, processional hall, Karnak, Thothmes III.	67
73.	Column in aisles of hypostyle hall, Karnak	68
74.	Palm-leaf capital	69
75.	Hathor-head capital, Ptolemaic	69
76.	Campaniform and Hathor-headed capital, Philæ	70
77.	Section of hypostyle hall at Karnak, showing the arrangements of the campaniform and lotus-bud columns	71
78.	Plan of temple and valley temple of Pyramid of Khafra, Gizeh	75
79.	The temple of the Sun at Abû Gûrab, reconstructed	79
80.	Southern temple of Amenhotep III. at Elephantine	83
81.	Plan of temple of Amenhotep III. near El Kab	84
82.	Plan of temple of Hathor, Deir el Medineh	85
83.	Plan of temple of Khonsû, Karnak	86

LIST OF ILLUSTRATIONS.

FIG.		PAGE
84.	Pylon with masts, from a bas-relief in the temple of Khonsû, Karnak	87
85.	The Ramesseum restored, showing the rise of the ground	88
86.	Crypts in the thickness of the walls round the sanctuary of Denderah	89
87.	The pronaos of Edfû, as seen from the top of the eastern pylon	90
88.	Plan of the temple, Edfû	91
89.	Plan of temple of Karnak in the reign of Amenhotep II.	92
90.	Plan of hypostyle hall, Karnak	93
91.	Plan of great temple, Luxor	94
92.	Plan of the island of Philæ	95
93.	Plan of speos, Kalaat-Addah, Nubia	96
94.	Plan of speos, Gebel Silsileh	97
95.	Plan of the Great Speos, Abû Simbel	98
96.	Speos of Hathor, Abû Simbel	98
97.	Plan of temple of Hatshepsût, Deir el Bahari	99
98.	Plan of temple of Seti I., Abydos	102
99.	Crio-sphinx from Wady es Sabûah	106
100.	Couchant ram, with statuette of royal founder, restored avenue at sphinxes, Karnak	106
101–106.	Decorative designs from Denderah	108
107.	Two Nile-gods, bearing lotus-flowers and libation vases	109
108.	Dado decoration, hall of Thothmes III., Karnak	109
109.	Ceiling decoration, from tomb of Bakenrenf (Bocchoris), Saqqara, Twenty-sixth Dynasty	110
110.	Zodiacal circle of Denderah	111
111.	Frieze of uraei and cartouches	115
112.	Wall of a chamber at Denderah, showing the arrangement of the tableaux	117
113.	Obelisk of Senûsert I., Heliopolis	122
114.	Obelisk of Senûsert I., Begig, Fayûm	123
115.	Table of offerings, Karnak	124
116.	Limestone altar	125
117.	Wooden naos, Turin Museum	126
118.	A mastaba	131
119.	False door in mastaba, from Mariette's *Les Mastabahs*	133
120.	Plan of forecourt in mastaba of Kaāpir	133
121.	Plan of forecourt in mastaba of Neferhotep	134
122.	Door in façade of mastaba	134
123.	Portico and door, from Mariette's *Les Mastabahs*	134

LIST OF ILLUSTRATIONS. xvii

FIG. PAGE
124. Plan of chapel in mastaba of Khabiûsokari, Fourth Dynasty 135
125. Plan of chapel in mastaba of Ti, Fifth Dynasty . . 135
126. Plan of chapel in mastaba of Shepsesptah, Fourth Dynasty 135
127. Plan of chapel in mastaba of Affi, Saqqara, Fourth Dynasty 135
128. Plan of chapel in mastaba of Thenti II., Fourth Dynasty, Saqqara 136
129. Plan of chapel in mastaba of the *Red Scribe*, Fourth Dynasty, Saqqara 136
130. Plan of the mastaba of Ptahhotep, Fifth Dynasty, Saqqara 137
131. Stela in tomb of Merrûka, Fifth Dynasty, Abûsîr . 138
132. Wall scene of funerary offerings, from mastaba of Ptahhotep, Fifth Dynasty 140
133. Wall painting, funeral voyage, mastaba of Urkhuû, Gizeh, Fourth Dynasty 142
134. Wall scene from mastaba of Ptahhotep, Fifth Dynasty 142
135. Plan of serdab in mastaba at Gizeh, Fourth Dynasty . 143
136. Plan of serdab and chapel in mastaba of Rahotep at Saqqara, Fourth Dynasty 144
137. Plan of serdab and chapel in mastaba of Thenti I., Saqqara, Fourth Dynasty 144
138. Section showing shaft and vault of mastaba at Gizeh, Fourth Dynasty 145
139. Section of mastaba, Saqqara, Sixth Dynasty . . 146
140. Wall painting of funerary offerings, mastaba of Nenka, Saqqara, Sixth Dynasty 147
141. Plan of royal tomb, time of Menes, First Dynasty, Nagada 149
142. Tomb of Senna, with panelled east wall, Denderah, Sixth Dynasty 150
143. Plan of tomb of King Qa, Abydos, First Dynasty . 151
144. Stela of King Perabsen, Abydos, Second Dynasty . 152
145. Royal tomb, Bêt Khallâf, superstructure . . . 153
146. Section of royal tomb, Bêt Khallâf 154
147. Step pyramid of Saqqara 155
148. Pyramid of Medûm 156
149. Section of passage and vault in pyramid of Medûm . 157
150. Section of the Great Pyramid. W. M. F. Petrie . 159

b

LIST OF ILLUSTRATIONS.

FIG.		PAGE
151.	Plan and section of the pyramid of Ûnas	163
152.	Portcullis and passage, pyramid of Ûnas	164
153.	Section of the pyramid of Ûnas	165
154.	Mastabat el Faraûn	167
155.	Section of "vaulted" brick pyramid, Abydos	170
156.	Section of "vaulted" tomb, Abydos	170
157.	Plan of tomb, Abydos	171
158.	Theban tomb with pyramidion, from scene in a tomb	171
159.	Theban tomb with pyramidion, from wall painting	172
160.	Section of apis tomb, time of Amenhotep II.	172
161.	Tombs in cliff opposite Assûan	173
162.	Façade of tomb of Khnûmhotep, Beni Hasan, Twelfth Dynasty	174
163.	Façade of tomb, Assûan	175
164.	Plan of tomb of Khnûmhotep, Beni Hasan	176
165.	Plan of unfinished tomb, Beni Hasan	177
166.	Funeral procession and ceremonies, from wall paintings, Thebes	178
167.	Plan of tomb of Rameses IV.	184
168.	Plan of tomb of Rameses IV., from Turin papyrus	184
169.	Plan of tomb of Seti I.	185
170.	Wall painting of the fields of Aalû, tomb of Rameses III.	187
171.	Wooden model of sailing boat, Beni Hasan, Twelfth Dynasty	192
172.	Wooden model and servants working, Beni Hasan, Twelfth Dynasty	193
173.	Pestle and mortar for grinding colours	195
174.	Comic sketch on ostracon. New York Museum	197
175.	Vignette from the *Book of the Dead* (Saïte period)	198
176.	Vignette from the *Book of the Dead*, from the papyrus of Hûnefer	199
177.	Part of scene on a wall of the pre-dynastic tomb of Hierakonpolis	200
178-9.	Scenes from the tomb of Khnûmhotep at Beni Hasan, Twelfth Dynasty	203
180.	Scene from a tomb painting in the British Museum, Eighteenth Dynasty	204
181.	Funerary repast, tomb of Prince Horemheb, Eighteenth Dynasty	205
182.	From wall painting, Thebes, Ramesside period	207
183.	From wall scene in tomb of Horemheb	209

LIST OF ILLUSTRATIONS. xix

FIG.		PAGE
184.	From wall scene, Ramesseum	209
185.	Archers, represented on walls of Medinet Habû	210
186.	Phalanx of Egyptian infantry, Ramesseum	211
187.	Hittite battalion, Ramesseum	211
188.	Pool and palm-trees, from wall painting in tomb of Rekhmara	212
189.	Scene from tomb of Rekhmara, Eighteenth Dynasty	213
190.	Scene from mastaba of Ptahhotep, Fifth Dynasty	214
191.	Palestrina mosaic	215
192.	Sculptor's sketch, from Old Kingdom tomb	219
193.	Sculptor's sketch, from Old Kingdom tomb	220
194.	Sculptor's correction, Medinet Habû, Rameses III.	220
195.	Bow drill	221
196.	Sculptor's trial piece, Eighteenth Dynasty	224
197–8.	Ceremonial palette of King Narmer, archaic period, Hierakonpolis	232
199.	King Khasekhemûi, limestone, Third Dynasty	233
200.	Rahotep, Third Dynasty, from Medûm	234
201.	Nefert, wife of Rahotep, Third Dynasty, from Medûm	235
202.	Panel from tomb of Hesi	236
203.	The Great Sphinx of Gizeh	238
204.	King Khafra, Fourth Dynasty	243
205.	Cross-legged scribe at the Louvre, Old Kingdom	246
206.	Cross-legged scribe, from Saqqara	247
207.	Sheikh el Beled, Old Kingdom	248
208.	Head of Sheikh el Beled	249
209.	Wooden statue of a woman, Old Kingdom	250
210.	The kneeling scribe, Old Kingdom	251
211.	A bread-maker, Old Kingdom	252
212.	The dwarf Nemhotep, Old Kingdom	253
213.	One of the Tanis sphinxes	255
214.	Statuette of Akhenaten, painted limestone	259
215.	Head of Seti I., bas-relief	260
216.	The god Amon, and Horemheb	261
217.	Head of a queen, Eighteenth Dynasty	262
218.	Head of Horemheb	263
219.	Queen Ameniritis	264
220.	The goddess Taûrt, Saïte work	265
221.	Hathor-cow in green basalt, Saïte work	266
222.	Squatting statue of Pedishashi, Saïte work	267
223.	Head of a scribe, Saïte work	268

LIST OF ILLUSTRATIONS.

FIG.		PAGE
224.	Colossus of Alexander II.	269
225.	Statue of Horus, Græco-Egyptian	270
226.	Group from Naga	272
227.	Slate palettes, predynastic and First Dynasty	274
228.	Flint knife, predynastic	275
229.	Flint teeth for sickles	276
230.	Girdle tie of Isis	278
231.	Frog amulet	278
232.	Lotus column amulet	278
233.	Sacred eye or *uzat*	279
234.	Scarab	279
235.	Stone vases, predynastic and First Dynasty	282
236.	Impression of cylinder-seal, First Dynasty	283
237.	Perfume vase, alabaster	284
238.	Perfume vase, alabaster	284
239.	Perfume vase, alabaster	284
240.	Perfume vase, alabaster	285
241.	Kohl-jar	285
242.	Black-topped pottery	286
243.	Red burnished pottery	287
244.	Pottery fish, predynastic	288
245.	Red pottery with basket-work designs, predynastic	288
246.	Vase painted to imitate mottled stone	289
247.	Decorated vase, predynastic	289
248.	Black incised pottery, predynastic	290
249.	Lenticular ampulla of Mykenæan type, Eighteenth Dynasty	291
250.	False-necked vase	291
251–3.	Decorated vases, pottery	292
254.	Parti-coloured glass vase, bearing name of Thothmes III.	297
255.	Lenticular ampulla, parti-coloured glass	297
256.	Parti-coloured glass vase	298
257.	Glass goblets of Nesikhonsû	298
258.	Hippopotamus in blue glaze	299
259.	Glazed ware, from Thebes	300
260.	Glazed ware, from Thebes	300
261.	Cup, glazed ware	301
262.	Decoration of interior of small bowl, Eighteenth Dynasty	301
263.	Lenticular vase, glazed ware, Saïte period	302

LIST OF ILLUSTRATIONS.

FIG.		PAGE
264.	Tiled chamber in step pyramid of Saqqara	303
265.	Tile from step pyramid of Saqqara	304
266.	Tile inlay, Tell el Yahûdîeh, Twentieth Dynasty	304
267.	Tile inlay, Tell el Yahûdîeh, Twentieth Dynasty	304
268.	Inlaid tiles, Tell el Yahûdîeh, Twentieth Dynasty	305
269.	Tile of relief, Tell el Yahûdîeh, Twentieth Dynasty	305
270.	Tile in relief, Tell el Yahûdîeh, Twentieth Dynasty	306
271.	Ivory spoon, combs, and hairpins, predynastic	307
272.	Tusk carved with human face	307
273.	Carved ivory from Hierakonpolis	308
274.	Ivory spoon	309
275.	Wooden statuette of officer, Eighteenth Dynasty	310
276.	Wooden statuette of priest, Eighteenth Dynasty	311
277.	Wooden statuette of the Lady Naï	312
278–9.	Wooden spoons, for perfume or unguents	313
280–1.	Wooden spoons for perfume or unguents	314
282–3.	Wooden spoons for perfume or unguents	315
284–5.	Wooden spoons for perfume or unguents	316
286.	Wooden spoon for perfume or unguents	317
287–9.	Chests	318
290.	Construction of a mummy-case, wall scene, Eighteenth Dynasty	319
291.	Mask of coffin of Rameses II., *tempo*, Twenty-first Dynasty	322
292.	Mummy-case of Queen Aahmesnefertari	323
293.	Panel portrait, Græco-Roman. National Gallery	326
294.	Carved and painted mummy canopy	328
295.	Mummy-couch with canopy, Græco-Roman	329
296.	Mummy-sledge and canopy	330
297.	Inlaid chair, Eleventh Dynasty	330
298.	Inlaid stool, Eleventh Dynasty	331
299.	Royal chair of state, wall painting, Rameses III.	331
300.	Women weaving, wall scene, Twelfth Dynasty	332
301.	Man weaving, wall scene, Twelfth Dynasty	333
302.	Border pattern in cut leather-work, Twenty-first Dynasty	334
303.	Bark with cut leather-work sails, Twentieth Dynasty	335
304.	Bark with cut leather-work sails, Twentieth Dynasty	336
305.	Bronze jug	340
306.	Bronze jug, seen from above	340
307.	Lamp, Græco-Roman period	341
308.	Bronze statuette of Takûshet	342

LIST OF ILLUSTRATIONS.

FIG.		PAGE
309.	Bronze statuette of Horus	343
310.	Bronze statuette of Mosû	344
311.	Bronze lion from Horbeit, Saïte period	346
312.	Gold worker, wall scene	347
313.	Gold cup of General Tahûti, Eighteenth Dynasty	350
314.	Silver vase of Thmûis	351
315.	Silver vase of Thmûis	351
316.	Ornamental vase in precious metal, wall painting, Twentieth Dynasty	351
317.	Crater of precious metal, wall painting, Eighteenth Dynasty	352
318.	Hydria of precious metal, wall painting, Eighteenth Dynasty	352
319.	Enamelled cruet, wall painting, Eighteenth Dynasty	353
320.	Enamelled cruet, wall painting, Eighteenth Dynasty	353
321.	Gold centrepiece of Amenhotep III., wall painting	354
322.	Crater of precious metal, wall painting, Eighteenth Dynasty	354
323.	Crater of precious metal, wall painting, Eighteenth Dynasty	355
324.	Ewer of precious metal, wall painting, Eighteenth Dynasty	355
325.	Signet-ring with bezel	357
326-9.	Bracelets, First Dynasty	358
330.	Gold *cloisonné* pectoral, Dahshûr, Twelfth Dynasty	359
331.	Mirror of Queen Aahhotep	360
332.	Bracelet of Queen Aahhotep	361
333.	Bracelet of Queen Aahhotep	362
334.	Diadem of Queen Aahhotep	362
335.	Bold *usekh* necklace of Queen Aahhotep	363
336.	Pectoral of Queen Aahhotep, bearing cartouche of of Aahmes I.	363
337.	Poniard of Queen Aahhotep	364
338.	Poniard of Queen Aahhotep	365
339.	Battle-axe of Queen Aahhotep	366
340.	Funerary bark of Queen Aahhotep	367
341.	Ring of Rameses II.	368
342.	Bracelet of Prince Psar	369

THE PRINCIPAL EPOCHS OF ANCIENT EGYPTIAN HISTORY.

PREDYNASTIC PERIOD.

This ended with Menes, who united the kingdoms of the North and of the South.

PROTO-DYNASTIC PERIOD.

THINITE: First and Second Dynasties. Steady development and organisation of the country.

MEMPHITE: Third Dynasty.

OLD KINGDOM.

MEMPHITE: Fourth, Fifth, and Sixth Dynasties.—An age of powerful Pharaohs, builders of the Pyramids.

A period of weak government and civil strife followed. A Theban family finally secured the chief power and gradually reunited the country.

MIDDLE KINGDOM.

THEBAN: Eleventh, Twelfth, and Thirteenth Dynasties. — Egypt highly prosperous. The feudal system fully developed under powerful Pharaohs. Nubia subjugated.

A period of civil war under the Fourteenth Dynasty was followed by the HYKSOS domination of the Fifteenth and Sixteenth Dynasties.

NEW KINGDOM, circa 1600-1080 B.C.

THEBAN: Seventeenth, Eighteenth, Nineteenth, and Twentieth Dynasties.—The great period of Asiatic Conquest and Empire was under the Eighteenth and Nineteenth Dynasties.

Egypt gradually declined under the later Ramessides (Rameses IV.-XII.) of the Twentieth Dynasty, and the Empire fell to pieces under the Twenty-first (Tanite) Dynasty.

FOREIGN DOMINATION, circa 950-666 B.C.

Twenty-second, Twenty-third, Twenty-fourth, and Twenty-fifth Dynasties.—Libyans and Ethiopians in turn occupied the throne, the seat of government being successively at Bubastis, Tanis, and Sais.

LATE EGYPTIAN PERIOD, 666-525 B.C.

SAITE: Twenty-sixth Dynasty.—A time of prosperity under native Pharaohs, and reversion to ancient conventions of art in Egypt.

PERSIAN DOMINATION, 525-408 B.C.

Twenty-seventh Dynasty. — The Persian monarchs reigned as Pharaohs.

The Twenty-eighth, Twenty-ninth, and Thirtieth Dynasties were Egyptian, but they only maintained their partial independence by the aid of Greek mercenaries, and were finally reconquered by Persia.

Alexander the Great took possession of Egypt 332 B.C.

EGYPTIAN ARCHÆOLOGY.

CHAPTER I.

ARCHITECTURE—CIVIL AND MILITARY.

THE earlier archæologists, when visiting Egypt, concentrated their attention upon tombs and temples, and manifested little or no interest in the existing remains of private dwellings and fortified buildings. Yet few countries have preserved so many relics of their ancient civil architecture, and within the last few years systematic excavations have been carried out with excellent results. Setting aside towns of Roman or Byzantine date, which till recently were standing almost intact at Kûft, Kom Ombo, and El Agandîyeh, considerable portions of ancient Thebes are still standing to the east and south of Karnak. At Memphis there are large mounds, the core of which is formed by houses in good preservation. Yet earlier are the remains at Abydos, where the plans of the Thinite town have been made out, and where vestiges of the primitive huts still exist.

At Kahûn the remains of a whole provincial town of the Twelfth Dynasty have been laid bare. In the royal town of Tell el Amarna of the Eighteenth Dynasty much important work has already been

done, and its streets and houses are now in process of being excavated.

At Tell el Maskhûtah the granaries of Pithom are standing; at Tanis and Bubastis Saïtic and Ptolemaic towns have been excavated. A long list might be made of less-known localities where ruins of private dwellings may be seen, which date back to the Ramessides, and even to the earliest dynastic period.

With regard to fortresses, Abydos itself can furnish two, of which one undoubtedly dates back to the earliest dynasties. The ramparts of El Kab, Kom el Ahmar, El Hibeh, Kûban (opposite Dakkeh), of Heliopolis, and of Thebes are standing, and most of them have been carefully excavated.

I.—PRIVATE DWELLINGS.

The soil of Egypt, periodically washed by the inundation, is a black, compact, homogeneous mud, which, when dry, acquires the hardness of stone; from time immemorial it has been used by the fellahîn in constructing their houses. The poorest huts of the present day are little more than a rudely shaped mass of this mud. A rectangular space 8 or 10 feet in width and 15 or 16 feet in length is enclosed by wicker-work made of palm-branches coated both inside and out with a layer of mud. As this coating cracks in the drying, the fissures are filled in, and another coating of mud is added until the walls attain a thickness varying from 4 to 12 inches. Finally the hut is roofed in with palm-branches and straw, covered with a layer of beaten earth. The height varies. Usually the ceiling is so low that to

rise suddenly is to run the risk of knocking one's head, while in some huts the roof is as much as 7 feet from the ground. There is no window of any description to admit light and air; occasionally there is a hole in the middle of the roof to let out the smoke, but this luxury is by no means universal. The remains of huts of the primitive period show that this method of building of the modern Egyptian is an inheritance from his remote ancestors of the time of the earliest dynasties. At Abydos, where the royal tombs of the First Dynasty have been found, enough vestiges of the ancient town remain to prove that the earliest dwellings of the Egyptians were similar to those of the fellahîn of to-day.

It is not always easy at the first glance to distinguish between the huts that are made of wattle and daub and those built of crude brick. The ordinary Egyptian brick is made of mud, mixed with a little sand and chopped straw, moulded into oblong bricks and dried in the sun. Building operations are begun by a man digging up the ground on the selected site. One set of men carry off the clods he turns up and heap them together, while another set knead them with their feet and reduce them to a homogeneous mass of mud. When the paste is sufficiently kneaded, the master workman runs it into moulds of hard wood. The bricks are carried off by an assistant and laid out in rows some distance apart to dry (fig. 1). A careful workman will leave them in the sun for six hours or even a whole day, after which the bricks are stacked in such a manner that the air can circulate freely among them, and so they remain for a week

or two before they are used. Frequently, however, the bricks are merely dried for a few hours in the sun and used while they are still moist. Notwithstanding this casual treatment, the mud is so tenacious that the brick does not easily get out of shape; the outer face disintegrates owing to atmospheric conditions, but inside the wall the bricks remain intact, and are still separable from each other. A good modern workman will easily turn out 1,000 bricks a day, and after a week's practice he will reach 1,200, 1,500, or even 1,800. The ancient workman, whose

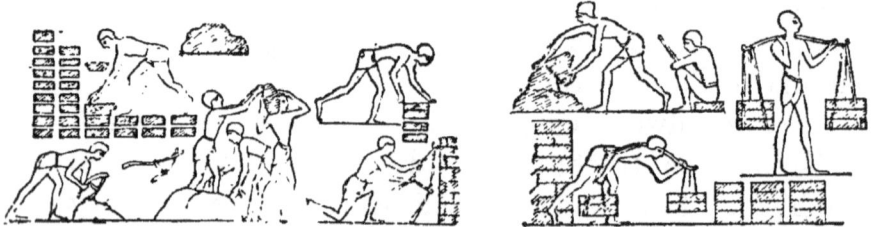

Fig. 1.—Brickmaking, from Eighteenth Dynasty tomb-painting, tomb of Rekhmara.

tools were the same as those of the present day, must have obtained equally good results.

The ancient mould in general use for medium-sized bricks measures 8·7 × 4·3 × 5·5 inches, and for the larger bricks, 15·0 × 7·1 × 5·5 inches, although both larger and smaller moulds have been discovered. Bricks from the royal brickyards are occasionally stamped with the cartouche of the reigning sovereign, those from private factories are marked with one or more conventional signs in red ink, a print of the moulder's finger or the maker's stamp. The greater number have no mark. The ordinary burnt brick does not appear to have been in common use before

the Græco-Roman period, although some are known of Ramesside times. Glazed bricks are occasionally found in the Delta; one of these, now in the Cairo Museum, is inscribed in black ink with the name of Rameses III. In that instance the glaze is green, but other fragments are blue, red, yellow, or white.

The nature of the soil does not admit of deep foundations. On the surface there is a shallow bed of made earth which, except on the site of large towns, is of no depth. Below this there is a very dense humus intersected by narrow veins of sand, and below this again—at the level of infiltration—there is a bed of mud, more or less liquid according to the season. At the present day the masons are content to dig through the made earth and to commence operations as soon as they reach virgin soil: if this should be too deep down, they lay the foundations about 3 feet below the surface. The Pharaonic Egyptians did likewise: I have never found any ancient dwelling where the foundations went deeper than 4 feet, and this was exceptional; in most cases the depth does not exceed 2 feet.

In many cases no trenches were dug; the ground was merely levelled, and probably well watered to increase the consistency of the soil, and the bricks were then laid on the surface. When the building was finished the scraps of mortar, the broken bricks, and all the accumulated rubbish of building material would form a layer about 8 inches to a foot deep round the base of the buildings, the buried portion of the walls thus taking the place of foundations. When the house was to be built on the site

of an earlier one fallen into decay or accidentally destroyed, it was not considered necessary to raze the old walls completely. The mass of ruin was levelled to an even surface, and the new building was begun several feet higher than its predecessor: thus every town is built on one or more artificial mounds which are sometimes as much as 80 or 90 feet in height.

Greek historians attribute this peculiarity to the sagacity of the kings, more particularly of Sesostris, who, they imagined, desired to place their palaces beyond reach of the inundations. Some modern authors have described the method by which they believe this was effected; that massive brick platforms were constructed at regular intervals, arranged in cross lines, the interstices filled with earth and rubbish, and the city built on this gigantic chessboard. Wherever I have excavated, more especially at Thebes, I have found nothing that answers to this description. The so-called platforms that intersect each other below the later buildings are merely the vestiges of earlier houses which are themselves resting on the remains of yet more ancient buildings.

Architects were not deterred by the shallowness of the foundations from boldly erecting lofty buildings; in the ruins of Memphis there are walls standing from 30 to 40 feet in height. The only precaution taken was to thicken the walls at the base and to vault the floors (fig. 2). The wall thickness for a low building was about 16 inches, but for a house of several stories it would be as much as 3 or 4 feet. Large beams embedded at intervals in the brickwork consolidated

and bound it together. The ground floor was frequently built of stone carefully worked, and brick was relegated to the upper stories. Limestone from the adjacent hills was the only stone systematically employed for this purpose. The fragments of sandstone, granite, and alabaster mixed with it were generally brought from some ruined temple. The Egyptians of those days had no more scruple than those of the present time in despoiling their ruined and neglected monuments. The houses of an ancient Egyptian town were clustered round its temple, and the temple stood in a rectangular enclosure to which access was obtained through imposing gateways in the surrounding brick wall. The gods dwelt in fortified mansions or redoubts, to which the people of the

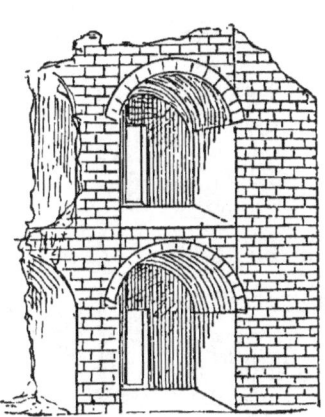

Fig. 2.—House with vaulted floors, against the northern wall of the great temple of Medinet Habû.

place might fly for safety in the event of any sudden attack upon their town. Such towns as were built all at one period by prince or king were fairly regular in plan, having wide paved streets at right angles to each other, with a stone channel down the middle to carry off water and drainage, and the buildings in line (fig. 3). Cities whose growth had been determined by the chances and changes of centuries were characterised by no such regularity. Their houses stood in a maze of blind alleys, and narrow,

8 ARCHITECTURE—CIVIL AND MILITARY.

dark straggling streets, with here and there the branch of a canal, almost dried up during the greater part of the year, and a muddy pond where the cattle drank and the women came for water. Somewhere

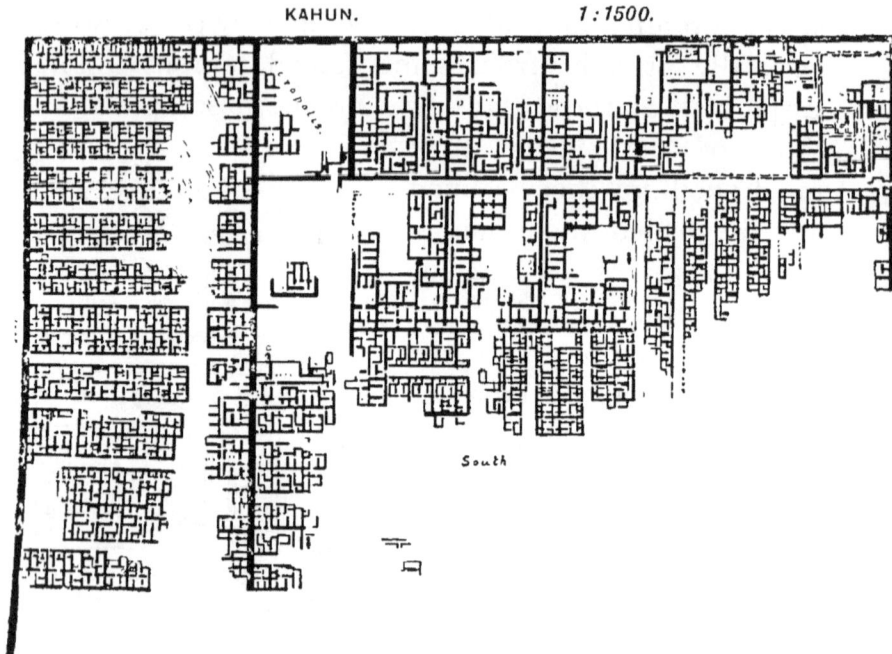

Fig. 3.—Plan of three-quarters of the town of Hat-Hotep-Senûsert (Kahùn), built for the officials and workmen employed in connection with the pyramid of Senusert II. at Illahûn. The workmen's quarters are principally on the western side. *Illahun, Kahun, and Gurob*, W. M. F. Petrie.

in each town was an open space shaded by sycamores or acacias, and hither on market-days came the peasants of the district two or three times in the month. There were waste places where rubbish and refuse were thrown to be quarrelled over by vultures, hawks, and dogs.

DOMESTIC ARCHITECTURE.

The poorer classes lived in hovels which, though built of brick, were little better than the huts of the fellahîn. At Karnak in the Pharaonic town, at Kom Ombo in the Roman town, at Medinet Habû in the Coptic town, the frontage of dwellings of this class rarely exceeds 12 or 16 feet in length. They consist of a ground floor, with occasionally one or two living-rooms above.

The richer classes, shopkeepers, small officials, and foremen, were better housed. These houses were built of brick, and were rather small, but they contained some half-dozen rooms, which communicated by means of doors that were usually arched over.

Fig. 4.—Plan of house, Medinet Habû.

Some few of the houses were two or three stories high. Frequently they were separated from the street by a narrow courtyard, at the back of which was a passage with chambers opening from it on either side (fig. 4).

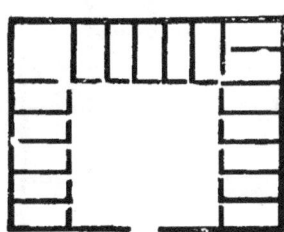

Fig. 5.—Plan of house, Medinet Habû.

More often the court was surrounded on three sides by chambers (fig. 5), while yet more often the house fronted directly on to the street. In the latter case the façade consisted of a high wall, painted or whitewashed, surmounted by a cornice. Even in better houses the only ornamentation of the outer walls consisted of angular grooving surmounted by representations of two lotus-flowers joined together at the neck (see figs. 27, 28). There

was no opening except the door and possibly a few small windows (fig. 6). Even in unpretentious houses the doorway was often of stone, the doorposts projected slightly beyond the level of the wall, and over the lintel was a painted or sculptured cornice. Having crossed the threshold, one passed successively through two small and dark apartments, the second of which opened into the central court (fig. 7). The best rooms in the houses of the wealthier citizens were sometimes lighted through a square opening in the centre of the ceiling supported on wooden columns. In the Twelfth Dynasty town of Kahûn the shafts of these columns rested on round stone bases. They were octagonal, and about 10 inches in diameter.

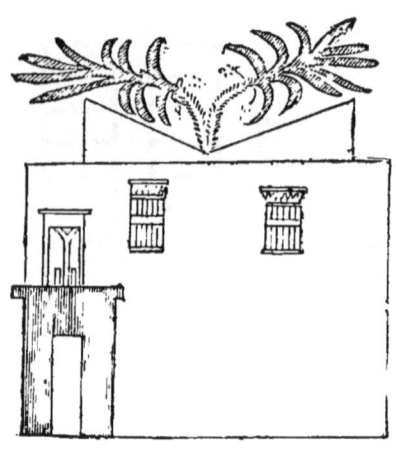

Fig. 6.—Façade of a house toward the street, New Kingdom.

The larger houses possessed a reception hall at the rear with a shady colonnade on the south side, while the principal hall was colonnaded and had a tank about 14 inches square in the centre sunk in the stone pavement (fig. 8). Even the poorer houses at Kahûn contained a stone tank, and there is evidence

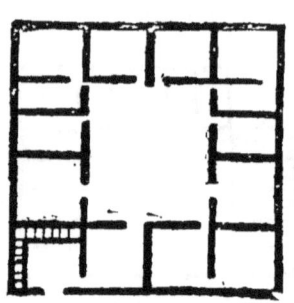

Fig. 7.—Plan of central court of house, second Theban period.

DOMESTIC ARCHITECTURE.

that this luxury was universal, except among the poorest, in houses of the Old Kingdom. At Tell el Amarna an elaborate bath with water supply has been found in the house of a high official of the Eighteenth Dynasty, and other indications bear witness to the excellent hygienic and sanitary arrangements known in ancient Egypt.*

In the poorer houses the family crowded together in one or two rooms during the winter, and slept out on the roof under mosquito-nets in summer. On the

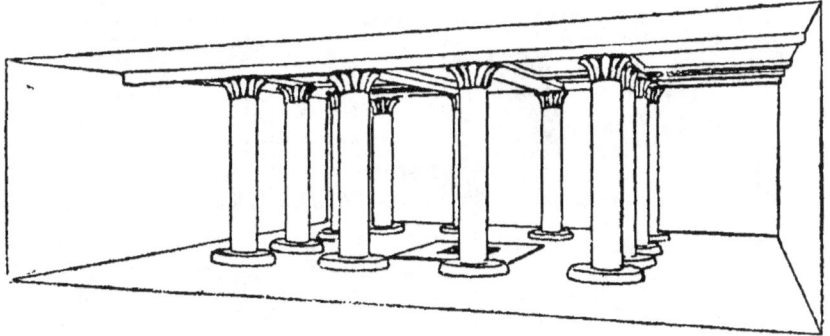

Fig. 8.—Restoration of the hall in a Twelfth Dynasty house. *Illahun, Kahun, and Gurob,* W. M. F. Petrie.

roof also the women gossiped and cooked. The ground floor included store-rooms, barns, and stables. Private granaries were usually built in pairs (fig. 11) in the same long, conical shape as the State granaries, of brick, carefully plastered with mud inside and out. In the walls and floors of their home the people would make hiding-places, where they could secrete their treasures—nuggets of gold and silver, precious stones and jewellery—both from thieves and tax-collectors. Wherever a second floor existed, the

* L. Borchardt, *Mittheilungen Orient. Gesellschaft.*, No. 50, 1912.

arrangement of rooms was almost exactly the same as on the ground floor. The upper rooms were reached by an outside staircase, very steep and narrow, with small square landings at frequent intervals. The rooms were oblong, and the door ordinarily afforded the only means for lighting and ventilation. In cases where windows were opened on to the street, they were mere irregular, un-

Fig. 9.—Wall-painting in a Twelfth Dynasty house, Kahûn. Below is a view of the outside, above is a view of the inside of the building. *Illahun, Kahun, and Gurob*, W. M. F. Petrie.

symmetrical air-holes near the ceiling, provided with a grill of wooden bars and closed with a wooden shutter. The floors were bricked or paved, or more frequently consisted of beaten earth. The walls were sometimes whitewashed, sometimes decorated with bright colours, red and yellow, or painted with familiar domestic scenes (fig. 9). The roof was flat. At Kahûn it consisted of beams of wood, thatched

and plastered with mud both inside and out. Sometimes it was furnished with one or two ventilators, the *mulkafs* of modern Egyptian dwellings, and generally there was a washhouse on the roof, and a small sleeping-chamber for the slaves or the guards (fig. 10).

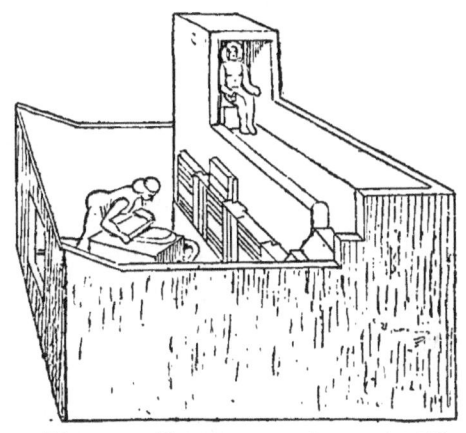

Fig. 10.—Box representing a house (British Museum).

The household fire was on the ground floor. The hearth was hollowed out of the earthen floor, usually to one side of the room, and the smoke escaped through a hole in the ceiling; branches of trees, charcoal, and dried cakes of ass or cow dung were used for fuel. At Abydos, in the primitive Thinite town, clustered round the Temple of Osiris, were found pottery hearths, in which charcoal was burnt —in one of them the cinders were still lying.

Fig. 11.—Mansion with granaries, from the tomb of Anna, Eighteenth Dynasty.

The mansions of the great and wealthy covered a considerable area; they generally stood in the midst of a garden or of a courtyard planted with trees, and like the

houses of the middle classes crenellated walls turned a blank front to the street (fig. 11). Thus the domestic life was secluded and concealed, and the pleasure of watching the passers-by was sacrificed to the advantages of not being seen. The door was approached by a flight of two or three steps or by a portico supported on columns (fig. 12), and adorned with statues (fig. 13), which gave it a monumental appearance, and indicated the social importance of the family; or again it consisted of a pylon similar to those at the entrance of the temples. The interior

Fig. 12.—Portico of mansion, second Theban period.

Fig. 13.—Portico of mansion, second Theban period.

WALL-PAINTINGS, TELL EL AMARNA.

almost resembled a small town divided into quarters by irregular walls. In some cases the dwelling-house stood at the farther end; while the granaries, stables, and domestic offices were distributed in different parts of the enclosure.

We have the remains of some houses at Tell el Amarna, and of the palace of Akhenaten of the Eighteenth Dynasty, and with their aid, guided by two of the numerous pictures or plans preserved in tombs of that period, we can gain a very fair idea of

the mansions of the great Egyptian nobles and of high officials.

The first of the pictorial plans that we will examine represents a Theban house, half palace, half villa

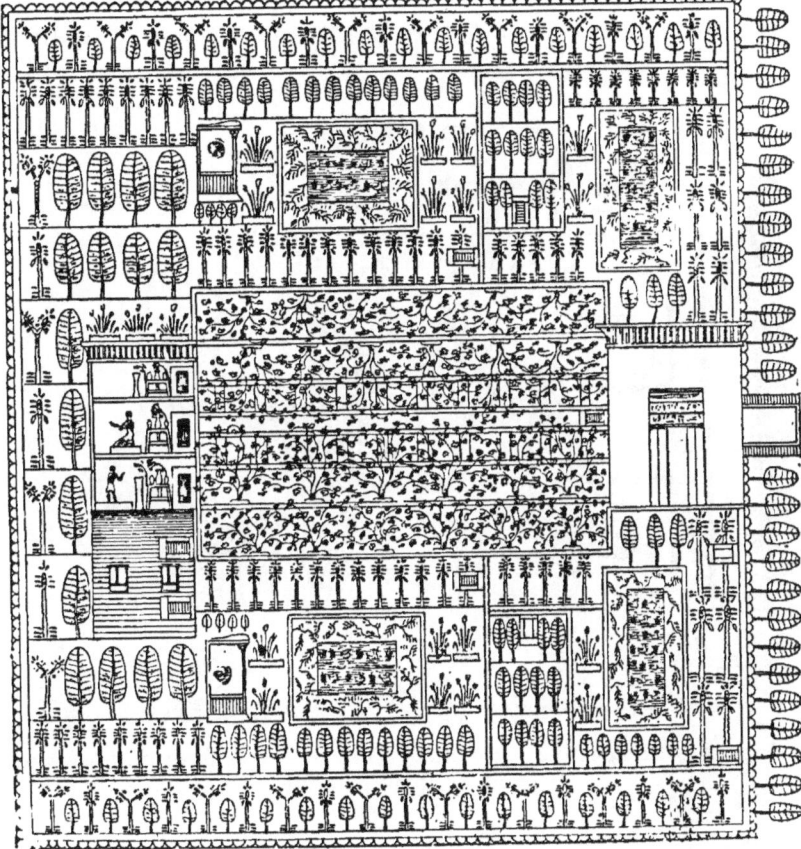

Fig. 14.—Plan of a Theban house with garden, from Eighteenth Dynasty tomb-painting.

(figs. 14, 15). The enclosure is rectangular, surrounded by a crenellated wall. The principal entrance opens upon a road bordered with trees, by the side of a canal or a branch of the Nile. The garden is

symmetrically divided by low stone walls. In the centre is a large trellis supported on four rows of small columns, to right and left are four pools stocked with ducks and geese, two leafy conservatories, two summer-houses, and avenues of sycamores, date-palms and dôm-palms. At the back facing the entrance

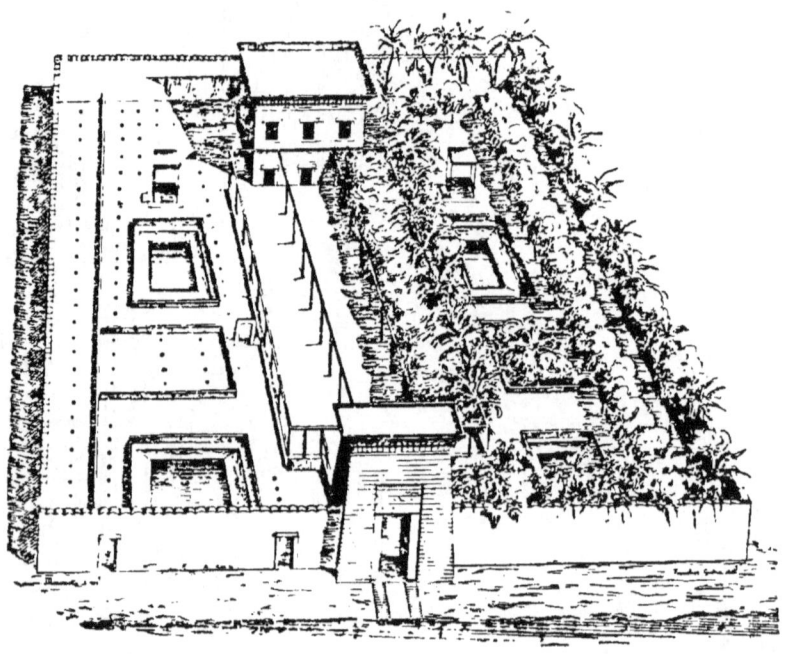

Fig. 15.—Perspective view of the Theban house, from Eighteenth Dynasty tomb-painting.

is the house, two-storied and of small dimensions, surmounted by a painted cornice.

The second plan is taken from one of the tombs of Tell el Amarna itself (figs. 16, 17). The house represented here, in the original picture stands at the end of a garden, surrounded by store-houses. It represents the palace of Aï, son-in-law to Akhenaten, who himself

FAÇADES OF MANSIONS.

in turn became King of Egypt. In front of the entrance to the palace there is an artificial pool of water with sloping sides protected by a curb, and with two sets of steps leading down to it.

The building itself is a rectangle, the façade wider than the sides. In the centre is a great doorway which opens into a courtyard or wide passage flanked by stone chambers. Two small chambers arranged symmetrically at each corner of the back wall contain the staircases that lead to the terraced roof. This outer building forms the frame to the actual dwelling-house. The façade has

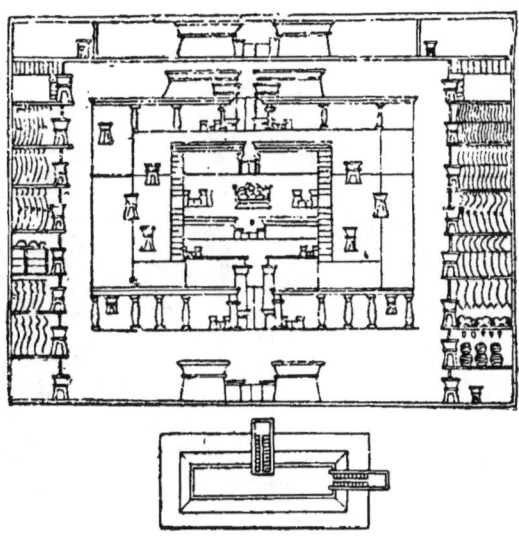

Fig. 16.—Part of the palace of Aï, from tomb-painting, Eighteenth Dynasty, Tell el Amarna.

a portico of eight columns, and is divided in the centre by the pylon. Passing through this doorway, one entered a sort of central passage divided by two transverse walls with doors in them so arranged as to form a series of three courts. The central one was flanked with chambers, the first and third opened right and left on smaller courts in which were the stairs leading to the roof. This central dwelling was the private dwelling of the king, or

the great nobles, where only the family and intimate friends had the right of access. The number of stories and the arrangement of the façade differed according to the caprice of the owner. The frontage was generally a plain wall. Sometimes it was divided into three parts, with the middle division projecting, in which case the two wings were colonnaded on each story (fig. 18) or surmounted

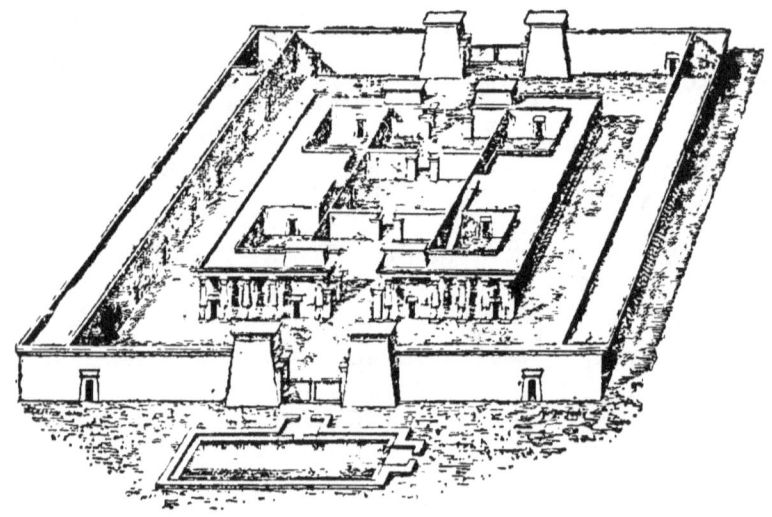

Fig. 17.—Perspective view of the palace of Aï, Eighteenth Dynasty, Tell el Amarna.

by an open gallery (fig. 19). The central pavilion occasionally has the appearance of a tower which dominates the rest of the building (fig. 20). The façade is often decorated with slender wooden colonnades that support nothing, but serve to relieve the severe aspect of the exterior. The decoration of the inner walls was generally very simple. They were usually whitewashed or colour-washed and bordered with a polychrome band, but in some

instances they were elaborately painted with pictured scenes. The ceilings were sometimes white, some-

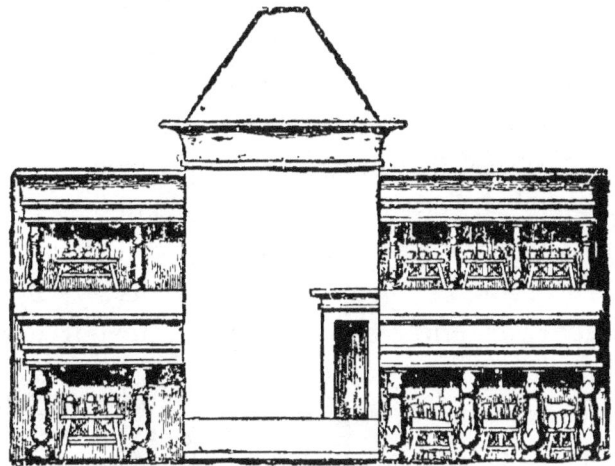

Fig. 18.—Frontage of house, second Theban period.

times decorated with geometric patterns (fig. 21), parti-coloured squares (fig. 22), or other conventional

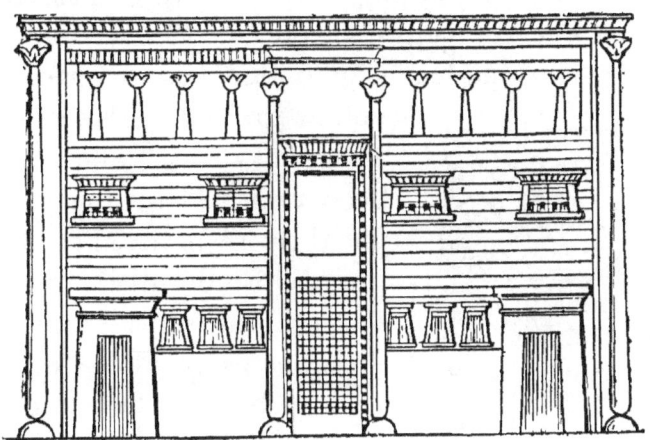

Fig. 19.—Frontage of house, second Theban period.

designs very similar to those in the tomb ceilings (fig. 23).

So far we have followed the pictured plans. We can now turn to the actual remains of the ruined palace of Akhenaten * at Tell el Amarna. A long double mud wall on the east extended the full length of the palace next the high road. In the centre this façade was broken by a great pylon with a chariot-way and two footways by which the palace was entered. To right and left were two chambers. At the south of the enclosure was an immense hall measuring 423 × 234 feet, containing 542 mud pillars 52 inches square, and communicating with five smaller halls. Here the pillars were whitened and the ceilings were painted with vine-leaves and bunches of grapes on a yellow ground. The palace is a mass of ruins. The stone has been removed by the villagers for their own use, but against the enclosing wall on the northeast are substantial remains of the queen's pavilion, including a large hall 21 feet × 51 feet, where is the well-known painted floor. Thence a door leads to an open colonnaded court. In the centre was a well 15 feet deep covered

Fig. 20.—Central pavilion of house, in form of tower, second Theban period.

Fig. 21.—Ceiling pattern from behind Medinet Hatû, Twentieth Dynasty.

Fig. 22.—Ceiling pattern similar to one at El Bersheh, Twelfth Dynasty.

* W. M. Flinders Petrie, *Tell el Amarna*, 1894.

with a canopy supported on beautiful columns and surrounded by a sculptured curb. Behind it are the remains of a *sakkieh*, or water-wheel. The passages surrounding it open into cubicles, and here at last we arrive at the sleeping-chambers of the ancient Egyptians. They measure 6 × 8 feet, and at the end of each is a sleeping-bench 2 feet wide by 6 feet long and 30 inches from the ground. Another bench at the side forms a table or seat.

Many of the pavements are painted. The limestone columns are inlaid with coloured glazes, the edges of which have been gilt. Wall painting was largely used. Above the ordinary dado, painted in red, white, and blue, were various scenes. One is thoroughly domestic. Single figures placed at intervals include a servant sweeping the floor with a palm-brush (fig. 24), and a cook who has left his wig behind, carrying two stands with bowls containing a joint of meat and some cakes. On the *harem* walls there are servants with cattle, a canal, a lake, lotus-plants, and sailing-boats. Elsewhere was a family group of the king and queen with their attendants and children. Religious scenes abound, and

Fig. 23.—Ceiling pattern from tomb of Aimadûa, Twentieth Dynasty.

the inevitable representations of bound captives also appear.

The finest pavement, which was almost perfect, was painted on a carefully prepared surface (fig. 25). It represented a tank of fish and lotus surrounded by groups of plants and flowers. Above these birds hovered, and calves and young cattle moved about among them. A black border round the tank repre-

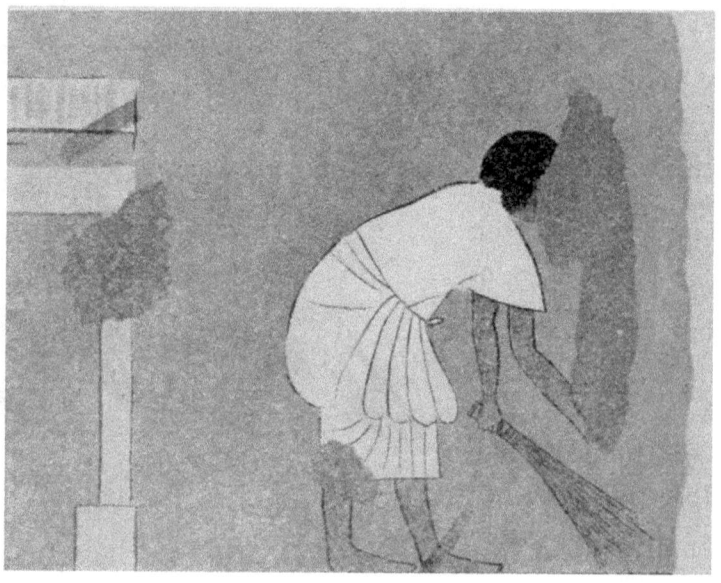

Fig. 24.—Wall-painting, palace of Tell el Amarna. W. M. F. Petrie.

sented the Nile mud, while the plants were growing on yellow sand. The whole design was most charming. The pavement, alas! was wantonly destroyed in 1912 by a native from the neighbouring village.

Some houses in the open desert were also excavated. They belonged to wealthy middle-class officials, and are of better quality than the houses of the Twelfth Dynasty of Kahûn. They vary much in detail, but

HOUSES OF TELL EL AMARNA.

the same important characteristics can be observed in all (fig. 26).

The approach to the house (A) was often up a flight of shallow steps, usually on the north, never on the south, and led to a room or possibly an open porch. Entering the house there is a lobby (Y) where the

Fig. 25.—Part of painted pavement, palace of Tell el Amarna. W. M. F. Petrie.

doorkeeper probably slept, and which leads into the columned loggia (L), well protected from the sun. There is a small room beyond (O). The centre of the house, and apparently the family sitting-room, is the square hall (H). It often has a bench or *mastaba* on one side. In front of this is the fire. There was no central hole in the roof, and the wide door may have afforded the only light, but it must be remembered in consider-

ing Egyptian architecture that in that land of sunshine a small opening will afford ample light for a large chamber. These are the public rooms. The remainder of the house divides into four parts, the master's room, and women's quarter; the men-servants' quarter; store rooms; and the staircase and cupboards. The room marked C is apparently the master's bedroom. D and E were probably used by the women for living and cooking, and they never lead outside the house.

The quarters for the men-servants have no communication with the women's quarters except in one instance. There is a large hall for their use, I, and a stone tank. J and K may be sleeping-rooms for the married

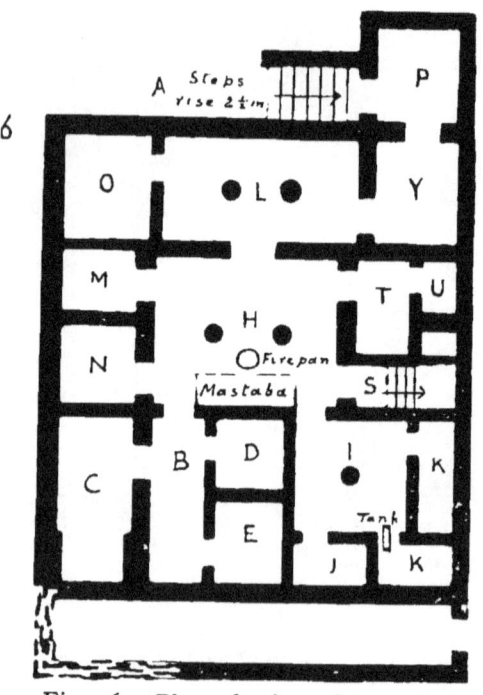

Fig. 26.—Plan of private house, Tell el Amarna. W. M. F. Petrie.

men. The staircase (S) is sometimes winding, and cupboards are arranged to fill in the spaces around and below it. The houses are enclosed in an outer wall. It was in a public building near by that the Tell el Amarna cuneiform tablets were discovered. These tablets bear the correspondence between Syria and the king of Egypt, and were discovered acciden-

tally by fellahîn in search of sebakh. The cuneiform scribe employed for the correspondence apparently lived close at hand.

The town of Tell el Amarna is now in process of being excavated.* At present two streets, roughly at right angles with each other, have been laid bare. These contained official houses built for the great court officials, the high priest, the chief architect, and others. Some of the walls still remain standing to a considerable height. The houses are not so important as the Palace of Aï, nor are the gardens so large, but they agree with the plans of smaller houses pictured in the tombs of the officials. The arrangement of the garden, the position of the house, and of the offices and stables are the same. The pool has not yet been found, but the well, with part of a large *shaduf* beside it is there, the garden beds, the summer-house surrounded by trees, the vegetable and herb gardens can be clearly traced, while in the stables the discarded harness was still lying. The house has the portico, the entrance hall, and two other halls, the stairs to the roof, the sleeping-chamber, or sometimes two, the bathroom, and the entrance door itself, so placed at right angles to the main passage, that visitors approaching could not command a view through the house—an arrangement we also observe in the houses of the middle classes just described.

Thus of the domestic buildings of the second Theban period we have a very remarkable amount of remains. The lamps made in the form of houses,

* L. Borchardt, *Mittheilungen Orient. Gesellschaft.*, Nos. 34, 1907, and 50, Oct. 1912.

which are found in such large numbers in the Fayûm, date only from Ptolemaic and Roman times; they serve to show that the same methods of building prevailed then as under the Eighteenth and Nineteenth Dynasties.

Fig. 27.—Door of a house of the Old Kingdom, from the wall of a tomb of the Sixth Dynasty.

As regards the domestic architecture of the Old Kingdom, the actual remains are few. Vestiges of the poorer houses of the Old Kingdom were found at Koptos. There the brick flooring was raised above the damp of the basal clay, by being laid on rows of inverted cylindrical pots of rough ware. There is evidence that previous to the Fourth Dynasty extensive use was made of wood. The flooring planks of a royal tomb of the First Dynasty at Abydos were placed on 17-inch beams, and the ceilings also of some of

the royal tombs were supported on great wooden beams nearly 20 feet in length. The stone roofing in several mastabas at Saqqara of the Fifth Dynasty is carved to imitate a roofing of beams.

To judge from the wall scenes, a large use seems to have been made of coloured matting laced to a framework, both for ceilings and inner walls ; good examples of the latter use may be seen represented in the tomb of Ptahhotep. Roofs of the Middle Kingdom at Beni

Fig. 28.—Façade of a Fourth Dynasty house, from the sarcophagus of Khûfû Poskhû.

Hasan are painted to represent ceiling beams with matting stretched between. The stelæ, tombs, and coffins of the Old Kingdom occasionally furnish us with drawings that show us the doorways of the period (fig. 27), and a sarcophagus of the Fourth Dynasty, that of Khûfû-Poskhû, is carved to resemble a house (fig. 28). From humbler graves of the Old Kingdom come a number of models of houses in rough pottery.* There is a great variety, ranging from mere huts of one or two rooms to the house of

* W. M. Flinders Petrie, *Rifeh*, 1907.

five rooms enclosed in a courtyard with high crenellated walls. The columned portico in front is almost invariable. The outside staircase to the roof is rarely absent, sometimes straight, sometimes winding; there are the *mulkafs*, the barred windows, the water tanks, and houses of two stories; on the roof are the small chambers, sometimes elaborated with colonnades; all as we have seen them under the Theban dynasties, and even the separate chambers, apart from the main building but within the enclosure, begin to appear.

2.—FORTRESSES.

The greater number of the towns, and even most of the larger villages, were walled. On the carvings of the archaic period we find them represented as oval or round enclosures, strongly fortified. After the union of the whole country under the dynastic sovereigns this jealous guarding of individual towns was still a necessary consequence of the geographical characteristics and political constitution of the country. Against the Bedouîn it was necessary to block the gorges leading to the desert: while against their king and their neighbours the great feudal lords fortified the towns in which they dwelt and those villages on their domains that commanded the mountain passes or the easily navigable parts of the river.

The earliest fortresses are those of Abydos, El Kab, and Semneh. Abydos was situated at the commencement of a road leading to the oases, and contained the celebrated sanctuary of Osiris. The renown of this temple attracted pilgrims, while the situation of

the town brought merchandise thither. The prosperity and wealth that accrued from these two sources exposed the city to incursions of Libyans, and it possessed two strongholds. The older of the two formed practically the core of the mound called locally the *Kom es Sultan* or "Mound of the King." Until recently the fort was remarkably perfect, but much of it has now been destroyed. It was a parallelogram of crude brick 410 feet long by 223 feet broad. The greater axis was from north to south. The principal entrance was in the west wall, not far from the north-west corner; and there were two of less importance, one on the south and the other on the east. The walls on the east side were from 24 to 36 feet high, having lost some of their original height, and they were about 6 feet thick at the top. They are not built in uniform courses, but as at El Kab two methods of building are employed, which are easily distinguishable. In the first the layers of bricks are strictly horizontal, in the second they are slightly concave and form a flattened arch of which the extrados rests on the ground. These two methods are regularly alternated. The object of this arrangement is obscure; it is said, however, that it takes the weight of the upper courses off the lower ones, and also that this construction is specially fitted to withstand earthquake shocks. Whatever the date of the walls, the fortress is extremely ancient, for as early as the Fifth Dynasty the noble families of Abydos invaded the enclosure, filling it with their tombs to the extent of depriving it of all strategic value. A second fortress, now called the *Shunet ez Zebib*, was

built some hundred metres to the south-east about the time of the Twelfth Dynasty, and replaced the stronghold of Kom es Sultan, but under the Ramessides it narrowly escaped sharing its fate. It was only the sudden decline of the town that saved it from being equally choked with tombs and funerary stelæ.

The Egyptians in early times possessed no engines

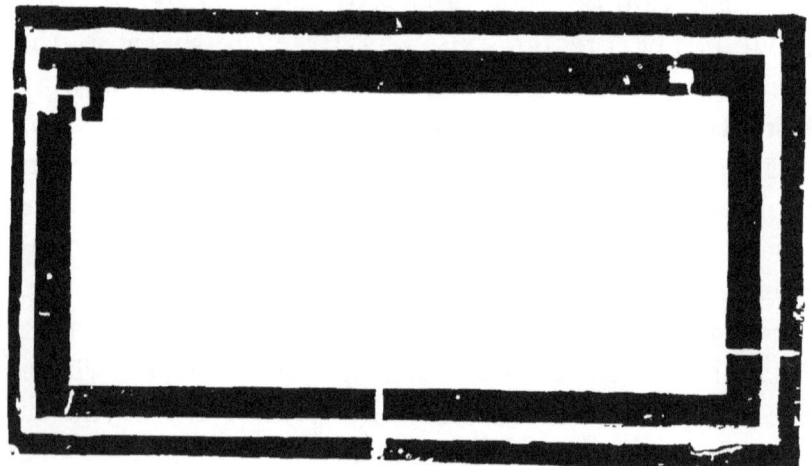

Fig. 29.—Plan of second fortress of Abydos, Eleventh or Twelfth Dynasty.

capable of breaking down massive walls. They had only three methods of forcing a stronghold; by escalade, sapping, or forcing the gates. The plan adopted by their engineers in building the second fort is admirably adapted for protection against these three modes of attack (fig. 29). The walls are long and straight, without towers or projections of any kind; they measure 430 feet in length on the east and west sides, and 255 feet on the north and south. The foundations rest directly on the sand, and no-

THE SECOND FORTRESS OF ABYDOS. 31

where are they more than a foot below the surface. The wall (fig. 30) is of crude brick laid in horizontal courses. It has a slight batter, is solid without loopholes of any sort, and is panelled outside with vertical angulated grooves similar to those on buildings of the Thinite period and Old Kingdom. The present height is 36 feet, and when perfect it cannot have exceeded 40 feet, a height which would amply suffice to safeguard the garrison against any escalade by portable ladders. The thickness of the wall is about 20 feet at the base, and about 16 feet at the top. The upper part is entirely destroyed, but figured representations (fig. 31) show that such walls were sometimes left plain and sometimes crowned with a continuous cornice and a narrow, low, crenellated parapet, the merlons of which were generally rounded, rarely square. The path round the ramparts, although narrowed by the thickness of the parapet, cannot have been less than 13 or 15 feet wide. It extended without a break round the four sides, and was reached by narrow staircases hidden

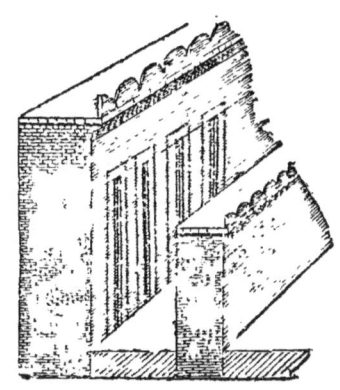

Fig. 30.—Walls of second fort at Abydos, restored.

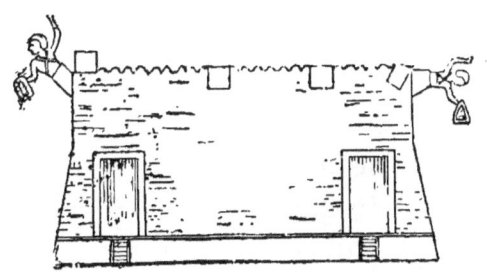

Fig. 31.—Façade of fort, from wall-scene, Beni Hasan, Twelfth Dynasty.

in the masonry and now destroyed. There was no foss, but, as a protection against sappers, a crenellated covering wall was erected some 10 feet in front of the main wall. This second wall was about 16 feet high. These precautions were sufficient to guard against sapping and escalade, but the gateways remained as so many gaping breaches in the fortifications. They formed the weak point on which attack and defence alike were concentrated. The fortress at Abydos had two gateways, the main one situated near the east end of the north front (fig. 32). A narrow opening (A), closed by massive wooden doors, marked the place in the covering wall. Behind it was a small *place d'armes* (B), constructed in the thickness of the main wall, and behind this a second door (C) as narrow as the first one. When the foe had forced this door, in face of the besieged posted on the walls, who would rain projectiles on him in front and on both sides, he had yet further perils to face. He had to cross an oblong court (D) hemmed in between the walls, and two counter forts built out at right angles. Here, completely exposed to the attacks of the defenders, he would have to force a postern gate (E), placed intentionally in the most inaccessible corner. The principle on which these gates were

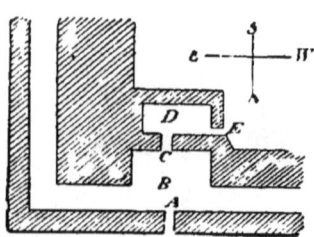

Fig. 32.—Plan of main gate, second fortress of Abydos.

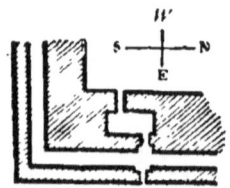

Fig. 33.—Plan of south-east gate, second fortress of Abydos.

constructed is practically the same everywhere, but they vary slightly according to the wishes of the engineers. At the south-east gate of the fortress of Abydos (fig. 33) the *place d'armes* between the two walls is omitted, and the court is constructed entirely in the thickness of the main wall. At Kom el Ahmar, opposite El Kab, the block of brickwork in which the door is cut projects boldly (fig. 34).

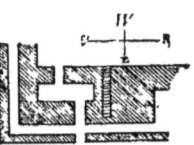

Fig. 34.—Plan of gate, fortress of Kom el Ahmar.

Various posterns disposed at irregular intervals facilitated the movements of the garrison and enabled them to carry out a variety of sorties.

The same system of fortification employed for fortresses was also employed for the defence of towns. Everywhere, at Heliopolis, at Sân, at Saïs, and at Thebes, the walls are straight, without towers or bastions: they form either a square or an elongated parallelogram, without foss or outposts. The thickness of the walls, which varies from 35 to 70 feet, renders such precautions unnecessary. The jambs and lintels of the gates, or at any rate of the principal ones, were of stone, sculptured with historical scenes

Fig. 35.—Plan of the walled city at El Kab.

and inscriptions, as, for instance, the door at Ombos, which Champollion saw yet *in situ*, and which dated from the reign of Thothmes III.

The oldest and best preserved walled city in Egypt, El Kab, dates back to the beginning of Egyptian history; the remains of the oval enclosure of pre-dynastic days can still be traced within the outer walls of the later fortress (fig. 35). This great stronghold was partially washed away by the Nile some years ago, but at the beginning of the nineteenth century it formed an irregular quadrilateral enclosure measuring 2,100 feet in length by about one-sixth less in breadth. The south front is constructed on the same principle as Kom es Sultan, sections of horizontal layers of brick alternating with others where they are concave. On the north and west the layers undulate regularly without a break from end to end of the walls. The walls are 38 feet thick, and average 30 feet in height. Stairways constructed in the thickness of the walls, and also spacious ramps, lead to the top. The enclosure contained a considerable population, and within the wall on the north side is a cemetery of the earliest type of graves. The temples were grouped together in a square enclosure, concentric with the outer wall, and this second enclosure served as a keep where the

Fig. 36.—Plan of walled city at Kom Ombo.

FORTIFIED HEIGHTS. 35

garrison could still hold out long after the rest of the camp had fallen into the hands of the enemy.

The rectangular plan, though excellent in flat country, was not always adapted for hilly country. When the site to be fortified was on a height, the Egyptian engineers understood well how to adapt the line of defence to the slope of the ground. At Kom Ombo (fig. 36) the walls exactly follow the outline of the isolated mound on which the town is perched. Their eastern front is broken by irregular projections that roughly suggest the modern bastion. At Kummeh and Semneh in Nubia, where the Nile emerges from the rocks of the second cataract, the arrangements are still more skilful, and show real genius. Senûsert

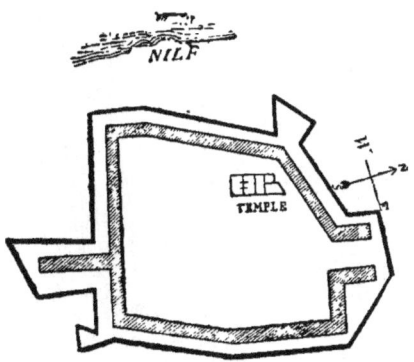

Fig. 37.—Plan of fortress of Kummeh.

(Usertesen) III. had there fixed the Egyptian frontier: the fortresses he constructed were intended to bar the waterway against the vessels of the negroes of the south.

At Kummeh, on the right bank, the position is one of great natural strength (fig. 37). Upon the rocky, precipitous hill an irregular square was enclosed measuring about 200 feet each way. Two long salients or elongated bastions were constructed, one on the north to command the road leading to the gate of the fortress, and the other on the south to

guard the course of the river. The covering wall is 13 feet in front of the main wall, and follows its lines except at two points, the north-west and south-east angles, where it has two bastion-like projections. On the opposite side of the river at Semneh the position is not so favourable. The east side is protected by a sheer cliff that descends perpendicularly to the river, but the other sides are only too easy of access (fig. 38). On the top of this cliff a wall about 50 feet high was built, but on the other side towards the plain the wall was over 80 feet in height, and bristled with counterforts (A, B), 50 feet long by 30 feet wide at the base, and 13 feet at the top. These were placed at irregular intervals according to the requirements of the defences; they had no parapets, and took the place of towers. They added much to the security of the fortress as they commanded the access to the top of the walls, and enabled the besieged to direct a flank attack against the enemy if any attempt was made to force the main walls. The interval between these counterforts is calculated so that the archers could sweep the whole intervening space with their arrows. Both curtains and salients are in crude brick, with large beams

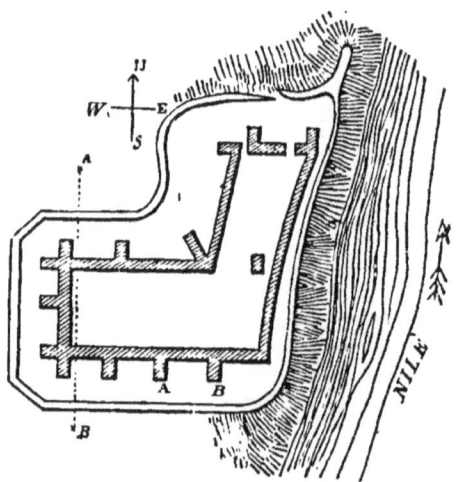

Fig. 38.—Plan of fortress of Semneh.

built horizontally into the mass. The outer face is in two sections, the lower one almost vertical, the upper one sloping at an angle of about 70 degrees, an arrangement which made it extremely difficult if not impossible to scale the walls. The whole of the enclosure inside the walls was filled in after the fashion of a *terre-plein* almost to the level of the ramparts (fig. 39).

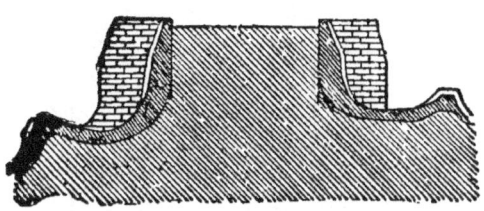

Fig. 39.—Section of the platform at A, B, of preceding plan.

Externally the covering wall of dry stone was separated from the main building by a foss 100 to 130 feet wide; it followed the general line of the main wall with considerable accuracy, and varied from 5 to 10 feet in height according to the situation. On the north it was cut by the winding pathway leading to the plain. These arrangements, clever as they were, could not save Semneh from falling into the hands of the enemy; a large gap on the south side between the two salients nearest the river marks the spot where the final assault was carried by the enemy.

Fig. 40.—Syrian fort.

The great Asiatic wars of the Eighteenth Dynasty which secured for the victorious Pharaohs their eastern empire taught the Egyptians new methods

of fortification. The nomads of southern Syria erected small forts to which they could retreat when threatened with invasion (fig. 40). The Canaanite and Hittite cities, such as Ascalon, Dapûr, and Merom, were surrounded by massive walls, generally built of stone, and flanked by towers (fig. 41). Cities built on plains, such as Qodshû (Kadesh), were entrenched behind a

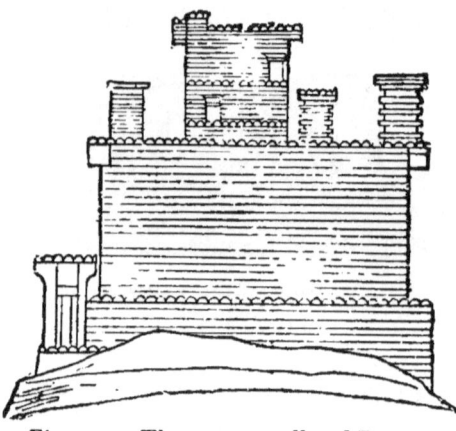

Fig. 41.—The town walls of Dapûr.

double foss filled with water (fig. 42). The Pharaohs introduced into the Nile valley some of these new types, whose value they had learnt during their campaign. From the beginning of the Nineteenth Dynasty, the eastern frontier of the Delta, the weakest point of Egyptian defences, was protected by a series of blockhouses similar to those of Canaan.

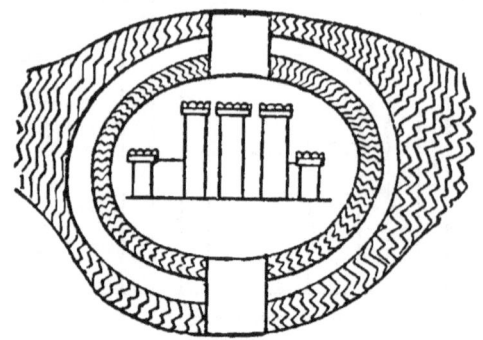

Fig. 42.--City of Kadesh, from bas-relief, Ramesseum.

Not content with appropriating the actual thing, the Egyptians also adopted the name and called these watch-towers by the semitic name of *magadilû*

(migdols). Brick did not appear to be sufficiently strong for towns exposed to incursions of Asiatics, and the walls of Heliopolis and Memphis were now cased in stone. Nothing now remains of these new fortifications, and we should be forced to turn to pictured representations to learn the appearance of these migdols, were it not that, owing to royal caprice, we possess a model in a place where we should least expect to find it— in the Theban necropolis.

Fig. 43.—Plan of the pavilion of Medinet Habû.

When Rameses III. planned his funerary temple (figs. 43, 44) he decided to commemorate his Syrian victories by giving it a military appearance. On the eastern side is a battlemented covering wall of

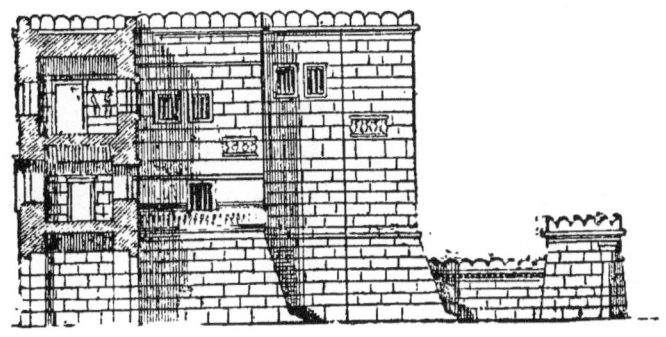

Fig. 44.—Elevation of pavilion, Medinet Habu.

stone, which averages 13 feet in height. In the middle of the wall is the gateway, protected by a huge quadrangular bastion. This is 6 feet 8 inches broad, flanked by two small oblong guardrooms,

the roofs of which are about 3 feet higher than the coping of the ramparts. Having entered this gateway, we are actually face to face with a *migdol*. Two blocks of masonry, themselves the basement of towers, enclose a court which is narrowed by successive projections of the masonry. These blocks are finally united by a building two stories high, which forms a lofty gateway. The eastern faces of the towers are on a sloping substructure about 16 feet high. This was built with two objects in view, first to increase the strength of the wall at a point where it was possible to sap it, and also because projectiles flung from the battlements would rebound against the slope and keep assailants at a distance. The total height is about 70 feet, and the breadth in front rather more than 80 feet. The buildings situated behind and at the sides of the gateway were destroyed in ancient times. The details of the decoration are adapted to the character—half religious, half triumphal —of the building. It is, however, improbable that real fortresses were decorated with brackets and bas-reliefs similar to those we see here on the walls of the guard-rooms. Such as it is, the so-called pavilion of Medinet Habû is a unique example of the perfection to which the Pharaohs had brought military architecture.

After the time of Rameses III. we are left almost entirely without examples of fortified buildings. Towards the end of the eleventh century B.C. the high priests of Amen repaired the walls of Thebes, of Gebeleyn, and of El Hibeh. The territorial division of the country which took place under the

successors of Sheshonk compelled the princes of the nomes to increase the number of their strongholds. The campaign of Piankhi on the borders of the Nile was a series of successful sieges, but there is nothing to lead us to suppose that the art of fortification had made any sensible progress at that time. When the Greek Pharaohs took the place of the native rulers they probably found fortifications similar to those constructed by the engineers of the Eighteenth and Nineteenth Dynasties.

3.—PUBLIC WORKS.

In such a country as Egypt a permanent system of roads is unnecessary; the Nile is the natural highway for commerce, and the top of the embankments and the footpaths that intersect the fields are amply sufficient for foot-passengers, for cattle, and for the transport of goods from village to village. Ferry-boats for crossing the river, fords wherever the canals were not too deep, and permanent causeways placed across water furrows, completed the system. Bridges were rare; up to the present time we only know of one in ancient Egypt; and whether that one was long or short, built of wood or of stone, supported on arches or formed of a single span, we know nothing. Under the walls of Zarû it crossed the canal that separated the eastern frontiers of the Delta from the

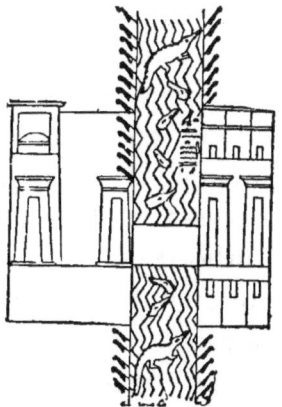

Fig. 45.—Canal and bridge of Zarû, from bas-relief, Karnak.

desert regions of Arabia Petræa. On the Asiatic side the bridge was protected by a fort (fig. 45). Thus the maintenance of means of communication, which is so costly an item among modern nations, played a very small part in the annual budget of the Pharaohs; they were responsible for only three important services, that of storing, of irrigation, and of mining and quarrying.

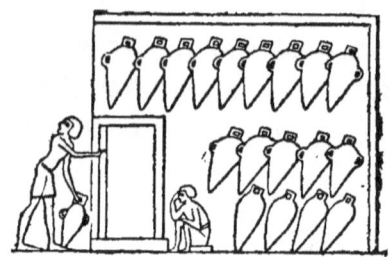
Fig. 46.—Cellar, with amphoræ.

Taxes were collected in kind, and Government officials were paid on the same system. Monthly distributions were made to the workpeople of corn, oil, and wine, while from end to end of the social scale, each functionary, in return for his services, received cattle, stuffs, manufactured goods, and certain quantities of copper or precious metals. It was, therefore, necessary that the fiscal authorities should have command of vast storehouses for the reception of the taxes demanded of the people. Each class of goods had its separate quarter walled in, and protected by vigilant guards.

Fig. 47.—Granary.

There were large stables for the cattle; cellars where the amphoræ were piled in regular layers or hung in rows on the walls (fig. 46), each with the date of the vintage written on the side; and oven-shaped granaries where the grain was

STOREHOUSES.

poured in through a shuttered opening in the roof (fig. 47), and taken out through a trap near the ground.

At Thûkû (identified with Pithom by M. Naville) the store-chambers are rectangular (A, A. fig. 48), of various sizes, and have no direct communication with each other: the wheat was both put in and taken out at the top. At the Ramesseum the thousands of ostraca and of jar-stoppers scattered over the place prove that the ruinous brick buildings immedi-

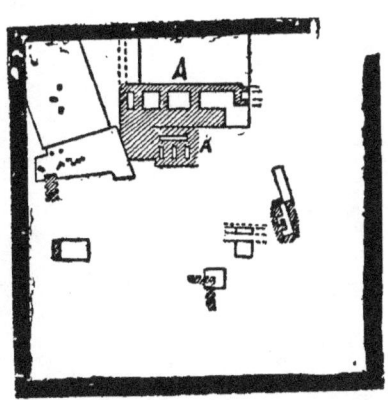

Fig. 48.—Plan of Pithom.

ately behind the temple contained the stores of wine belonging to the god. These chambers are long vaulted passages placed closely side by side, and were originally surmounted by a platform (fig. 49).

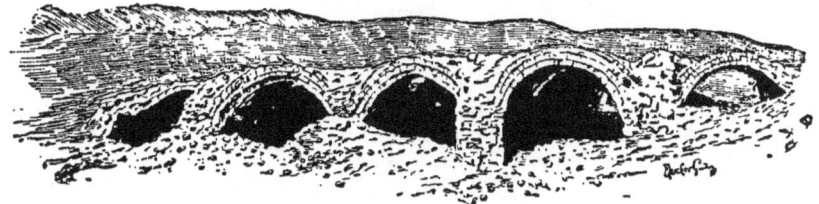

Fig. 49.—Store-chambers of the Ramesseum.

Philæ, Ombos, Daphnæ, and most of the frontier towns of the Delta possessed store-houses of this kind, and many more will be discovered when a systematic search is made for them.

The system of irrigation has not greatly changed during the course of centuries. Some new canals have been cut, others have slightly changed their course, while a larger number have been silted up, owing to the negligence of the proprietor, but the general scheme and methods of irrigation are the same. They do not demand much skilled labour. Wherever I have been able to examine the ancient canals, I have found no trace of masonry, either at the commencement or even at the weak points of their course. They are mere ditches from 20 to 70 feet wide; the earth flung out during the work of excavating, and thrown to right and left formed irregular sloping banks from 7 to 14 feet high. An early bas-relief, now at Oxford, shows one of the kings of the archaic period, in full state, pick in hand, breaking the sod for a new canal or some other public work, while an attendant holds a basket (fig. 50).

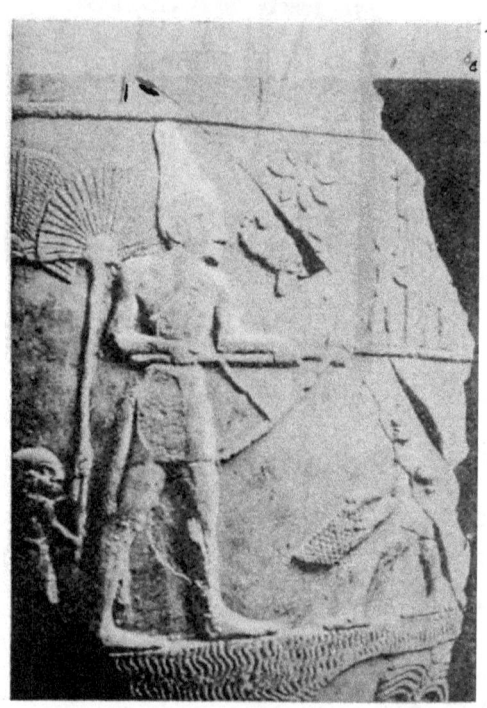

Fig. 50. King, wearing the crown of upper Egypt, attended by fan-bearers, inaugurating some public work. Part of carved mace head, Oxford.

IRRIGATION.

The ancient canals were generally straight, but occasionally some slight irregularity in the ground would turn them out of their course, and they would form immense curves. The dykes that traverse the plain, intersect the canals at intervals and divide the valley into basins, which retain the water during the months of the inundation. These dykes are generally of earth, though sometimes of baked brick, as in the province of Girgeh. The embankment at Kosheish is very exceptional; it is constructed of worked stone, and was made by Menes, the first king of the First Dynasty, for the benefit of his new city of Memphis. This system of dykes began near Silsilis, and extended to the sea, keeping close to the Nile throughout its course, except at Beni Sûef, where it threw out an arm in the direction of the Fayûm. It crossed the rocky barrier of the Libyan mountains near Illahûn by a narrow and sinuous gorge, which possibly was artificially deepened and then widened into a fanlike network of many ramifications. The inundation retreated after having watered the province, and the water nearest the Nile returned by the way it came, while the remainder found its way into a series of lakes, the largest of which is known to-day as the Birket el Karûn. If we are to believe Herodotus, the matter was by no means so simple. King Moeris desired to establish a reservoir in the Fayûm to regulate the uncertain supply of water from the inundation, which was called after him Lake Moeris. Did the inundation prove insufficient, the water in the lake could be let loose to the required extent and maintain the flood at the

height required for middle Egypt and the western Delta. Another year, if the flood proved too great, Moeris could absorb the overplus and retain it till the flood subsided. Two pyramids crowned with colossal figures, one representing the king who constructed the lake and the other his wife, were situated in the middle of the lake. So says Herodotus, and he has puzzled engineers and geographers. How was it possible in the Fayûm to find a site for a piece of water not less than 90 miles in circumference? The best accredited theory of our day was that of Linant, that it was situated at the base of the Libyan mountains between Illahûn and Medinet el Fayûm; but recent excavations have proved that the supposed embankments are modern, and probably do not date back more than 200 years. If Herodotus ever visited the Fayûm it must have been in the summer, when the whole district has the appearance of a huge lake. What he mistook for the borders of the lake were the embankments that divide the basins and afford communication between the various towns. Major Brown has lately shown that the nucleus of "Lake Moeris" was the Birket el Karûn. It was known to the Egyptians as *Miri*, the Lake; from this the Greeks derived their *Moiris*, a name extended also to the inundation of the Fayûm.

I do not believe in the existence of an artificial lake. The only works of that class attempted by the Egyptians are less pretentious; these are the stone barriers constructed at the mouth of the ravines that descend from the mountains into the plain. One of the most important was observed in 1855 by Dr.

STORAGE OF WATER. 47

Schweinfurth, about six miles and a half to the southwest of the baths of Helwân, at the entrance of Wady Gerraweh (fig. 51). It answered two purposes—it stored up water for the workmen engaged in the neighbouring alabaster quarries, and it broke the power of the torrents that rush down from the desert after the winter rains. The ravine measures about 240 feet in width, and the sides 40 to 50 feet in height. The dam was constructed of three successive layers making a total thickness of 143 feet. There was first a layer of clay and rubbish from the hillside (A), then a piled-up mass of large blocks of limestone, and finally a facing wall of worked stones backed the whole on the east side (B). Each layer of stone was narrower than the one below it, and the whole dam formed a sort of immense staircase. Thirty-two of these steps still exist out of the original thirty-five, and about one-fourth of the barrage is still standing at the two ends, though the centre has been swept away by the torrent (fig. 52). A similar barrier transformed the lower part of Wady Genneh into a small lake whence the miners of Sinai procured their water supply.

Fig. 51.—Dyke at Wady Gerraweh.

Fig. 52.—Section of Dyke at Wady Gerraweh.

Most of the localities from which Egypt obtained her metals and valuable stone were difficult of access, and the mines would have proved useless had not the Egyptians constructed roads and rendered life more possible for those who laboured there. The route to the quarries of Wady Hammamat where diorite and grey granite were obtained was provided at intervals with cisterns hewn in the rock. Some meagre springs ingeniously husbanded and stored in these cisterns made it possible to establish whole villages at the quarries and also at the emerald mines on the borders of the Red Sea. Hundreds of voluntary workers, as well as slaves and condemned criminals, lived there in misery under the command of a dozen taskmasters, and under the brutal control of mercenary soldiers, either Libyans or negroes. The slightest revolution in Egypt, an unsuccessful war, or any political trouble would for a time put an end to this unnatural existence; the labourers would desert, the Bedouin would harry the colony, the guards in charge of the convicts would return to the valley of the Nile, and the work would be abandoned.

The choicest materials such as diorite, basalt, black granite, porphyry, green or yellow breccia were only sparingly used for architectural purposes, as it was necessary to organise regular expeditions of soldiers and workmen to procure them, and they were reserved almost exclusively for sarcophagi and valuable statues. The quarries of limestone, sandstone, alabaster, and red granite which supplied the ordinary material for temples and funerary monuments were found in the Nile valley, and were therefore easily obtained. When

the vein intended to be worked formed one of the lower strata of the mountain, tunnels and chambers were excavated often to a considerable distance. Square pillars of the rock left standing at intervals supported the roof, and stelæ carved in the most conspicuous places recorded for posterity the names of the kings and engineers who commenced and carried on the work. Several of these quarries when exhausted or aban-

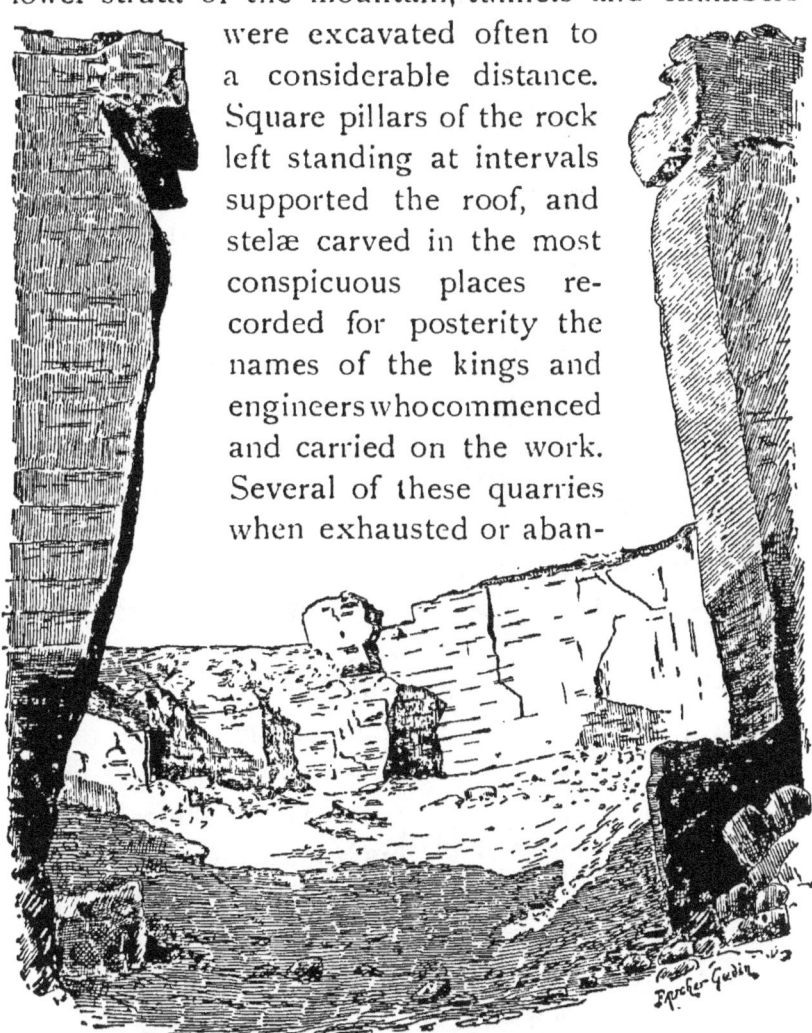

Fig. 53.—Quarries of Silsilis.

doned were turned into chapels; the Speos Artemidos for instance, which was dedicated by Hatshepsut, Thotmes III., and Seti I. to Pakhet, the local goddess.

The most important limestone quarries are at Tùrah and Massarah, almost opposite Memphis. This stone was in great request for sculptors and architects, and was in fact one of the finest materials employed for statuary. Strong as it is, it lends itself marvellously to the most delicate requirements of the chisel, it hardens by exposure and soon acquires a creamy colour very restful to the eye. At Silsilis there are vast beds of sandstone, and these were quarried in the open (fig. 53). There we find escarpments from 40 to 50 feet high worked from top to bottom with the pick, or sometimes divided into stages to which access is afforded by steps scarcely wide enough for a man. The walls are grooved with parallel lines, some horizontal, some sloping from left to right or from right to left in such a fashion as to form blunted chevrons, enclosed in a rectangular frame of grooves an inch, or an inch and a half wide, and 9 or 10 feet in length. These are scars left by the scratching of the tools of the ancient workman, and show the method he employed to obtain his blocks. They were sketched out on the rock in red ink, sometimes in the form in which they were to appear in the projected

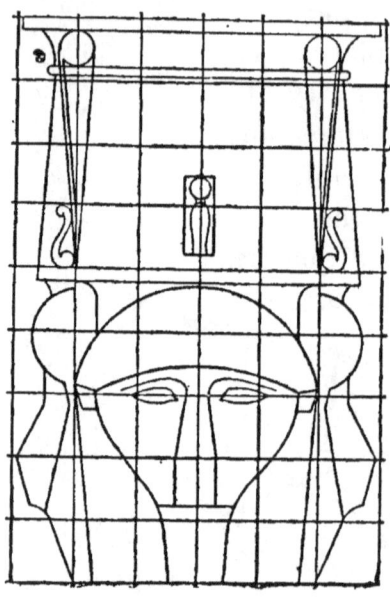

Fig. 54.—Draught of Hathor capital in quarry of Gebel Abû Fêdah.

building. The members of the *Commission d'Égypte* copied the diagrams and squared designs of several capitals in the quarries of Gebel Abû Fêdah (fig. 54). These outlines having been drawn, the vertical incisions were made by means of a long metal chisel driven in perpendicularly or obliquely by powerful blows from a mallet. The horizontal detachments were effected solely by bronze or wooden wedges inserted in the direction of the rock strata. The first working of the block was often done before it was detached from the rock; thus at Assûan we see an immense length of granite which is probably an unfinished obelisk, and

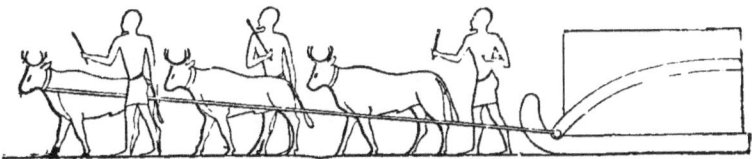

Fig. 55.—Bas-relief from one of the stelæ of Aahmes, at Tûrah, Eighteenth Dynasty.

at Tehneh there are drums of columns only half disengaged.

Transport was effected in various ways. At Assûan, at Silsilis, at Gebel Sheikh Herîda, and at Gebel Abû Fêdah the quarries are literally washed by the waters of the Nile, and the stone was merely rolled from its place on to the barges. At Kasr es Said and at Tûrah, localities some distance from the river, boats were brought to the foot of the cliff by means of canals constructed for the purpose. Where it was impossible to arrange for transport by water, the stone was loaded upon sledges drawn by oxen (fig. 55) or even dragged by gangs of workmen with the help of rollers.

CHAPTER II.

RELIGIOUS ARCHITECTURE.

As the earliest dwellings we know of the Egyptians were made of wattle and daub, so were the temples of the primitive period. An attempt was made to give them some dignity of appearance. A few posts in front marked off a small enclosure, on either side of the doorway were two high masts, and over the door protruded four curved objects; what they were we cannot identify from the few representations that are all we have to guide us. A carving of the time of Menes, first king of United Egypt, shows a small sanctuary that lacks even this decoration, but it is surrounded by a palisade, and inside the enclosure are the masts and also a symbol of the goddess Neith, to whom doubtless the building was dedicated.

This primitive method of temple building was soon superseded. The Egyptians early acquired the art of building in stone, and by the time of the Pyramid builders they had carried it to the highest perfection. The Pharaohs desired to build *eternal dwelling-places* for the gods, and for this purpose stone appeared to be the only material sufficiently durable to withstand the attacks of men and the ravages of time.

I.—MATERIALS AND PRINCIPLES OF CONSTRUCTION.

It is a mistake to suppose that the Egyptians used only large blocks for their buildings. The size varied greatly according to the purpose for which they were intended. Architraves, drums of columns, lintels, and door jambs were sometimes of very considerable dimensions. The largest architraves known, those above the central aisle of the hypostyle hall at Karnak, average 30 feet in length. Each one represents a solid block of 40 cubic yards and weighs about 65 tons. Generally, however, the blocks are not larger than those in ordinary use among ourselves. They vary from 3 to 4 feet in height, from 3 to 8 feet in length, and from 18 inches to 6 feet in breadth.

Some temples are built throughout in one kind of stone, but more frequently materials of various kinds and quality are associated, although in unequal proportions. Thus the main buildings of the temples of Abydos are of very fine limestone, while in the temple of Seti I. the columns, architraves, jambs, and lintels, all those parts where limestone might not be sufficiently strong, are in sandstone, and in the temple of Rameses II. they are in sandstone, granite, and alabaster. Similar combinations are to be seen in the temples of Karnak, Luxor, Tanis, Deir el Baharî, Gizeh, and Memphis. At the Ramesseum, at Karnak, and in the Nubian temples, where all these materials are combined, the columns rest on a solid foundation of crude brick. The stones were dressed more or less carefully according to the position they were to occupy. When the walls were of medium thickness

they were well wrought on all sides. When the wall was thick the core consisted of blocks roughed out as nearly cubic as possible and piled together, while the gaps between them were filled in with chips, pebbles, or mortar. The casing stones were carefully wrought on the upper and lower sides as well as on the face, while at the back they were roughed with the pick to hold the mortar. The largest of these blocks were used for the lower courses, a very necessary precaution, as the architects of the Pharaonic period afforded almost as shallow foundations for the temples as they did for houses and palaces. At Karnak the foundations of the walls, columns, and obelisks are barely 7 to 10 feet in depth; at Luxor, on the side close to the river, the walls rest on a gigantic substructure of three courses of masonry, each of them about $2\frac{1}{2}$ feet in height. At the Ramesseum the course of dried brick which supports the colonnade does not appear to measure more than 7 feet. These depths are very insignificant, but the experience of ages has proved them to be sufficient. The hard compact humus which everywhere forms the soil of the Nile valley is so contracted by the annual subsidence of the inundation that it is rendered almost incompressible. The weight of the masonry gradually increased as the building progressed, and thus the maximum of pressure was attained and a solid basis secured. Wherever I have bared the foundations of the walls, I can testify that they have not shifted. This is the case even at Karnak, which I examined after the fall of the columns in 1899.

It was customary at the building or rebuilding of

FOUNDATIONS AND FOUNDATION DEPOSITS. 55

a temple to place deposits under the foundations consisting of small squares of the building materials and models of the tools employed. Also a number of amulets, which were probably intended to secure by magic the safety of the temple. These foundation deposits are generally found in a layer of clean sand, and marvellously fresh and uninjured. Many of the objects are inscribed with the name of the royal founder of the temple, and it was by means of its intact foundation deposits that one of the ruined temples to the south of the Ramesseum was identified as that of Queen Taûsert of the end of the Nineteenth Dynasty, although all its walls were razed to the ground. Among the glazed objects found in this deposit were scarabs, plaques, models of offerings, besides many beads. The metal objects include adze, knife, axehead, hoes, and chisels, made in thin sheet copper. There were also jars and cups, an ebony cramp, and a model corn-grinder. The foundation deposits of the Eighteenth Dynasty temple at Deir el Baharî furnished numerous models of workmen's tools, including the wooden centrings used in constructing brick vaulting. These were neatly inscribed in blue ink with the cartouche of the foundress Hatshepsût. Two deposits at the western entrance of this temple afford evidence of a ceremony customary at the foundation of a temple.* An animal was slain and the flesh laid on a floor of clean sand over which the blood was allowed to drip; vessels containing unguents and wine were smashed and their contents,

* Earl of Carnarvon, *Five Years' Exploration at Thebes*, Oxford University Press, 1912.

together with grains of corn, were poured into the cache in addition to the offering of flesh and blood.

The system of construction employed by the ancient Egyptians in many points resembles that of the Greeks. The stones are often placed with dry joints without binding of any sort, the masons trusting to their weight to keep them in position. Sometimes they are held together by metal cramps of copper or lead or, as in the temple of Seti at Abydos, by dovetails of sycamore wood, marked with the royal cartouche. Elsewhere they are bound together by mortar laid on more or less thickly. The specimens of mortar I have hitherto collected are of one or other of three kinds. The first is white and easily reduced to a powder, being merely lime, the second is grey and rough to the touch, a mixture of lime and sand, the third owes its reddish appearance to pounded brick-dust mixed with the lime and sand. The judicious use of these methods enabled the Egyptians to rival the Greeks in the skilful laying of regular courses of even blocks with the vertical joints symmetrically alternated. If the work is not always equally good the fault must be attributed to the imperfect mechanical means at their disposal.

Outer walls, party walls, and secondary façades were usually perpendicular, and the building materials required for them were raised by a huge lifting jack placed on the top. The walls of pylons, of principal façades, and sometimes even of secondary façades were built with a batter of varying slope. For their construction inclined planes or ramps were erected and heightened as the building progressed. Both methods

were equally dangerous. However carefully the blocks were protected there was great risk of damaging the edges and corners or even of breaking the blocks in pieces. They almost always required some re-working, and in order to avoid waste, the workman would actually insert pieces of stone in places that had been badly chipped, or he would bevel the end, making the joint sloping instead of vertical. If a stone was too short or not high enough, the difficulty was met by inserting a supplementary slab, or again a stone that was too large was allowed to overlap and fill a corresponding gap in the course above or below it (fig. 56). These expedients, at first designed to remedy accidents, degenerated into habitually careless ways of working. The masons who had inadvertently drawn up too large a block did not trouble to lower it again, but adjusted it by one of the expedients just mentioned.

Fig. 56.—Masonry in temple of Seti I. at Abydos.

The architect did not give sufficient attention to superintending the working or the laying of the blocks and would allow the vertical joints to come immediately over each other for two or three courses. When utilising materials from ruined edifices he would not trouble to work them into shape; round shafts of older columns were thus mixed with rectangular blocks in the walls of the Ramesseum.

The main building completed, the facing was worked smooth, the joints were re-worked and washed over with a coating of cement or stucco, coloured to match the masonry, which concealed the

imperfections of the original work. The walls rarely end abruptly, they are bordered by a torus round which a sculptured ribbon is entwined, and crowned either with the splayed cornice surmounted by a flat band (fig. 57), or, as at Semneh, by a square cornice, or, as at Medinet Habû, by a line of battlements. Thus framed they have much the appearance of huge panels without projections and almost without openings. Windows, always rare in Egypt, are here mere air-holes, intended to give light to the

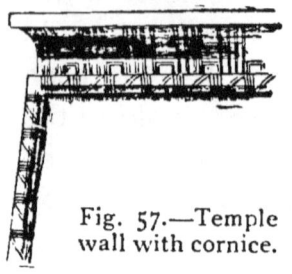

Fig. 57.—Temple wall with cornice.

staircases, as in the second pylon of Horemheb at Karnak, or else on festival days to support the ornamental woodwork. The doorways afforded little relief to the flat surface of the building (fig. 58) except when the lintel was surmounted by a flat band and cornice. The pavilion at Medinet Habû is the solitary exception, and has real windows, but it was constructed on the model of a Syrian fortress and can only be quoted as an exception.

Fig. 58.—Niche and doorway in temple of Seti I. at Abydos.

The floor of the court and chambers consisted of rectangular paving stones arranged with considerable

regularity except in the inter-columnar spaces. Here, hopeless of adapting them to the curved line of the bases, the architects fitted in fragments of stone without order or method (fig. 59). Vaulting,* which was customary in dwelling-houses, was scarcely ever employed in the temples. It is, however, to be found at Deir el Baharî, and in the seven parallel sanctuaries at Abydos. Even in these instances it is effected by corbelling.

Fig. 59.—Pavement of the portico of Osiris in temple of Seti I. at Abydos.

The corbel is formed by three or four horizontal courses, each of which projects beyond the preceding one, until the two sides meet. The rough curve thus obtained is then chiselled into the form of an arch (fig. 60). The roof is usually formed of large stone slabs placed closely together; when the space between the walls was not too great, a single row of slabs covered it, but when this was not possible the roof supports had to be placed at intervals varying in number according to the space to be covered. Architraves

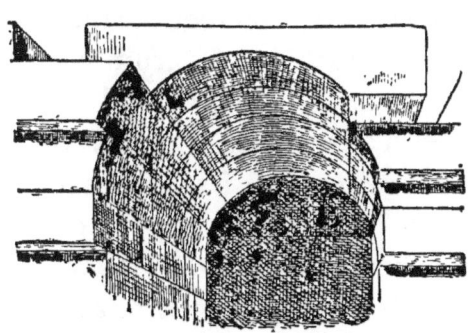

Fig. 60.—Corbelled arch in temple of Seti I. at Abydos.

* The earliest true arch known in Egypt is in a mastaba at Bêt Khallaf of the Second or Third Dynasty.

resembling immense stone beams were laid across the supports and formed a framework on which the roofing slabs were laid.

There were two types of these supports, the pillar and the column. Some of these are monoliths. The pillars of the great granite temple at Gizeh measure 16 feet in height by 4½ feet in width, and the red granite columns found scattered among the ruins of Saqqara, Bubastis, Memphis, and Alexandria, range from 20 to 26 feet in height and are all cut in one piece. But columns and pillars are commonly built in courses, which are often irregular, like those of the walls that surround them. The great columns of Luxor are not even solid, two-thirds of the diameter are filled up with yellow cement which has lost its strength and crumbles between the fingers. The capital of the column of Taharka at Karnak is composed of five courses of stone, each about 4·8 inches high. The upper and most projecting one is composed of twenty-six stones the points of which converge towards the centre and are held in place solely by the weight of the square die above it. The same carelessness we have already observed in the workmanship of the walls also occurs in the workmanship of the pillars and columns.

Fig. 61.—Hathor 'pillar, Abû Simbel.

The quadrangular pillar, with parallel or slightly sloping sides, and with or without base or capital, appears frequently in Memphite tombs. It occurs also at Medinet Habû, and at Karnak in what is

known as the processional hall. The sides are frequently covered with pictures or hieroglyphic inscriptions, and the principal face of the pillar has a special scheme of decoration. There are stems of lotus or papyrus on the pillar-stelæ of Karnak, a Hathor head surmounted by the sistrum of the goddess at the smaller speos of Abû Simbel (fig. 61), a standing figure of Osiris in the first court at Medinet Habû, and of Bes at Denderah and Gebel Barkal. At Karnak, in the chapel that was probably constructed for Horemheb from the ruins of a sanctuary of Amenhotep II. and III., the pillar is capped by a cornice, separated from the architrave by a shallow abacus (fig. 62).

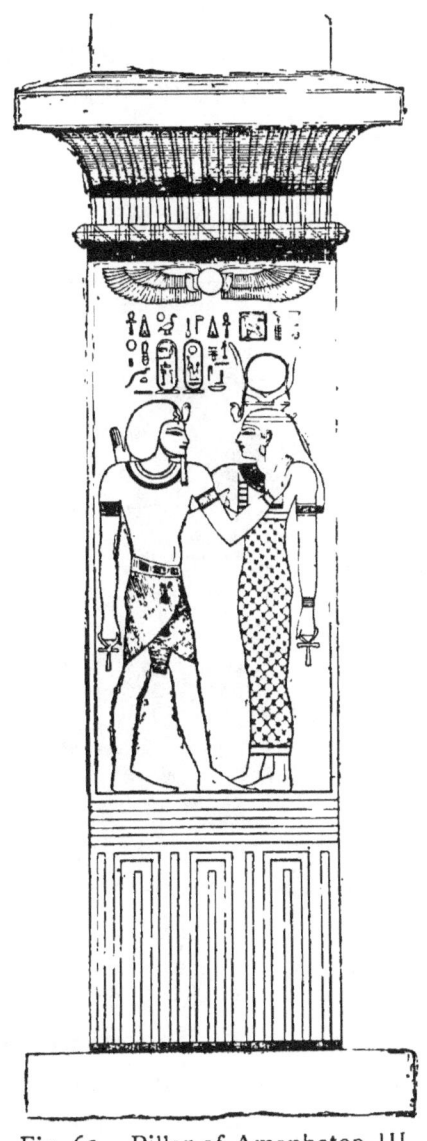

Fig. 62.—Pillar of Amenhotep III., Karnak.

By cutting away the four edges the pillar is rendered octagonal and by

again removing the eight edges it becomes sixteen-sided. Some pillars in the tombs of Assûan and Beni Hasan are of this type, as well as in the processional hall of Karnak (fig. 63) and in the funerary temples of Deir el Baharî.

Besides the types thus regularly evolved there are others of abnormal derivation, pillars with six, twelve,

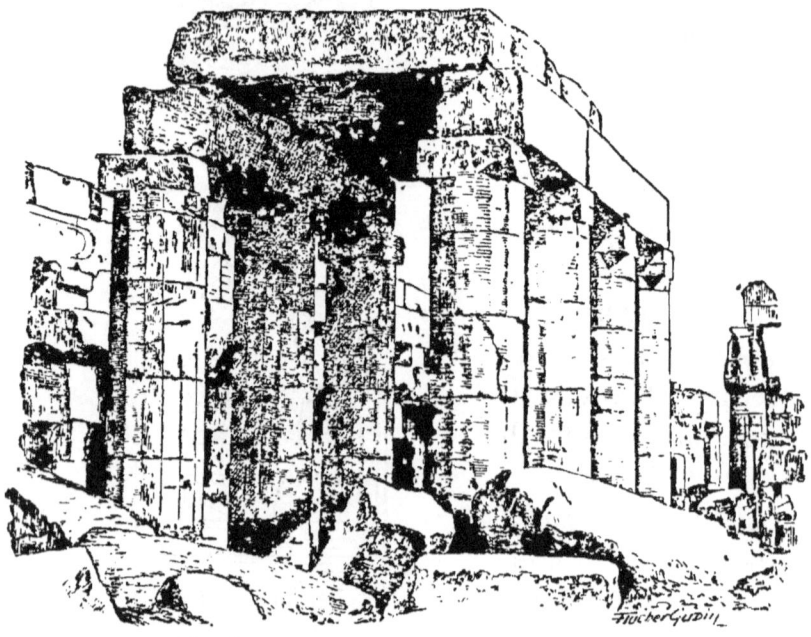

Fig. 63.—Sixteen-sided pillars, Karnak.

fifteen, or twenty sides, or verging on a perfect circle. The pillars of the portico of the temple of Osiris at Abydos end the series. Here the main part of the pillar presents a curvilinear section scarcely broken by the plain band at the top and bottom which is of the same diameter. Frequently the sides are slightly fluted; and sometimes, as at Kalabsheh, the

flutings are divided by four fillets into four groups of five (fig. 64). The polygonal pillar has always a broad, low disc-shaped plinth. At El Kab it has a Hathor head projecting from the face of the pillar near the top (fig. 65), but almost everywhere else it ends in a simple square abacus which joins it to the architrave. Thus treated it bears some likeness to the Doric column and explains why Jomard and Champollion, in the first ardour of discovery, called it *proto-Doric*, a title for which there is little justification.

Fig. 64.—Fluted pillar, Kalabsheh.

The column does not rest immediately upon the ground. It always has a plinth similar to that of the polygonal pillar, a solid disc intended to distribute the weight. This base is generally plain, or ornamented at most with a line of hieroglyphs, it is sometimes flat, sometimes rounded off at the edge.

The principal variants of the column resolve themselves into four classes: 1st, the column with campaniform or bell-shaped capital, on which is carved either lotus or papyrus in flower or bud; 2nd, the column with lotus-bud capital; 3rd, the column with palm-leaf capital; 4th, the column with Hathor-head capital.

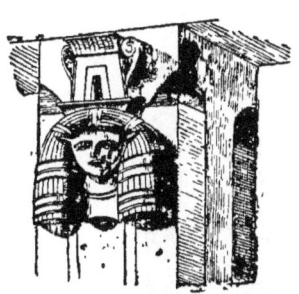

Fig. 65.—Polygonal Hathor-headed pillar, El Kab.

64 RELIGIOUS ARCHITECTURE.

I. *Column with Bell-shaped Capital.*—The shaft is generally plain or simply sculptured with inscriptions or bas-reliefs. Sometimes, however, as at Medamot, it is compounded of six large and six small columns alternated. During Pharaonic times the lower part swelled out slightly in bulbous form and was decorated with curvilinear triangles in imitation of the large leaves that sheathe the sprouting plant. The curve is so calculated as to equalise the diameter at the base and at the top. In the Ptolemaic period the bulb often disappeared, owing probably to Greek influence: the columns that surround the first court of the temple at Edfû rise straight from their plinths. The shafts invariably contract either from the bulb or immediately from the base, and end above in three or five superimposed flat bands. At Medamot, where the shaft is clustered, the architect evidently considered that a single tie did not appear sufficient to secure the cluster of twelve columns, and he has marked out two other rings of flat bands

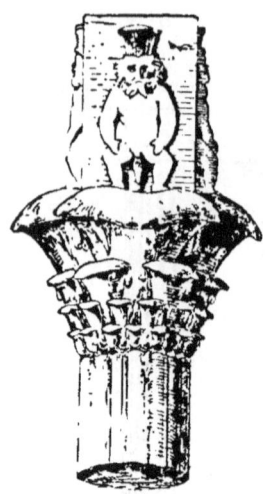
Fig. 66.—Column with square die.

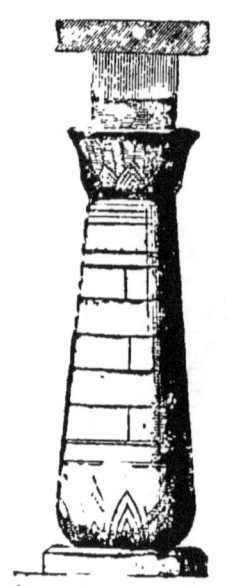
Fig. 67.—Column with campaniform capital, Ramesseum.

at regular intervals. Round the neck of the bell-shaped capital is a row of leaves similar to those at the base, and from these spring stems of lotus and papyrus in flower and bud. The height of the capital and its projection vary according to the taste of the architect. At Luxor the campaniform capitals measure 11½ feet in diameter at the base, 17¼ feet at the top, and 11½ feet in height. At Karnak in the hypostyle hall the height is 12¼ feet, and the greatest diameter 21 feet. A square die surmounts the whole. This is fairly low, and almost completely masked by the curve of the capital. In rare instances, as in the small temple of Denderah, the die is higher, and on each face is sculptured in relief a figure of the god Bes (fig. 66).

This column with campaniform capital is most usually employed in the central aisles of hypostyle halls, as at Karnak, the Ramesseum (fig. 67), and Luxor; but it is not confined to that purpose, and it is to be seen in the porticoes of the Fifth Dynasty valley temples at Abûsir, and those of Medinet Habû, Edfû, and Philæ. A very curious variant is to be seen in the processional hall of Thothmes III. at Karnak, where the campaniform capital is reversed as well as the shaft itself (fig. 68); the smaller end of the column rises from the plinth and the largest part is at the top. This ungraceful arrangement met with no success, and we find no

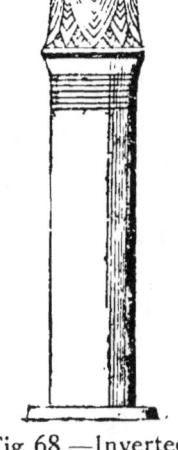

Fig. 68.—Inverted campaniform capital, Karnak.

trace of it elsewhere. Other novelties were happier, especially those that enabled the artist to introduce decorative elements derived from the flora of the

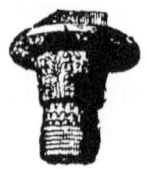 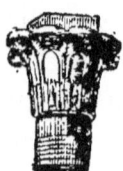 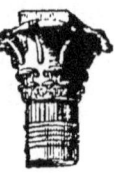 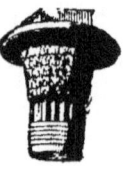

Fig. 69.—Compound capital. Fig. 70.—Ornate capitals, Ptolemaic.

Nile valley. As we approach the Ptolemaic period we find the capitals decorated with groups of dates and of half-unfolded blossoms (fig. 69), while under

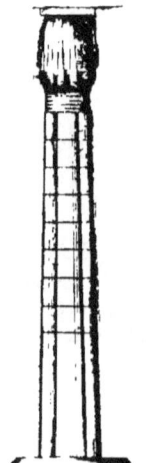

Fig. 71.—Lotus-bud column, Beni Hasan.

the Ptolemies and Cæsars the capitals became wreaths of flowers and leaves symmetrically arranged and painted in the brightest colours (fig. 70). There is a great variety of designs; at Edfû, Ombos, and at Philæ one might imagine that the artist had vowed never to repeat the same pattern on the same side of the portico.

II. *Column with Lotus-bud Capital.*—It is probable that this column originally represented a bundle of lotus-stems, the buds tied together round the neck by four or five bands to form the capital. The columns of Beni Hasan consist of four rounded stems (fig. 71), while those of the Labyrinth, the processional hall of Thothmes III., and of Medamot consist of eight stems with projecting ridges on the face of the column (fig. 72). The foot

LOTUS-BUD CAPITALS. 67

of the column is bulbous and adorned with leaves; the top is bound with three or five bands. From the lowest of these descends a moulding of three vertical bands in the space between each pair of stems and forms a kind of fringe round the upper part of the column. A surface thus broken up is not well adapted for hieroglyphic decoration, and therefore the projections were gradually done away with and the surface left plain. In the hypostyle hall at Gurneh the shaft is divided into three sections: the middle one is plain and covered with sculptures, while the upper and lower divisions are formed of clustered stems. In the temple of Khonsû, in the lower parts of the hypostyle hall of Karnak, and in the portico of Medinet Habû, the whole shaft is plain; the fringe under the bands is retained, however, and the existence of the stems is indicated by a slight ridge in the intervals between the bands (fig. 73). The capital also became degraded. At Beni Hasan it is gracefully fasciculated from top to bottom. In the processional hall of Thothmes III. at Luxor and at Medamot a

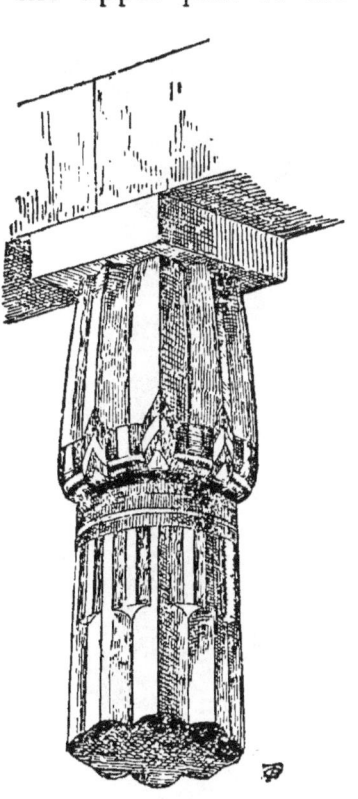

Fig. 72.—Lotus-bud column, processional hall of Thothmes III., Karnak.

circle of small pointed leaves and channellings surrounds the base and impoverishes the effect; the capital is little more than a truncated and fluted cone. In the hypostyle hall at Karnak, at Abydos, the Ramesseum, and at Medinet Habû, the flutings are superseded by a variety of ornamentations, triangular leaves, hieroglyphic inscriptions or bands bearing cartouches flanked with uraei, which fill the space thus left vacant. The abacus is not concealed as in the campaniform columns, but stands out boldly and bears the royal cartouche.

Fig. 73.—Column in aisles of hypostyle hall, Karnak.

III. *Column with Palm-leaf Capital.*—This column rises direct from its plinth, and tapers regularly and slightly to the top. It supports a crown of palm-branches springing from the band, their heads curving under the weight of the abacus (fig. 74). This column, well known in work of later date, is now shown to be of very early origin. The funerary temples attached to the pyramids of the Pharaohs of the Fifth Dynasty at Abûsir have been excavated, and many columns of this type have been found. It is very charming and graceful. At Abûsir, below the central palm-branch, there falls from the fivefold

band a short loop, which may represent the cord by which the Egyptian climbs the palm. The plinth is low and somewhat flat; above the capital there is a cubical block of stone.

IV. *Column with Hathor-head Capital.*—We find examples of the Hathor-headed column dating from ancient times, as at Deir el Bahari, in the temples both of the Eleventh and Eighteenth Dynasties; but this order is best known in buildings of the Ptolemaic period, as at Contra Latopolis, Philæ, and Denderah. The shaft and base present no special characteristics, they resemble those of the

Fig. 74.—Palm-leaf capital.

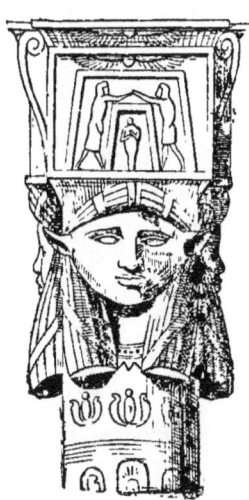

Fig. 75.—Hathor-head capital, Ptolemaic.

campaniform columns. The capital represented Hathor, the woman's head with the heifer's ears, carved in high relief on each side of a square block. Her hair, bound over the brows by three vertical bands, falls behind the ears and over the shoulders. Each head supports a fluted cornice, on which stands a naos flanked by two volutes and crowned by a shallow abacus (fig. 75). Thus four Hathor-heads form the capital of the column. Seen from a distance the whole structure recalls one of those sistra represented in religious bas-reliefs held in the

hands of queens and goddesses. It is in fact a sistrum; but the usual proportions have been disregarded—the handle is enormous, while the upper part of the instrument is immeasurably reduced. This design proved so popular that it was unhesitatingly combined with elements borrowed from other orders. The four heads of Hathor placed above a campaniform capital furnished Nectenebo with the composite type employed in his pavilion at Philæ (fig. 76). The combination cannot be said to be very satisfactory; nevertheless, seen in position it is less ugly than it appears in drawings.

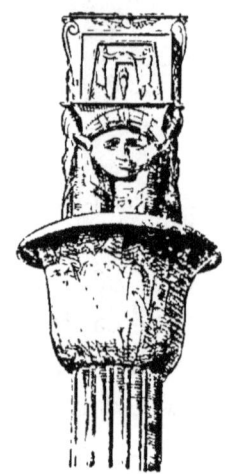

Fig. 76.—Campaniform and Hathor-headed capital, Philæ.

Shafts of columns were regulated by no fixed rules of proportion or arrangement. The architect could, if he wished, assign equal heights to columns of very different diameters, and, without regard to any considerations apart from those of general harmony, he could design the various parts on whatever scale he pleased. The dimensions of the capital bore no fixed relations with those of the shaft, and the height of the shaft in no way depended on the diameter of the column. At Karnak the dimensions of the campaniform columns of the hypostyle hall are as follows: the capital is 10 feet high, the shaft is rather less than 55 feet high, and measures 11 feet 8 inches in diameter near the base: at Luxor the capital is $11\frac{1}{2}$ feet high, the shaft 49 feet high, and $11\frac{1}{4}$ feet

round the bulb. At the Ramesseum shaft and capital measure 35 feet, round the bulb 6½ feet. There is a similar irregularity in the arrangement of the architraves; their height is determined by the taste of the architect or the necessities of the building. So also with the spacing of columns. Not

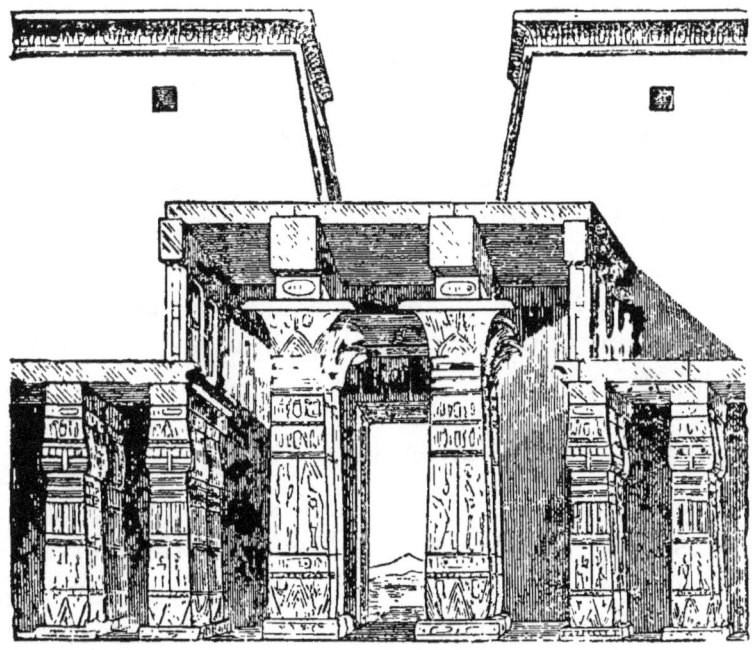

Fig. 77.— Section of hypostyle hall at Karnak, showing the arrangements of the campaniform and lotus-bud columns.

only do the intercolumnar spaces vary greatly in different temples and chambers, but in some instances, as in the first court of Medinet Habû, they vary in the same portico. This was the case when the various architectural types were employed separately, when they were associated in the same building; it was not considered necessary to give them fixed

proportions in harmony with each other. In the hypostyle hall of Karnak the campaniform columns support the highest part, and the lotus-bud columns are relegated to the lower aisles (fig. 77). In the temple of Khonsû there are halls where the lotus column is the highest, and others where the campaniform columns are the loftiest. At Medamot all the columns that still remain are of uniform height. Egypt never had definite orders of architecture such as Greece possessed. Her architects attempted all possible combinations to which the elements of the column lent themselves, but without assigning to them such definite proportions, that, given one member of it, it would be possible to deduct even approximately the dimensions of the remaining parts.

2.—TEMPLES.

Most of the famous sanctuaries, Denderah, Edfû, Abydos, were founded before Menes by the Servants of Horus. It is probable that originally they were mere huts, but they were rebuilt, remodelled, and added to by successive generations till nothing remained of the primitive design to show us what it was like. The funerary temples of the Memphite kings have actually been excavated, and furnish abundant examples of the religious architecture of the great pyramid period.

Seneferû, last king of the Third Dynasty, built his pyramid at Medûm, and on the east wall is his small temple, built entirely of limestone. It consists of a passage, a chamber, and finally a court, where

stood two stelæ nearly 14 feet high, flanking a limestone altar. The whole is plain, without decoration or inscriptions. There are traces of a walled causeway leading to it from the plain.* The temple was much visited during the Eighteenth Dynasty by scribes, who left *graffiti* recording their admiration of the building and their belief that Seneferû had raised it for himself and his queen.

The ruined funerary temple of the second pyramid of Gizeh, that of Khafra, was completely excavated in 1910, and the plan recovered.† The builders of the pyramids brought their materials by boat during the inundation to the foot of the hill, where a quay was constructed to receive them, and the weighty stones were then dragged up a sloping causeway to the building site. The pyramid and its temple completed, it appears that a gateway that was also a temple was built on the quay, and the causeway covered in, thus connecting the upper temple with its complement below. Ramps were also constructed by which the high quay or terrace could be approached from the valley after the water had subsided. The valley temple would be of great importance to visitors arriving by water during the inundation, and it was provided with everything necessary for the cult of the dead.

The temple of the second pyramid has been completely ruined, but the valley temple is almost perfect, the well-known granite temple that stands about 50

* W. M. F. Petrie, *Medûm.*

† U. Hölscher, *Das Grabdenkmal des Königs Chephren.* Ernst von Sieglin Expedition, 1912,

yards to the south of the sphinx. It was discovered in 1853, and partially excavated. In 1910 the façade was relieved of the 30 feet of sand under which it was buried; the causeway that connects it with the upper pyramid temple was also cleared, and the entire group can now be studied as a whole, flanked by the great sphinx, which probably represents Khafra himself guarding his temples and pyramid by the magic power possessed by a sphinx.

The main axis extends from east to west. The core masonry of the valley temple is of fine Tûrah limestone; the casings, pillars, architraves, and every part of the building visible from below was constructed of great blocks of red granite or alabaster. The façade was plundered in ancient times, and little of the casing remains. Mounting one of the two ramps (fig. 78) that led to the quay, the visitor was confronted by a building that externally resembled a mastaba. The sloping walls were unbroken save by two doors near the north and south corners of the façade. These doors were guarded on both sides by sphinxes, over 25 feet in length, of which only the substructures now remain. In front of the façade in the centre was a naos, which closed with double doors, and probably contained a statue of the Pharaoh. The granite doorways were inscribed, but most of the blocks have disappeared. The plan of the interior is very simple. Both doors communicate with a vestibule, which opens into a hall in shape of the letter T, supported by sixteen square granite pillars 16 feet high. At the south-west corner of this hall there is a recess, in which are six niches in two rows

GRANITE TEMPLE OF KHAFRA. 75

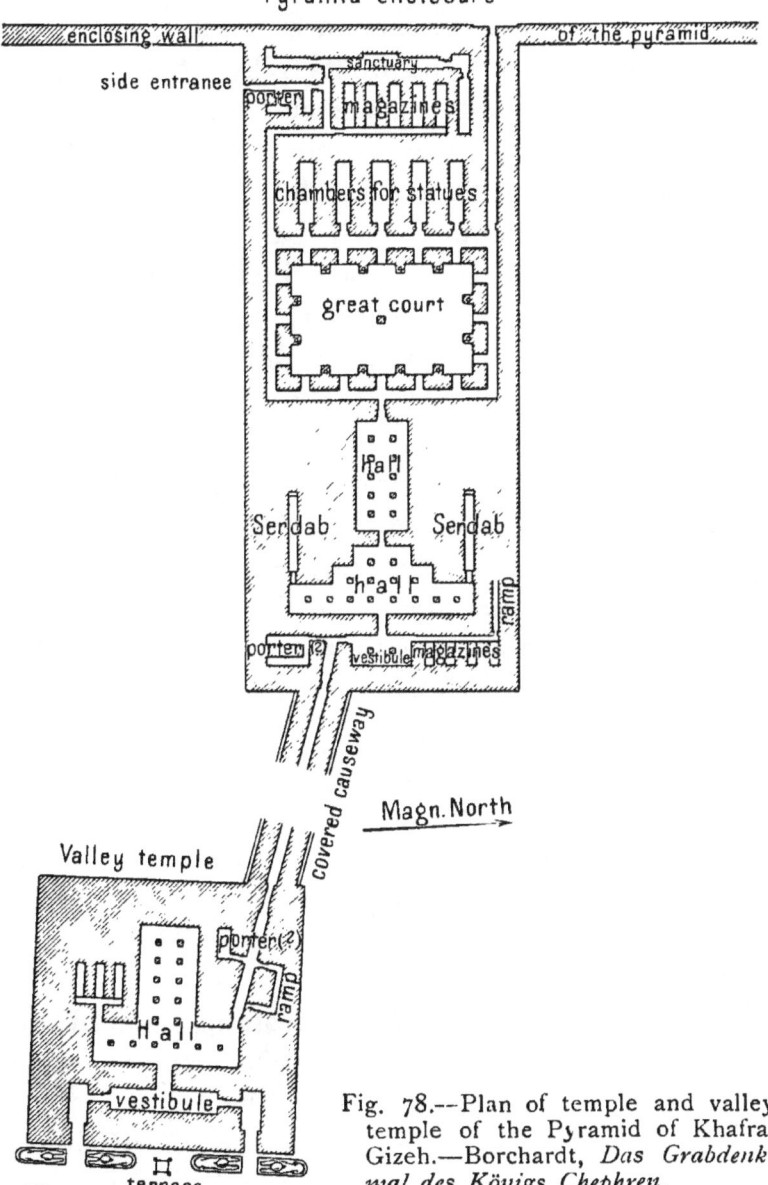

Fig. 78.—Plan of temple and valley temple of the Pyramid of Khafra, Gizeh.—Borchardt, *Das Grabdenkmal des Königs Chephren*.
By permission of Messrs. Hinrichs.

one above another. The transverse corridor which unites them is provided with small openings for ventilation, a very necessary arrangement, as here doubtless were stored the lights, oils, sacred vessels, and other requirements of the cult. At the north-west corner of the great hall there is a chamber built entirely of alabaster, which has hitherto been called the porter's lodge, but which has only the same scanty ventilation as the magazines. The roof is reached by ramps.

The great hall is lighted by oblique openings constructed in the angle of the roof and the top of the walls. The floor, like that of the vestibule, is of alabaster. There are no inscriptions, bas-reliefs, or paintings, and yet the walls produce as great an impression as the most richly decorated temples, the result of severe simplicity of outline, and exactness of proportion, combined with the grandeur of solid blocks of granite. A mass of fragments of broken statuary, and a careful examination of the flooring under the alabaster by the members of the Sieglin Expedition, have shown that round this hall was ranged a series of twenty-three seated statues of Khafra, more than life-size. Most of them were in alabaster, others were in mottled blue-grey diorite and in greenish metamorphic schist.

The causeway is of plain limestone, lighted by small apertures at regular intervals. It measures 1,308 feet in length, and opens at the top end into the upper temple. On the left was a small chamber, which may have been a doorkeeper's lodge, and on the right was the vestibule flanked on the north side

by store-chambers. Two halls in succession led to the great court. Two very deep, narrow cells, apparently serdabs (cf. p. 143), communicated with the first of these halls by two small slits. The great open court was surrounded by a passage, and all round its walls at regular intervals were doorways that opened into it, five on each long wall, and three at each end. These doorways were painted with hieroglyphic inscriptions in green and blue, and between each was an Osiride figure, presumably a portrait of Khafra. The surrounding passage opened on the west side into five deep and narrow chambers, each of which probably contained a statue of the king, as similar recesses for statues have been found in the mortuary temples of the Fifth Dynasty. Behind was a series of magazines or storerooms. Against the western wall was the sanctuary, with the niche for the false door and stela, in its place parallel to the eastern wall of the pyramid.

At the south-west corner there was a second entrance, for the convenience of those who approached the temple from the high ground, with chambers for the doorkeeper. The work of the upper temple was similar to that of the lower one; the walls were cased with granite over a core of limestone. The great granite columns of the upper temple are destroyed, but the pavement of the second hall still shows the cavities where they stood.

The valley temple of Menkaura was never finished according to the original plan. The work was probably stopped by the death of the king, but magnificent statuary had been prepared, and was

found in 1909 by Dr. Reisner during his excavations there.

The temples of the three pyramids of the Fifth Dynasty at Abûsir have also been excavated.* The façade of the valley temple is lightened by a columned portico. Inside, the heavy pillars of the Fourth Dynasty give way to the graceful polygonal or palm-leaf columns. The covered causeway leads to the upper temple. Here the arrangements are in the main similar to those of Khafra. There are the halls and courts, the side entrances, the narrow chambers for statues, and the sanctuary the Holy of Holies against the west wall. In some cases ramps lead from one court to another, and within the enclosing wall are dwellings for the priests. The decorations are elaborate. The walls of the upper and lower temples, and of the long covered passages, are finely sculptured, and the ceiling of the pillared hall in the temple of Ne-user-ra is covered with gold stars on a blue ground.

It was known from the inscriptions that certain kings of the Memphite dynasties had erected special temples to the sun-god. The hieroglyph determinative that followed the name of these temples showed an obelisk on a high platform or base. At Abû Gurab, near Abûsir, the place of one of these sun-temples has been recovered—namely, one built by King Ne-user-ra of the Fifth Dynasty (fig. 79). It consists of two courts; the principal one on the western side is a rectangular enclosure, held up by a

* L. Borchardt, *Grabdenkmal des Königs Sahure*. *Deutsch-Orient. Gesellschaft.*

TEMPLE OF THE SUN. 79

strong retaining wall. Under the pavement traces have been found of brick buildings, levelled in preparing the foundations. The temple axis runs from east to west, the entrance being in the middle of the east wall. Covered passages and chambers surrounded the courts. A square mastaba-shaped structure with sides sloping at an angle of 14 degrees

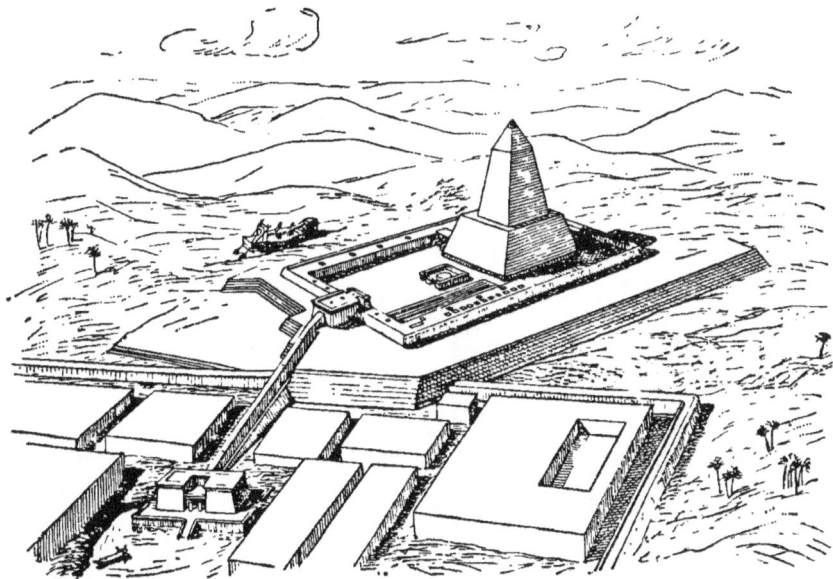

Fig. 79.—The temple of the Sun at Abû Gûrab, reconstructed.—From *A Handbook of Egyptian Religion* (A. Erman). By permission of Messrs. Constable & Co.

occupied the place of the sanctuary, towards the western end of the court. It was cased below with granite, above with fine limestone, and on it undoubtedly stood the obelisk, the symbol of the sungod himself. Access to this was afforded by a staircase inside the base. In the courtyard below, directly opposite the entrance, but near the obelisk on its

truncated pyramid, stands a flat, rectangular altar, 4 feet high, formed of five alabaster blocks. The main walls are built of yellow limestone faced with slabs of white. In many parts the walls are finely sculptured with scenes in relief, some of them relating to the overflowing fertility and fecundity of fields and flocks due to the beneficent might of the sun, of which the produce is offered him in turn by personified figures of each season.

North of the altar is a channelled platform slightly raised above the pavement level, the channels deepening towards the east, which was probably a place of slaughter for sacrificial victims. Opposite to it, at the east end, are nine (originally ten) great basins cut in quadrangular blocks of alabaster.

Somewhat to the south of the temple outside the retaining wall were found the remains of a boat, the sacred *boat of the sun*, about 100 feet long, for use in the solar ceremonies. It was constructed of brick and wood. The wood has rotted away, but the brickwork of the boat is easily visible and recognisable. Such is the temple constructed in honour of the sun by Ne-user-ra within a short distance of his own pyramid and funerary temple. It is a type of building previously unknown to us.

Some scattered remains of temples of the Twelfth Dynasty in Nubia, the Fayûm, and at Sinai, are not sufficient to prove whether they merited the praises lavished on them in contemporary inscriptions. Much of the masonry of the ruined temple of the Eleventh Dynasty at Deir el Baharî is extremely good. It is finely jointed and laid in regular courses

THE SANCTUARY.

of deep and shallow blocks alternately, similar to the splendid masonry of the Twelfth Dynasty at Dahshûr.*

The temples of the Theban kings, of the Ptolemies, and of the Cæsars are many of them intact, and easy to be reconstructed by those who study them on the spot. At first sight they seem to present a great variety as to arrangement, but on a closer examination they are found to conform to a single type. The sanctuary, as we saw it in the primitive temples, is still there, but it has gathered round it an assemblage of courts and chambers. The sanctuary is a small, low, and dark chamber, inaccessible to all except Pharaoh and the priests. A sacred bark with its tabernacle of painted wood standing either on a pedestal, in a niche in the wall, or on a block of stone, contained the image or symbol of the god, and on certain days an image of the animal sacred to him, or even a living animal. These sanctuaries were fitted with a metal framework into which double doors were inserted, closed with wooden bars, and jealously sealed. The sacred bark was taken out on stated days to be carried in procession round the town and then returned to the sanctuary. The directions for the elaborate daily ceremonies are carefully set forth to prevent any possibility of mistake. A temple might contain nothing more than this single chamber, and yet be as much a temple as the most complex building, but it rarely happened, at any rate in the larger towns, that the people would be content to provide the deity with

* Naville, *The Eleventh Dynasty Temple at Deir el Bahari*, vol. i. Egypt Exploration Fund, 1910.

such bare necessaries. Storehouses for sacrificial and ceremonial objects, for flowers, perfumes, stuffs, and precious vases, were crowded round the *divine house*. In front of the block thus formed were built one or more colonnaded halls, where priests and devotees assembled. Before these was an open court surrounded by colonnades to which the crowds had access, and which was entered by a gateway flanked by two towers, in front of which were placed two statues or obelisks. Round the whole was an enclosing brick wall, and an avenue of sphinxes that lead up to the entrance provided ample room for the great processions on feast days. Any Pharaoh who desired could add a hall even more sumptuous than those of his predecessors, and his example would in turn be followed by his successors. Thus from reign to reign the original sanctuary became more and more surrounded by halls and courts, pylons and porticoes. Whether the result of vanity or of piety, the temple expanded till the work was at last stopped for want of space or money.

The less elaborate temples were often the most beautiful. This was the case with the temple of Amenhotep III. on the island of Elephantine, of which drawings were made by members of the French expedition at the end of the eighteenth century, before its destruction in 1822 by the Turkish governor of Assûan. The best preserved of these, the southern one (fig. 80), had only one hall, in sandstone, 14 feet high, 31 feet wide, and 39 feet long. The walls, which were straight and surmounted with the usual cornice, stood on a stone basement some 8 feet high.

This platform was surrounded by a parapet breast-high. Round the temple was a colonnade, composed of seven square pillars on each side without capital or base. At each end were two lotiform columns. Pillars and columns rested on the parapet, except at the east end, where a set of ten or twelve steps enclosed between walls the same height as the parapet led up to the *cella*. The two columns at the head of the steps were more widely spaced than those at the other end, and in the wide

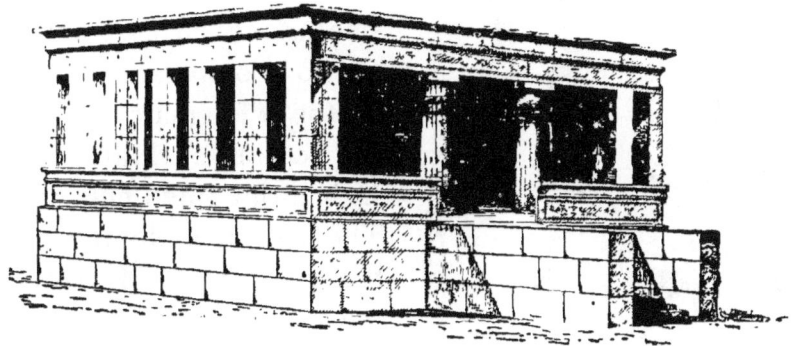

Fig. 80.—Southern temple of Amenhotep III. at Elephantine.

opening a richly decorated doorway was visible. There was a second door at the other end under the colonnade. Later, during the Roman period, advantage was taken of this arrangement to modify the plan. The intercolumnar spaces at the end were filled up, and thus an additional chamber was obtained, rough and without decoration, but sufficient for the requirements of the cult. The temples of Elephantine recall the peripteral temples of the Greeks, and this resemblance to one of the well-known forms of classical architecture perhaps ex-

plains the admiration manifested by the French savants on first seeing them.

The temples of Mesheikh, El Kab (fig. 81), and Sharona are more elaborate. At El Kab there is a hall of four columns (A), a chamber (B), supported by four Hathor pillars, and in the end wall facing the doorway a niche (C) approached by four steps. The most complete specimen we possess of these small sanctuaries belonging to provincial towns is of the Ptolemaic period, the temple of Hathor at Deir el Medineh (fig. 82). The length is double the breadth, the walls slope inwards and are bare of ornament on the outside face, with the exception of the doorway, which projects and is covered with sculptured scenes. The interior is in three parts: a portico (B) of two campaniform columns, a pro-naos (C), reached by a set of four steps and divided from the portico by a wall the height of a man. This is ranged between two campaniform columns and two pilasters with Hathor capitals; finally there is the sanctuary (D), flanked by two small cells (E, E), lighted by two air-holes in the roof. The roof is reached from the

Fig. 81.—Plan of temple of Amenhotep III. near El Kab.

TEMPLE OF KHONSÛ, KARNAK. 85

southern angle of the portico by a staircase lighted by a window (F) from the outside. This is merely a temple in miniature, but the various parts are so finely proportioned that it is difficult to imagine anything more graceful and charming.

As much cannot be said for the temple built by the Pharaohs of the Twentieth Dynasty to the south of Karnak, in honour of the god Khonsû (fig. 83), but although the style may not be beyond reproach, the plan is so distinct that one is inclined to adopt it as the type of the Egyptian temple in preference to others more majestic or graceful. On analysis it resolves itself into two parts separated by a thick wall (A, A). In the centre of the smaller part is the Holy of Holies (B), open at both ends and entirely isolated from the rest of the building by a passage (C), 10 feet in width; to right and left are small dark chambers (D, D); behind a hall of four columns (E), on which open seven other chambers (F, F). This was the house of the god, and the only communication from without was by two doors (G, G) in the central wall (A, A), which opened on a hypostyle hall (H), greater in breadth than in length, and divided into three aisles. The central aisle rests on

Fig. 82.—Plan of temple of Hathor, Deir el Medineh.

four campaniform columns 23 feet in height; the side aisles have only two lotiform columns 18 feet high. The central portion is 5 feet higher than the side aisles. Advantage was taken of this difference in height to secure light. In the space between the upper and lower roofing windows with stone mullions were inserted, through which the light filtered. The court (J) was square, surrounded by a double colonnade. The entrance to this hall was by four lateral posterns, and by an immense gateway between two quadrangular towers, with sloping fronts. This pylon (K) measures 105 feet in length, 33 feet in width, and 60 feet in height. It contains no chamber, but a narrow staircase, which leads straight to the lintel of the gateway, and from there to the summit of the two towers. The faces of these towers are lined with four angulated grooves up to a third of their height, corresponding with as many square holes worked through the block of masonry. In these grooves great wooden masts were placed, made of beams jointed into each other, strengthened at intervals by a species of clasp, and fastened by wooden clutches fixed in the square holes. Near the top fluttered pennants of various colours (fig. 84).

Such was the temple of Khonsû, and similar to it

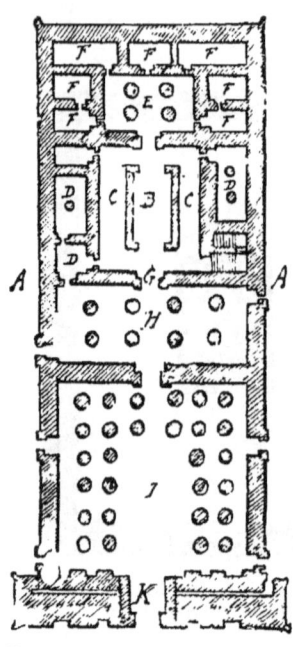

Fig. 83.—Plan of temple of Khonsû, Karnak.

in the main lines were the majority of the greater temples of the Theban and Ptolemaic periods: Luxor, the Ramesseum, Medinet Habû, Philæ, Edfû, Denderah. Half in ruins as they are, their very aspect is strangely overpowering and alarming. As the Egyptian divinities elected to be enshrouded in mystery, the plan of the building was so arranged as to lead gradually from the glare of the outside world to the darkness of their abode. On first entering there were vast spaces where sun and air could freely enter. The hypostyle hall was shaded in twilight, the antechamber to the sanctuary was yet more dim, while beyond in the farthest recesses of the temple almost complete darkness reigned. The sensation of aloofness produced by this gradual loss of light was augmented by artifices in the construction of the building.

Fig. 84.—Pylon with masts, from a bas-relief in the temple of Khonsû, Karnak.

The halls were not on the same level. The floor rose in proportion to the distance from the entrance (fig. 85), and there were always steps to be mounted in passing from one part to another. The difference in level was not more than 5 feet 3 inches in the temple of Khonsû, but it is combined with a lowering of the roof which is very noticeable. From the pylon to the wall at the farthest end the height of the roof decreases in pro-

gressive stages: the peristyle dominates the first hypostyle; this overtops the sanctuary, while the second hypostyle and the end chamber are yet lower. The effect is very noticeable when seen from the summit of one of the pylons; the roofs of the different halls sink lower and lower to the surrounding wall, like a series of wide steps. The architects of the Ptolemaic period introduced some important modifications. They contrived secret passages and crypts in the thickness of the wall, where the priest could conceal the treasure of the god (fig. 86). They also erected chapels and oratories on the roof, where, screened by the high parapets, they could unseen

Fig. 85.—The Ramesseum restored, showing the rise of the ground.

perform the mysteries of the death and resurrection of Osiris.

The sanctuary had hitherto had two entrances opposite each other, they left but one; the colonnade that extended across the back of the court—or where the court did not exist, on the façade of the temple—now became a new court, the pronaos. The outer row of columns is retained, but it is connected by a wall surmounted by a cornice that reaches to about half the height of the shafts, and prevented the outer throng from seeing what was taking place beyond (fig. 87). This hall is supported by two, three, or even four rows of columns, according to the size of

the rest of the building. For the rest, a comparison of the plan of the temple of Edfû (fig. 88) with that of the temple of Khonsû will show how little

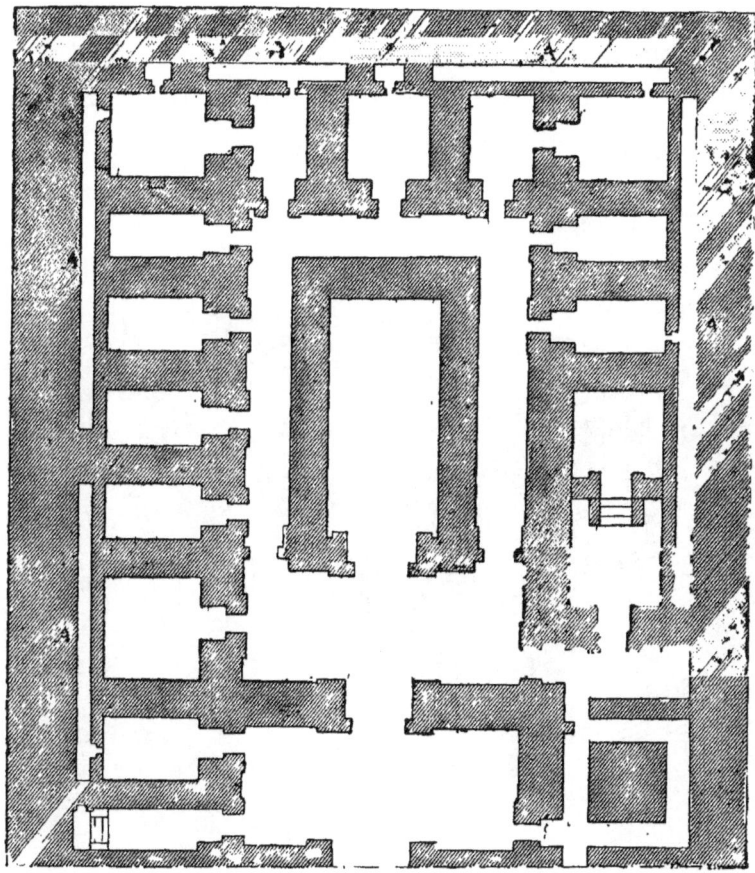

Fig. 86.—Crypts in the thickness of the walls round the sanctuary at Denderah.

they differ from each other. Thus equipped the building sufficed for all the requirements of the cult. When it was enlarged, as a rule neither the sanctuary nor the chambers surrounding it were altered, but

the outlying parts, the courts, hypostyle halls, and pylons. Nothing serves better than the history of the temple of Amon at Thebes to illustrate the proceedings of the Egyptians under such circumstances. It was founded by Senûsert (Ûsertesen) I., probably on the site of a yet earlier temple. Both Amen-

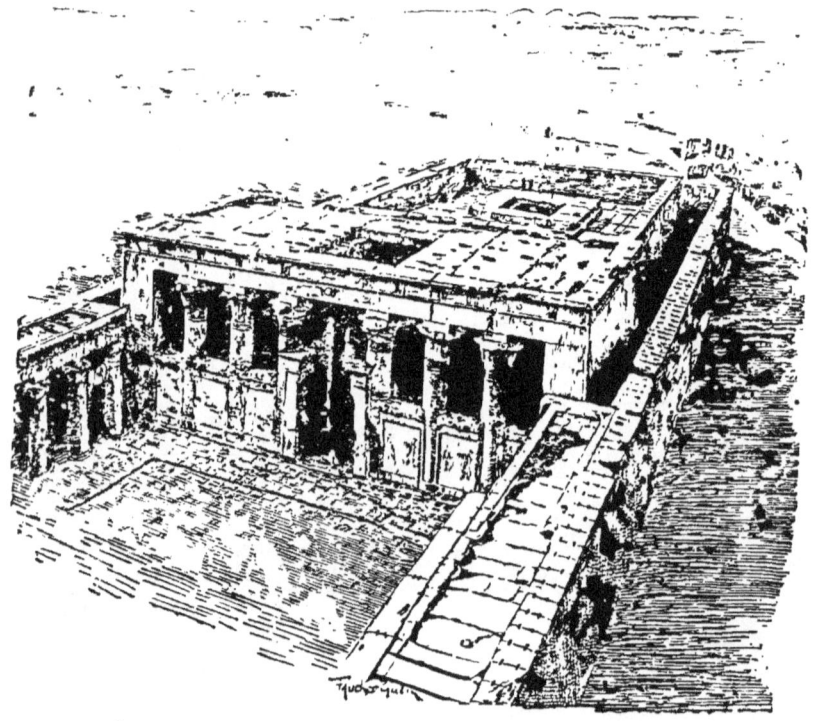

Fig. 87.—The pronaos of Edfû, as seen from the top of the eastern pylon.

emhat II. and Amenemhat III. did some work there, and the Pharaohs of the Thirteenth and Fourteenth Dynasties presented statues and tables of offerings. In the seventeenth century before our era it was still intact, when Thothmes I., enriched as he was by foreign conquest, resolved to transform it.

THE TEMPLE OF KARNAK.

In front of the temple, as it then existed, he first added two halls, preceded by a court and flanked by separate chapels; then three pylons at intervals, one behind the other. The whole presented the appearance of a rectangle placed crossways against another of vast dimensions. Thothmes II. and Hatshepsût covered the walls built by their father with bas-reliefs, but added little to his work. Hatshepsût, however, in order to place her obelisks between two of the pylons, broke down part of the southern wall and destroyed sixteen of the columns that stood there. Thothmes III. began by altering certain parts, which no doubt he considered unworthy of his god: the first pylon and the double sanctuary, which he constructed of the red granite of Syene (Assûan). To the eastward he built some chambers, of which the most important, now called

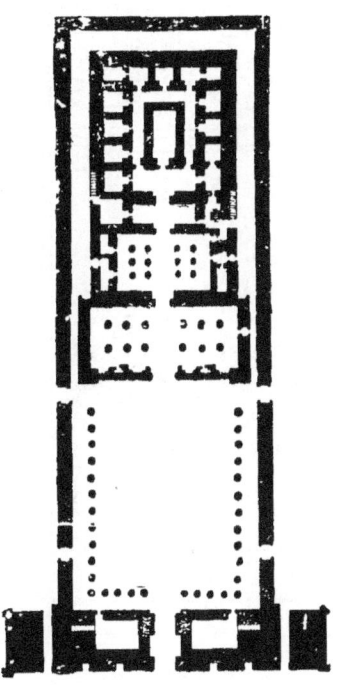

Fig. 88.—Plan of temple, Edfû.

the processional hall, served during processions as a station and resting-place for the sacred bark. He surrounded the whole with a stone wall and excavated the lake on which the sacred barks floated on feast days; then, with a sudden change of axis, he erected two pylons facing southwards. In doing this he destroyed the correct proportions which up to that

92 RELIGIOUS ARCHITECTURE.

time had existed between the main building and the façade. The outer enclosure was too wide for the first pylon, and did not properly accord with the new. Amenhotep III. corrected this defect; he built a sixth pylon, which was more massive and therefore better suited to the façade. The temple might now have been considered complete; it surpassed in size and boldness of execution anything that had hitherto been attempted (fig. 89). But the Pharaohs of the Nineteenth Dynasty attempted yet more. They only constructed one hypostyle hall (fig. 90) and

Fig. 89.—Plan of temple of Karnak in the reign of Amenhotep III.

one pylon, but the hypostyle is 170 feet in length by 329 feet in breadth. In the centre is an avenue of twelve campaniform columns, the highest that have ever been employed inside a building; in the side aisles, which are lower, there is a whole regiment of lotiform columns, 122, drawn up in battle array of nine files. The roof of the central portion is 75 feet

high, while the pylon stands about 50 feet higher still. During a whole century three Pharaohs laboured to bring the hypostyle hall to perfection. Rameses I. conceived the plan, Seti I. finished the building, Rameses II. almost completed the decorations. The Pharaohs of the subsequent dynasties endeavoured to secure some vacant spaces on the columns, where they could inscribe their names and share the glory of the three founders; but they went no farther. Arrested at this point the building seemed incomplete; a final pylon and a colonnaded court were still wanting. Nearly three centuries elapsed before any attempt was made to supply them. Finally the Bubastites decided to commence the colonnades, but their work was feeble and their resources limited.

Fig. 90.—Plan of hypostyle hall, Karnak.

Taharka the Ethiopian for a time imagined that he was capable of rivalling his great predecessors, and he devised a hypostyle hall even larger than the ancient one. But his measurements were wrong; the columns of the central aisle were placed too far apart to support a stone roof: they support nothing, and only remain to bear witness to his incompetency. Eventually the Ptolemies, conforming to the traditions of the native Pharaohs,

applied themselves to the work; but the revolts in Thebes interrupted their projects: the earthquake of the year 27 B.C. overthrew part of the temple, and the pylon remained for ever unfinished.

The history of Karnak is that of other great Egyptian temples. By studying them on the spot one learns the reason of the irregularities that are to be found in them. The plan is always practically the same, and their growth is produced in the same manner; but the architects did not always foresee the importance to which their work would attain, and the site chosen by them in some cases did not admit of a normal development. At Luxor (fig. 91) the building progressed methodically under Amenhotep III. and Seti I., but when Rameses II. wished to add to what had been done by his predecessors, an easterly bend of the river obliged him to deviate in the same direction. His pylon is not parallel with the boundary wall of the last court of Amenhotep III., and his colonnades form a distinct angle with the general axis of the previous work. At Philæ (fig. 92) the deviation is even greater. Not only is the larger pylon out of line with the smaller one, but the two

Fig. 91.—Plan of great temple, Luxor.

southern colonnades diverge considerably, and naturally they do not accord with the pylon. This is not the result of negligence or of deliberate intention. The original plan was as regular as could be devised by any designer, however devoted to symmetry; but it could not be adapted to the requirements of the site, and the architects, therefore, could not do otherwise than make the best of the irregularities to which they were condemned by the nature of the ground. This necessity often inspired them in the happiest fashion. Philæ shows with what skill they could evolve beauty and charm from this unavoidable disorder.

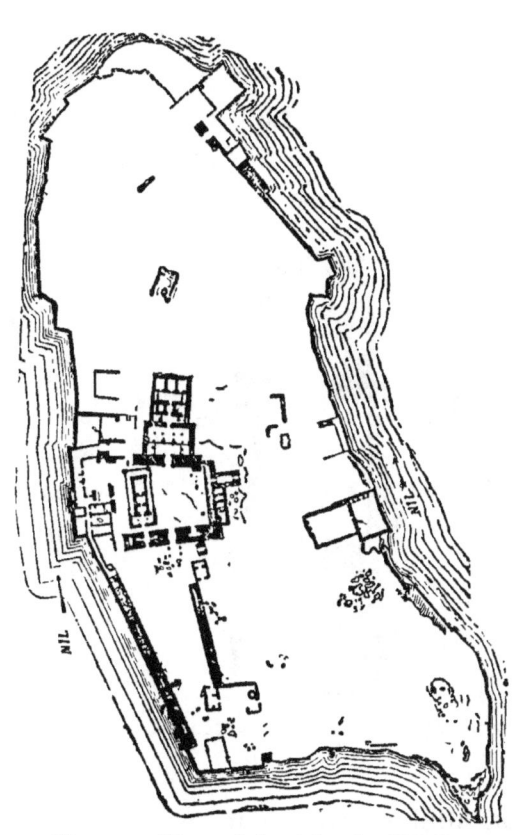

Fig. 92.—Plan of the island of Philæ.

The idea of rock-cut temples must early have occurred to the Egyptians. They carved out the mansions of the dead in the mountain side. Why did they not also do the same for their gods? Nevertheless, the earliest temples we know con-

structed entirely in the rock do not date back farther than the early reigns of the Eighteenth Dynasty. These temples are generally to be found where the belt of cultivated land is narrowest, near Beni Hasan, at Gebel Silsileh, and in Nubia. All varieties of the temples described above are found in the speos, more or less modified by local conditions. The Speos Artemidos is approached by a pillared portico, and it contains only a square chamber with a niche at the back for the goddess Pakhet. At Kalaat-Addah (fig. 93) a narrow, roughly worked façade (A) faces the river, and is reached by a steep flight of steps; immediately behind this is a hypostyle hall flanked by two recesses (C), then a sanctuary of two stories (D). The chapel of Horemheb (fig. 94) at Gebel Silsileh is composed of a gallery parallel to the Nile, resting on four massive pillars cut out of the living rock; and of a chamber opening out of the gallery at right angles. At Abû Simbel the entrance to the temples is cut actually in the face of the cliff. The front of the great temple (fig. 95) is carved to resemble a sloping pylon, with a cornice, and guarded, as usual, by four colossal seated figures and by smaller statues; but here the colossi are almost 66 feet high. Inside the entrance

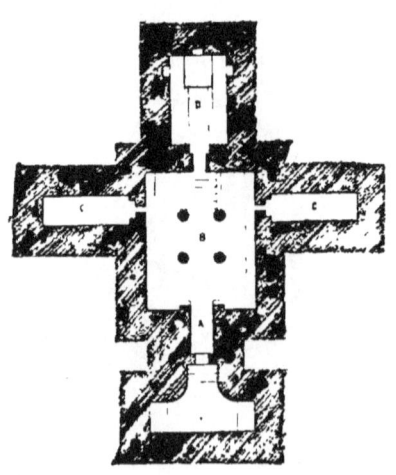

Fig. 93.—Plan of speos, Kalaat-Addah, Nubie.

is a hall, 130 feet long by 60 feet broad, which takes the place of the ordinary peristyle. Eight Osiride statues are backed by as many columns, and appear to be supporting that part of the mountain. Beyond this is a hypostyle hall, a transverse gallery that isolates the sanctuary, finally the sanctuary itself between the chapels and the other members of the triad. Eight crypts at a lower level than the central nave branch out at unequal intervals to right or left

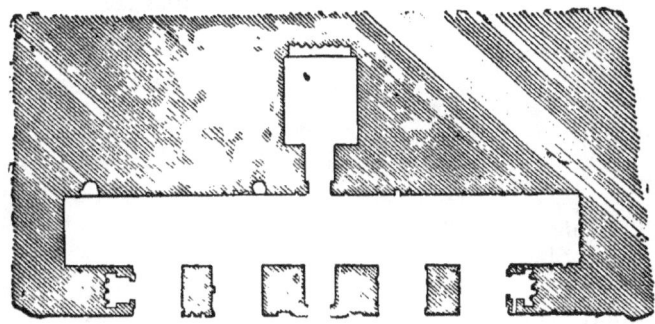

Fig. 94.—Plan of speos, Gebel Silsileh.

of the peristyle. The entire area from the threshold to the back of the speos measures 180 feet.

The speos of Hathor, some hundred feet to the north, is of smaller dimensions. The façade is adorned with standing figures, four of which represent Rameses, and two his wife Nefertari. There is neither peristyle nor crypt (fig. 96), and the chapels are placed at the two extremities of the transverse passage instead of being in line with the sanctuary; the hypostyle hall has six Hathor columns.

Where space permitted, only a portion of the temple was sunk in the rock, and the front was

constructed of blocks of stone in the open, thus forming a hemi-speos. At Derr the peristyle only is in the open; while at Beit el Wally the pylon and court, at Gerf Hossein and Wady es Sabûa the pylon, the rectangular court, and the hypostyle hall are all outside. The most celebrated hemi-speos is at Deir el Baharî, in the Theban necropolis, which was built by Queen Hatshepsût as her funerary temple (fig. 97). The sanctuary and two accompanying chapels were excavated in the mountain about 100 feet above the valley level. The whole temple is situated on the lower slopes of a great bay in the mountains. It consists of a forecourt with colonnades at the far end to right and left. A broad ramp ascends from the middle of this court to the second court, which also has colonnades at the west end, supported on square pillars and covered with sculptured scenes. A second ramp leads to the upper terrace and colonnades, and through a granite gateway we reach the main

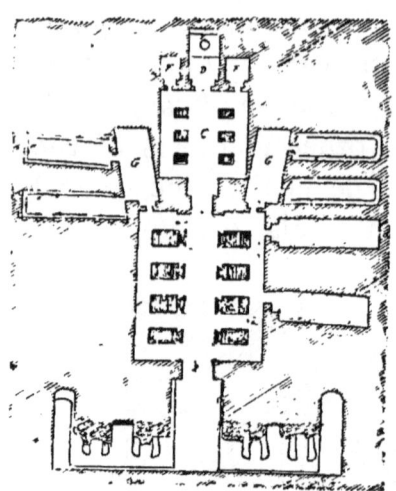

Fig. 95.—Plan of the Great Speos, Abû Simbel.

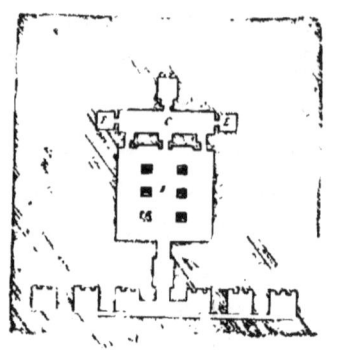

Fig. 96.—Speos of Hathor, Abû Simbel.

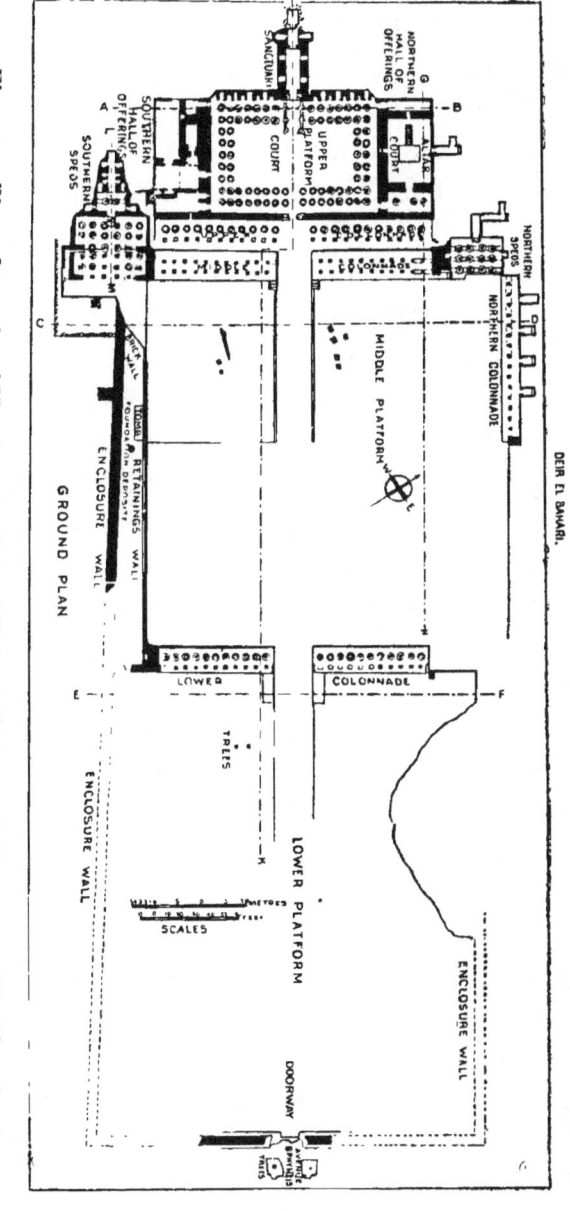

Fig. 97.—Plan of temple of Hatshepsût, Deir el Bahari, Eighteenth Dynasty.—*The Temple of Deir el Bahari*, E. Naville.

court. Here, on the left, is the covered court where sacrifices were offered to the deceased queen, and on the right is another court, in which stands the altar, one of the very few found *in situ* in Egypt. It is rectangular, made of fine limestone, and measures 16 feet by 13 feet. A flight of ten steps on the western side leads to the top, which is 5 feet above the pavement, and surmounted by a heavy cornice. Here we have the cliffs towering above us, and we enter the mountain itself, passing a variety of chambers and recesses, and finally reach the sanctuary. The temple is surrounded by a retaining wall, finely worked in limestone blocks. The colonnades of the first court were planted with a variety of trees, of which vestiges still remain.* At the south-west corner a shrine of Hathor is hewn out of the rock; in front of it are two colonnades, the foremost of which is supported on sixteen-sided columns and square Hathor-headed columns.

A causeway from the plain and an avenue of sphinxes led to the temple. At its lower end stood Hatshepsût's valley temple.† Never finished, it was begun on the same plan as the upper temple. An outside wall 20 feet in height encloses an upper and lower court, divided by a colonnaded terrace. The terraced temple was regarded as showing great originality, and it was not till 1903 that the model that inspired it was excavated. Close to the temple of Hatshepsût, on the south side, is a smaller temple

* E. Naville, *The Temple of Deir el Bahari*. Egypt Exploration Fund.
† Earl of Carnarvon, *Five Years' Exploration at Thebes*. Oxford University Press.

constructed by Mentuhotep II. of the Eleventh Dynasty.* The forecourt does not exist, but we have the broad ramp flanked by colonnades leading up to a platform artificially shaped and squared. Here is the entrance to the temple, a granite gateway leading into an open court, surrounded by a colonnade of 150 octagonal columns. In the open court are still the remains of a large structure, faced with limestone and topped by a heavy cornice. It is 70 feet square and 10 feet high. This was the base of the brick-built pyramid, which the Abbot papyrus refers to as existing here. It did not contain the sepulchral chamber, and it is the only instance known of a pyramid enclosed in the funerary temple. Another granite doorway at the back of the covered hall leads into an open columned hall, the space for which has been hewn out of the cliff, and this again opened into a hypostyle hall of eighty columns.

A sloping passage from the open court leads downwards into the rock, and at a distance of 500 feet opens into a granite-lined chamber containing an alabaster shrine. The wooden double doors and their metal fittings have disappeared, but here we have at length reached the sanctuary. The temple is in ruins with the exception of the rock-cut chambers. The work is very fine, and the rock is everywhere masked with blocks of sandstone or of limestone.

The polygonal columns, of which there are such extraordinary numbers, are eight-sided, instead of

* E. Naville, *The Eleventh Dynasty Temple at Deir el Bahari*, vol. i. Egypt Exploration Fund, 1910.

sixteen-sided, as in the neighbouring temple. During the Eighteenth Dynasty the building was invaded by a Pharaoh, probably Thothmes III., who constructed at the north end a chapel to Hathor, and cut a shrine for her in the rock. The shrine remained forgotten and untouched for many centuries till its discovery in 1906. It was a vaulted chamber, containing the carved figure of a cow, the sacred animal of the goddess Hathor. Both cell and cow have been removed to Cairo, where they can be studied at leisure in the Museum.

Fig. 98.—Plan of temple of Seti I., Abydos.

The Egyptians had another type of temple that may rank between the hemi-speos and the detached temple. This is the temple that backed on to the mountains without entering it. The great granite temple at Gizeh and the temple of Seti I. at Abydos are two good examples of this kind. The first has already been described (p. 73). The area of the second (fig. 98) was cut out of a compact low belt of sand which divides the desert plain. The temple was buried almost to the roof on the west and north sides, the walls scarcely rose above the ground level, and the stairs

that led to the roof led also to the top of the hill. The front of the temple that stood out clear had nothing peculiar about it—two pylons, two courts, and a shallow portico with square pillars. But from this point the arrangements were unusual. Instead of one hypostyle hall there were two, separated from each other by a wall with seven doors; neither of them have a central nave, and the sanctuary opens immediately on to the second of them. The sanctuary is of the usual form, oblong with a door at each end; but the small chambers, which in other instances surround it, are here placed side by side in a line with it, two to the right and four to the left. Moreover, they have corbelled vaulting, and their only means of lighting is by the door. Behind the sanctuary we find similar peculiarities. The hypostyle hall abuts on the end wall, and the various chambers attached to it are irregularly disposed to right and left. As though this were not enough, an entire wing, consisting of a court, a columned hall, some passages and dark recesses, stands out square from the main building on the left flank, with nothing to balance it on the right. These irregularities are explained by an examination of the site. Behind the hypostyle hall at the rear the hill is very shallow, and actually slopes away. Had the usual plan been adopted, the cliff must have been cut away, and the building would have lost the characteristic desired by the founder, of a temple built against the cliff. Several years later when Rameses II. built a memorial temple for himself a few hundred yards to the north-west, he carefully avoided his

father's example; his temple, built on the summit of the hill, had ample room, and the usual plan was carried out.

Most temples, even the smallest, are surrounded by a wall forming a quadrilateral enclosure. At Medinet Habû this wall is of sandstone, low and crenellated; but this is a whim which is in accord with the rest of the building. Elsewhere the doorways are of stone, and the walls of dried brick are built in wavy courses. The enclosing walls were not intended to shut off the temple or to conceal from the eyes of the profane the ceremonies carried on there, but they marked the limits of the divine house and served at need to repulse any enemy whose cupidity might be aroused by the accumulated treasures of the temple. The avenues of sphinxes, or, as in the case of Karnak, a series of pylons graduated in size, led from the gates of the enclosing wall to the various entrances to the building, and they also formed wide roads for triumphal processions. The remainder of the enclosure was occupied partly by stables, cellars, and the granaries of the priests, and partly by private dwellings. As in Europe in case of foreign invasion, the population crowded round the churches and monasteries, so in Egypt they hurried to the temples to share the protection afforded the god by the terror of his name and the strength of his ramparts. At first a wide space was reserved by the side of the walls and the pylons, but as the population steadily increased, this space became gradually filled up with houses, which were even built against the walls.

In the course of centuries these houses were so

frequently destroyed and rebuilt that many of the temples were at last partially buried in the accumulation of rubbish, and were much lower than the surrounding buildings. Herodotus mentions this fact with reference to Bubastis, and an examination of the various sites proves that the same thing happened with many of them. At Ombos, Edfû, and Denderah, the only wall round the city was that of the god, while El Kab possessed two enclosing walls, that of the city and that of the temple. The latter formed a keep to which the garrison retired as a last resort. At Memphis and at Thebes there were as many keeps as temples; but at Thebes these sacred fortresses, at first separate and surrounded by their own group of houses, were from the close of the Eighteenth Dynasty connected with each other by avenues of sphinxes. The most usual of them was the andro-sphinx—the human-headed lion; but there was also the crio-sphinx—the lion with the ram's head (fig. 99); and in places where the local cult rendered such substitution appropriate, there were kneeling figures of rams holding a figure of the sovereign between their forelegs (fig. 100). The avenue from Luxor to Karnak was composed of these various types. This road is a mile and a quarter in length, and it bends in various directions; but this must not be considered a proof that the Egyptians disliked symmetry. The two temple enclosures were not orientated in the same direction, and avenues traced perpendicularly from each of them could never have met; they had to be turned from their original direction. We may conclude by

saying that the people of Thebes saw almost as much of their temples as we see at the present day. The sanctuary and its immediate surroundings were closed to all who did not belong to the highest order

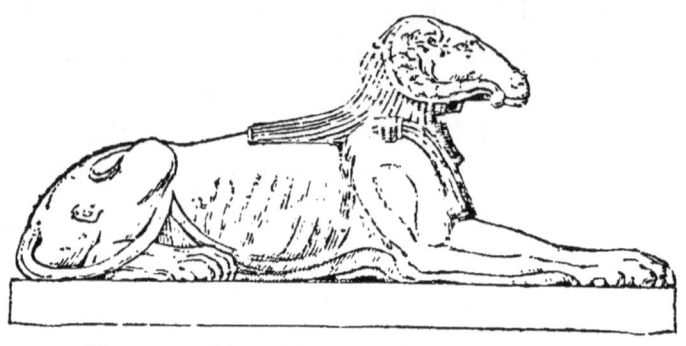

Fig. 99.—Crio-sphinx from Wady es Sabûah.

of the priesthood ; but they had access to the enclosure, to the courts, and to the hypostyle hall; some were even allowed to penetrate farther into the

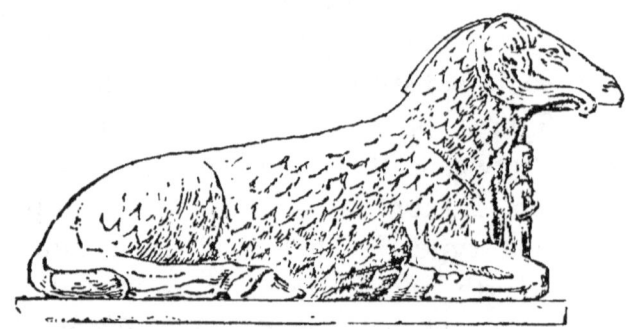

Fig. 100.—Couchant ram, with statuette of royal founder, restored, avenue of sphinxes, Karnak.

temple, according to their rank in the civil or religious hierarchy, and they were able to admire the achievements of their architects almost as freely as we admire them to-day.

3.—DECORATION.

Ancient tradition asserts that the earliest Egyptian temples contained no sculptured figures, no inscriptions, no material symbols. The temple of Seneferû is entirely plain. The valley temple of Khafra is plain with the exception of the doorways of the façade, although it contained magnificent statues. The upper temple also appears to have had only the same scanty decoration. It was early plundered, and blocks bearing the name of Khafra were utilised in building the northern temple of Lisht. The fine sculptures and painted decoration in the funerary temples at Abûsir show how completely this primitive simplicity was abandoned by the time of the Fifth Dynasty.

By the Middle Kingdom the walls were covered with scenes and inscriptions, although the columns as yet bore little more than the royal cartouche. During the great Theban period all the plain surfaces, pylons, wall facings, and shafts of columns were covered with scenes and texts. Under the Ptolemies and the Cæsars these inscriptions were so crowded that the masonry was lost sight of under the mass of ornamentation with which it was covered. A very cursory glance is sufficient to show that these scenes were arranged with much care. They are connected and lead on from one to another, forming a mystic volume where the official relations between gods and men are set forth for those capable of understanding them. The temple was built as an image of the world, as the Egyptians imagined it to be. The earth, they believed,

was a shallow flat plane oblong in form. The sky stretched over it was, according to one conception, like an immense iron ceiling, according to another

Figs. 101 to 106.—Decorative Designs from Denderah.

Fig. 101.

Fig. 102.

like a shallow iron vault. As it could not remain in position without some support the idea arose that it was prevented from falling by four props or gigantic

Fig. 103.

Fig. 104.

pillars. The temple pavement was the natural equivalent of the inhabited world. The four corners of the chambers represented the supports; the ceiling,

Fig. 105.

Fig. 106.

which at Abydos, and in several other localities, was vaulted, but which was generally flat, corresponded exactly to the Egyptian conception of the sky. Each

part was decorated appropriately to its signification. All that touched the ground was covered with vegetation; the columns represented the plants or trees that abound on the banks of the Nile. The base of the walls was decorated with long stems of papyrus or lotus (fig. 101), among which cattle were occasionally depicted. In some cases a dado had a charming design of groups of river plants emerging from the water (fig. 102), or again we find full-blown flowers alternated with single buds (fig. 103) or connected by cords (fig. 104), or again the emblematic plants that symbolise the union of the two Egypts, of

Fig. 107.—Two Nile-gods, bearing lotus-flowers and libation vases.

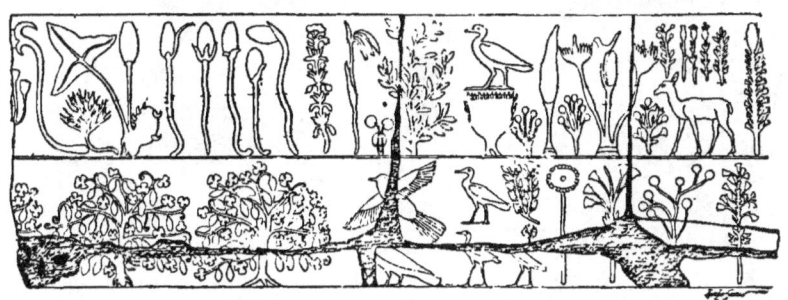

Fig. 108.—Dado decoration, hall of Thothmes III., Karnak.

the north and of the south, under one Pharaoh (fig. 105), birds with human arms, seated in adoration over the sign used to denote solemn festivals, or crouching prisoners, a negro and an Asiatic bound two and two to a stake (fig. 106). On the ground level, Niles, both male and female, either kneel (fig. 107) or advance

majestically in procession, their hands full of fruit and flowers. These are the nomes, the lakes and districts of Egypt, that are shown bringing their produce to the god. At Karnak in one instance Thothmes III. had the flowers, plants, and animals of the lands conquered by him sculptured on the lower courses of the

Fig. 109.—Ceiling decoration, from tomb of Bakenrenf (Bocchoris), Saqqara, Twenty-sixth Dynasty.

walls (fig. 108). The temple ceilings were painted dark blue and sprinkled with five-pointed stars painted yellow, occasionally interspersed with the cartouches of the royal founder. Bands of hieroglyphs at intervals broke the monotony of this Egyptian night. The vultures of Nekheb and Ûazît, goddesses of the

south and the north, armed with emblems of universal domination (fig. 109), hover over the central aisle of the hypostyle hall and on the soffits of the doors, above the head of the king as he passed to the sanctuary.

At the Ramesseum, at Edfû, Philæ, Denderah,

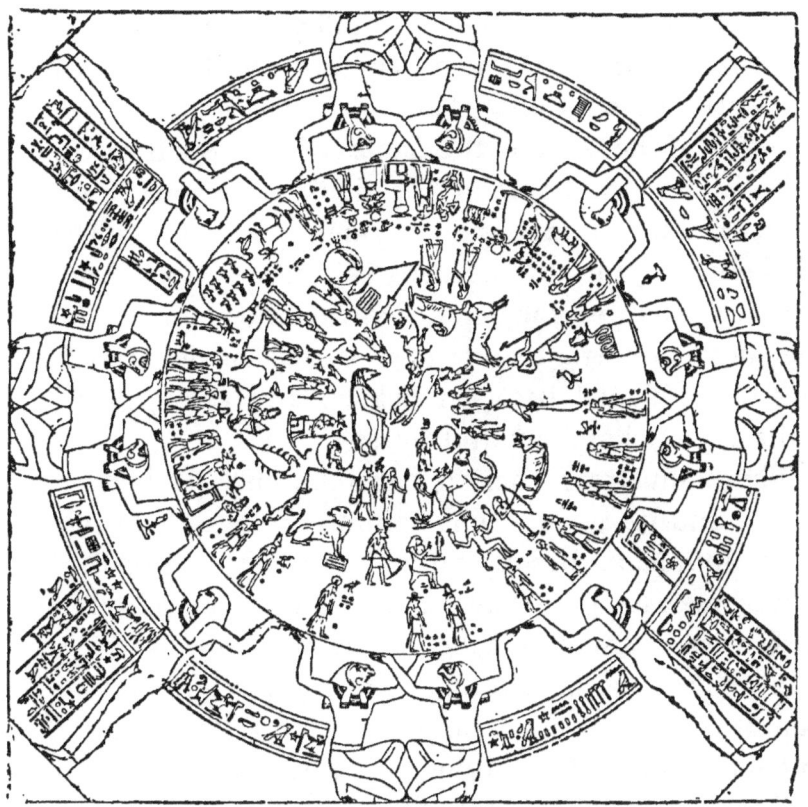

Fig. 110.—Zodiacal circle of Denderah.

Ombos, and Esneh, the very depths of the firmament appeared to open, and reveal their inhabitants to the eyes of the faithful. There the celestial ocean displayed its waters, over which sailed the sun and moon, escorted by the planets, the constellations and decani,

while the genii of months and of days marched in interminable succession. During the Ptolemaic period, signs of the zodiac, copied from the Greek, are found among astronomical figures of purely Egyptian origin (fig. 110). The decoration of the architraves that support the stone roof is quite independent of that of the roof itself. On them legends are inscribed in immense hieroglyphic characters, setting forth the beauties of the temple, the names of the royalties who built it, and the name of the deity to whom it was consecrated. In fact the ornamentation of the base of the walls, and of the roof is confined to a small number of subjects which are always the same; while the most important and most varied scenes may be said to be placed between heaven and earth, on the walls of the chambers and pylons.

These illustrate the official relationships between Egypt and its gods. The common folk had no right to communicate directly with the divinity. For them it was necessary to have a mediator, who, partaking both of the human and the divine nature, was able to comprehend both equally. Thus the reigning king, Son of the Sun, was alone of sufficiently lofty descent to behold the god, to serve him, and speak with him face to face. Sacrifices could only be offered by him, or at his express command; offerings for the dead were supposed to pass through his hands, and the family invoked his name (*seten de hotep*) in order that they might reach their destination in the next world. Thus the king is depicted everywhere in the temple, standing, sitting, kneeling, slaying the victim and presenting parts of it, pouring wine, milk, oil, and

burning incense. The whole of mankind is acting through him, and performing through him its duty to the immortals. When the ceremony performed by him demands the presence of several people, then it is only the assistants, his own family as far as possible, who are seen taking part. The queen standing behind him, as Isis stands behind Osiris, has her hand raised to protect him, shakes the sistrum or beats the tambourine in order to ward off evil spirits from him, or holds the bouquet, or the libation vase. His eldest son tightens the net, or lassoes the bull, or recites the prayer, while the king tenders to the god everything prescribed by the ritual. The prince is occasionally replaced by a priest, but no other human being has any but very subordinate parts. They are butchers, or servants, they drive the chariot, or carry the palanquin of the god. The god, on the other hand, is not always alone. Next to him are his wife and his son, then the divinities of adjacent nomes, and in a general way all the gods of Egypt. From the moment that the temple is regarded as the image of the world it should, like the world, contain all the gods, great and small. They are generally arranged in rows behind the god of the temple, either sitting or standing, and partake of the homage offered to him. Sometimes, however, they claim a more active part in the ceremonies. The spirits of On, and of Khonsû kneel at the feet of the sun and acclaim him. Horus, Set, or Thoth conduct the Pharaoh to his father, Amon-Ra, or with him they perform the ceremonies usually assigned to the prince or the priest; they help him to overthrow the victim,

to snare the birds intended for sacrifice, they pour over his head the water of youth and of life that will cleanse him from all impurities. The position and functions of these subordinate gods are strictly defined by the theology.

The sun journeying from east to west, as stated in the texts, cut the universe into two worlds, the north and the south. Like the universe the temple was double and an imaginary line, drawn through the axis of the sanctuary, divided it into two temples, the temple of the south on the right, and the temple of the north on the left. This fiction of duality was pushed even further; each chamber was divided in imitation of the temple into two parts, of which the right was that of the south and the left of the north. In order to be complete the homage of the king must be paid both in the temple of the north and of the south, both to the gods of the north and of the south, with the produce both of the north and of the south. Thus each scene must be represented at least twice, on a wall to the right and on a wall to the left. Amon on the right receives the wheat, the wine, and the drink-offerings of the south; on the left he receives the wheat, the wine, and the drink-offerings of the north; and that which applies to Amon applies equally to Mût, Khonsû, Mentû, and many others. In practice the want of space prevented this being always carried out, and one often finds a single scene, in which the products of the north and of the south are placed together before an Amon who represents in himself the Amon of the north and the Amon of the south. This deviation from established usage

is, however, exceptional, and symmetry was re-established as soon as circumstances permitted.

During Pharaonic times the scenes were not much crowded together; the surface to be covered defined below by a line drawn above the decoration of the dado, is bounded above by the usual cornice, or by a frieze of uraei, of bundles of lotus arranged side by side, of the royal cartouches with their divine symbols (fig. 111), or of emblems connected with the local cult —Hathor-heads for instance in a temple of Hathor— or of a horizontal line of dedicatory inscription deeply carved in fine hieroglyphs. The space thus enclosed sometimes formed one single register, but as often it was divided into two registers, one above another; it was only on very lofty walls that this number was exceeded.

Fig. 111.—Frieze of uraei and cartouches.

Figures and texts were widely spaced, and the scenes followed each other almost without definite divisions; it was left to the spectator to discover the beginning and the end. The heads of the kings were actual portraits drawn from life, and for the gods also their features were copied as closely as possible; for Pharaoh being the son of the gods, the surest method of obtaining their likeness was to model it on the portrait of the king. The secondary figures were represented with equal care, but where there were too many of them they were arranged in superposed rows of two or three, of which the total height never exceeded that of the principal personages. The offerings, the sceptres, the jewellery, the

vestments, the headdresses, the furniture, and all the accessories were located with minute regard for elegance and accuracy. The colours were so combined as to secure one dominant tone in any one part of the building. Thus there are chambers which might accurately be styled the blue hall, the red hall, the green hall, the golden hall. So much for the classical periods.

The nearer we approach to later times, the more crowded the scenes become. Under the Greeks and Romans they are so numerous that it was only possible to arrange them on the wall by means of four (fig. 112), five, six, or even eight registers. The principal figures seem to be compressed in order to save space, while thousands of explanatory hieroglyphs fill up the gaps between them. The gods and kings are no longer portraits of the reigning sovereign, but conventional types without life or vigour, while, with regard to the secondary personages and the accessories, the only anxiety was to crowd them together as closely as possible. This was not owing to lack of taste; these changes were due to the prevalence of a religious idea, the sole object of the decoration was not merely to please the eye; when applied to a piece of furniture, to a house, a temple, or a coffin, it possessed magical virtue, of which every being or action represented, every word inscribed or pronounced at the time of consecration, determined the power and character. These scenes were therefore amulets as well as decorations. So long as they lasted, they secured to the god the benefit of the homage rendered, or the sacrifice offered by the king,

and they confirmed to the king, living or dead, the favour granted him by the god in recompense for his

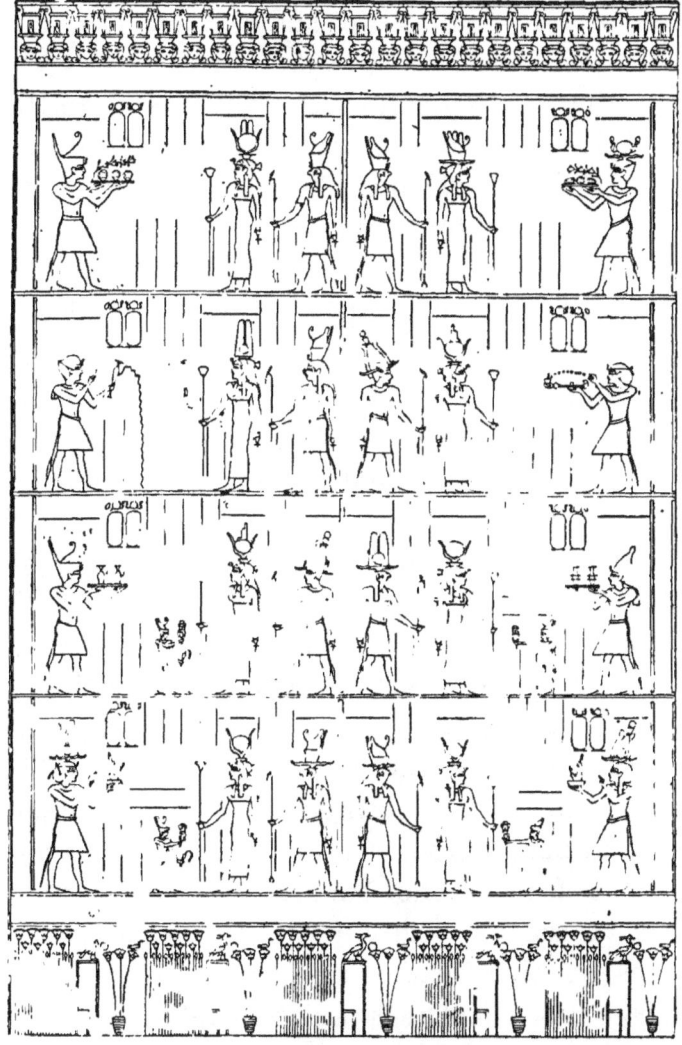

Fig. 112.—Wall of a chamber at Denderah, to show the arrangement of the tableaux.

piety, they preserved the wall on which they were carved from destruction, and also the whole area of

the temple to which the wall belonged. During the Eighteenth Dynasty it was supposed that one or two amulets of this kind were sufficient to obtain the desired effect, but later it was thought advisable to increase the number, and as many were added as could find room on the walls. One medium-sized chamber of Edfû or Denderah furnishes more material for study than the hypostyle hall of Karnak, and the chapel of Antoninus Pius at Philæ, had it been completed, would have contained more scenes than the sanctuary at Luxor with the passages surrounding it.

Observing the extraordinary variety of subjects dealt with, one is tempted to think that the decoration does not form a continuous scheme from beginning to end, and that, while several series are doubtless developments of a single idea either historical or religious, others are merely placed together without any connecting link. On each face of a pylon at Luxor and the Ramesseum a field of battle is represented, on which one can almost follow the struggle of Rameses II. with the Kheti day by day. There we see the royal camp surprised just as the Pharaoh had arrived before Qodshû (Kadesh), the camp forced, then the defeat of the barbarians, their flight, the garrison of the city sallying forth to their relief, and the disasters that befell the Syrian prince and his generals. Elsewhere it is not the field of battle that we see, but the sacrifice of human life that marked the close of each campaign; the king grasping his prostrate prisoners by the hair and brandishing his mace as though about to kill them at a single blow. At Karnak, along the outer wall, Seti I. is shown

hunting down the Bedouîn tribes of Sinai. At Medinet Habû we see Rameses III. destroying the fleet of the peoples of the sea, or he is counting the severed hands of the Libyans brought him as trophies by the soldiery. Then without any attempt at transition we find a peaceful scene—Pharaoh pouring out a libation of perfumed water to his father Amon. It does not appear possible to establish any connection between these scenes, and yet one is a necessary consequence of the other; if the god had not granted victory to the king, the king would not in turn have performed the ceremonies in the temple. The sculptor has recorded the events on the wall in the order in which they occurred. The victory, then the sacrifice; the benefits bestowed by the god, and then the act of gratitude performed by the king. If we study them as a whole, we find that the multitude of episodes are linked together in the same manner; all the scenes, including those which at the first glance appear most unaccountable, represent various stages in one single action, which begins at the entrance, and develops as we pass through the courts till it ends at the sanctuary. Pharaoh enters the temple. In the courts his eye is everywhere met by records of his victories, but these pictures which appear intended solely to flatter his vanity are homage to the god. This is so well understood by the latter that, concealed in his shrine and surrounded by his priests, he forthwith emerges to meet the king. The rites prescribed in this case are recorded on the walls of the hypostyle hall where they were performed, and then the king and the god together sought the

sanctuary. Arrived at the door that divided the public part from the mysterious regions of the temple, the priestly escort halted, and the Pharaoh, passing the threshold, was received by the gods. He performed one after another all the prescribed religious exercises, and then, having acquired merit, and with senses refined by virtue of his prayers, he ventured among the immortals and penetrated at length into the sanctuary, where his divine father revealed himself to him, and conversed with him face to face. The decorations give a faithful representation of this mystic interview, the friendly welcome of the divinities, the gestures and offerings of the king, the vestments successively laid aside and donned by him, the crowns he wore, the visions he recited and the benefits resulting from them—all these are engraved on the walls in their respective positions; Pharaoh and his small escort are placed facing the door at the farther end with their backs to the entrance; while the gods, with the exception of those escorting the king, face the entrance door, with their backs to the sanctuary. Should the royal memory fail during the ceremony, the king had only to glance at the walls to see what was next to be done.

This was not all; each part of the temple had its individual decoration and furniture. The walls of the pylons were not only furnished with the masts and streamers already mentioned, but with statues and obelisks. The statues, four or six in number, were of limestone, granite, or sandstone; they represented the royal founder, and were sometimes of colossal size. The two Memnons seated at the

entrance of the chapel of Amenhotep III. at Thebes measure about 50 feet in height. The colossus of Rameses III. at the Ramesseum stood 57 feet high, and that at Tanis at least 70 feet. The greater number of statues, however, did not exceed 20 feet. They mounted guard infront of the temple, facing outwards as though to ward off any approaching enemy. The obelisks of Karnak are almost all swallowed up in the multitude of courts. This circumstance is easily explained. Each pylon, with its accompanying obelisks, was originally the external façade, and was in turn relegated to a secondary position by the additional courts of successive Pharaohs. The proper position of the obelisks is in front of the colossi, on each side of the main entrance. They are always in pairs, but often of unequal height. They have been variously explained as being emblems of Amon-Generator, or a finger of the god, or a ray of light. Roughly shaped stone stelæ, bearing the name of the deceased king, were placed in front of the tombs of the kings of the earliest dynasties, and small limestone obelisks, about 3 feet in height, are found in tombs as early as the end of the Third Dynasty. They are placed to right and left of the stela—that is to say, on either side of the door that leads to the dwelling of the dead. In their origin * they may have been models of the celebrated *benben stone* of Heliopolis, the earliest incarnation of the sun god Ra, and closely related to the *baityle*, so well known in Syria and Palestine. Like the sphinx and the statues of the kings, they

* English Editor.

Fig. 113.—Obelisk of Senûsert I., Heliopolis.

were regarded as possessing magic powers that enabled them to protect the building before which they were placed from all evil, the attacks of mortal enemy, or of malignant spirits. Erected before the pylon gates, they were made of granite, and their dimensions are considerable. The shaft of the obelisk at Heliopolis (fig. 113) measures 68 feet, and those at Luxor are respectively 77 and $75\frac{1}{2}$ feet, while the highest known, that of Queen Hatshepsût at Karnak, rises to a height of 109 feet. To move such masses, even at the present time, and to calibre them accurately, is a serious task, and it is difficult to realise how the Egyptians succeeded in raising them with nothing more than ropes and sacks of sand. Hatshepsût boasts that her obelisks were quarried, shaped, transported, and erected within seven months, and we have no reason to doubt her word. Obelisks were almost invariably square in section, the faces slightly convex, and sloping slightly from top to bottom. The base was a single square block inscribed with texts or carved in high relief with cynocephali adoring the sun. The point was carved into a pyramidion, occasionally covered with bronze

or copper-gilt. Scenes of offerings to Ra-Harmakhis, Horus, Atûm, and Amon are carved on the sides of the pyramidion and on the upper part of the shaft. Below, on the four vertical faces, there are parallel lines of hieroglyphs setting forth the praises of the king, and sometimes a scene of offering at the bottom.

This is the usual form of obelisk. Here and there one comes across one of a different type. That at Begig, in the Fayûm, is rectangular in section, and bluntly rounded at the top (fig. 114). A mortise at the summit shows that it was surmounted by some metal object, probably a hawk, as on the obelisk carved on one of the votive stelæ in the Cairo Museum. This form lasted till the final decay of Egyptian art. One has been found at Axûm, in the middle of Ethiopia, dating from about the fourth century of our era.

Fig. 114.—Obelisk of Senûsert I., Begig Fayûm.

Such were the accessories to the decoration of the pylon. The inner courts and hypostyle halls had also colossi of their own. Some of these, backed on to the front faces of the pillars or walls, were only half disengaged from the masonry, and were even built up with it in courses. They represented the Pharaoh standing, mummified, and bearing the insignia of Osiris. Others, under the peristyle at

Luxor, and at Karnak between each column of the central aisle, are also statues of the Pharaoh, but here he is Pharaoh triumphant, clad in royal apparel. The right to dedicate a statue in the temple was also a royal prerogative, and although the king occasionally permitted some favoured person to dedicate theirs by the side of his own, it was always a special favour, and the inscription on such statues mentions that it was placed there *by the king's grace.* Rarely as this privilege was granted, it resulted in a vast accumulation of votive statues, so that in the course of centuries the courts and passages of some temples were crowded with them. At Karnak the sanctuary enclosure was furnished outside with a kind of broad bench breast-high, on which the statues were placed with their backs to the wall. So crowded was the temple, that at last it was found absolutely necessary to get rid of some of the statues. They were temple property, and could not be disposed of. In the course of the third century B.C. a deep trench was dug near the south wall of the hypostyle hall, and about a thousand statues were buried. Here they remained in safety till the beginning of this century, when M. Legrain discovered them, and they are now ranged in numbers in the Cairo Museum.

Fig. 115.—Table of offerings, Karnak.

Attached to each statue as it stood in the sanctuary was a rectangular table of offerings (fig. 115) formed

TABLES OF OFFERINGS. 125

of a block of stone with a projection on one side to form a spout, and the upper part hollowed more or less deeply. On it are often carved loaves, joints of beef, libation vases, and other objects usually presented to the deceased or to the gods. The tables of offerings of King Ameni Entef Amenemhat at Cairo consist of blocks of red granite more than 3 feet in length, the top of which is hollowed into cups spaced at regular intervals, each cup-hole being reserved for one particular offering. There was a cult connected with these statues, and the tables were altars upon which sacrificial offerings of meat, cakes, fruits, vegetables, and the like were placed during the performance of the ritual which ensured the offerings reaching the deceased.

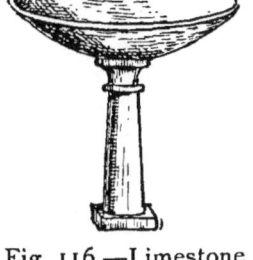

Fig. 116.—Limestone altar.

The sanctuary and the surrounding chambers contained the objects required for the cult. The bases of altars varied in shape, some square and massive, others polygonal or cylindrical. Some of these last are not unlike a small cannon, which is the name given them by the Arabs.

A perfect specimen was discovered at Menshîyeh in 1884 (fig. 116). It is of white limestone, hard, and polished like marble. The foot is a very long cone with no ornament except a torus about half an inch below the top. Upon this the large hemispherical basin is fixed into a square mortise.

The naos is a small shrine of wood or stone (fig. 117) in which the spirit of the deity was at

all times expected to dwell, and which on certain festivals contained his actual image. The sacred barks were built after the model of a boat, in which the sun pursued his daily course round the world. In the centre was the naos, covered with a veil that prevented spectators beholding what was within it. The crew was complete, each god at his appointed

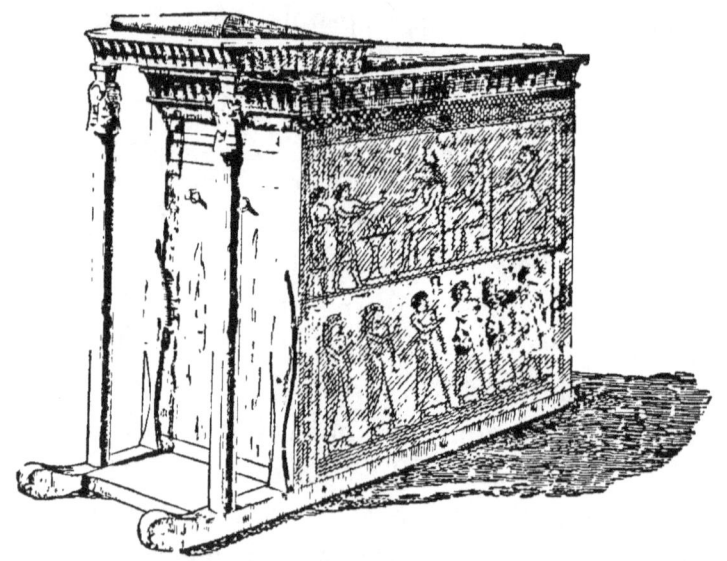

Fig. 117.—Wooden naos, Turin Museum.

place, the pilot at the helm, the look-out at the prow, the king on his knees before the door of the naos.

We have not yet found any of the statues employed at the ceremonies in honour of the gods, but we know their appearance, the part they played, and the materials of which they were made. They were animated, and in addition to their bodies of stone, metal, or wood, they possessed a soul, procured by magic from the divinity they represented. They

spoke, they moved, they acted—not metaphorically, but actually. The Pharaohs undertook nothing without their counsel. They addressed them, consulting them as to affairs of state, and after each question they showed approval by bowing the head, or if the reply was unfavourable they remained immovable. The stela of Bakhtan (a priestly document of Persian or Ptolemaic times) states that a statue of Khonsû placed its hands four times on the neck of another statue in order to transmit to it the power of chasing away demons. Hatshepsût despatched an expedition to Punt, the *Land of incense*, after having conversed with the statue of Amon in the darkness of the sanctuary. In theory the divine spirit alone was supposed to produce these miracles, but in practice the speech and movement were the result of human intervention. Interminable avenues of sphinxes, gigantic obelisks, massive pylons, halls of a hundred columns, mysterious chambers where the day never penetrated—the entire Egyptian temple was built to serve as an abode for an articulated puppet in whose name a priest spoke, and of which he pulled the wires.

CHAPTER III.

TOMBS.

THE Egyptians regarded man as constituted of various entities, each of which possessed its own functions and life. There was the visible form, the body to which the *ka* or *double* was attached during life. The *ka* was a replica of the body, of a substance less dense, a coloured but ethereal projection of the individual: the *ka* of a child would reproduce the child, that of a woman the woman, that of a man the man, each of them feature for feature. Then there was the *ba*, the soul represented in the form of a bird, sometimes with a human head. There was also the *khu* or *luminous*, and one or more other entities perhaps of less importance. These elements were not imperishable, and if left to themselves they would gradually cease to exist, and the man would die a second time—that is to say, he would become non-existent. The existence of the *ka* depended on the body, and to save that from destruction was the object of the survivors. By the process of drying and embalming the body they could prolong its existence for ages, while by means of prayers and offerings they saved the *double*, the *soul*, and the *luminous* from the second death, and procured for them all that was necessary for pro-

longed existence. The *double* scarcely quitted the place where the mummy dwelt; the *soul* and the *luminous* left it to follow the gods, but they always returned to it as a traveller returns home.

At first the grave was a mere shallow pit in which the dead was laid on a mat surrounded by weapons, food, pottery, ornaments, and a palette on which to rub the paint with which he coloured his face. The body was laid on the left side in a crouching attitude, with the head either to the north or the south. This earliest form of grave was soon elaborated, and through the Thinite period we can trace its development. The deep rectangular pit roofed with timber and mud, then brick-lined, with steps leading down to it; the superstructure of mud and brick carefully whitened on the outside, and with its two niches on the east side where offerings and prayers could be made for the dead. Every stage can be traced from the primitive grave to the elaborate tomb of the Old Kingdom. The tomb of the Egyptian was a dwelling-house, his *eternal house*, in comparison to which earthly houses were but inns for temporary convenience. The arrangement of these *eternal houses* corresponded faithfully to the conception held regarding the future life. They contained private apartments for the soul, where after the day of the funeral no living creature could enter without committing sacrilege. In the fully equipped tombs halls of audience were provided for the *double*, where priests and friends came with prayers and offerings, while between the two were passages of various lengths. The arrangement of these three sections varied

greatly, according to the period, the locality, the nature of the site, and the social position and caprice of the individual. The part accessible to the public was often above ground, and formed a separate building. In other cases it was excavated in the mountain side as well as the tomb itself, or again the sepulchral chamber with the passages leading to it was in one locality, while the place for offering and prayer was at a distance on the plain. But, however varied in detail and grouping, the principle always remains the same. The tomb is a dwelling intended to promote the well-being and secure the preservation of its occupant.

I.—MASTABAS.

We have already alluded to the graves of the pre-dynastic and archaic period. The cemeteries of that early period abound in Lower Nubia and Upper Egypt, and mastabas of the Second Dynasty have been found as far north as Saqqara. The great mastabas of the Memphite period are found at Memphis, at Medûm, and between Abû Roash, and Dahshûr. The mastaba (fig. 118) is a quadrangular building which from a distance might be mistaken for a truncated pyramid; the name was applied to them by the natives on account of their shape, *mastaba* being the Arabic word for a bench or platform. Many of these mastabas are from 30 to 40 feet in height, 150 feet in length, and 80 feet in width, while others are barely 10 feet high or 15 feet long. The sides slope symmetrically,

THE MASTABA. 131

and are usually quite smooth, but sometimes the courses recede one above another like a series of steps. The materials employed are brick or stone. The stone is always limestone worked in blocks about 32 inches long, 20 inches high, and 24 inches wide. Three kinds of limestone are used; for the best worked tombs the fine white stone from Tûrah or the compact silicious stone of Saqqara, and for ordinary tombs the marly limestone of the Libyan mountains. This last contains thin layers of salt and is veined with crystallised gypsum, and is exceedingly friable and unsuited for ornamentation. The brick is merely sun-dried, and is of two kinds. The most ancient, which fell into disuse as early as the Sixth

Fig. 118.—A mastaba.

Dynasty, is small ($8\frac{3}{4} \times 4\frac{1}{2} \times 5\frac{3}{4}$ inches), yellowish, and made of sand mixed with a little clay and gravel. The other kind is black, compact, well moulded, made of mud mixed with straw, and fairly large ($15 \times 7 \times 5\frac{1}{2}$ inches). The working of the stone inside the building varies according to the material employed by the architect. Nine times out of ten it is only the outside walls of the stone mastabas that are regularly worked. The inside is constructed of roughly quarried rubble, fragments of limestone and rubbish roughly laid in horizontal courses embedded in mud, or even piled up without mortar of any kind. The brick mastabas are almost always uniform in construction, the external faces carefully

built with mortar, and the interstices of the inner layers filled in with fine sifted sand.

It was intended that the mastaba should be correctly orientated, the four sides to the four cardinal points, the greater axis stretching from north to south; but the masons did not trouble to find the exact north, and the orientation is rarely accurate. At Gizeh the mastabas are arranged according to a symmetrical plan, and form actual streets; at Saqqara, Abûsir, and Dahshûr they are flung in disorder on the plain, in some places crowded, in others far apart. The modern Mussulman cemetery at Siût shows a similar lack of arrangement, and furnishes an idea of the appearance of a Memphite necropolis during the latter part of the Old Kingdom.

An unpaved platform, consisting of the final layer of the masonry, forms the top of the mastaba: this is thickly strewn with pottery, which is almost buried in the earth employed in the building, and laid most thickly above the hollow parts of the interior. The walls are bare, the doors generally face east, occasionally north or south, but never west. There were two of these, one reserved for the use of the dead, the other accessible to the living; but that intended for the dead was merely a narrow high niche in the east face, near the north-east angle. Vertical grooves were worked on the face of the niche, and formed a frame and a narrow sunk panel. Even this pretence of a means of entry was sometimes omitted, and the soul had to manage as best it might. The door for the living was of more or less importance, in accordance with the chamber to which it led. In more than

one instance, as in the earliest form of mastaba, the door and chamber are combined in one shallow recess containing a stela and a table of offerings (fig. 119). This is occasionally protected by a wall projecting from the face of the mastaba, which forms a kind of forecourt opening towards the north; in the tomb of Kaāpir the court is square (fig. 120), in that of Neferhotep at Saqqara it is of irregular form (fig. 121). When the plan of the tomb includes one or more chambers, the door is in

Fig. 119.—False door in mastaba, from Mariette's *Les Mastabahs*.

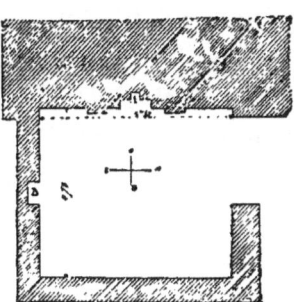

Fig. 120.—Plan of forecourts, in mastaba of Kaāpir.

the centre of a small architectural façade (fig. 122) or under a shallow portico of two square pillars without base or abacus (fig. 123). It is of almost rudimentary simplicity — the two door-jambs are either plain or have bas-reliefs representing the deceased, and surmounted by a cylindrical drum carved with his name and titles. In the tomb of Pohûnika at Saqqara the door-jambs represent two pilasters each crowned with two lotus-flowers in relief.

The chapel itself was generally small, and out of all proportion with the size of the building (fig. 124), but there was no precise rule to determine its size. In the tomb of Ti (fig. 125) there is successively a portico (A), a square antechamber with pillars (B), a passage (C), with a small chamber on the right (D) opening into a final chamber (E). There is plenty

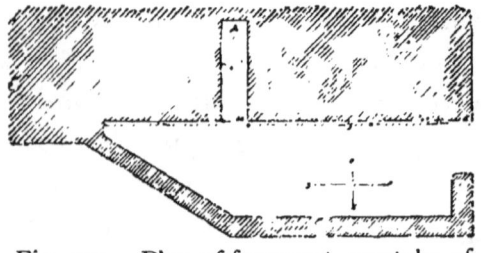

Fig. 121.—Plan of forecourt, mastaba of Neferhotep.

of space for more than one person of importance, and the inscriptions show that the wife of Ti reposed there with her husband. The tomb was not so complicated when it was intended for one person only.

Fig. 122.—Door in façade of mastaba.

A short narrow gallery leads to an oblong chamber, which crosses it at right angles. The rear wall is often straight, and the whole resembles a well-balanced hammer (fig. 126). In other cases the wall is recessed opposite the entrance, and gives the form of a cross with the head considerably shortened (fig. 127). This was the most usual arrangement, but the architect was at liberty to disregard

Fig. 123.—Portico and door, from Mariette's *Les Mastabahs*.

it at will. One chapel consists of two parallel galleries connected by a transverse passage (fig. 128). In another the chamber opens at one corner on to the

Fig. 124.—Plan of chapel in mastaba of Khabiūsokari, Fourth Dynasty.

gallery (fig. 129); or again in the tomb of Ptahhotep the available area was hemmed in between earlier constructions, and was not large enough. Here the

Fig. 125.—Plan of chapel in mastaba of Ti, Fifth Dynasty.

Fig. 126.—Plan of chapel in mastaba of Shepsesptah, Fourth Dynasty.

Fig. 127.—Plan of chapel in mastaba of Affi, Saqqara, Fourth Dynasty.

new mastaba was combined with the earlier one by making the entrance common to both, and the chapel of the one was enlarged by the whole of the space occupied by the other (fig. 130).

The chapel was the reception-room of the *double*. There the relatives, friends, and priests celebrated the funerary sacrifices on the days prescribed by law, "at the feasts at the beginning of the seasons, at the feast of Thoth, on the first day of the year, at the feast of Ûaga, at the great feast of Sothis, at the procession of the god Min, at the feast of loaves, at the feasts of the months, the half months, and of the days." The offerings were deposited in the principal hall at the foot of the west wall at the precise spot where the entrance to the *eternal house* was indicated. At first this was marked by an actual door, framed and decorated like the ordinary door of a house. As,

Fig. 128.—Plan of chapel in mastaba of Thenti II., Saqqara, Fourth Dynasty.

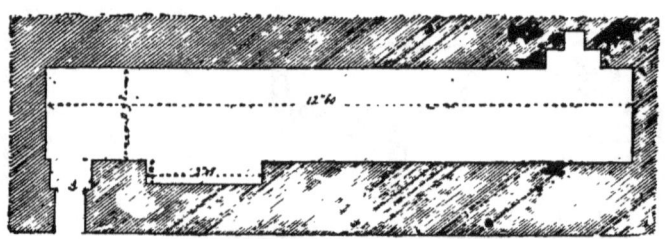

Fig. 129.—Plan of chapel in mastaba of the *Red Scribe*, Saqqara, Fourth Dynasty.

however, it was to remain for ever closed to the living it was not long before this door was walled up and a mere false door substituted for it. A hieroglyph inscription carved on the lintel commemorated the name and rank of the occupant. Representations of him, standing or seated, were carved on the sides,

while a scene painted or carved on the back of the recess showed him seated before a table and reaching out his hand for the repast provided for him. A flat table of offerings fixed in the floor between the jambs of the false door received the offerings of food and drink. The general appearance of the recess is that

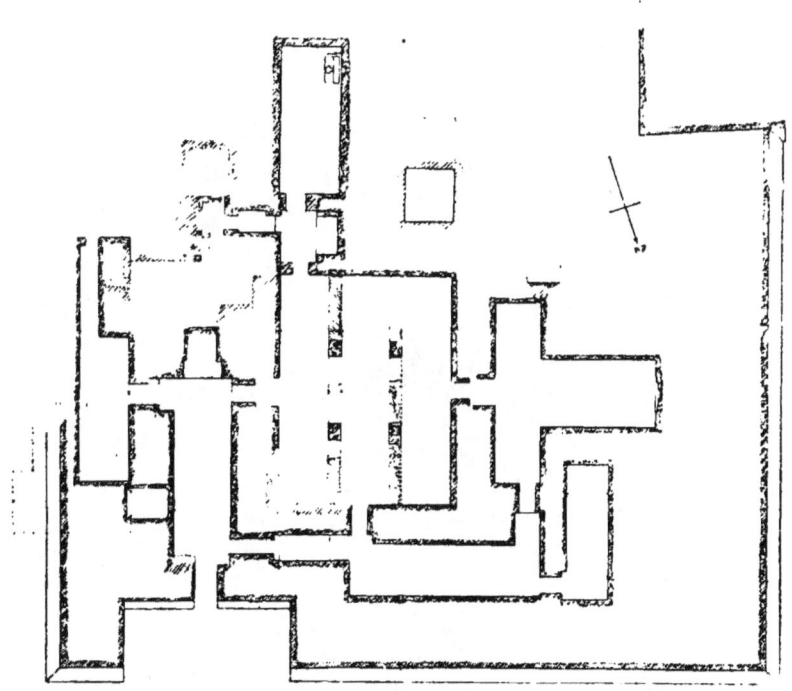

Fig. 130.—Plan of the mastaba of Ptahhotep, Saqqara, Fifth Dynasty.

of a somewhat narrow doorway. As a rule it was empty, but occasionally it contained a portrait of the dead man, either the head and shoulders, or a complete statue of him (fig. 131), standing with one foot forward as though about to pass the gloomy threshold of his tomb, descend the steps into the chapel or *ka*

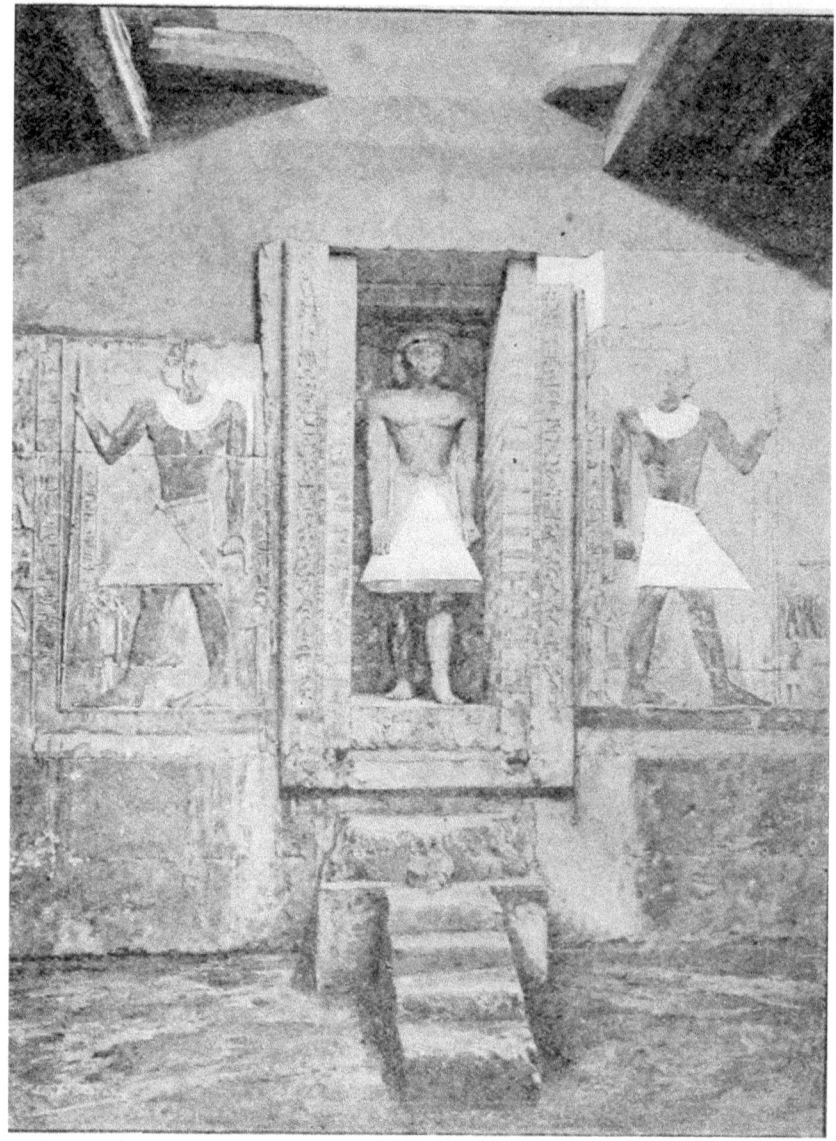

Fig. 131.—Stela in tomb of Merruka, a false door containing a statue of the deceased, Abûsir, Fifth Dynasty.

chamber, and partake of the heaped-up offerings of food laid on the table, as he was expected to do as

soon as the ceremonies were concluded, and his living visitors had departed.

Theoretically these offerings should have been repeated year by year throughout the ages, but the Egyptians soon realised that this could not be. After two or three generations the dead of bygone times would be neglected in favour of others more recent. Even when they were endowed with pious foundations whose revenues were intended to provide offerings and priests to serve them, the hour of oblivion was only deferred. Sooner or later the *double* would be forced to search for food among the town refuse and corrupt filth lying about on the ground.

The survivors therefore conceived the idea of inscribing on the stela a list of the food and drink he would require, with an invocation to the gods of the dead, Osiris or Anubis, to supply him with all good things necessary. Offerings of real provisions were not necessary. Any chance stranger in times to come who should simply repeat the magic formula of the stela aloud would thereby secure the immediate enjoyment by the deceased of the good things there set forth. The name and titles of the deceased inscribed on the door-posts and lintels were no mere epitaph for the information of future generations; all the details given as to the name, rank, and function of the deceased were intended to secure the continuity of his individuality and civil status in the life beyond death. In order to ensure that the funerary offerings should for ever retain their virtue they were painted and described on the walls of the chapel (fig. 132). The painted or sculptured representations of persons

and things ensured their actual possession and enjoyment by the individual for whose benefit they were

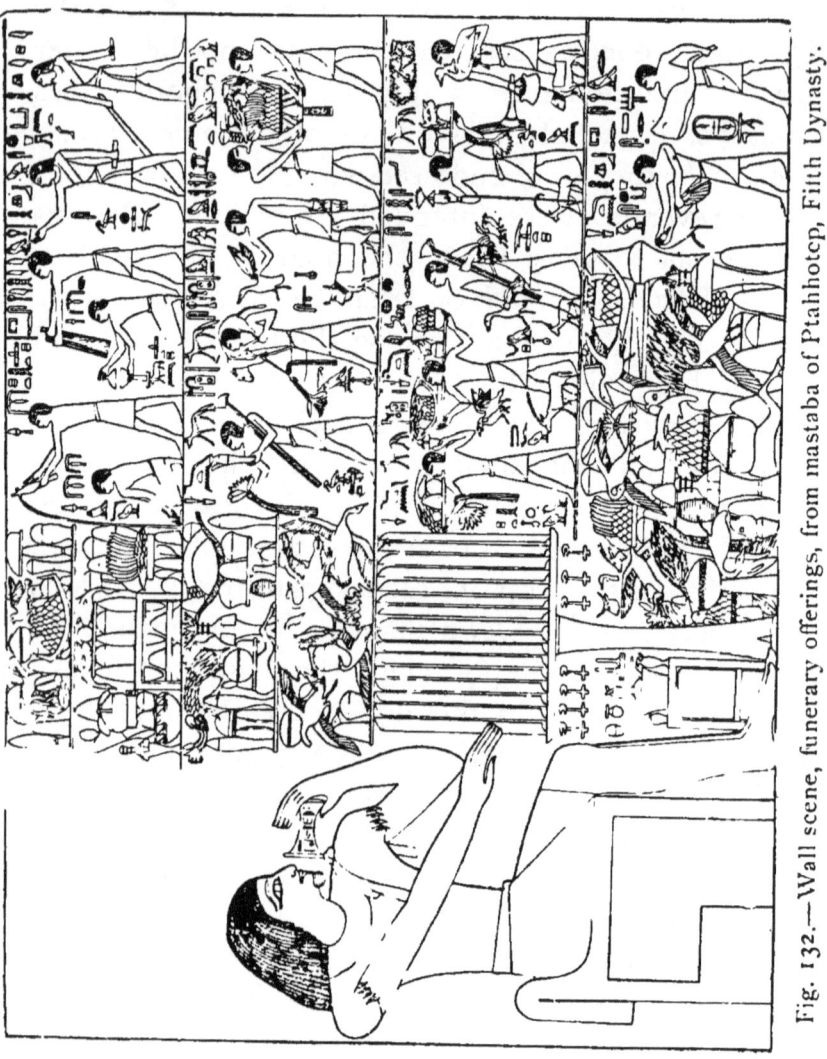

Fig. 132.—Wall scene, funerary offerings, from mastaba of Ptahhotep, Fifth Dynasty.

executed. Thus the *ka* saw himself depicted on the walls eating and drinking, and he ate and drank accordingly.

This idea once admitted, many further developments were evolved from it. Not only were fictitious provisions provided, but the domains from which they were supposed to come were also added, with flocks, labourers, and slaves. Was it a question of how to provide food for all eternity, it was only necessary to draw the different parts of an ox or a gazelle ready prepared for the butcher—the shoulder, the haunch, the ribs, the breast, the heart and liver and the head; but it was also quite easy to represent the history of the animal from a very early period—its birth, its life in the pastures, then the slaughter-house, the cutting up of the creature, and the final offering. In the same way with regard to cakes or loaves, there was no difficulty in depicting the field labour, the sowing, the harvest, beating out the grain, storing it in the granary, and kneading the dough. Clothing, ornaments, and furniture afforded a pretext for introducing spinning and weaving, gold-working and joiner's work. The master is represented of immense size, out of all proportion to the workpeople and cattle. Various tactful scenes show him in his funeral barge travelling full sail (fig. 133) to the other world, on the very day when he was deposited in the depths of his new abode. Elsewhere he is seen in full activity inspecting his imaginary vassals as he had formerly inspected the real ones (fig. 134). His ornaments are not forgotten, and he is provided with dancing girls, musicians, or his favourite gaming-board at which he is seen playing. Varied as these scenes are, they are not arranged without method. They all converge towards the false door that is

supposed to communicate with the tomb chamber; those nearest the door represent the details of the

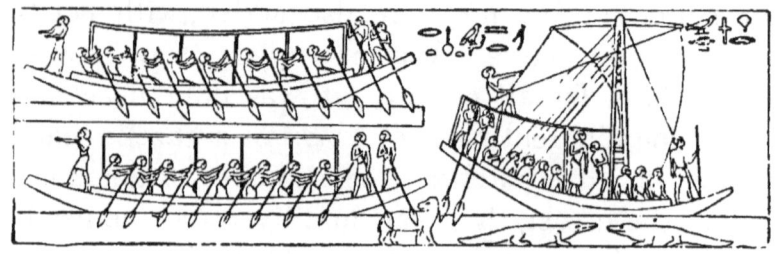

Fig. 133.—Wall painting, funeral voyage, mastaba of Urkhuû, Gizeh, Fourth Dynasty.

sacrifice and offerings, followed in the retrograde order of the sequence of events, the first preliminaries being at the greatest distance from the stela. At the

Fig. 134.—Wall scene from mastaba of Ptahhotep, Fifth Dynasty.

door the figure of the occupant appears to await his visitors and bid them welcome. There is an infinite variety, the inscriptions are shortened or lengthened

according to the caprice of the scribe, the false door loses its architectural character, and is often nothing more than a stone of medium size, a stela bearing the name and protocol of the occupant; large or small, bare or richly ornamented, the chapel always remained the dining-room, or perhaps rather the buttery, where the deceased could feed when hungry.

On the other side of the wall a narrow lofty recess or passage is concealed. To this archæologists give the name of *serdab*, a term borrowed from the Arabs. The greater number of tombs have only one of these, but in some instances there are three or four (fig. 135). They communicate neither with each other nor with the chapel, and they may be described as buried in the masonry (fig. 136); safely walled up in them were statues of the deceased, sometimes of his wife and children. If there is any connection with the outside world it is by means of an opening in the wall a man's height from the floor (fig. 137) and almost too small for a hand to be inserted. At this orifice the priests would murmur prayers and burn incense; the *double* was at hand to profit by them, and his statues would certainly benefit. To carry on existence as he had done on earth the man still required a body, but the corpse disfigured by the process of embalming was only an imperfect representation of the living form. The mummy was alone and easily destroyed, it might be

Fig. 135.—Plan of serdab in mastaba at Gizeh, Fourth Dynasty.

burned, or dismembered and scattered abroad. If it should disappear what would become of the *double*? The statues hidden in the serdab, whether of stone, metal, or wood, became after consecration the actual body. By the piety of the relatives the number of these *ka* statues was multiplied, and thus the supports of the *double* were also increased. A single body gave him one chance of prolonged existence, whereas twenty bodies gave him twenty chances. It was with similar intention that statues of his wife and children were placed with that of the deceased, and also figures

Fig. 136.—Plan of serdab and chapel in mastaba of Ra-hotep at Saqqara, Fourth Dynasty.

Fig. 137.—Plan of serdab and chapel in mastaba of Thenti I., at Saqqara, Fourth Dynasty.

of his servants occupied with their various domestic duties, grinding corn, kneading bread, or sealing up the wine-jars. The figures that were painted on the chapel walls were detached and assumed a solid form in the serdab.

All these precautions did not prevent every possible means being adopted to preserve what remained of the actual body from decay and from damage by spoilers. In the tomb of Ti a steep passage-way from the centre of the principal chamber leads to the vault, but this is very exceptional. The entrance to

THE VAULT.

the vault is usually a vertical shaft, which descends from the centre of the platform (fig. 138), or more rarely from a corner of the chapel. The depth varies from 10 to 100 feet, the shaft is carried down through the masonry into the rock, when it opens on the south side into a corridor so low that it is impossible to walk upright. Beyond this is the funeral chamber, and here the mummy is concealed in a massive sarcophagus of white limestone, red granite, or basalt. In rare cases it is inscribed with the name and titles of the deceased, and still more rarely it is decorated; some examples are known carved in imitation of a house, with its grooves on the façade, its doors, and windows. The accessories placed in the vault are very simple; alabaster vases for perfumes, bowls into which the priest poured some drops of the liquids offered to the dead man, rough pottery jars for water, an alabaster or wooden head-rest, and a votive offering of a scribe's palette. The body having been placed in the sarcophagus and sealed up, the attendants placed joints of a newly sacrificed ox or gazelle on the floor. The entrance to the passage was then carefully blocked up, and the shaft filled up with fragments of stone mixed with sand and earth. This mixture, when freely watered, formed an almost

Fig. 138.—Section showing shaft and vault of mastaba at Gizeh, Fourth Dynasty.

impenetrable cement. The body thus left in solitude henceforth received no visit except from its *soul*, its *luminous*, and its *double*. The *double* could leave the chapel and come and go at pleasure, while the *soul* from time to time abandoned the celestial regions when it journeyed with the gods, and spent some hours with its mummy.

Up to the time of the Sixth Dynasty the walls of the tomb chamber are bare. Once only did Mariette find in it fragments of inscriptions belonging to the *Book of the Dead*. In 1881, however, I found tombs at Saqqara, where the sepulchral chambers had been decorated in preference to the chapel. They were built of brick, and the place for offerings was merely a niche containing a stela. Inside, the shaft was replaced by a small rectangular court, on the western side of which was the sarcophagus.

Fig. 139.—Section of mastaba, Saqqara, Sixth Dynasty.

Above the sarcophagus there was a limestone chamber of the same length and breadth as the sarcophagus, and about $3\frac{1}{2}$ feet high, covered with a flat ceiling of stone slabs. A niche was constructed at the end or to the right to take the place of the serdab. Above the flat roof was a vaulting, with a radius of about 18 inches, to take off the weight of the superincumbent masonry, and above that again were courses of bricks carried

up to the level of the platform. The chamber occupies about two-thirds of the cavity, and looks like an oven with the mouth open. Sometimes the chamber was only completed after the interment, and the stone walls actually rest on the cover of the sarcophagus (fig. 139). More frequently they are supported on brick substructures, and the sarcophagus

Fig. 140.—Wall painting of funerary offerings, from mastaba of Nenka, Saqqara, Sixth Dynasty.

could be opened or closed at will. The decoration, whether painted or sculptured, is the same everywhere. Each wall was regarded as an actual house containing the objects represented or enumerated on it. Care was taken, therefore, to provide a large door by which the deceased could obtain access to his property. On the wall to the left he found a profusion of food (fig. 140), and also|the table of offerings.

The end wall provided him with household utensils, linen, and perfumes, their names and quantities carefully noted. The scenes are repetitions of those in the chapels. They have been removed from their original position and transferred to the tomb chamber, thus rendering them far more secure than they could be in chambers that were accessible to all comers.

The stately stone mastabas of the nobles and officials of the court of Khûfû cluster near his pyramid at Gizeh. The humbler brick-built mastabas of less important folk of the Fourth and Fifth Dynasties are near by. From them, recent excavations by Dr. Reisner have brought to light many fine portrait figures hitherto concealed in the untouched serdabs. Many of these *ka* statues of limestone, finely painted, are now in Boston, and form an interesting study of men, with their wives and children, who must have been officially connected with the building of the great pyramids.

2.—ROYAL TOMBS AND PYRAMIDS.

The great mastaba at Nagada and the tombs at Abydos are the earliest royal tombs known in Egypt. The outer walls of the Nagada tomb are recessed at intervals with vertical grooves very similar to those on the walls of early Babylonian buildings (fig. 141). Similar panelling is frequently found on mastabas of the early period, and of the Old Kingdom (fig. 142).

At Abydos there is a series of royal tombs of the First and Second Dynasties. They consist of im-

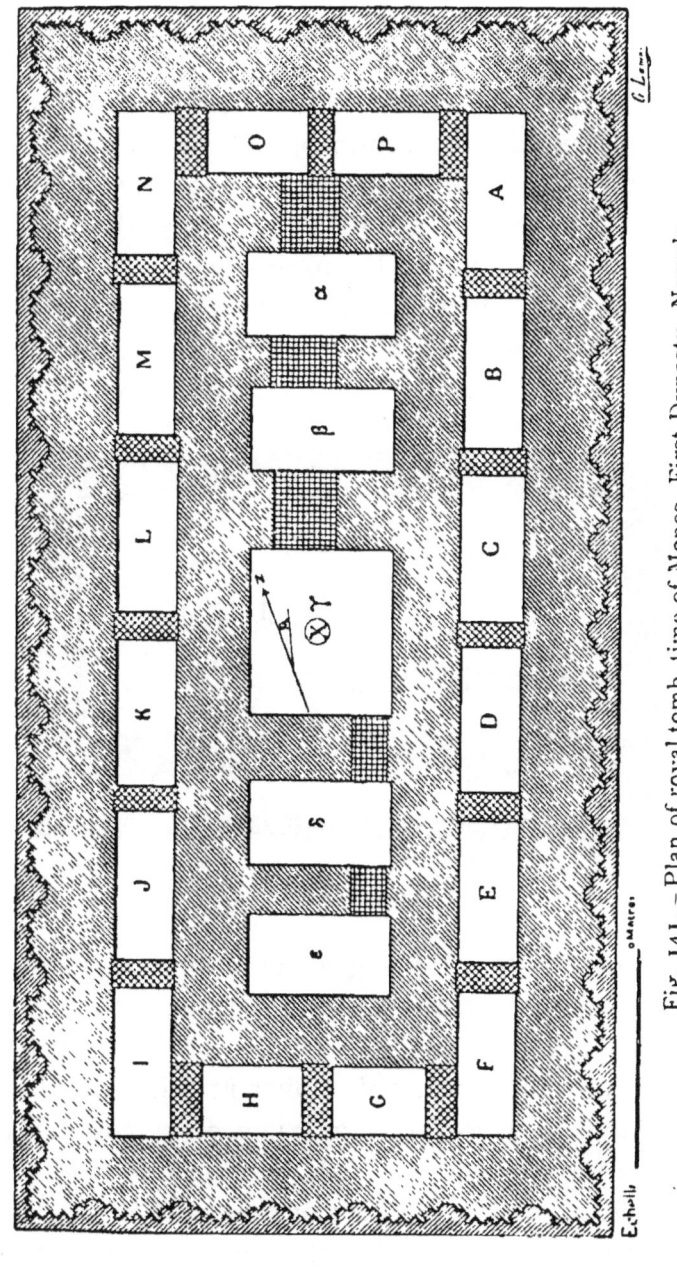

Fig. 141. — Plan of royal tomb, time of Menes, First Dynasty, Nagada.

mense rectangular pits from 10 to 14 feet deep, and lined with bricks. The tomb chamber is in the centre, surrounded by a number of smaller chambers which contained offerings and also the bodies of servants, whose *kas* would accompany their master to the future world. The tombs vary considerably. The brick walls were lined with wood; at first the tomb chamber was of wood or of brick, and floored with wood. A stairway (fig. 143) was soon introduced

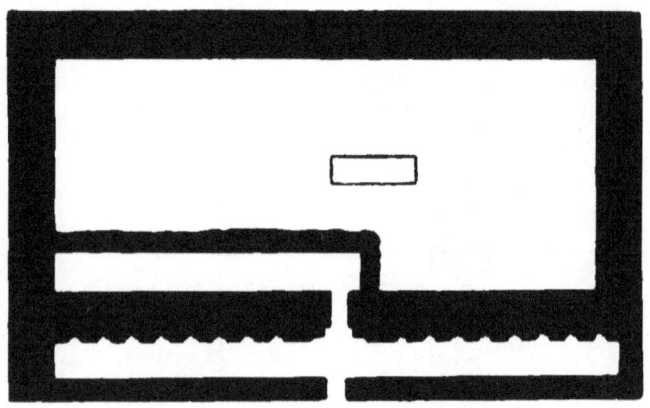

Fig. 142.—Tomb of Senna, with panelled east wall, Denderah, Sixth Dynasty.

on the north side, then a granite floor was provided for the tomb chamber, and by the time of the Second Dynasty there is a tomb chamber built of hewn stone. The tomb was roofed over at the ground level with beams of wood and a layer of straw. Above this sand was piled, and a low retaining wall some 3 or 4 feet high shows the very modest height of the superstructure. In front of the tomb at the east side (in one instance on the south) two large stone steiæ were erected on which were carved in hieroglyphs the

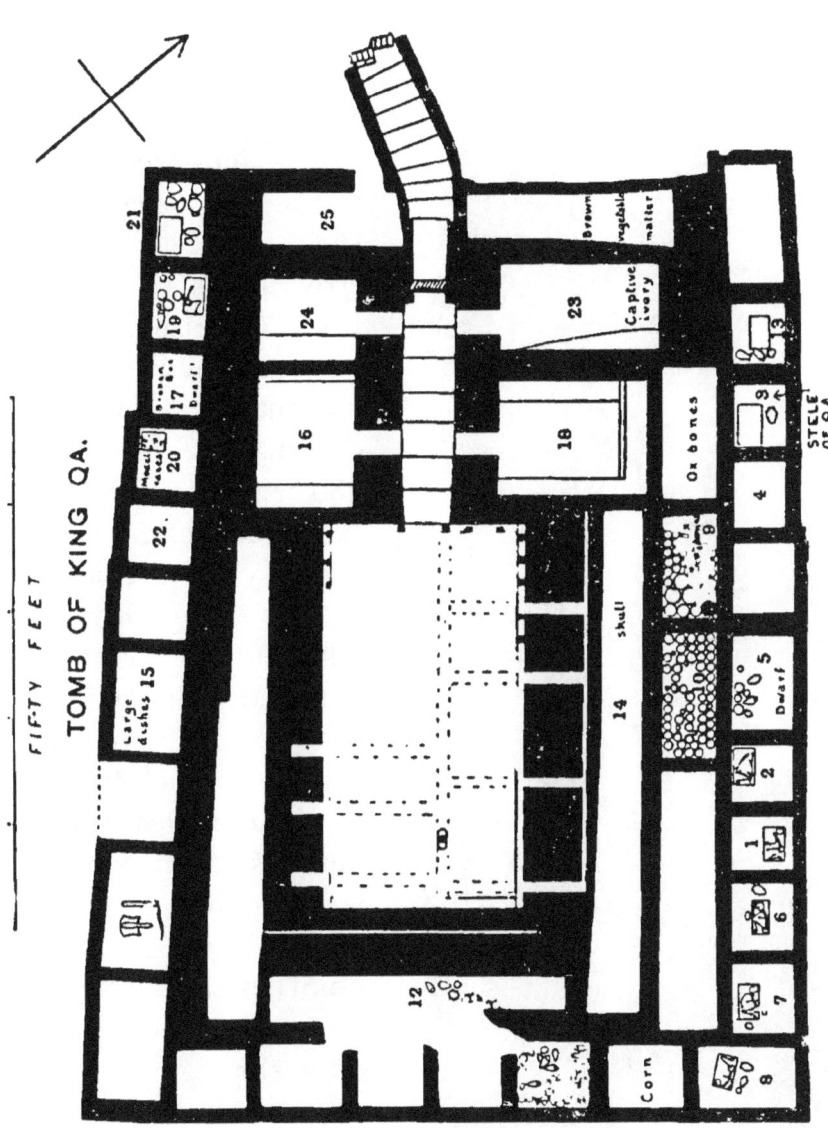

Fig. 143.—Plan of tomb of King Qa, with subordinate interments round it, Abydos, First Dynasty.

name of the king (fig. 144). It was here that the offerings for the dead were brought.*

The royal tomb of Bêt Khallâf, built by Zeser of

* W. M. Flinders Petrie, *Royal Tombs*, vol. i., ii.

Fig. 144.—Stela of King Perabsen, Abydos, Second Dynasty.

the Second or Third Dynasty, has developed into an unmistakable mastaba (fig. 145). The superstructure is of crude brick, and rises about 33 feet above the present level of the desert. It measures 280 feet long by 153 feet wide. The bricks employed average 11 × 5 × 3½ inches. The outer walls are panelled with vertical grooves. A stairway (fig. 146), which turns at right angles after perhaps eight steps, leads down to the desert level; at this point it passes through an archway and opens on a sloping passage covered by a barrel roof of brick. This continues to a depth of 54 feet below the ground, and gives access to a series of galleries and chambers

opening to right and left, and to the stone-lined tomb chamber (f). The passage was closed at five separate points by large slabs of limestone, let down shafts constructed for the purpose. These stones increased in size as they neared the chamber entrance. The largest was 17 feet in height, 8 to 9 feet in width, and 2 feet thick.

The tomb chamber had been rifled in Roman times,

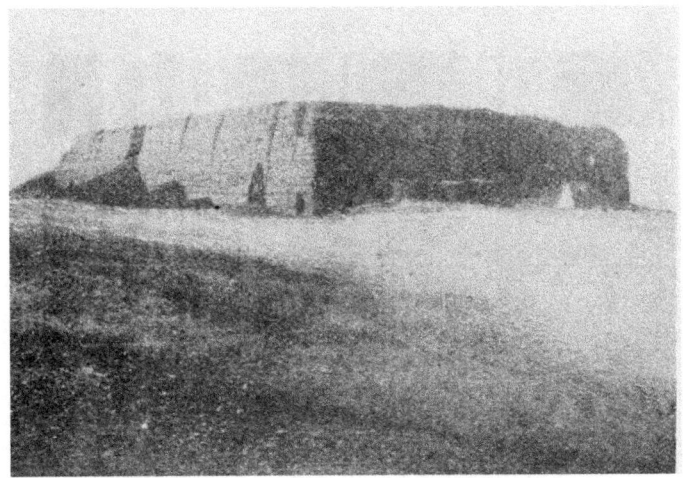

Fig. 145.—Royal tomb, Bêt Khallâf, superstructure.—*Egypt Research Account*, J. Garstang.

but broken vessels lay there in piles, inscribed with the royal name. The plunderers had dug a way for themselves; the portcullises were undisturbed, and the stairway was crowded with alabaster vases, tables of offerings, and wine-jars, some of them stamped and sealed with the royal name and titles. The entrance at the top had been carefully bricked up and concealed, and had successfully guarded its secret.*

* J. Garstang, *Mahasna and Bêt Khallâf*.

With the second tomb built by King Zeser we approach yet nearer to the type of the true pyramid. The great step pyramid of Saqqara is built of stone, and has the appearance of six superposed mastabas (fig. 147). It is not accurately orientated; the northern face deviates 4° 21′ E. of the true north. The base is not square, but a rectangle elongated from east to

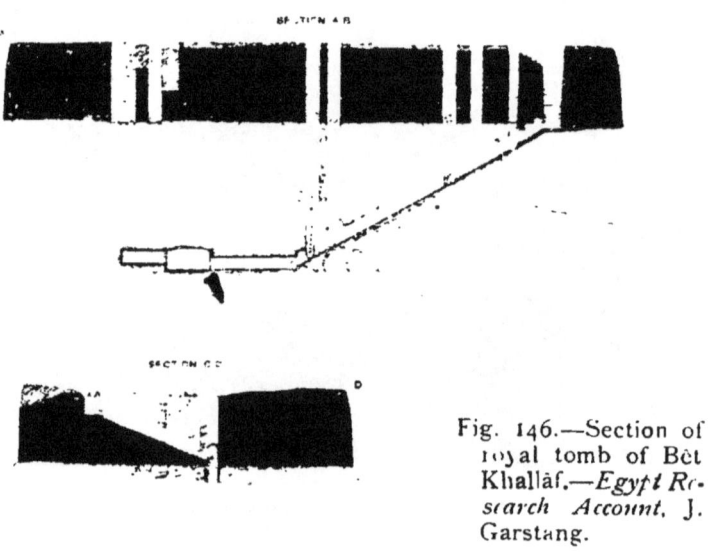

Fig. 146.—Section of royal tomb of Bêt Khallâf.—*Egypt Research Account*, J. Garstang.

west measuring 395 × 351 feet. It is 196 feet high. The lowest step, with its sloping sides, is 37½ feet high, and the succeeding steps each recede about 7 feet. It is built entirely of limestone from the surrounding desert plateau. The stone is small and badly quarried, the courses are concave, on the same method of construction as that employed for quays and fortresses. An examination of the walls where they are broken shows that the external face

of each step has two coverings, each with its regular revetment. The building forms a solid mass, and the chambers are cut out in the rock below the pyramid. The most important of the four entrances is on the north side, and the passages form a perfect labyrinth dangerous to enter. Colonnades, galleries, chambers, all lead to a central pit, at the bottom of which a hiding-place is contrived, no doubt intended

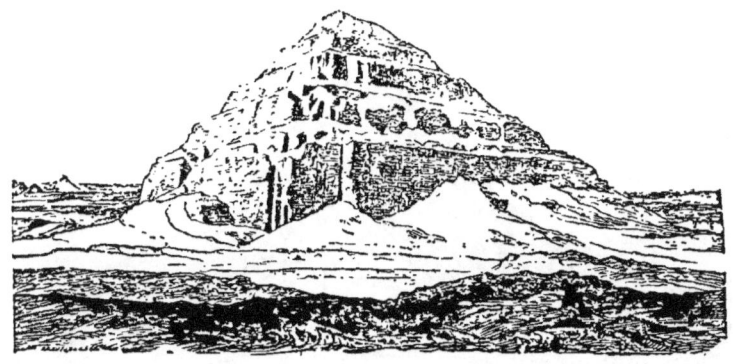

Fig. 147.—Step pyramid of Saqqara.

to contain the most valuable objects of the funerary outfit.

The stone pyramid of Zowyet el Aryan has recently been examined by Dr. Reisner, and proves to be also a step pyramid, apparently of the Third Dynasty.

The next advance we note in this development of the royal tombs is the pyramid of Seneferû, last Pharaoh of the Third Dynasty, and the predecessor of Khûfû. His pyramid is at Medûm. It consists of three square stages with sloping sides resembling three mastabas placed one above another (fig. 148). Like the step pyramid of Saqqara, it is a cumulative

mastaba. The entrance is on the north, about 53 feet above the sand (fig. 149). At a distance of 60 feet the passage enters the rock. At 174 feet it runs level for 40 feet, when it stops and rises perpendicularly for 21 feet, and then opens on the floor of the vault. A set of beams and ropes which are still in place above the opening show how the spoilers drew the sarcophagus out of the chamber in ancient times. We have already seen (p. 72) that the small chapel

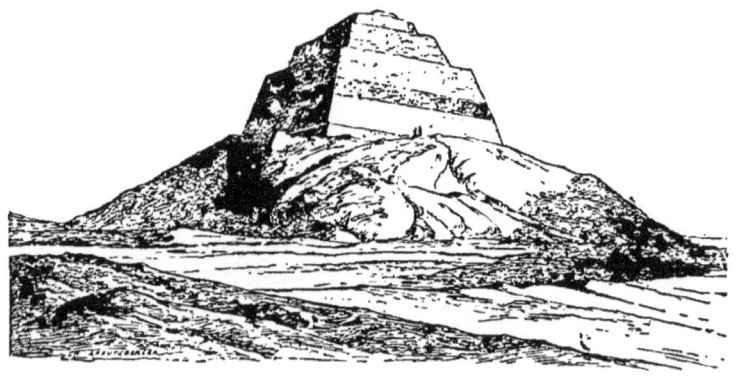

Fig. 148.—Pyramid of Medûm.

built against the eastern slope of the pyramid remains intact.

Thus by the time of the Fourth Dynasty the royal tomb, like the mastaba, consisted of three parts, the chapel, the passage, and the vault, but on a special plan of which the ordinary tomb gives no idea. There is the pyramid, inside which is the sepulchral chamber and the passages, while the chapel or hall of offerings has developed into an actual temple built on the eastern face of the pyramid, in most cases supplemented by the valley temple at the foot of the hill.

The pyramid and upper temple were surrounded by a high stone wall enclosing a rectangular temenos paved with large stone slabs. The door was always in the northern face. On three sides of the pyramid long galleries were dug in the solid rock to contain offerings and provisions for the dead king and the members of his family.

As we have seen, the oldest stone pyramid of the northern group is that of Zeser at Saqqara. The latest belong to the Pharaohs of the Thirteenth Dynasty. The construction of these monuments was therefore a continuous work that lasted for thirteen

Fig. 149.—Section of passage and vault in pyramid of Medûm.

or fourteen centuries under government direction. The granite, basalt, and alabaster required for the sarcophagus and for various details of the construction were the only materials of which the use and quantity were not regulated beforehand, and that had to be brought from a distance.

In order to procure them each king despatched one of the principal nobles of his court on a special mission to the quarries of the south, and the speed with which he procured the blocks formed a powerful title to the favour of the sovereign. The rest of the material did not involve such a cost. If the building was of brick, the bricks were moulded on the spot

with earth from the valley at the foot of the hill. If of stone the nearest part of the plateau would furnish abundance of marly limestone. For the walls of the chambers, and for the outside facing, limestone from Tûrah was usually employed, and even this had not to be brought across the Nile for the special purpose. At Memphis there were stores always full, that supplied the stone for public buildings, and consequently for the royal tombs. The blocks taken from these reserve stores were conveyed by water to the foot of the hill, and were then raised to the site by the sloping causeway. The internal arrangement of the pyramids, the length of the galleries, the size at the base, and the height are very variable; the pyramid of Khûfû (Cheops) rose to a height of about 481 feet above the ground; the smallest was less than 30 feet. It is not easy to realise why the Pharaohs should build monuments so greatly varying in dimension, and it has been imagined that the size of the building was in direct proportion to the time devoted to building it, that is to say, to the length of each reign. It was supposed that as soon as a king came to the throne, a pyramid was hastily begun, of sufficient size to contain all the essentials of a tomb; and that from year to year new courses of stone would be added round the original kernel until death put a stop for ever to the growth of the monument. It may have been thus in certain instances, but in most the facts do not justify this hypothesis. The smallest of the pyramids of Saqqara is that of Ûnas, who reigned thirty years, while the two imposing pyramids of Gizeh were built by Khûfû

and Khafra, who respectively governed Egypt for twenty-four and twenty-three years. Merenra, who died very young, has a pyramid as large as that of Pepi II., who lived to be more than ninety. The plan for each pyramid was generally made once for all by the architect according to the instructions received by him, and the resources placed at his disposal. Once begun, the work was carried through without any additions or curtailment, except in case of accident.

Like the mastabas, the pyramids were supposed to face the four cardinal points, but whether from ignorance or negligence the greater number are not accurately orientated, and many of them vary considerably from the true north. Those at Gizeh, however, are very accurate. They form eight groups stretching from north to south on the edge of the Libyan desert—from Abû Roash to the Fayûm, by Gizeh, Zowyet el Aryan, Abûsir, Saqqara, Dahshûr, and Lisht. The group at Gizeh consists of nine, including the pyramids of Khûfû, Khafra, and Menkaûra, which were anciently reckoned among the wonders of the world. The ground on which Khûfû built his pyramid was very irregular. A small rocky mound (fig. 150) was roughly cut and enclosed in the

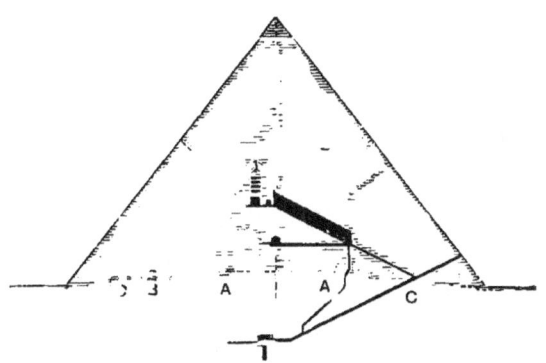

Fig. 150.—Section of the great pyramid. W. M. F. Petrie.

masonry of the foundations, and a sloping shaft leading to an underground chamber shows signs of the existence of an earlier tomb. The original height of the pyramid was 481 feet, and the width of the base 755 feet, but the ravages of time have reduced these measurements to 454 feet and 750 feet respectively. Until the Arab conquest it was cased with fine limestone, to which the action of the air had given a variety of colours. The blocks were so skilfully joined that they appeared to be one single piece from top to bottom. The casing was begun at the top, the cap was first placed in position, then the courses were added in succession till the base was reached. The whole of the interior was arranged with the object of concealing the exact position of the sarcophagus, and to baffle any marauders who by chance or by perseverance had succeeded in discovering the entrance. The first difficulty was to discover the entrance under the facing stones that masked it. It was nearly in the middle of the north face at the level of the eighteenth course of masonry about 45 feet above the ground, and was closed by a single block balanced on a pivot. This having been swung aside gave access to a sloping passage 47.6 inches high and 41.2 inches wide which descended a distance of 317 feet, passing an unfinished chamber and ending 60 feet beyond in a cul-de-sac. Here was the initial disappointment. Careful examination, however, combined with determination not to be foiled, would be rewarded by discovering in the roof, 62 feet from the entrance, a block of granite that contrasted with those surrounding it. It was so hard that the marauders having

exhausted themselves in trying to break or displace it, adopted the method of working a way for themselves through the softer stone that surrounded it. This obstacle surmounted, they found themselves in an ascending corridor that diverged from the first at an angle of 120°, and which divides into two branches. One extends horizontally towards the centre of the pyramid, and ends in a granite chamber with a pointed roof, called without any sufficient reason "the Queen's Chamber." The other, which continues to ascend, changes its character and appearance. It is now a gallery, 148 feet long and 28 feet high, built of the fine hard stone of the Mokattam mountains, so polished and so finely adjusted that it would be difficult to insert "a needle or even a hair" between the joints. The lower courses are perpendicular, but the seven upper courses are corbelled to such an extent that the top courses are only 21 inches apart. A new obstacle was encountered at the end, where the corridor that led to the tomb chamber was closed by a single slab of granite; to this succeeded a small vestibule divided into equal sections by four portcullises. These have been so completely demolished that no fragment of them now exists, but they were probably of granite. The royal sepulchre is a granite chamber with a flat roof 19 feet high, 34 feet in length, and 17 feet wide. Here there is no figure or inscription to be seen, nothing but a granite sarcophagus, mutilated and without its cover.

Such were the precautions taken against the depredations of man, and the event proved them to be efficacious, for the pyramid long guarded the deposit

entrusted to it. But the actual weight of the materials was a very serious danger, and in order to save the central chamber from being crushed by the 300 feet of stone that surmounted it, five low hollow spaces were left in the masonry above. The upper one of these has a pointed roof formed of two rows of stone slabs resting against each other at the top. Thanks to this contrivance, the central pressure is thrown almost entirely on to the lateral faces and the tomb chamber is relieved; none of the stones of which it is formed are crushed, although some have been displaced, probably by earthquakes.

The interior arrangements of the pyramids of Khafra and Menkaûra differ entirely from those of Khûfû. That of Khafra (Khephren) has two entrances both on the north side, one from the platform before the pyramid, the other 50 yards above the ground. On the east side are the vestiges of the funerary temple, but at the present day the glory of the pyramid is its valley temple, the great granite temple with its adjacent sphinx.

The pyramid of Menkaûra (Mycerinus) has retained part of its casing, the lower part of which was of red granite and the upper part of limestone. The entrance gallery descends at an angle of 26°, and soon enters the rock. The first chamber to which it leads is decorated with panels carved in the stone, and the exit is closed by three portcullises of granite. The second chamber appears to be unfinished; but this was merely an artifice intended to mislead robbers. A passage concealed with great care in the floor gave access to the tomb chamber. There lay the

THE PYRAMID OF ÛNAS. 163

mummy in a sarcophagus of sculptured basalt, which was still intact at the beginning of the nineteenth century. Carried off by Vyse, it foundered off the coast of Spain with the vessel bearing it to England. The valley temple of this pyramid was left unfinished, but magnificent statuary placed there in readiness shows that the king's death or some other misfortune alone prevented the erection of another fine building in keeping with that of Khafra.

The pyramids of Sahû-ra, of Ne-ûser-ra, and of Nefer-ar-ka-ra, of the Fifth Dynasty, are at Abûsir. They have recently been excavated

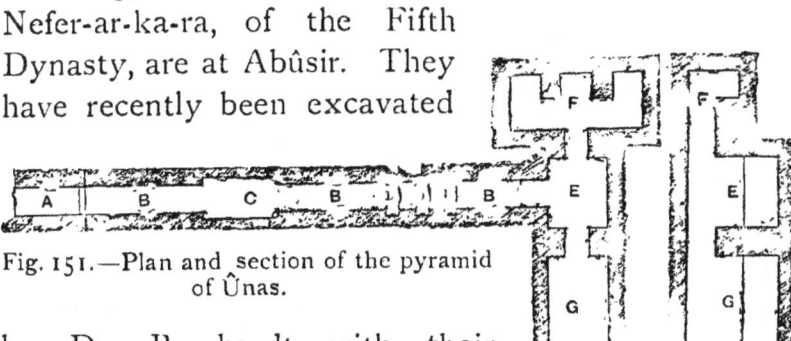

Fig. 151.—Plan and section of the pyramid of Ûnas.

by Dr. Borchardt with their temples and valley. The temple of Nefer-ar-ka-ra, begun in stone, was hurriedly finished in brick; but the valley temple of Ne-ûser-ra contained columned halls filled with sculpture and statuary. His great causeway, which formed the approach to the pyramid and upper temple, consisted of a narrow covered passage lined with fine limestone and exquisitely sculptured. The valley temple of Sahû-ra contained beautiful specimens of palm and papyrus columns, while a drain of hammered copper about 450 yards long carried off the rain water from the upper temple. The group of pyramids, with their temples, causeways, and

valley temples, fronted by landing-stages, must have presented a magnificent appearance to visitors arriving by water.

Most of the pyramids of the Fifth and Sixth Dynasties at Saqqara were built on one plan, and are only distinguished from each other by their size. In the pyramid of Ûnas (fig. 151) the entrance (A) is just below the first visible course of stone about the centre of the north face, and the passage (B) descends by a gentle slope between limestone walls; it was blocked at intervals all along its length by huge stones that had to be broken in order to reach the first chamber (C). After leaving this chamber the limestone gallery continued some distance farther, where for a time it gives place to walls, floor, and ceiling of polished syenite, after which the limestone reappears, and the gallery opens on to the vestibule (E). The portion lined with granite contains three portcullises of the same material at intervals of 2 or 2½ feet (D). Above each of these there is a hollow that contained the portcullises upheld by supports until they should be required (fig. 152). After the mummy had been laid in place, the workmen, when departing, would remove the supports, and the three portcullises, falling into their places, cut off all communication

Fig. 152.—Portcullis and passage, pyramid of Ûnas.

with the outside world. The vestibule was flanked on the east by a serdab with a flat roof, divided into three niches and choked with stone chips hastily swept there by the slaves when they cleaned out the chambers to receive the mummy. The pyramid of Ûnas has preserved all these. In the pyramids of Teti and Merenra the separating walls were very wisely done away with in ancient times, and no trace of them remains beyond a line of attachment, and a lighter colour on the wall in the places they originally covered. The tomb chamber (G) was to

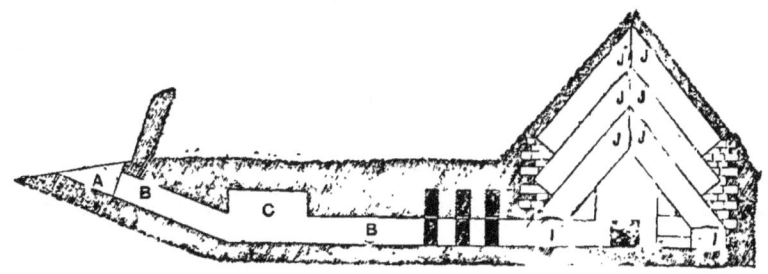

Fig. 153.—Section of the pyramid of Ûnas.

the west of the vestibule. The sarcophagus lay along the western wall, the feet to the south, the head to the north (H). The ceiling of the two principal chambers is pointed. It consists of large limestone beams, which lean against each other at the top, and at the lower end rest on a low bench (I), which is carried round outside the walls. The first pair of beams is surmounted by a second, and this again by a third, and the whole (I) forms an effectual protection for the vestibule and tomb chamber (fig. 153).

The pyramids of Gizeh are the work of some of

the Pharaohs of the Fourth Dynasty, and the pyramids of Abûsir of the Pharaohs of the Fifth Dynasty. The five pyramids of Saqqara, which are uniform in plan, belong to Ûnas of the Fifth, and his four successors of the Sixth Dynasty, Teti, Pepi I., Merenra, and Pepi II. They are contemporary with the mastabas with painted tomb chambers already described. It is not surprising therefore to find inscriptions and decorations here also. Everywhere the ceilings are strewn with stars and decorated in imitation of the sky at night; but the remainder of the decoration is very simple. In the pyramid of Ûnas, where decoration plays a more important part, it is only to be found at the end of the funerary chamber. The wall near the sarcophagus is faced with limestone, and engraved to represent the great monumental doors by which the deceased was supposed to enter his store-house of provisions. Figures of men and animals and scenes of daily life and sacrificial details are not represented there—nor would they be in place. They were to be found in the places where the *double* led its public life, and where visitors actually performed the sacrificial rites: the passages and tomb chamber where the soul alone could enter could admit no other ornamentation than that which dealt with the life of the soul. The texts are of two kinds. The least numerous concern the provision for the *double*, and are a literal transcription of the formulæ by which the priest ensured that every object should pass from this world to the next: this was the final resource for the *double* in case the real sacrifices

should cease or the magical scenes in the chapel be destroyed. The greater part of the inscriptions referred to the soul, and preserved it from the dangers which it must face in heaven and on earth. They taught it the sovereign incantations against the bite of snakes and venomous creatures, the passwords that conferred on them the right to enter the company of the good gods, and the exorcisms that warded off the influence of the evil gods. While the destiny of the *double* was to continue as the shade of terrestrial life, a destiny to be accomplished

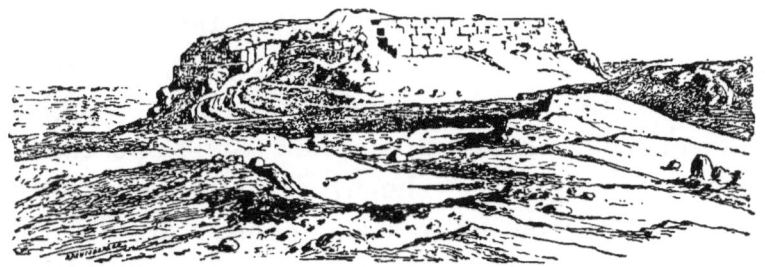

Fig. 154.—Mastabat el Faraûn.

in the chapel, the destiny of the soul was to follow the sun across the sky, and for this he depended on the instructions written for him on the walls of the tomb chamber. It was through their merit that the absorption of the dead man into Osiris was completed, and that he enjoyed for ever the immunities essential to a divine being. Above in the chapel he was a man, and he there comported himself after the fashion of a man; here he was a god, and he comported himself after the fashion of a god.

The enormous rectangular flat-topped building called by the Arabs Mastabat el Faraûn, " the seat

of the Pharaoh" (fig. 154), stands by the side of the pyramid of Pepi II. It has been thought to be an unfinished pyramid or a tomb on which an obelisk once stood. It is in fact a pyramid left unfinished by Ati, the first Pharaoh of the Sixth Dynasty. Recent excavations have shown that the pyramids of Dahshûr belong to two different periods. One of them, the northern pyramid, dates from the Third Dynasty. It is built of brick, and belongs to Seneferû, who, like Menes and Zeser, appears to have built two tombs for himself, while the others are of the Twelfth and Thirteenth Dynasties. The latter differ curiously from the usual type. The lower half of one of the stone pyramids rises at an angle of $50°\ 41'$, while in the upper half the slope changes abruptly to $42°\ 59'$. The whole appearance is that of a mastaba crowned by an immense attic.

At Lisht, where the pyramids are exclusively of Pharaohs of the first Theban period, there is again a change in the situation. In one of them at least, in the pyramid I attribute to Senûsert I., the sloping gallery leads to a perpendicular shaft, into the bottom of which open chambers, which are now filled with water. The pyramids of Illahûn and Hawara, where Senûsert II. and Amenemhat III. were buried, are on the same plan as those of Lisht, and like them are full of water.

The use of pyramids did not end with the Twelfth Dynasty: they are to be found at Manfalût, at Hekalli, south of Abydos, and at Esneh. Until the Roman period the semi-barbarous rulers of Ethiopia made it a point of honour to give their tombs a

pyramidal form. The earliest, the pyramids of Nûrri, the resting-places of the Pharaohs of Napata, recall in their construction the pyramids of Saqqara; the later ones, those of Meroë, present some new characteristics. They are higher than they are broad, built of small stones, and occasionally finished at the angles with a round or square moulding. The east face has a false window surmounted by a cornice, and is flanked by a chapel preceded by a pylon. These pyramids are not all dumb. Here, as on the walls of ordinary tombs, are scenes from the funerary ritual or from the books that record the vicissitudes of life beyond the tomb.

3.—TOMBS OF THE THEBAN EMPIRE.

Excavated Tombs.

Two classes of tombs superseded the mastaba throughout Egypt. In the first, the chapel was constructed above ground, and the principle of the pyramid was combined with that of the mastaba; in the second, the entire tomb, including the chapel, was excavated in the rock.

The earliest examples of the first class of these tombs are to be found in the Theban necropolis of the Middle Kingdom. The tombs are built of crude brick, large and black, without any admixture of straw or grit. The lower part is a mastaba, either square or oblong in plan, measuring sometimes as much as 40 or 50 feet on the longest side. The walls are perpendicular, and rarely high enough to allow a man to stand upright inside: on this base is a pointed

pyramid, which varies from 12 to 30 feet in height, covered on the outside with a coat of plaster and painted white. Owing to the poor quality of the ground it was impossible to excavate a burial chamber, and the builders were forced to conceal it in the building itself. A chamber with corbelled vaulting, closely resembling an oven, is frequently to be found in the centre (fig. 155), and contains the mummy, but more usually the tomb chamber is constructed partly

Fig. 155.—Section of "vaulted" brick pyramid, Abydos.

Fig. 156.—Section of "vaulted" tomb, Abydos.

in the mass but also partly in the foundations, while

the space above is constructed merely to relieve the weight (fig. 156). In many cases there was no external chapel, and the stela placed on the lower part of the building, or embedded in the outer face of the wall, marked the place for offerings. Sometimes a vestibule was added in front where the relatives could assemble (fig. 157), and in very rare cases one finds a low girdle wall defining the pyramid area. This compound form prevailed in the Theban cemeteries from the early years of the Middle Kingdom. Several kings and nobles of the Eleventh Dynasty built tombs for themselves at Drah Abu'l Neggeh very similar to those at Abydos (fig. 158). Mentuhotep II. built himself an immense mastaba about 130 feet long, on which he placed his pyramid, actually in the western court of his funerary temple at Deir el Baharî, while his sepulchral chamber was reached by a long gallery cut in the rock behind.

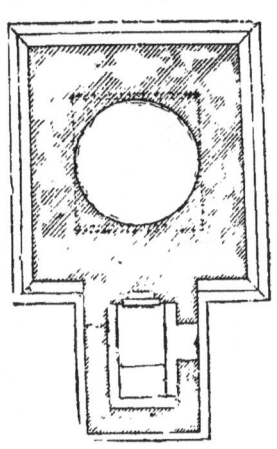

Fig. 157.—Plan of tomb, Abydos.

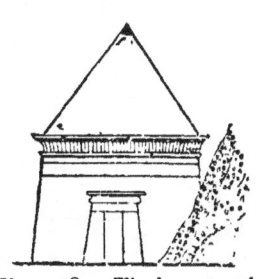

Fig. 158.—Theban tomb, with pyramidion, from scene in a tomb at Sheikh Abd el Gûrneh.

During the centuries that followed, the relative size of pyramids and mastabas was modified. The mastabas which we have seen as insignificant basements gradually recovered their original importance, while the pyramid became smaller, and was finally reduced to an insignificant

pyramidion (fig. 159). They abounded in the necropolis of Thebes of about the Ramesside period, but they have all perished, and it is from contemporary paintings that we learn the numerous varieties, while the chapel of one of the apis bulls that died under Amenhotep III. still stands to prove that the fashion extended as far as Memphis. Of the pyramidion scarcely any traces remain, but the mastaba is intact. It is a limestone cube, standing on a basement, supported at the angles by four columns and crowned with a hollowed cornice: a set of five steps led up to the inner chamber (fig. 160).

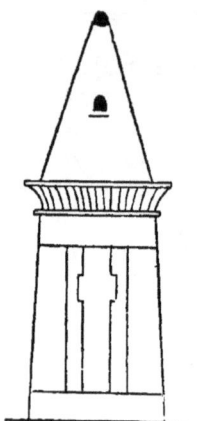

Fig. 159.—Theban tomb with pyramidion, from wall painting.

The earliest examples of the second kind of tomb, those to be seen at Gizeh among the mastabas of the Fourth Dynasty, are neither large nor highly decorated. During the Sixth Dynasty they were more carefully constructed, and in more distant localities, at Bersheh, Sheikh-Said, Kasr es Said, Denderah, and Nagada; but it was later that they attained their full development, during the long interval that divided the last Memphite kings from the first Theban rulers.

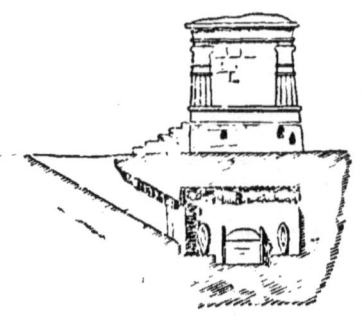

Fig. 160.—Section of apis tomb, time of Amenhotep III.

Here, again, we find the various elements of the

mastaba. The architect chose by preference limestone ridges well in sight, high enough on the cliff to be safe from the gradual rise of the cultivated ground, and yet sufficiently low for the funeral procession to reach it without difficulty.

The finest of these tombs belong to the great feudal lords, who at the time of the Middle Kingdom divided the territory of Egypt among themselves; the princes of Minieh rest at Beni Hasan, those of Khnûm at Bersheh, and those of Siût and Elephantine at Siût and opposite Assûan. Sometimes, as at Siût,

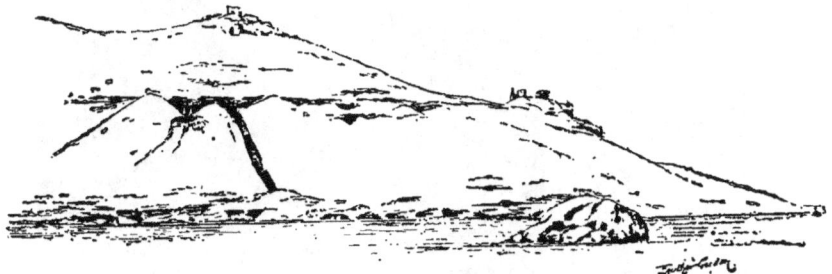

Fig. 161.—Tombs in cliff opposite Assûan.

Bersheh, and Thebes, the tombs are at different levels on the side of the cliff; in other cases, as at Assûan (fig. 161) and Beni Hasan, they follow the limestone strata, and are ranged in an approximately straight line. A sloping road or stairway, constructed of roughly hewn stone, led from the valley to the entrance of the tomb. At Beni Hasan and Thebes the road disappeared more or less completely beneath the sands, but the stairway of one of the Assûan tombs is still intact with its two lateral flights of steps for the men and the central slide up which the coffin and the heavy funeral furniture were dragged. The

funeral procession, having slowly ascended it, paused in front of the tomb to perform the last rites for the mummy.

The plan of the chapel is not uniform in any group. Many of the Beni Hasan tombs have a portico, where the pillars, bases, and entablature are all carved in the rock itself. In the tombs of Ameni

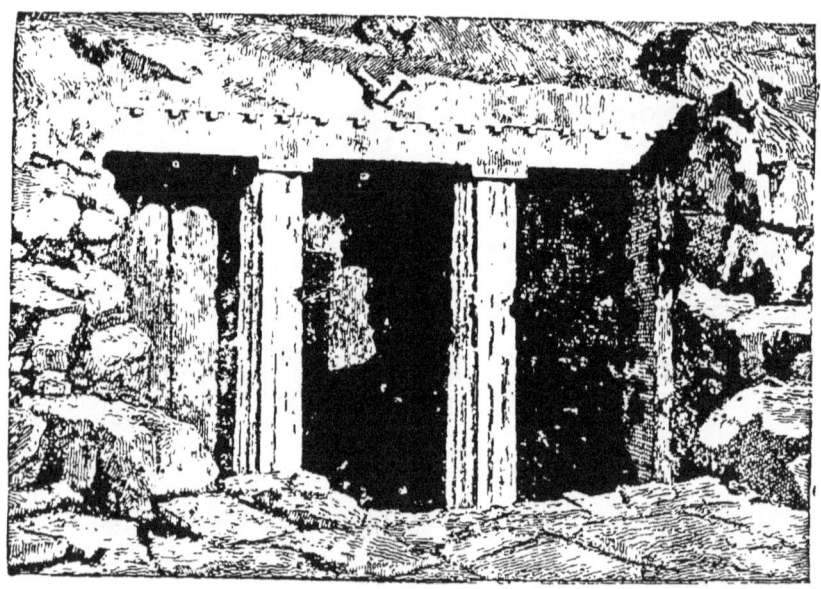

Fig. 162.—Façade of tomb of Khnûmhotep, at Beni Hasan, Twelfth Dynasty.

and Khnûmhotep (fig. 162) the portico is composed of two polygonal columns. At Assûan (fig. 163) a rectangular lintel crosses the narrow door carved out of the sandstone, at about one-third of its height, thus forming the semblance of a door within the doorway. At Siût, in front of the tomb of Hepzefa, there is a regular porch about 24 feet high, with a vaulted roof of centred stones, charmingly painted

and sculptured. More often it was considered sufficient to smooth and straighten the sloping face of the rock for a space corresponding to the intended width of the tomb. This method had the double advantage of forming a platform enclosed on three sides, and also of obtaining a vertical façade which could be decorated if desired. Sometimes the doorway placed in the centre of this façade had no frame, and sometimes it was framed by two uprights and a slightly projecting lintel. Where inscriptions exist they are very simple. At the top are one or two horizontal lines, and on the sides one or two vertical lines accompanied by a human figure, either seated or standing. These comprised a prayer and the name, titles, and parentage of the deceased. The chapel has usually only one chamber, which is either square or oblong, with a flat or slightly vaulted roof, and lighted only from the door. Sometimes the pillars and architraves cut

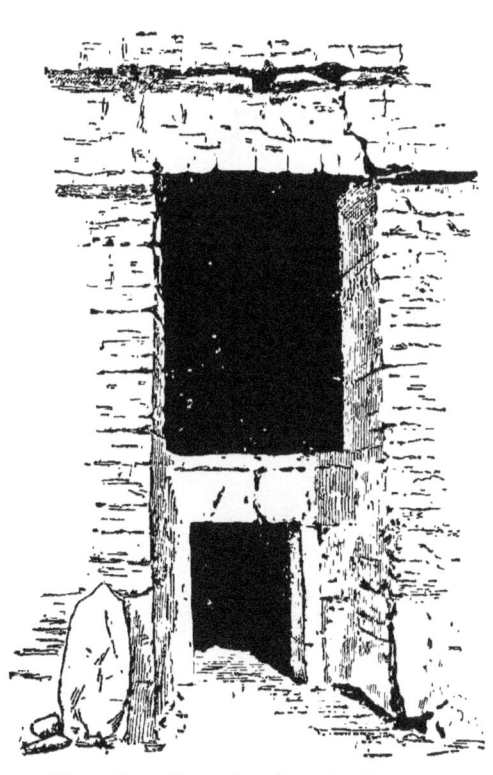

Fig. 163.—Façade of tomb, Assûan.

in the live rock give it the appearance of a hypostyle hall. The tombs of Ameni and Khnûmhotep, the two wealthiest nobles of Beni Hasan, each possess four of these pillars (fig. 164). Other chapels have six or eight, variously arranged. An unfinished tomb was originally a single chamber with rounded roof and six columns. Later on it was enlarged on the right side, and the new addition formed a kind of portico with a flat roof supported on four columns (fig. 165).

To hollow out a serdab in the living rock was almost impossible, and movable statues left in a place accessible to all comers would be liable to be stolen or damaged. The serdab was therefore combined with the chapel and converted into a sanctuary. This was a more or less spacious niche cut out of the rear wall, and almost invariably opposite the door. There the figures of the deceased and his wife were

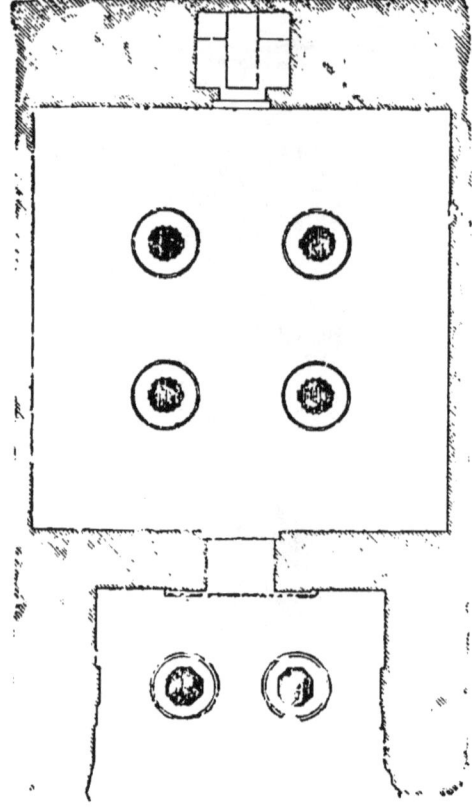

Fig. 164.—Plan of tomb of Khnûmhotep, Beni Hasan.

TOMB DECORATIONS OF NEW KINGDOM. 177

enthroned, also carved out of the rock; on the walls were paintings of the funerary feast, and the entire decoration of the chapel converged towards the sanctuary, as in the mastaba it converged towards the stela. The stela, however, is still here in its old place on the west wall. With the New Kingdom we find some changes in the decoration of the chapel and sanctuary. On the whole it is much the same as of old, but with noteworthy additions. The progress of the funeral procession and the taking possession of the tomb by the *double*, which hitherto were scarcely represented, are ostentatiously set forth on the walls of the Theban tomb. The convoy approaches with the weeping women, the crowds of friends, the men carrying funerary furniture, the barks, and the catafalque drawn by oxen. It arrives at the door; the mummy is placed upright on its feet, receives the farewells of the family, and undergoes the final manipulations necessary to adapt it for its future life (fig. 166). The sacrifice and its preliminaries, field labour, sowing, harvesting, rearing of cattle, manual crafts, all appear as before, and are painted with a profusion of bright colours.

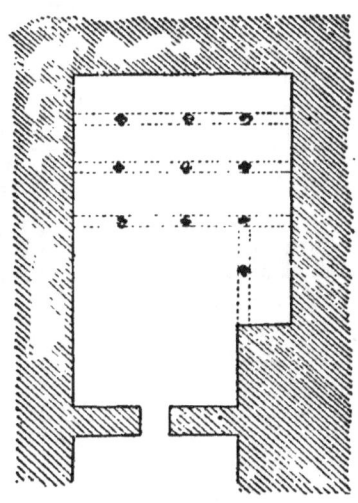

Fig. 165.—Plan of unfinished tomb, Beni Hasan.

Many details now appear that had not been given during the early dynasties, and others are absent that

were never previously omitted; but centuries had elapsed, and in twenty centuries many changes come about even in conservative Egypt. We may search almost in vain for the herds of gazelles, for under the Ramessides these animals were rarely domesticated. The horse, on the contrary, was now well known in the rich valley, and it is to be seen pawing the

Fig. 166.—Funeral procession and ceremonies from wall paintings, tomb of Manna, Thebes, Nineteenth Dynasty.

ground where formerly gazelles were pastured. The trades are more numerous and complicated, the tools more perfect, and the aspirations of the deceased more varied and personal. When the rules for tomb decoration were first formulated the idea of future retribution did not exist, or was very dimly conceived. The deeds done by man here below exercised

no influence on the fate that awaited him elsewhere; good or bad, from the moment that the rites had been performed over him, and the prayers recited, he must necessarily continue wealthy and happy. In order to establish his identity it was of course necessary to state his name, titles, and parentage; there was no need to describe his past in detail. But when beliefs in rewards and punishments arose, it was recognised that it would be advisable to guarantee for each individual the merit of his own actions, and biographical details were added to the summary of social standing that had hitherto been considered sufficient. At first there were only a few words, but about the time of the Sixth Dynasty we find actual pages of history in the tomb of Ûna, a high official, who records the services rendered by him under four sovereigns. Then, again, at the beginning of the New Kingdom, drawings and paintings combine with inscriptions to immortalise the exploits and achievements of the deceased. Khnûmhotep of Beni Hasan expatiates in detail on the origin and grandeur of his ancestors. Khetî displays on the walls the vicissitudes of military life, manœuvres of soldiers, war-dances, besieging of fortresses, battle, and bloodshed. The Eighteenth Dynasty perpetuates in this as in all else the traditions of earlier ages. Aï, in his fine rock-tomb at Tell el Amarna, recounts the episodes of his marriage with the daughter of Akhenaten. Neferhotep of Thebes received the decoration of the golden collar from Horemheb, and he records with much complacency the smallest incidents of the investiture, the

discourse of the king, the year and the day on which this supreme distinction was conferred on him. Another, who had presided over a survey, shows himself accompanied by his land surveyors with their measuring-lines, and he is also presiding at a census of the human population, as formerly Ti presided at a numbering of his cattle. The stela shares in the new characteristics that transform mural decorations; in addition to the ordinary prayers it contains a panegyric on the deceased, a sketch of his life, and only too rarely his *cursus honorum*, with the dates.

When space permitted, the tomb chamber was immediately below the chapel; the shaft was sometimes cut in a corner of one of the chambers, and sometimes outside in front of the door. In the large cemeteries at Thebes or Memphis, for instance, it was not always possible to superpose the three—tomb, shaft, and chapel. There was risk of interfering with tombs on a lower level if an attempt was made to give the usual depth to the shaft. Two methods were adopted to avoid this danger. Either a long horizontal gallery was made, at the end of which the shaft was sunk, or a horizontal or slightly sloping disposition of the chambers was substituted for the old vertical arrangement. In this case the passage opens from the centre of the near wall; the mean length varies from 20 to 130 feet. The tomb chamber is small and plain like the gallery. Under the Theban dynasties the *soul* was no more concerned about the decorations than it was under the Memphite Pharaohs, but when the walls were decorated the figures and inscriptions related far more to the life of the *soul*

than to that of the *double*. In the tomb of Harhotep, who flourished in the time of the Senûserts (Twelfth Dynasty), and in similar rock-tombs, the walls, with the exception of the doorways, were divided into two registers. The upper part belonged to the *double*, and beside the table of offerings there are objects similar to those figured in certain mastabas of the Sixth Dynasty, stuffs, jewels, weapons, and perfumes, which Harhotep would require to ensure eternal youthfulness of limb. The lower register belonged to both the *double* and the *soul*, and there one reads fragments of liturgical works, the *Book of the Dead*, *Ritual of Embalmment*, *Ritual of Funerals*, whose magic virtues protected the soul and afforded comfort for the *double*. The stone sarcophagus and the wooden coffin are covered with writing, for precisely as the stela was an epitome of the entire chapel, so the sarcophagus and coffin formed an epitome of the sepulchral chamber, and imitated a vault within the actual vault.

As at Memphis, there are royal tombs at Thebes, that should be studied to realise to what perfection the decoration of the passages and tomb chambers was carried. Nothing now remains of the earliest of these, which were once scattered over the plain and on the southern slope of the hills. The mummies of Amenhotep I., of Sekenenra, and of Aahhotep have survived the stone resting-places intended to safeguard them. As early as the beginning of the Eighteenth Dynasty all the best places had been occupied, and it was necessary to search elsewhere for a suitable site on which to establish a new royal

cemetery. Behind the mountain that borders the Theban plain on the north there was a rocky hollow, enclosed on all sides and communicating with the rest of the world only by mountainous tracks. It divides into two branches, one of which turns sharply to the south-east, while the other extends some distance to the south-west, and again divides into secondary ramifications. On the east it is dominated by a mountain that recalls on a gigantic scale the step pyramid of Saqqara. The engineers observed that this valley was only separated from the wady that leads to the plain by a barrier some 500 cubits thick. There was nothing here to daunt such experienced sappers as the Egyptians. They cut a tunnel 50 or 60 cubits deep through the solid rock, at the end of which a narrow passage like a gateway gives access to the valley beyond. Was this gigantic work undertaken under Amenhotep I.? His successor, Thothmes I., is at all events the first Pharaoh whose tomb has been found here. He was followed by Thothmes II., Hatshepsût, Thothmes III., and most of their successors, and then by the Pharaohs of the Nineteenth Dynasty, and the Ramessides one after another. Herihor was perhaps the last, and completed the series. So many sovereigns gathered here won for the locality the name of the Valley of the Tombs of the Kings, a name it retains to the present day.

The tombs were not complete, the chapel stood far off on the plain, at Gûrneh, at the Ramesseum, at Medinet Habû, and these have already been described. Like the Memphite pyramid, the Theban tomb con-

tains only the corridors and the tomb chamber. During the day the pious soul incurred no serious danger, but at evening, when the eternal waters that flow round the heavens sink in the west and plunge behind the mountains that bound the earth on the northern side, the soul with the sun bark and its escort of luminary deities entered a world that was strewn with ambuscades and perils. For twelve hours the sacred convoy traversed the dark subterranean regions, where genii, some hostile, others friendly, endeavoured either to obstruct its passage or aided in surmounting the difficulties of the way. At intervals a gate, defended by a gigantic serpent, opened before it, and permitted the bark to enter an immense hall, full of flames and smoke, of monsters with hideous faces and of executioners who tortured the damned. Then the bark once more entered narrow, gloomy corridors, and encountered more blind journeying in the horrors of darkness, struggles with malevolent genii, and again the joyous reception of the propitious gods. By the morning the sun had reached the extreme limit of the land of darkness; he quitted it with the first beams of dawn, and finally rose in the east to herald the new day. The tombs of the kings were fashioned as far as possible on the model of the underworld. They had their galleries, their doors, and their vaulted halls that penetrated far into the heart of the mountain. The arrangement of tombs in the valley was made without any consideration of sequence of dynasty or succession to the throne. Each sovereign pierced the rock at a place where he hoped to find a suitable vein of stone, and

with so little regard for his predecessors that the men engaged in the work had often to change the direction in order to avoid damaging a neighbouring tomb. The plans of the architect were very simple, and could be modified at will; it was not considered necessary to carry them out scrupulously, and thus the actual

Fig. 167.—Plan of tomb of Rameses IV.

measurements and arrangement of the tomb of Rameses IV. (fig. 167) differ at the sides and in their order from the original plan which is preserved on a papyrus now in the Turin Museum (fig. 168). Nothing, however, could be simpler than the general arrangement. A square door with very sober decora-

Fig. 168.—Plan of tomb of Rameses IV., from Turin papyrus.

tion opened on a gallery leading to a chamber of varying dimensions. From this a second gallery opened on to a second chamber, and thence at times to other chambers, and finally to that in which the coffin lay. In some of the tombs, the whole length from the entrance to the far end is on a gentle slope perhaps interrupted by two or three low steps; in others the various parts are in stages one below

THE TOMBS OF THE KINGS.

another. In the tomb of Seti I. (fig. 169) a steep staircase and an uneven slope (A) leads to an ante-chamber and two halls with pillars (B). A second stairway (C) opening from the floor of the ante-chamber descends to the second part (D), which is of less scanty proportions than the first, and contains the sarcophagus. The tomb was not intended to end there; a third staircase (E) had been made at the end of the principal chamber, which, according to the original design, would have led to another set of chambers, but the death of the king put an end to the work. As we pass from one tomb to another we

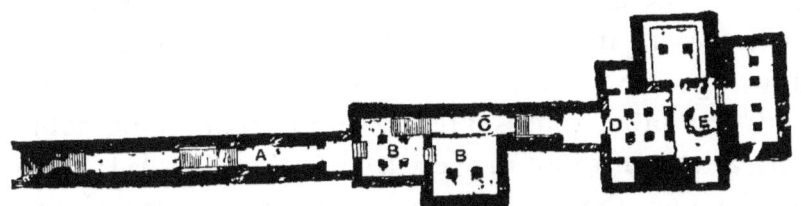

Fig. 169.—Plan of tomb of Seti I.

find that the general arrangement does not vary greatly. In the tomb of Rameses III. the entrance gallery is flanked by eight small lateral cells. Elsewhere the amount of painting that has been completed and the extent of the galleries form the only differences. The smallest of these rock-tombs does not exceed 5 feet in length, while the tomb of Seti I., which is the most complete, is more than 470 feet in length, and then not finished. The same devices that were employed by the engineers of the pyramids to throw tomb robbers off the scent were adopted in the Theban tombs—false shafts, mere cul-de-sac, were sunk, and painted and sculptured walls were built

across the galleries. When the burial had taken place the doors were walled up, large rocks were placed before the entrance, and the original appearance of the hillside was restored as far as possible.

Seti I. has provided us with the most complete type we possess of this form of sculpture; the figures and hieroglyphs in his tomb are real models of drawing and of graceful sculpture. The tomb of Rameses III. already shows signs of deterioration. The greater part of it is summarily painted, yellow abounds, and the reds and blues suggest the colouring children delight in daubing on their pictures. A little later mediocrity reigned unchallenged, the drawing became feeble, the colours increasingly crude, and the later tombs are no more than lamentable caricatures of those of Seti I. and Rameses III. Up to the end the decoration remained the same, and everywhere it is on the same principle that prevails at the pyramids. At Thebes as at Memphis its object was to secure for the *double* the enjoyment of its new habitation, to introduce the soul to the company of the divinities, both of the solar cycle and of the Osirian cycle, and to guide it through the labyrinth of the infernal regions; but the Theban priests endeavoured to present to the eye by means of drawing what the Memphites confided by writing to the memory of the deceased, and he was enabled to behold what formerly he had been forced to read on the walls of his tomb. Where the texts of Unas recount how Unas, now identified with the sun, sails on the celestial waters or enters the Elysian fields, the scenes in the tomb of Seti I. show Seti in the

solar bark, and the scenes in the tomb of Rameses III. show Rameses in the Elysian fields (fig. 170). Where the walls of the pyramid of Ûnas have only the text of the prayers recited over the mummy to open his mouth to give him the use of his limbs, to supply him with clothing, perfumes, and food, the tomb of Seti shows the mummy itself, and the *ka* statues that form the support of the *double*, the priests who are performing for them the *opening of the mouth*, who are clothing them, anointing them, and serving them with various dishes from the funeral banquet.

Fig. 170.—Wall painting of fields of Aalû, tomb of Rameses III.

The star-strewn ceilings of the pyramids represent the starry sky, but they do not provide the soul with the names of the heavenly bodies. On the ceilings of some of the rock-tombs of Thebes the constellations are drawn, each with its proper figure, while astronomical tables describe the aspect of the heavens during each fortnight of the months of the Egyptian year, and the soul had only to raise his eyes to learn in what region of the firmament his nightly course would lie. The whole design forms an illustrated account of the journeys of the sun, and in consequence

of the soul during the twenty-four hours of the day. Each hour is represented, with its domain separated by boundaries, the doors guarded each by an immense serpent who bore a name such as *Fire face, Flaming eye, Evil eye.* The third hour of the day was when the fate of souls was decided ; the god Anubis weighs them, and, according to the indications given by the balance, assigns them an abode. The guilty soul is delivered over to the cynocephali who serve as assessors of the tribunal ; they drive him off with rods after changing him into a sow or some other impure animal ; the pure soul passes into the fifth hour, where with his fellows he cultivates the fields, reaps the corn of the celestial harvest, and, his appointed task finished, enjoys his leisure under the guardianship of kindly genii. After the fifth hour the celestial waters became a vast battlefield where the luminary deities pursued the serpent Apopi, captured and bound him in chains, and finally at the twelfth hour they strangled him. But their triumph was not of long duration. The victorious sun was carried by the current into the realms of the hours of the night, and once across the threshold he was assailed, like Virgil and Dante at the gates of the Inferno, by horrid noise and clamour. Each circle had its own voice which could not be confounded with the voice of any other. One was like the buzzing of an immense number of wasps, another like the lamentations of women for their husbands and of animals for their mates, and another like the growling of thunder. The sarcophagus as well as the walls was covered with these scenes, whether sinister or joyous. It was usually of

red or black granite. As it was the last piece of the funerary outfit to be carved, there was not always time to complete it, but when it was finished the scenes and texts that covered it formed an epitome of the whole tomb. The deceased found depicted on it the details of the superhuman destiny awaiting him, and also learned from it to taste the blessedness of the gods. Private tombs were rarely decorated with such completeness, but two at least of the rock-tombs of the Twenty-sixth Dynasty, those of Petamenoph at Thebes and of Bakenrenf at Memphis, rival the royal tombs in this respect. In the first there is a complete edition of the *Book of the Dead*, the second has long extracts from the same book from the *Book of the Opening of the Mouth*, and from the Pyramid Texts, the religious formulæ found in the pyramids.

As each part of the tomb had its special decoration, so it had its special furniture. Few traces are left of the chapel fittings; the stone table of offerings is usually all that has survived. The objects immured in the serdab, galleries, and tomb chamber have suffered less from the ravages of time and the hand of man. Under the Old Kingdom the statues were always enclosed in the serdab; the tomb chamber contained little beyond the sarcophagus, some head-rests in limestone and alabaster, geese carved in stone, occasionally some scribes' palettes, frequently vases of various forms in pottery diorite, granite, alabaster, and compact limestone, some heaps of grain and other food produce, and the bones of victims sacrificed on the day of the funeral. Under the Theban dynasties the supplies for the dead

became richer and more complete. The *ka* statues of the family and servants, which formerly were placed with that of the master in the serdab, were now relegated to the tomb chamber, and had diminished in size. On the other hand, many of the objects that formerly were painted on the walls were now supplied in the round. Thus we find funerary barks with their crews, the mummy, the women mourners, the priests, and the disconsolate friends; offerings of loaves in baked clay, erroneously called funerary cones, stamped with the name of the deceased; clusters of grapes in glazed ware, and the limestone moulds with which the deceased was supposed to make pottery; oxen, birds, and fish to take the place of creatures of flesh and blood. Furniture, kitchen utensils, toilet requisites, weapons, and musical instruments abounded, most of them carefully broken before they were placed in the grave; they were thus killed, that their souls might follow their lord into the other world and serve him there.

The small statuettes, made in wood, stone, and in blue, white, or green glaze, are placed by the hundred, or even by the thousand, among the piled-up heaps of provisions and boxes. These statuettes were at first the serdab statues made of much smaller size, and like them intended to provide a body for the *double* and also for the soul. They were clothed in the same way as the individual whose name they bore was clothed during his lifetime. Later on, their functions became less important, and their duties were confined to answering for their owner when

he should be called upon by the gods, and executing in his stead the demands made upon him for labour in the Elysian fields. These small figures are called respondents, *ushabtiu*. They carry labourers' tools, and they are modelled to represent a mummified body, with the head and hands free and unbandaged. The canopic jars, with their heads of a sparrow-hawk, a cynocephalous ape, a jackal, and a man, were employed as early as the Eleventh Dynasty to contain the viscera, which were necessarily abstracted from the body during the process of embalmment. The mummy itself was more and more encumbered with cartonnage, papyri, and amulets, which formed a complete suit of magic armour, as each piece safeguarded the limbs and the soul that animated them.

Theoretically every Egyptian had a right to an *eternal house* built on the plan the development of which we have just traced. The graves of the middle-class or less wealthy folk at Beni Hasan consist of a deep rectangular pit of one chamber, reached by a vertical shaft. On their painted wooden coffins were placed models of boats, both sailing (fig. 171) and rowing, and figures of servants carved in the round, ready to carry their luggage, neatly tied up, or placed in baskets, or to cook, brew, or grind corn for them (fig. 172). Rows of these graves are found at Beni Hasan, where the humbler folk rest in the cliff below the stately tombs of their feudal lords.

The poor subsisted very well without all that was considered necessary for the great and wealthy. They

were buried wherever it could be done most cheaply, in old tombs that had been robbed or abandoned, in natural fissures of the mountains, in shafts where a lodgment could be had for a small price, or in trenches dug for public use. At Thebes during the time of the Ramessides there were trenches dug in the sand always ready to receive corpses.

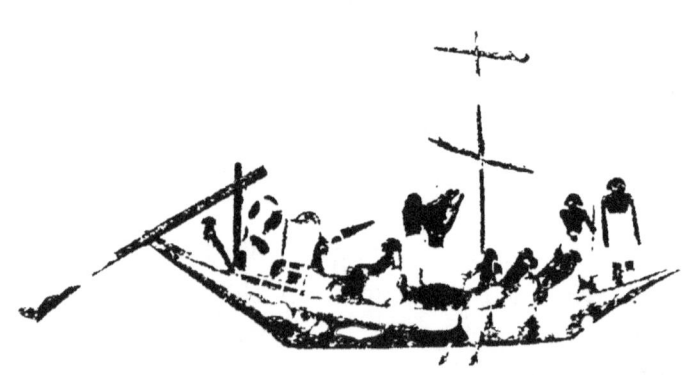

Fig. 171.—Wooden model of sailing boat and crew. Round the cabin hang the weapons and shield required by the deceased in the future life. Beni Hasan, Twelfth Dynasty, Ashmolean Museum.

The funeral rites over, the attendants shovelled a thin covering over the corpses collected during the day, sometimes singly, sometimes in batches of two or three, sometimes so crowded together that no attempt was made to lay them out in regular rows. Some of them were only protected by their bandages, others were wrapped in palm-leaves bound together in the shape of a basket. Those most cared for are placed in a rude wooden box without inscription or

painting. Many are thrust into old coffins without any attempt being made to fit the coffins to their new occupants, or flung into a chest made out of pieces of three or four broken mummy-cases. There was no question of providing a funerary outfit for people of this class; at the most they have with them a pair of worn-out leather shoes, a pair of

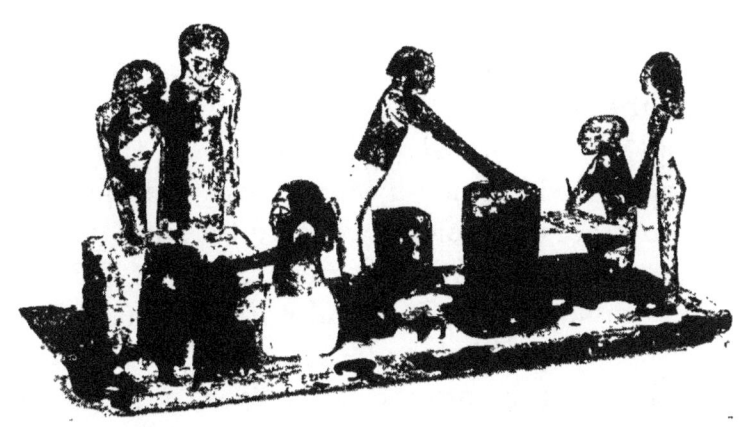

Fig. 172.—Rough wooden model of servants at work. A squatting scribe records the results, overlooked by the mistress. Beni Hasan, Twelfth Dynasty, Ashmolean Museum.

sandals made either of cardboard, or of plaited osiers, a travelling-staff for the celestial highways, rings in glazed pottery, bracelets or necklaces made of a single row of small blue beads, figurines of Ptah, Osiris, Anûbis, Hathor, and Bast, mystic eyes, scarabs, and, more important than all, strings twisted round the arm, the neck, the leg, and the body to protect them from magical influences.

CHAPTER IV.

PAINTING AND SCULPTURE.

THE greater number of the statues and bas-reliefs that decorated the temples and tombs of ancient Egypt were painted. Coloured stones, such as granite, basalt, diorite, serpentine, and alabaster, sometimes escaped the painter's brush, but sandstone, limestone, and wood were rigorously subjected to it, and if one occasionally finds some object in these materials that shows no traces of colour, we may be sure that the paint has been accidentally removed, or that the work was left unfinished. The sculptor and the painter were inseparably allied, and the former had scarcely finished his work before the latter took possession of it; the same artist was often equally skilled in the use of the brush and the chisel.

I.—DRAWING AND COMPOSITION.

Of the system adopted by the Egyptians for teaching drawing we know nothing. They had learned from experience to determine the general proportions of the body, and to establish fixed relations between the different parts, but they never took the trouble to tabulate those proportions or reduce them to a system. In what remains of their work there is nothing that leads us to believe that they ever possessed an official

canon based on the length of the human finger or foot. Their method was one of routine and not of theory. They had models made by the master himself, which were repeatedly copied by the pupils until they could reproduce them correctly. That they also studied from nature is shown by the facility with which they seized a human likeness and rendered the characteristics and movements of various animals. Their first attempts were made on slabs of limestone roughly smoothed, on a piece of wood covered with a wash of white stucco, or on the reverse side of old, valueless manuscripts. New papyrus or vellum was too expensive to be wasted on the daubings of pupils. The Egyptians had neither pencil nor stylus, but they used reeds, the ends of which, soaked in water, split into minute fibres and formed a brush more or less fine, according to the size of the stem.

Fig. 173.—Pestle and mortar for grinding colours.

The palette was a narrow rectangular piece of wood, with a vertical groove at the lower end in which to lay the brush, and with two or more cup-like depressions at the upper end, each of which contained a cake of dry ink, red and black being the colours most constantly in use. A small pestle and mortar to pound the colours (fig. 173), and a cup of water to damp and wash the brushes, completed the outfit of the apprentice. Palette in hand, and without any kind of support for his wrist, he seated himself cross-legged before his model, and practised copying it in black. The master criticised the copy, and corrected the faults in red ink.

The drawings that have come down to us are on small pieces of limestone, and are most of them in very bad condition. They have been found in great abundance in recent years, and may be seen in most large collections in Europe and America, as well as in Cairo. The subjects are very varied. They include sketches of birds and animals, many of them hieroglyphic characters; Pharaoh on his throne, or smiting the foe, or otherwise depicted as he is seen on the monuments; divinities and their worshippers. There are also sketches of less conventional character, some of them comic. At Turin there is a charming study of a female figure, half nude, bending backwards as though in the act of turning a somersault. The lines are flowing, the action graceful, and the modelling is delicate. The artist was not hampered then as now by the use of a stiff implement. The reed brush attacked the surface perpendicularly, and with it the artist could make a line as thick or fine as he wished, could prolong it, or stop and turn with perfect ease. So supple an instrument lent itself marvellously to rendering the humorous and laughable incidents of daily life. The Egyptian, gay and sarcastic by nature, early practised the art of caricature. A papyrus in the Turin Museum records in a series of spirited vignettes the amorous exploits of a shaven priest and a singer (priestess) of Amon. On the reverse are serio-comic scenes of animals. An ass, a lion, a crocodile, and an ape are giving a concert of vocal and instrumental music; a lion and a gazelle are playing at draughts; the Pharaoh of all the rats mounted in a chariot drawn by dogs is

hastening to assault a fort garrisoned by cats; a cat of fashion, having a flower on her head, has quarrelled with a goose; they have come to blows, and the unhappy fowl has succumbed in terror. Cats were among the favourite animals of Egyptian caricaturists. An ostracon in the New York Museum depicts a cat of high rank in full dress seated on a couch, while a wretched Tom of piteous appearance, with his tail between his legs, is handing her refreshments (fig. 174).

We also possess an abundance of pen drawings illustrating religious works. Almost all of these works are copies of the *Book of the Dead* and the *Book of knowing that which is in the Underworld*. They were copied by hundreds from ancient manuscripts preserved in the temples, or in families where the cult of the dead was the hereditary profession. The artist therefore had to make no demands on his imagination; all he had to do was to transcribe as well as possible from the copy given him. The rolls of the *Book of knowing that which is in the Underworld* which we possess are not earlier than the Twentieth Dynasty. The workmanship is often bad, and the figures are little more than summary scrawls hurriedly drawn and badly proportioned. Copies of the *Book of the Dead* are so numerous that from this source alone a history of miniature painting in Egypt

Fig. 174.—Comic sketch on ostracon in New York Museum.

might be compiled; some are as early as the Eighteenth Dynasty, while others are of the time of the earlier Cæsars. The oldest copies are for the most part remarkably fine in execution. Each chapter has a vignette representing a divinity either in animal or human form, and a sacred emblem, or the deceased in adoration before the divinity. These small designs are, in some instances, ranged in a single line above the text (fig. 175); in others they are scattered about the pages like the illuminated capitals

Fig. 175.—Vignette from the *Book of the Dead*, Saïte period.

of our manuscripts. At intervals large pictures occupy the entire height of the papyrus. At the beginning of the roll comes the burial scene, then towards the middle occurs the judging of the soul, and at the end is shown the arrival of the soul in the fields of Aalû. Here the artist had scope to exercise his talent and show the extent of his powers. We see the mummy of Hûnefer upright before the stela and tomb (fig. 176); the women of the family are bewailing him, while the men and the priest present offerings to him.

The papyri of the princes and princesses of the

family of Pinotem in the Cairo Museum prove that the good traditions of the school were maintained among the Thebans as late as the Twenty-first Dynasty, but they declined rapidly under the succeeding dynasties, and for centuries we find nothing

Fig. 176.—Vignette from the *Book of the Dead*, from the papyrus of Hûnefer.

but rude and valueless drawings. The downfall of the Persian domination occasioned a revival; the tombs of the Greek period have yielded papyri with vignettes carefully executed in a dry and conventional style, which contrasts strangely with the broad, bold

style of earlier work. The broad-tipped brush has been superseded by a fine-pointed pen, and artists vied with one another in the delicacy of their strokes. The lines with which they overloaded their figures—the details of the beard, the hair, and the folds of the garments—are sometimes so minute that it is difficult to distinguish them without a magnifying-glass.

Fig. 177.—Part of scene on the wall of the pre-dynastic tomb of Hierakonpolis.—F. W. Green, *Hierakonpolis*, vol. ii. (*Egypt Research Account*).

Valuable as these documents are, they do not afford a fair estimate of the full powers and technical methods of the Egyptian artists; it is to the walls of their temples and tombs that we must turn if we wish to understand their methods of composition.

The earliest funerary example of Egyptian decorative art we possess is on the walls of the predynastic tomb of Hierakonpolis (fig. 177). The carefully

smoothed and plastered brick wall was covered with a wash of pale yellow ochre. On this the figures were outlined in red ochre, and painted in black, bright green (probably obtained from pounded malachite), a pasty white, and with red and yellow ochre. In the foreground are human beings, animals, and what may be a trapping scene; in the middle distance are six large vessels with cabins; the background is filled in with herding and hunting scenes. The drawing of the animals is good; the human beings are grotesque. The men are fighting with sticks, and protecting themselves with shields made of animal skins. The vanquished foe is literally represented as overthrown. Some seated women on the right are clad in white petticoats. There is no attempt at defining the river-banks, and many of the figures seem to be inserted at haphazard.*

The conventions of the drawing of historical times differed considerably from ours. Man or beast, the subject was never more than an outline against the surrounding background, and the object of the artist was therefore to introduce only such objects as offered a distinct profile that could readily be seized and adapted to a flat background. In the case of animals the problem was easily solved, the line of the back and the body, the head and the neck, in flowing curves parallel to the ground, could be outlined in one long stroke of the reed-pen, while the legs are well detached from the body. The animals are life-like, each with the gait and action and flexion of the limbs peculiar to it. The slow, measured tread of

* Quibell and Green, *Hierakonpolis*, vol. ii. p. 20 *et seq.*

the ox; the short step, the meditative ear, and the sarcastic mouth of the ass; the jerky little trot of the goat; the spring of the greyhound when hunting,— all these are rendered with unfailing felicity of line and expression. And when we pass from domestic animals to wild ones, we find the same perfection of treatment, the calm strength of the lion in repose, the stealthy, sleepy tread of the leopard, the grimace of the ape, and the somewhat slender grace of the gazelle and antelope have nowhere been better rendered than in Egypt. But to project the whole figure of man in the same way without deviating from nature was not so easy. The human figure does not lend itself to being reproduced in outline. To draw it in profile is to omit some of the most important features; the contour of the forehead and nose, the curve of the lips, and the cut of the ear are lost when the head is drawn full face, while the bust, on the contrary, must be shown full face in order that the outline of both shoulders may be rendered, and that the arms may be duly shown one on each side of the body. The contours of the lower part of the body model to best advantage when seen from a three-quarters point of view, while the legs should be seen from the side. The Egyptians had no scruple in combining these contradictory points of view in the same figure, part in profile and part full face. The head, with the eye almost invariably full face, is in profile on a full-face bust; the bust surmounts a trunk seen from a three-quarters point of view, while the legs, again, are in profile. These conventions were accepted as early as the

Thinite period, and prevailed throughout Pharaonic times.

And yet one finds figures that are composed more in accordance with our rules of perspective.

In the case of most of the personages in the tomb of Khnûmhotep at Beni Hasan, an attempt has been made to rescue them from this system of malformation. The bust is in profile like the head and legs, but one or other of the shoulders is thrust forward in order to show both arms (fig. 178), and the effect is not happy. But observe the peasant who is fattening a goose, and still more the man who is throwing his

Fig. 178. Fig. 179.
Scenes from the tomb of Khnûmhotep at Beni Hasan, Twelfth Dynasty.

weight on to the neck of a gazelle to force it to lie down (fig. 179). Here the action of the arms and hips is accurately rendered, the perspective of the back is perfect, the projection of the chest caused by the position of the arms is correctly drawn without any exaggeration, and the body is well placed upon the haunches. The varied movements and postures of the wrestlers of Beni Hasan, and of the dancing women in the Theban tombs, are rendered with perfect freedom (fig. 180).

But these are exceptional; elsewhere tradition has been more powerful than nature, and to the end

Egyptian artists continued to deform the human figure. Their men and women are actual monsters from the anatomical point of view, even though they are by no means so hideous and absurd as they have been represented by many of our copyists. The distorted parts of the body have been joined to each other with such ingenuity that the combination does not strike one as unnatural. The correct and the fictitious lines follow and complete each other so cleverly that the former appears to be the natural

Fig. 180.—From a tomb painting in the British Museum, Eighteenth Dynasty.

complement of the latter. The convention once recognised and admitted, it is difficult to overestimate the skill shown on many of the monuments. The line is firm and even, drawn to the end with one long resolute sweep of the brush. Ten or twelve such strokes sufficed to draw a life-size figure; one single stroke outlined the head from the nape of the neck to the base of the throat, another represented the rise of the shoulders and the fall of the arms, two accurately curved lines indicated the contour from the armpits to the point of the feet, two finished the

legs, and two the arms. The details of clothing and jewellery at first summarily indicated were afterwards worked out in minute detail, and one can almost count the tresses of hair, the folds of the garment, the enamel on the girdle or bracelet. This admixture of natural ability and of intentional awkwardness of rapid execution and of patient re-working does not exclude either elegance of form, the grace and truth of the attitudes, or the precision of the movements. The figures are peculiar, but they are alive, and for any one who regards them without prejudice, their

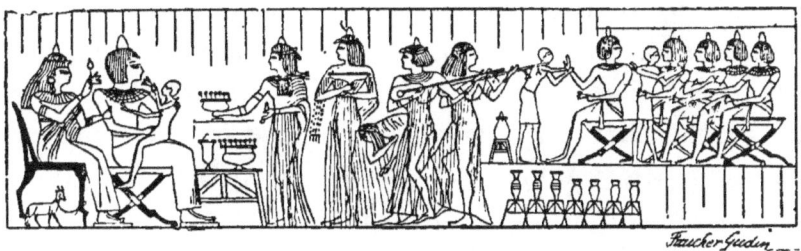

Fig. 181.—Funerary repast, tomb of Prince Horemheb, Eighteenth Dynasty.

very strangeness lends a charm that is not always to be found in later work more conformed to the verities.

We admit, then, that the Egyptians knew how to draw. But were they, as has often been asserted, ignorant of the art of composition? Let us choose a scene at random from one of the Theban tombs— that which represents the funeral banquet offered to Horemheb (fig. 181) by members of his family. The subject is half realistic, half imaginary. The deceased and his relations already in the other world are here depicted in company with the living. Visible,

but not mixing with them, they are assisting at the banquet rather than partaking of it. Horemheb is seated on a folding stool to the left of the spectator; on his knees is a little princess, daughter of Amenhotep III., of whom he was the adoptive father, and who died before him. His mother, Senûit, behind him on his right, seated in a large chair, is grasping her son's arm with her left hand, while with the right she offers him a lotus-bud. A tiny gazelle, which perhaps was buried near her, like the gazelle found beside Queen Isiemkheb in the hiding-place at Deir el Bahari, is tied to the leg of the chair. The members of this supernatural group are of gigantic size; seated as they are, the heads of Horemheb and his mother are on a level with those of the women standing before them. It was essential that the gods should be larger than men, kings larger than their subjects, and the dead larger than the living. The relatives and friends are ranged in a single row facing their deceased ancestors, and appear to be talking among themselves. The feast has begun, the jars of wine and beer in their wooden stands are already opened. Two young slaves are rubbing the living guests with sweet-scented essences taken from an alabaster jar. Two sumptuously attired women are presenting to the deceased metal bowls full of flowers, grain, and perfumes, placing them in turn on a square table. Meanwhile three other women are playing the lute, singing, and dancing, thus completing the homage offered to the deceased.

As the tomb is here the scene of the banquet, the background of the picture is formed by walls covered

Fig. 182.—From a wall painting, Thebes, Ramesside period.

with hieroglyphs, in front of which the guests were seated during the ceremony. Elsewhere the scene of action is clearly indicated by tufts of grass or by trees if it occurred in the open country, by red sand if in the desert, or by a belt of reeds and lotus if in the marshes. In one place we are shown a woman of quality entering her house (fig. 182). One of her daughters who is thirsty is taking a long draught of water from a *gûllah*, two little naked children with shaven heads, a boy and a girl, have run to the street door to meet their mother, and the toys she has bought for them during her absence are being handed to them by a servant. Above we see a vinery heavy with clusters, and trees laden with fruit; this is the garden, but the mistress and her two eldest girls have crossed it without stopping, and have entered the house. Half the front of the house has been removed, and we can see what they are doing inside, where three servants are bringing them refreshments. The picture is not badly composed, and it might be transferred to a modern canvas without much alteration, but the same clumsiness or prejudice that led the Egyptian to place a head in profile on a full-face bust, has prevented his arranging his scenes in proper sequence, and has forced him to adopt expedients of some ingenuity to atone for the absence of perspective.

Again, when drawing a number of persons engaged in the same action it was usual to separate them as much as possible to avoid the outline of one overlapping another, or else they were flatly superposed as though they were of only two dimensions and had

ABSENCE OF PERSPECTIVE. 209

no breadth. A herdsman walking in the midst of his cattle treads on precisely the same ground-line as the beast which partly conceals his body. In the case of a company of soldiers advancing in marching order

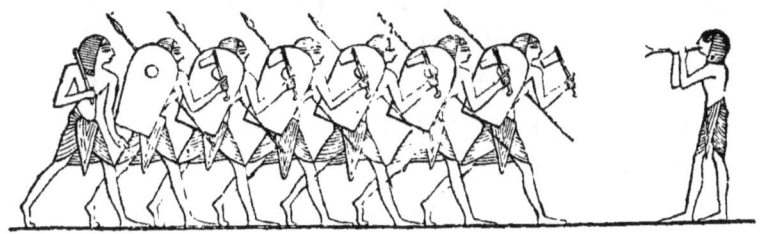

Fig. 183.—From wall scene in tomb of Horemheb.

to the sound of the trumpet, the head and feet of the farthest figure are on the same level as those of the soldier nearest to the spectator (fig. 183). Where the chariots defile before Pharaoh one could swear that

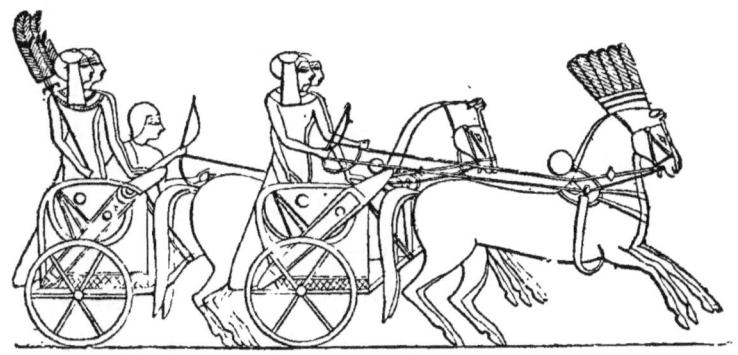

Fig. 184.—From wall scene, Ramesseum.

all the wheels follow each other in the same rut, were it not that the body of the first chariot partially hides the horses of the one that follows next (fig. 184). In these examples the men and chariots are placed so close together, whether by accident, or in reproducing

14

the actual scene, that the defect is not too apparent, and the Egyptian artist has made use of the same contrivance that was employed later by the Greek sculptors. Elsewhere the Egyptians have attempted to secure greater accuracy. In the case of the archers in the battle scene of Rameses III. at Medinet Habû, an attempt which is almost successful has been made to render them in perspective. The line of helmets falls and the line at the base of the bows rises with perfect regularity, but the feet are all on one parallel line, and do not follow the direction of the other lines as they should (fig. 185).

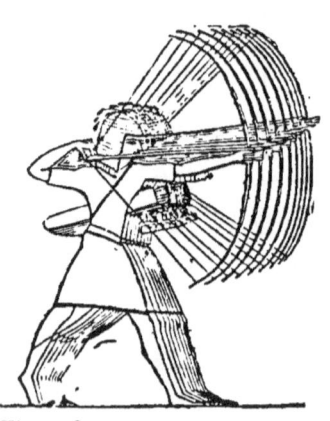

Fig. 185.—Archers, represented on walls of Medinet Habû.

This mode of representation is not uncommon during the Theban period. For figuring troops of men or of animals performing the same action at the same moment it was employed by preference, but it involved a difficulty which was serious in the eyes of the Egyptians; with the exception of the first man the human figure was almost entirely concealed, a very small part only being left visible. When therefore it was impossible to group all the figures without hiding some of them the whole mass was broken up into several groups each of which represented an episode, and these were ranged one above another in the same vertical plane. The height given to each man does not depend on his position in ordinary perspective, but

on the number of rows needed by the artist to illustrate his subject. If he only required two rows, the space was divided into two, if he wished for three, it was divided into three, and so forth, while in the case of minor details the register could be lowered. Thus in the funeral feast of Horemheb the amphoræ are arranged in a space considerably narrower than that in which the guests are seated. The secondary scenes were generally separated by a line, but this line was not indispensable, and more especially when large bodies of men regularly drawn up had to be expressed, the vertical rows overlapped one another to an extent that varied according to the fancy of the artist. At the battle of Kadesh the files of the Egyptian phalanx overtop one another as high as the waist (fig. 186), while scarcely more than the head of the Hittites is visible (fig. 187).

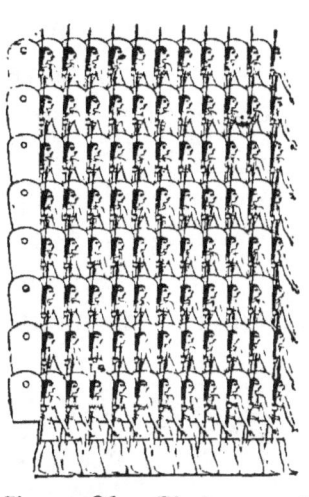

Fig. 186.—Phalanx of Egyptian infantry, Ramesseum.

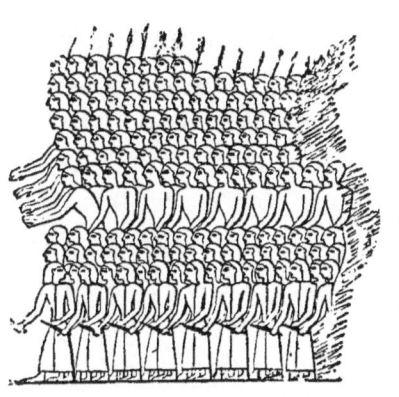

Fig. 187.—Hittite battalion, Ramesseum.

This latitude in the grouping of men and animals is by no means the greatest that Egyptians permitted themselves; houses,

landscapes, trees, and water are even more strangely treated. A canal is represented by a narrow rectangle placed upright on its side with wavy lines drawn across it. To leave no doubt in the mind of the spectator that it is intended to represent a piece of water, crocodiles and fish are drawn in it; boats are balanced on the upper edge, while herds of cattle are fording it breast-high. The place where the water ends and the bank begins is marked by a fisherman with his line. In other places the rectangle looks as though it were suspended half-way up the trunks of five or six palm-trees (fig. 188), and then we are given to understand that the water is flowing between two rows of trees. Or again, as in the tomb of Rekhmara (fig. 189), the trees are neatly laid down along the four sides of a pool, and a boat in profile bearing a dead body and dragged by slaves also in profile, is sailing unconcernedly on the vertical face of the water. Each of the rock-tombs of the Ramesside period can furnish more than one instance of such original contrivances, and, after studying them, one scarcely knows which is most marvellous, the obstinacy of the Egyptian who would not adopt the natural laws of perspective, or the wealth of imagination that could invent such a variety of false relations between such various objects.

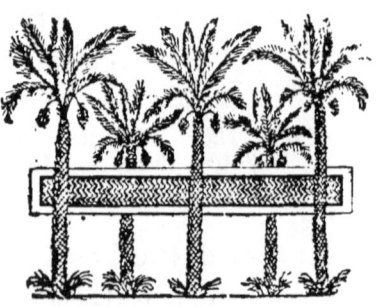

Fig. 188.—Pool and palm-trees, from tomb of Rekhmara, Eighteenth Dynasty.

SELECTION AND SEQUENCE OF SCENES. 213

When applied to large spaces these proceedings are less startling than they are on small panels. One feels that the most experienced artist would be forced to resort to some artifice if called upon to cover the walls of a pylon, and this consideration renders us more indulgent especially as the subjects treated in these immense bas-reliefs are never confined to one

Fig. 189.—Scene from tomb of Rekhmara, Eighteenth Dynasty.

single episode. Restricted as they were to commemorating the victories of the Pharaoh, the Pharaoh necessarily plays the principal part; but instead of choosing from among his mighty deeds a dominant episode, the artists employed elected to detail the successive events of his campaign: a night attack on the Egyptian camp by a band of Asiatics, spies sent by the prince of the Kheti to mislead the Pharaoh as to his plans, the military camp of the king surprised

and broken into by the Hittite chariots, the battle of Kadesh and its various incidents. In this way the pylons of Luxor and of the Ramesseum give us an illustrated history of the campaign of Rameses II. against the Syrians. It was after the same fashion that painters of the early Italian schools represented

Fig. 190.—Scene from mastaba of Ptahhotep, Fifth Dynasty.

in one piece and in unbroken sequence the events of their own history. The scenes are placed on the walls without any definite separating lines, and there is the same difficulty in dividing the groups and distinguishing the various personages that we experience with the bas-reliefs on the column of Trajan.

This method is reserved for the outside of the

temples. In the interior and in the tombs the different parts of a picture are divided into registers, placed in rows one above another from the basement to the cornice. This adds another difficulty to those we

Fig. 191.—Palestrina mosaic.

encounter in endeavouring to understand the meaning and style of the Egyptian artists. We imagine that we are looking at a variety of subjects when in reality we are gazing at disjointed parts of a single composition. Take for instance one of the walls of the tomb

of Ptahhotep at Saqqara (fig. 190). In order to grasp the thread that links the various parts together we may compare it with the Roman mosaic of Palestrina (fig. 191), which represents some of the same scenes, but in a manner more in conformity with our methods. In the foreground is the Nile, which extends to the foot of the hills. On the farther bank are towns and obelisks, farms and towers that are Græco-Roman in style and resemble the buildings of Pompeii far more than Pharaonic monuments. The great temple on the right, in the middle distance, to which two travellers are making their way, has a pylon in front against which are placed four colossal Osirian figures, and alone suggests the general arrangement of Egyptian architecture. To the left some men in a large boat are harpooning crocodiles and the hippopotamus. To the right a company of legionaries led by a priest and massed in front of a temple appear to be saluting a galley as it is rowed up the river. In the centre of the picture men and women half nude are singing and carousing under the shelter of a bower thrown over a branch of the river. Papyrus skiffs occupied by single boatmen, and a variety of small vessels fill in the gaps in the composition. The desert commences behind the line of buildings, and here the river widens out into pools at the foot of abrupt hills. In the upper part of the picture various animals either real or imaginary are hunted by bands of archers with shaven heads.

Like the Roman artist the Egyptian placed himself on the bank of the Nile, and reproduced all he saw between himself and the horizon. At the base of the

wall painting (fig. 190) the Nile is seen flowing between its banks, boats come and go, and boatmen quarrel and strike each other with their poles. In the register above are the river-banks and the adjacent fields, where a group of slaves hidden in the bushes are trapping birds. Above, again, boat-building, cord-making, and fish-curing are carried on. Finally, under the cornice there are the bare cliffs and wild desert plains, where greyhounds are pulling down gazelles and scantily clad huntsmen are lassoing wild birds. Each register corresponds to one plane of the landscape ; but the artist, instead of placing his planes in perspective, has separated and superimposed them. Everywhere in the tombs, as even in the primitive tomb of Hierakonpolis, we find similar combinations, scenes of inundation and of civil life on the lower part of the walls, and the hills and hunting scenes above.

Sometimes the artist inserted between these two registers another containing pastoral scenes, labourers and artisans working at their trades, and occasionally the intermediate scenes are entirely omitted, and the Nile and the desert are placed next to each other. The mosaic of Palestrina and the Pharaonic tomb paintings represent the same subject treated according to the conventions and methods of two different schools of art. Like the mosaic the wall-painting represents not a series of isolated scenes, but a regular composition which may be interpreted with ease by those who can read the artistic language of the period.

2.—TECHNICAL PROCESSES.

The preparation of surfaces about to be decorated required much time and care. As the architects were unable to give a perfectly flat surface to the walls of the temple or pylon the decorators were forced to adapt themselves to slight irregularities in places. The blocks of which the walls were formed were rarely homogeneous, and the limestone strata in which the tombs were excavated almost invariably contained nodules of flint, fossils, and petrified shells. When the tomb was to be painted, the wall which had been roughly levelled was washed over with a coat of black clay mixed with finely chopped straw, similar to the mixture used in brick-making. In preparing for sculpture, however, the sculptor was forced to arrange his subject so as to avoid as far as possible the irregularities of the stone. If they occurred in the midst of the figures, and were not too hard, they were worked over with the chisel, but if this could not be done they were removed and the hole was plugged with white cement, or with carefully fitted pieces of limestone. This was no small undertaking, and we could point to tomb chambers where as much as a quarter of the wall-space is made up of inserted slabs of limestone. This preliminary work accomplished, the whole was washed over with a thin coat of fine plaster mixed with white of egg, which concealed all inequalities or repairs and formed a smooth polished surface, over which the brush of the designer could be employed with freedom.

In unfinished chambers or parts of chambers, and even in the quarries, we constantly find sketches in red or black ink of the bas-reliefs with which it was intended to cover them. The plan, first made out on a small scale, was then squared and transferred to the wall on the large scale by assistants and pupils. In some places the subject is summarily indicated by two or three rapid strokes of the reed-brush. This is the case with certain scenes that were copied by Prisses d'Avennes from the Theban

Fig. 192.—Sculptor's sketch from tomb, Old Kingdom.

tombs (fig. 192). Elsewhere the outline is fully drawn, and the figures on their squaring lines only await the sculptor. Some sculptors took the pains to determine the position of the shoulders and the poise of the body by horizontal and vertical lines, on which they marked the height of the knee, the hips, and other parts of the body (fig. 193). Others with more confidence in their own powers attacked their subject at once, and drew in their figures without any sort of guide; this was done by the

artists who decorated the tomb of Seti I. and the southern walls of the temple of Abydos. Their line is so pure and their facility of execution so amazing that it has been supposed that they made use of stencilling; but this opinion is at once abandoned when we examine the figures closely and take the trouble to measure them with a compass. The forms of some are slighter than others, the contours of the chest are more accentuated in others, or the legs are farther apart. The master did not find much to correct in the work of these assistants. Here and there he altered a head, he flattened or accentuated a knee, or modified the arrangement of some detail. In one instance, however, at Kom Ombos several of the divinities on the roof were badly placed, and their feet came where their arms should have been: the master readjusted their position on the same squared surface without effacing the original sketch. Here, at any rate, the error was noticed in time; at Karnak on the northern wall of the hypostyle hall, and again at Medinet Habû, the error was only discovered after the sculptor had completed his work. The figures of Seti I. and Rameses III. sloped backwards, and appeared about to overbalance; they

Fig. 193.—Sculptor's sketch from Old Kingdom tomb.

Fig. 194.—Sculptor's correction, Medinet Habû.

were filled in with cement or stucco and cut afresh. The cement has now fallen out, and traces of the first chiselling are once more visible; thus both Seti I. and Rameses III. have two profiles, one scarcely marked, the other cut in high relief (fig. 194).

The sculptors of the Pharaonic age were not so well provided with tools as those of our own day. One of the kneeling scribes in the Cairo Museum has been carved out of limestone with the chisel; the flat lines made by the tool are visible on his skin. A statue in grey serpentine in the same collection shows traces of two different tools: the body is marked all over with the point; the head is unfinished, but it has been blocked out by chipping it with a small hammer. Similar observations and study of the monuments have shown that the Egyptians were familiar with the drill (fig. 195), the toothed chisel, and the gouge, but there has been endless discussion as to whether their metal tools were iron or bronze. Iron has been considered out of the question for *a priori* reasons. It has been argued that it was regarded as impure, and that it must have been impossible to employ it even for the most ignoble purposes without contracting impurity that would be injurious to the soul both in this world and the next. But the uncleanness of an object has never prevented its use. Pigs were impure, but they were bred nevertheless in considerable numbers in certain provinces, for Herodotus

Fig. 195.—Bow drill.

states that swine were let loose in newly sown fields in order that they might tread in the grain. Like many things in Egypt, iron was pure or impure according to circumstances. While certain legends called it "the bones of Typhon," and condemned it as baneful, other equally ancient legends affirmed that it was the actual metal of which the sky was made, and owing to this authoritative statement it was named *ba-en-pet*, the celestial metal. The only metal found in the Great Pyramid is a piece of iron, and though objects made of iron are rarely found in comparison with the immense numbers found in copper and bronze, this may be accounted for by the fact that iron is soon consumed by rust, and where it has survived it has only done so owing to a combination of very exceptional circumstances. It is certain that the Egyptians were acquainted with iron, and made use of it at all periods, and it is no less certain that they never possessed steel. The question then arises how they managed to work the hardest stones, such as we almost hesitate to attempt to-day—diorite, basalt, serpentine, and syenite. The various manufacturers of antiquities who work granite for the benefit of tourists have solved the question. They work with twenty or more points and chisels of inferior iron, which are rendered unusable by a few blows. The first one spoilt, they take another, and so on, until their store is exhausted, when they take the whole collection to the forge to be put to rights. The proceeding is neither so slow nor difficult as might be imagined. There is now in the Cairo Museum a life-size head which was produced by one

of the best forgers in Luxor in less than a fortnight from a block of black granite streaked with red. I have no doubt the ancients worked in the same way; they mastered the hardest stones by means of iron, copper, and bronze. The method once discovered, practice would teach them how to work with greater ease and to produce as regular and delicate work with the tools they possessed as we can produce with ours. As soon as the apprentice had learned to handle the point and mallet the master placed graduated models before him that represented the successive stages in representing an animal, part of a human body, and the entire human body from the first rough sketch to the finished work (fig. 196). Every year these trial pieces are found in sufficient numbers to establish a progressive series. Some were intended to teach carving in bas-relief and others for practice in statuary, and they show us the methods employed for both.

The Egyptians understood three principal forms of bas-relief—either by simple engraving with the point or by cutting away the ground and allowing the figures to stand out, or again by leaving the background untouched and sinking the figures themselves, modelling them in relief in the hollow. The first method was very quickly accomplished, but it had the disadvantage of being only very slightly decorative. Rameses III. made use of it in several places at Medinet Habû, but it was generally applied to stelæ and small objects; the risk of breakage was small, and it necessitated no re-dressing of the face, and there were no projections to be endangered by

blows or chipping. The second method was most in use, and appears to have been taught in the schools

Fig. 196.—Sculptor's trial piece, Eighteenth Dynasty.

in preference to the others. The models were small square or oblong tablets, squared off to enable the pupil to enlarge or reduce the design without altering

the proportions. Some of these models were worked on both sides, but more frequently on one side only. The subjects include an ox, the head of an ape, a ram, a lion, or of a divinity; occasionally we find the design repeated, merely outlined on the left and finished in detail on the right. In no instance does the relief exceed $\frac{1}{3}$ inch, and it is generally even less. This is no indication that the Egyptian could not work in very much higher relief. At Medinet Habû and at Karnak, in the upper part of the temple and where the carvings are exposed to the full glare of sunlight, the projection is as much as $2\frac{1}{2}$ inches, both in granite and in limestone. If they were less deep, the figures would be absorbed and lost in the glare, and only a confusion of lines would be visible to the spectators below.

Models intended for the study of statuary in the round are even more instructive. Many of them are plaster casts of works of art known in the schools. Every part of the body, the head, the arms, legs, and trunk were cast separately. In order to make an entire body, the various parts were selected and built up as required into a statue of a man or a woman, kneeling or standing, seated on a chair or squatting on the heels, the arms extended or hanging down. This curious collection was found at Tanis, and dates probably from Ptolemaic times. Students' models of the Pharaonic period are in soft limestone, and almost all of them represent the reigning sovereign. They are cubical in shape, and measure about 10 inches. On one side cross lines were drawn at right angles, which regulated the relative

position of the features. Then on the opposite face the work was begun according to the scale given on the reverse. On the first block a mere oval was designed; a projection in the middle and two depressions to right and left indicated vaguely the position of the nose and eyes. The form assumes more definite lines as we pass from one block to another, and the face gradually emerges from the stone. The contours of the face are regulated by lines drawn by the artist from top to bottom of the block, the angles are cut away, and worked into correct form, the features begin to appear, the eye is hollowed out, the nose and mouth assume their proper forms. By the time we reach the last block all is complete except the uræus and details of the head-dress. We have no school piece in granite or basalt, but, like our monumental masons, the Egyptians always kept in hand a stock of half-finished statues in hard stone that could be completed in a few hours. The hands, the feet, and the bust only required a few final touches, but the head was scarcely blocked out and the clothing was only sketched; half a day's work would be sufficient to transform the head into a portrait of the purchaser and to arrange the short skirt according to the newest fashion. Two or three of these unfinished statues show us the method of procedure as completely as if we possessed a series of teachers' models. The regular continuous cutting of limestone could not be applied to volcanic rock, which could only be worked by means of the point. When by expenditure of time and patience the desired result had been reached, there would still

be various rough places, nodules of heterogeneous substances that the sculptor had not dared to meddle with for fear of injuring the surrounding work, and for these he had to employ another implement. Over the projection he placed the sharp edge of a pebble, and on this he dealt cautious blows with a rounded pebble until the projection was reduced to powder under the blows of this novel axe and mallet.

After these defects had been corrected, the monument would still look dull and lacking in finish. It required polishing in order to efface the marks of the point and mallet. The operation was exceedingly delicate; an unlucky slip of the hand, one moment of carelessness, and the work would be injured past repair. The dexterity of the workmen rendered such a catastrophe very rare. Take, for instance, the highly polished statue of Sebekemsaf at Cairo, or the colossal figure of Rameses II. at Luxor. The play of light at first prevents the eye seizing the delicacy of the work, but by placing ourselves in a favourable light, we find that the detail of the knee and chest, of the shoulder and face, are no less finely rendered in granite than in limestone. The Egyptian sculptures are no more injured by the very high polish than was the work of Italian sculptors of the Renaissance.

After leaving the hands of the sculptor the work passed into those of the painter. A sandstone or limestone figure would not be considered complete if it were allowed to retain the natural colour of the stone, and the statues were painted from head to

foot. In bas-reliefs the background was usually left plain, but the figures were coloured. In this respect the Egyptians were far better equipped than is usually supposed. The most ancient painters' palettes—and some are known of the Fifth Dynasty—have separate divisions for yellow, red, blue, brown, white, black, and green. Others of the Eighteenth Dynasty provided for three varieties of yellow, three of brown, and two each of red, blue, and green, at least fourteen or sixteen different shades. Black was obtained by burning the bones of animals; white was made of gypsum mixed with honey or albumen; the yellows are ochre or sulphuret of arsenic, the orpiment of our modern painters; the reds are ochre, cinnabar, or vermilion; the blues are lapis lazuli, or sulphate of copper. If the materials were rare or costly, local productions were substituted for them. Lapis lazuli was replaced by blue frit coloured with sulphate of copper and reduced to an impalpable powder. The colours were kept in small bags, and doled out when required, slightly moistened with water containing a little gum tragacanth. This was applied by means of a reed-pen or a hair-brush, of which the artist usually employed only two, one with a fine point for outlines and delicate parts of the work, and a broad one for large surfaces. When well prepared the pigments were remarkably solid, and have scarcely changed during the course of centuries. Where the reds have darkened, the greens faded, or the blues turned green or grey, it is only on the surface, the colours below are still brilliant and unchanged. Until the Theban period no precaution was taken

to preserve them from the action of air and light; about the time of the Twentieth Dynasty the custom arose of covering them with a transparent varnish soluble in water, which was probably the gum of some variety of acacia. This varnish was not applied universally; some painters used it for the entire picture, others merely varnished the ornaments and accessories, and omitted the flesh tints and clothing. In course of time it cracked, and became so dark as to damage the pictures it was intended to preserve. The Egyptians no doubt realised the mischief that attended its use, for we do not meet with it after the Twenty-sixth Dynasty.

The Egyptians used flat, uniform washes of colour; they did not paint in our sense of the word, they illuminated. Just as in drawing they rendered the outline and almost entirely suppressed the internal modelling, so in painting they simplified the colouring and merged all variety of tones and play of light and shade in one uniform tint. Egyptian painting is never entirely true nor yet entirely false, it follows nature as closely as possible, but does not attempt to imitate it faithfully, sometimes understating, sometimes exaggerating and substituting ideal conventional renderings for the visible reality. Water is always blue, either plain or spaced, with black zig-zag lines. The buff and bluish hues of the vulture are rendered by vivid red and bright blue: the flesh tints of the men are brown, those of the women are yellow. The colour assigned to each object was taught in the schools, and the convention, once thoroughly established, was transmitted without

change from one generation to another. At various times some adventurous artist would attempt to break through these conventions. Thus in the Sixth Dynasty tombs at Deir el Gebrawi there are instances of women depicted with brown skins. There are men with yellow skins at Saqqara of the Fifth Dynasty, at Meir in tombs of the Twelfth Dynasty, and at Abû Simbel of the Nineteenth Dynasty, while in the tombs of Thebes and Abydos, about the period of Thothmes IV. or Horemheb, and at El Kab and Beit el Wally of the Nineteenth Dynasty, there occur figures with bright rose or crimson flesh tints.

It must not, however, be supposed that the impression produced by this artificial colouring was crude and discordant. Even in works of small size, such as illuminated copies of the *Book of the Dead*, the decoration of coffins, or of funerary coffers, there is harmony and softness of colouring. The most vivid tones are boldly placed in juxtaposition, but with full knowledge of their relations to each other, and of the phenomena which naturally result from those relations. They do not jar, nor do they kill one another; each has its full value, and by their proximity to each other they give rise to half-tones that harmonise with them.

When we pass from small to great, from a leaf of papyrus or a panel of sycamore-wood to the walls of tombs and temples, we find the habitual use of flat tints both soothing and pleasant to the eye. Every wall is treated as a whole, and a harmony of colour is preserved throughout the superposed registers. In some cases the colours are distributed rhythmically

or symmetrically from stage to stage and balance one another, in others one colour predominates and determines the general tone to which the others are subordinated. The vividness of the whole is always proportioned to the amount of light that will play on the wall. Where the halls are completely dark the colour is as brilliant as possible, as otherwise it would scarcely be observable by the flickering light of torches or lamps. On the outside walls and on the pylons the colouring is as vivid as it is in the remotest depths of rock-tombs. However powerful it might be, the glaring effect was neutralised by the sun. In places where twilight reigned, such as beneath the temple porticoes and in the antechambers of tombs, the colouring is soft and subdued. Painting in Egypt was only the humble handmaid of architecture and sculpture. To compare it with our own, or even with that of the Greeks, is not to be thought of, but if we accept it for what it is in the secondary position assigned to it, we must admit that it possesses some unusual merits. It excelled for large decorative schemes, and if the fashion of painting our mansions and public buildings should ever return, we should lose nothing by making a study of Egyptian methods and conventions.

3.—SCULPTURE.

It is now possible for us to trace to some extent the development of sculpture in Egypt from the rude attempts of the earliest Thinite period. In Oxford, at the Ashmolean Museum, are two statues found at Koptos, representing the local deity. The modelling

is exceedingly rough; the arms project but slightly from the body, and the legs are merely indicated by

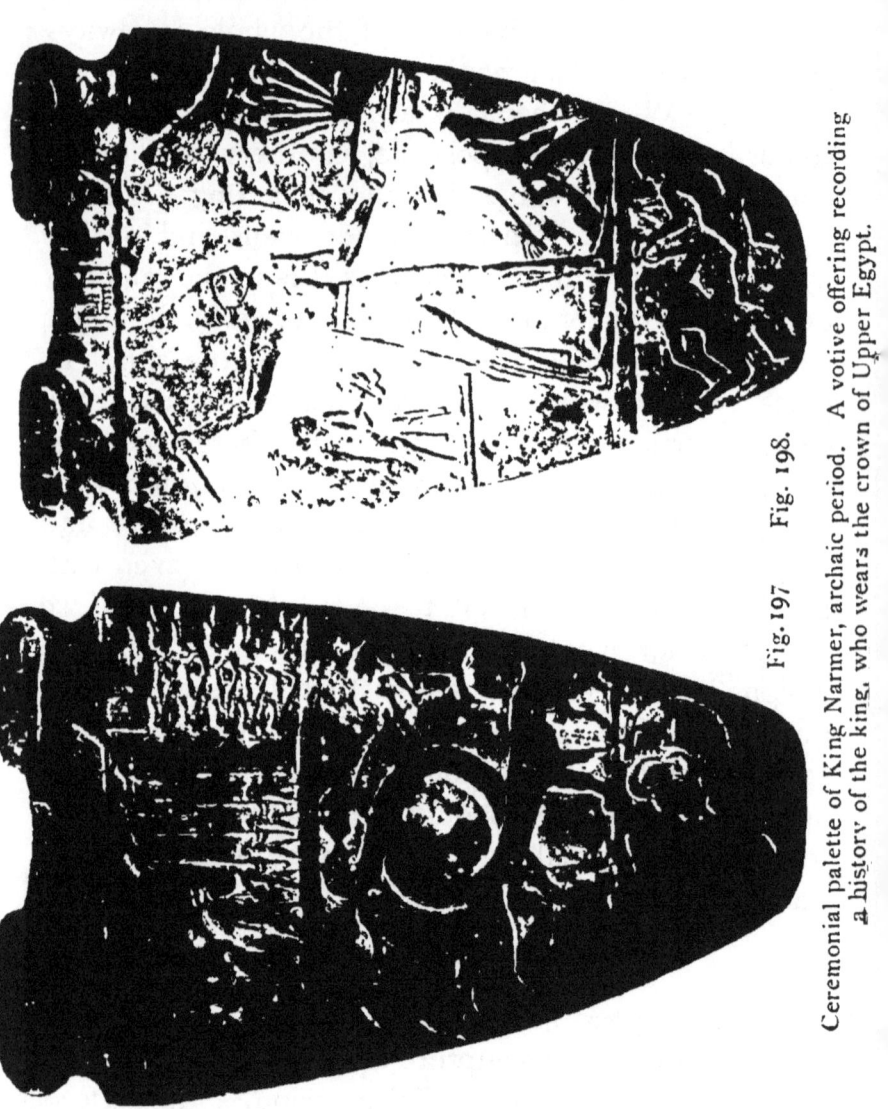

Fig. 197 Fig. 198.

Ceremonial palette of King Narmer, archaic period. A votive offering recording a history of the king, who wears the crown of Upper Egypt.

a groove in front and behind. Round the body of each figure is wound a girdle. The same museum

CARVINGS OF THE EARLY PERIOD. 233

possesses a statue found at Hierakonpolis even more slightly worked. All three represent standing figures, and are more than life-size.

In marked contrast to these figures are the finely carved limestone maceheads and the great palettes of schist or slate. On some of these the human figure is shown in correct perspective, but on the palette of King Narmer (figs. 197, 198) we find the strange conventional method of representing the human figure that obtained throughout the history of Egypt. Executed in very low relief, these carvings show the mastery of line and composition which the sculptors of their day were to hand down to posterity. Some small ivory figures carved in the round are known of this period, which are rendered with much spirit. The earliest named royal statue dates from the early part of the Third Dynasty. There is a seated figure of King Khasekhemûi in the Cairo Museum carved in schist, and another in limestone is to be seen in Oxford. The figures are similar in attitude and costume. The pose is somewhat awkward, but the

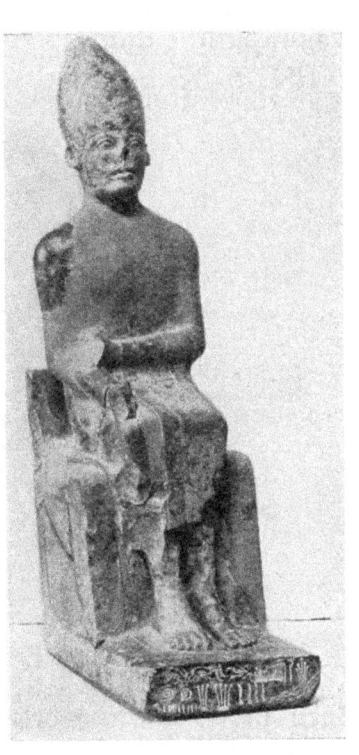

Fig. 199.—King Khasekhemûi, Third Dynasty, at Oxford.

conventional attitude of later Egyptian art is already adopted (fig. 199). The face shows calm power and alert expression. The excellence of the work, notwithstanding some roughness of execution, proves that the Pharaoh of that period could command the services of an experienced sculptor, trained in a school that was rapidly gaining power and certainty of treatment.

It is to be hoped that future excavations will pro-

Fig. 200. Rahotep, Third Dynasty, from Medûm.

duce many more works of the primitive dynasties that yet sleep undiscovered beneath the sands of Egypt. Those of the Old Kingdom are daily exhumed from the tombs and temples scattered over the great pyramid area. These have not yielded Egyptian art as a whole, but they have familiarised us with one of its schools, the school of Memphis. There were other schools, notably those of the Delta, Hermopolis, Ekhmim, Abydos, Denderah, Thebes,

Assûan, whose work does not begin to appear earlier than about the Sixth Dynasty. Memphis was the capital, and the presence of the Pharaoh must have attracted all the talent of the vassal principalities. Judging from the result of excavation in the Memphite necropolis alone, it is possible to determine the characteristics of both sculpture and painting in the

Fig. 201.—Nefert, wife of Rahotep, Third Dynasty, from Medûm.

time of Seneferù and his successors with as much exactness as if we were already in possession of all the monuments which the valley of the Nile still holds in reserve for future explorers.

Of the close of the Third Dynasty we have two remarkable works from Medûm. Rahotep (fig. 200), notwithstanding his high title of General, is of humble birth. Well-made and powerfully built

as he is, there is a rustic element of surprise and subserviency in his expression. His wife Nefert (fig. 201), on the contrary, is a princess of the blood royal, and her whole figure denotes dignity and resolution, which are very skilfully rendered by the sculptor. She is wearing a close-fitting garment opening in a point in front. Beneath the material the shoulders, the bosom, the body, and the thighs are modelled with a grace and purity of outline which it is impossible to praise too highly. The round, plump face is surrounded by a ponderous wig, confined by a richly ornamental bandeau. Here, as in most statues of women of the Old Kingdom, the natural hair appears on the forehead below the wig. Both husband and wife are in limestone, and are painted, the husband a reddish brown, the wife a light buff.

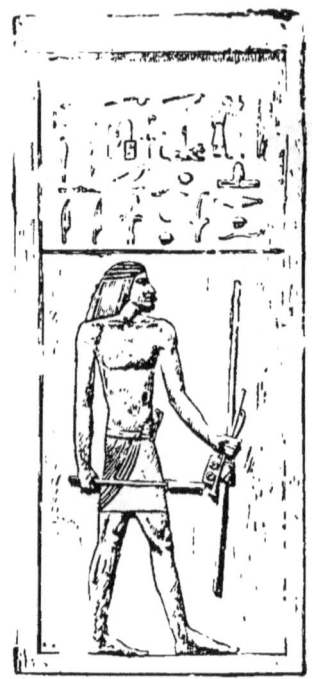

Fig. 202.—Panel from tomb of Hesi, Third Dynasty.

The six wooden panels of the tomb of Hesi in the Cairo Museum are perhaps the most important that we possess of their kind. There is no grouping. In each of them Hesi is either standing (fig. 202) or sitting, and above his head are four or five lines of hieroglyphs, but the purity of line, the rendering of the human frame, and the fineness of execution are admirable. Never

has wood been carved by a more skilful hand nor with a more delicate chisel.

But the art of the sculptor was not steadily progressive. The contemporary sculptors of any given period were not all possessed of equal skill, and though several might show themselves capable of good work, there would be others who were merely craftsmen, and we must beware of mistaking what is due to their incompetence or inexperience for archaic clumsiness. Thus there are certain pieces known to belong to the Fifth and Sixth Dynasties which possess all the characteristics which are quoted as belonging to works of far greater antiquity.

One of the most ancient and remarkable pieces of statuary known is a colossus—the sphinx of Gizeh. Its date has been the subject of endless discussion. Recent discoveries point to its being Khafra himself, a portrait head of the Pharaoh with the body of a lion guarding his pyramid and temples from all evil by the magic power possessed by a sphinx, or, as others have thought, it may be far older, a relic of even more remote times.

Carved out of the solid rock at the extreme edge of the desert, the sphinx seems to raise his kingly head, conscious of divine descent, in order to be the first to behold the rising of his father the sun (fig. 203). For centuries it was buried to the chin in the sand, but even this did not preserve it from ruin. The battered body now only bears a general resemblance to a lion, the feet and chest, repaired under the Ptolemies and Cæsars, retain only a portion of the stone facing with which they were then covered to

conceal the ravages of time. The lower part of the head-dress has fallen away, and the narrow portion of

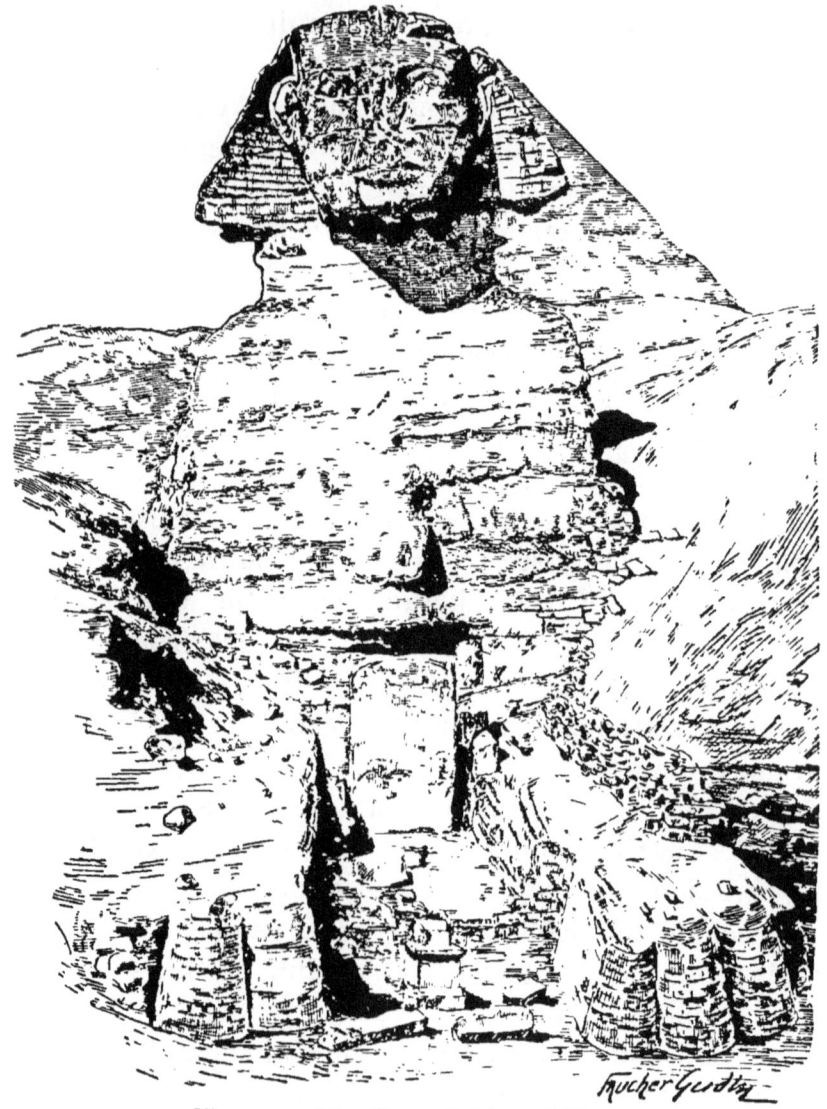

Fig. 203.—The Great Sphinx of Gizeh.

neck still remaining does not seem strong enough to support the weight of the head. The nose and beard

have been broken by fanatics, and the red colour that gave life to the features is almost entirely effaced. And yet the whole figure in its decay preserves a commanding expression of power and grandeur. The eyes gaze into the distance with an intensity of profound thought, the mouth still smiles, the mutilated face breathes power and repose. The art that conceived and carved this prodigious statue out of the solid rock is a complete art, master of itself, certain of its results.

The artists of Memphis excelled in the use of the brush and chisel, and the scenes traced by them in thousands on the walls of the tombs bear witness to unusual artistic ability. The relief is low, the colouring sober, and the composition is good. Buildings, trees, vegetation, and the incidents of country life are summarily indicated, and introduced only when they are absolutely indispensable for complete understanding of the scene represented. Men and animals, on the contrary, are treated with abundance of detail and with a fidelity and facility of rendering such as we rarely find rivalled in the schools of later date.

In the statues we do not find the same variety of attitude that we observe in the pictured scenes. A professional mourner, a woman grinding corn, the baker kneading bread, are as rare in the round as they are numerous in bas-relief. In the greater number of statues the figure is either walking with one leg advanced or seated on a chair or a block of stone; sometimes kneeling, more often seated cross-legged, the body upright, and the legs flat on the ground in the squatting attitude of the modern

fellahîn. This monotony is explained by the purpose for which these statues were made. They represented the actual body of the individual for whom the tomb or temple was built, and the bodies of his relations and retainers, his slaves, and the members of his household. The master is always either sitting or standing, and it would be impossible to give him any other position. The tomb was, in fact, the eternal house where he continued the life he formerly lived in this world, and the scenes depicted on the walls show the details of his life after death. In one place he is presiding over the preliminaries of the offerings by which he is to be fed, sowing and harvesting, the care of cattle, fishing, hunting, and working at various trades, and he *superintends all works that are done for the dwelling-place of eternity*; for this he stands with raised head, his arms either hanging down or holding a staff and baton. Elsewhere he is provided with a succession of dishes containing offerings, and for this he is seated at ease in a chair of state. These two positions of the bas-reliefs he also retains in the statues. Standing, he is supposed to receive the homage of his vassals; seated, he shares the family meals. The household also adopt the attitude adapted to their rank and occupation. The wife stands by his side, or she is seated on the same seat with him, or on a separate one, or she is crouched at his feet as she did during life. The son is dressed like a child if the statue was made during his infancy, or if he was represented when a man he has the bearing and equipments proper to his position. The slaves are grinding the corn, the cellarers are sealing up the

wine-jars, the mourners are weeping and tearing their hair. His social world followed the Egyptian to the tomb and there stood in the same relation to him that it had done before his death. The Pharaoh must still remain the monarch, seated on his throne, protected by the sacred serpent the uræus, or overshadowed by the guardian hawk. Whether, like Menkaûra, he is standing in company with the gods, or with his wife in the affectionate attitude adopted by sovereign and subjects alike, he is unmistakably Pharaoh, conscious of supreme power, of divine descent, and of actual divinity.

The influence exerted on the sculptor by this conception of the other world did not end here. As soon as the *ka* statue was regarded as the posthumous support of the *double*, it became absolutely necessary that the new body of stone should be a copy—even if only a summary one—of the body of flesh in order that the *double* might adapt itself with ease to its new support. The head is therefore a faithful portrait, while the body, on the contrary, is that of a person in the highest state of development in order that he may fully enjoy his physical powers in the company of the gods. The men are always in the prime of life, and their women have the slender proportions of girlhood. This ideal was only abandoned when the anomaly was too obvious. The statue of a dwarf possessed all the innate deformities of a dwarf, for if an ordinary body were placed in the tomb, the *double* accustomed to the deformities of its members would be unable to accommodate itself to the new con-

ditions, and would be deprived of the support necessary for further existence. The sculptor was only at liberty to vary the details and general accessories ; he could make no change in the usual attitude and resemblance without diminishing the utility of his work.

This continued repetition of pose and subject produces a feeling of monotony in the mind of the spectator, an impression which is increased by the peculiar appearance of the columns or shafts which are placed behind the statues. These are sometimes rectangular and end at the base of the skull, or they narrow near the top and are lost in the hair, or the top is rounded and appears above the head. The arms are often separated from the body, they are in one piece with the sides and hips. When the leg is advanced for walking it is often united up the entire length to the pediment at the back by a narrow band of stone. It may be thought that this is accounted for by the lack of adequate tools, and that the sculptor hesitated to remove the superfluous stone for fear of injuring the statue. This explanation may hold good for the earliest work, but not after the Fourth Dynasty, for we can point to many examples even in granite where all the limbs are free, whether they are worked with the chisel or with the drill. Although the use of tenons persisted to the last, it was not owing to the difficulty of removing them, but from an exaggerated respect for the teaching of former ages.

Until recently very few museums possessed statues of the Memphite school. Egypt and Paris, besides many of inferior work, possessed about twenty fine

STATUARY OF THE OLD EMPIRE. 243

examples: the *crossed-legged scribe*, Sekhemka, and Pahûrnefer in Paris; the *Sheikh el Beled*, Khafra, Ranefer, the kneeling scribe, and a cross-legged scribe at Cairo. Recent excavations in the Pyramid area have yielded many more fine works of this period. Among the most perfect we have the statues of Menkaûra and the wonderful series of slate triads from his valley temple; the alabaster statuette that probably represents Khûfû (Kheops) and the statue of Ne-user-ra in rose granite. A very fine series of limestone statuettes painted and quite uninjured have been recovered by Dr. Reisner from serdabs of Fourth and Fifth Dynasty mastabas at Gizeh. These statuettes show the same vigorous characteristics as the larger statues, and many of them are exceedingly fine. Some of them are now at Boston.

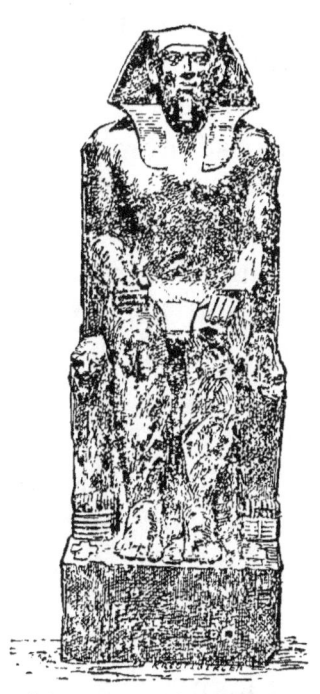

Fig. 204.—King Khafra, Fourth Dynasty.

Khafra is a king (fig. 204). He sits squarely and proudly on the throne of the Pharaohs, his hands on his knees, his head raised, and his gaze assured. If the inscription that bears his name were destroyed and all insignia of his rank obliterated, we should still recognise him as a king by his bearing. Every trait shows the man accustomed from infancy to feel himself invested

with supreme authority. His statue carved in diorite was found with others less perfect in his valley temple. Of Khûfû we possess as a certainty only a small ivory carving, now at Cairo, but minute as it is, it is a fine piece of portraiture that will bear examination through a magnifying-glass. The valley temple of Menkaûra has yielded royal statues that are exceedingly fine. The slate triads are worked with extraordinary finish of texture. In the triad now at Boston the king is standing by the side of the goddess Hathor, and wears the crown of Upper Egypt and the false beard. In the centre is a seated figure of the goddess, her left arm round the king, and her right hand on his arm. On her other side is the goddess of the nome. A very fine group is of Menkaûra and his queen carved in a fine dark slate. The portraits are life-like, and a comparison of the numerous statues shows that they belong to two periods; some represent Menkaûra early in his reign, and others as an older man. A beautiful head carved in alabaster of Shepseskaf, his son and successor, was found among a mass of fragments. The face is that of a youth wearing the royal uræus. The shrewd somewhat projecting under-lip closely represents that of his father. The mouth is firmly set and the cheery powerful face is strongly individual.

The bronze statue of Pepi I. of the Sixth Dynasty found by Quibell at Kom el Ahmar represents the Pharaoh standing, the right arm down, the left raised to hold the sceptre or staff. The bust, legs, and arms were hammered out and fitted together most accurately; the face, hands, and feet were cast. Round

the loins was a dress of gold, and a wig of blue stone was on the head, but both have disappeared. The eyes were black and white enamel inserted in bronze eyelids.

Ranefer belonged to one of the great noble families of his time. He stands upright in the attitude of a prince inspecting a march-past of his vassals, but he does not impress us with the intense power and calm decision of Khafra.

The original of the *cross-legged scribe* at the Louvre was not a handsome man (fig. 205), but the fidelity and vigour of his portrait compensate in great measure for what it lacks in ideal beauty. With his legs crossed beneath him in one of the attitudes familiar to Orientals, but almost impossible for a European to maintain, the upright bust well balanced from the hips, his head raised, his hand holding the reed-pen, and placed ready on the outstretched papyrus, he still waits, as he has done for six hundred years, for the moment when his master will consent to resume his interrupted dictation. The face is almost square, the strongly marked features indicate a man of mature age, the broad thin-lipped mouth is slightly raised at the corners, which are almost lost in the projection of the surrounding muscle, the cheeks are hard and bony, the thick heavy ears stand out from the head, and the hair is coarse and closely cropped over the low forehead. The large well-opened eyes owe their peculiar vivacity to an ingenious contrivance of the ancient artist. The stone orbit that forms the setting has been hollowed out and filled with black and white enamel; a bronze setting defines the edge

of the eyelids, while a small spangle of ebony inserted behind the iris arrests and reflects the light and gives an appearance of actual sight. The flesh is slightly flaccid, as it should be with a man of middle age, whose

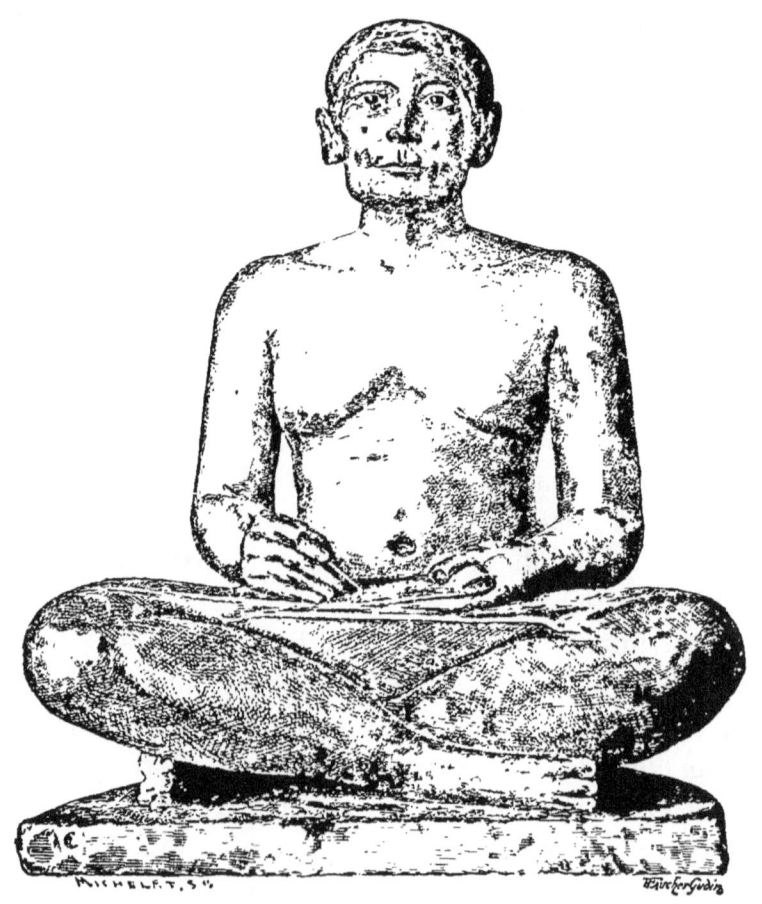

Fig. 205.—Cross-legged scribe at the Louvre, Old Kingdom.

occupations do not admit of active exercise. The back and arms stand out well, the hands are hard and bony, the fingers are unusually long, the details of the knees are carefully modelled. The whole body is

governed by the dominating sense of waiting, which also prevails in the expression of the face. The muscles of the arm, the bust, and shoulder are all in semi-repose, ready to resume their interrupted task.

The cross-legged scribe of Cairo (fig. 206) was dis-

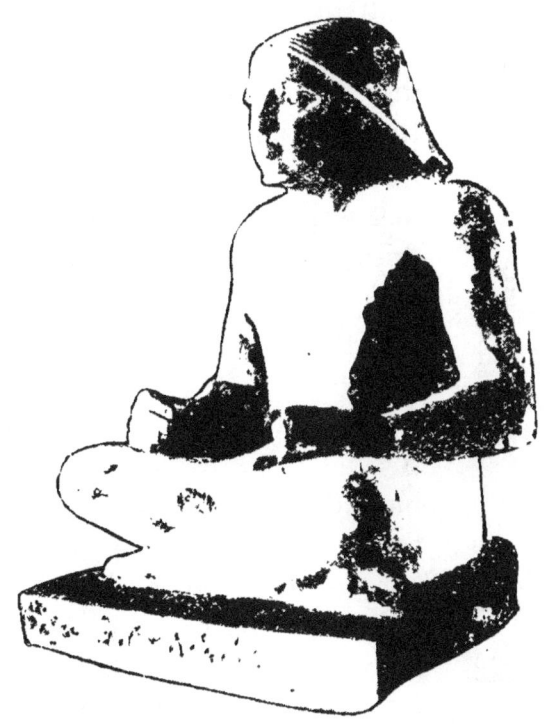

Fig. 206.—Cross-legged scribe, from Saqqara.

covered by M. de Morgan at Saqqara in 1893. This statue exhibits much the same vigour of expression and execution as its fellow of the Louvre, while representing a young man of full, firm, and supple figure.

The *Sheikh el Beled* (fig. 207), Raemka, was *overseer of the works*, probably one of the chiefs of

the corvée who built the Great Pyramids. By birth one of the middle class, he is very conscious of the importance conferred on him by his office, and his whole bearing denotes contentment and official self-assurance. We seem to see him with his knotted staff of acacia-wood in his hand superintending his gangs of workmen. The body is stout and heavy, the neck is thick, the head, despite its vulgarity (fig. 208), is not wanting in energy, the eyes are inlaid. The original feet have perished and new ones have been provided. When the figure was first discovered at Saqqara, it closely resembled the *Sheikh el Beled*, the headman of the place. The fellahîn immediately named it the *Sheikh el Beled*, and the name has clung to it. It is carved in wood, and so is another figure of the same period from an adjacent tomb (fig. 209). It is now a mere trunk without arms or legs, yet enough remains to show that it represented a good type of the middle-aged Egyptian matron.

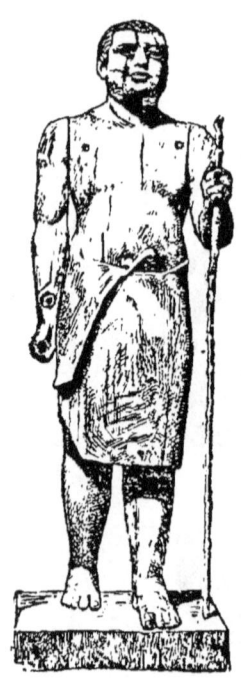

Fig. 207. — Sheikh el Beled, Old Kingdom.

The *kneeling scribe* of Cairo (fig. 210) must have belonged to one of the lower ranks of a bureaucracy similar to that which exists at the present day on the borders of the Nile. If he had not died more than six thousand years ago I could swear that I met him six months ago in one of the villages of

Upper Egypt. He has just brought a roll of papyrus or a tablet covered with writing to be examined by his chief. Kneeling as custom ordained, his hands crossed, his shoulders stooping, his head slightly tilted, he waits in suspense until the reading is over. What were his thoughts as he waited? The scribes were not without apprehension when they had to submit their work to their superiors. The staff

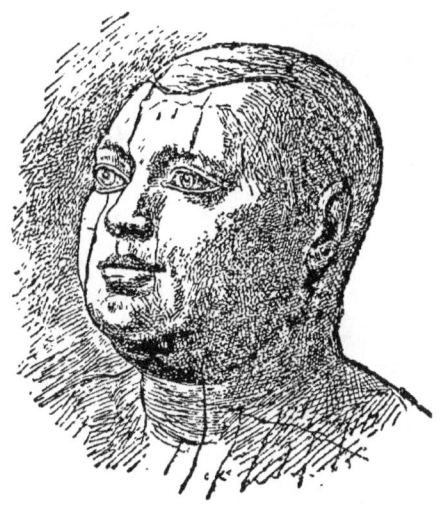

Fig. 208.—Head of the Sheikh el Beled.

played a large part in administrative relationships, and an error in addition or an order misunderstood was followed in due course by blows. The sculptor has rendered with inimitable skill the expression of resigned uncertainty and sheepish gentleness that resulted from a life passed entirely in servitude. The mouth smiles, because etiquette enjoined that it should, but there is nothing joyous in the smile, while the cheeks and nose are puckered up in

agreement with the expression of the mouth. The enamelled eyes have the fixed stare of a man who is waiting without any definite object on which to fix his gaze or concentrate his thoughts. The face is lacking in intelligence and vivacity; but then his occupation did not demand great powers of mind.

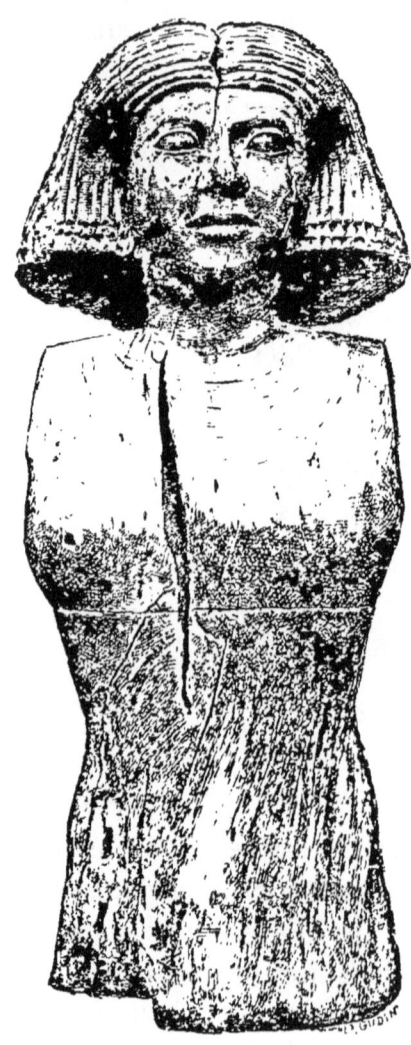

Fig. 209.—Wooden statue of a woman, Old Kingdom.

The statues of the scribes are in painted limestone, but whatever the material, diorite, alabaster, slate, wood, or limestone, the chiselling is everywhere free, subtle, and delicate. The head of the scribe and the bas-relief portrait of the Pharaoh Menkaûhor in the Louvre, the dwarf Nemhotep, and the slaves preparing food offerings, at the Cairo Museum, are in no way inferior to the *cross-legged scribe* or the *Sheikh el Beled*. The baker kneading his dough (fig. 211) belongs entirely to his work. The flexion of the thighs and the

effort with which he presses on the kneading-trough are perfectly natural. The dwarf has a long, big head and huge ears (fig. 212). The face is foolish, the eyes are narrow slits sloping upwards to the temples, and the mouth is misshaped. The chest is powerful and well developed, but the trunk not in proportion with the rest of the body, and the sculptor has been well advised in concealing the lower part under an ample white skirt, for one feels it is too long for the arms and legs. The abdomen is abnormally prominent, while the hips are set so far back that they act as a counterpoise. The thighs are little more than rudimentary, and the entire figure, resting on small, misshapen feet, seems as though it must overbalance and fall forward. It would be difficult anywhere

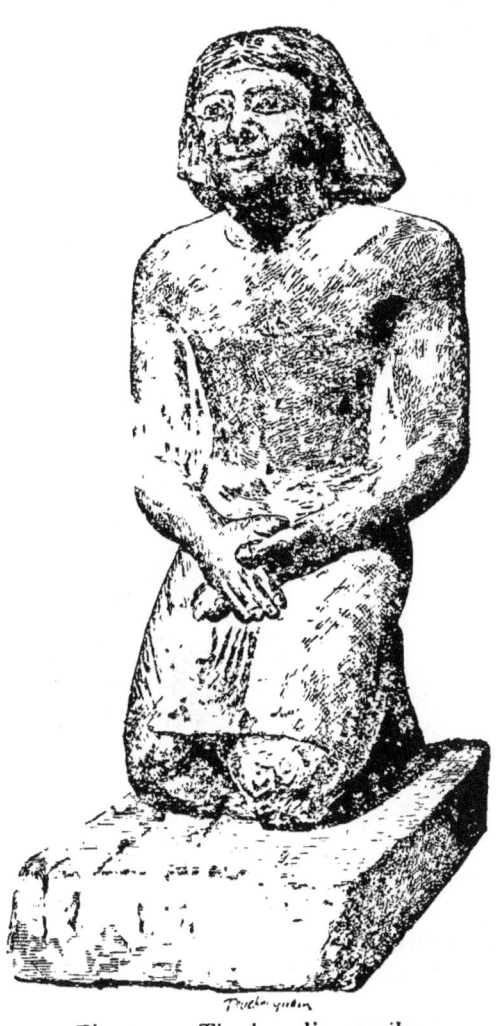

Fig. 210.—The kneeling scribe, Old Kingdom.

to find a work of art where such deformities are represented in so lifelike a manner, free from exaggeration.

Theban art is closely related to that of Memphis. Its methods, materials, composition, and designs are those of the Memphite school, but there are also points of divergence. By the beginning of the

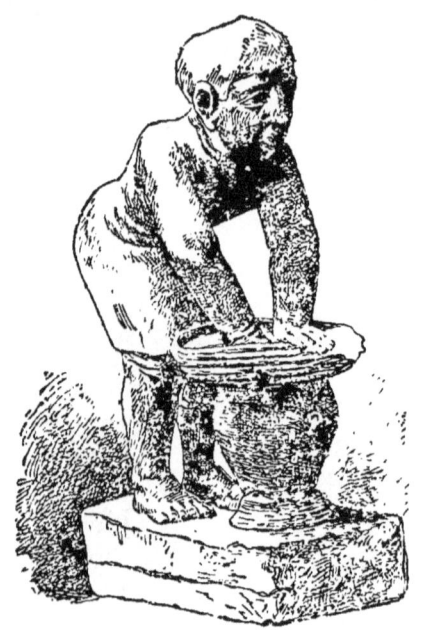

Fig. 211.—A bread-maker, Old Empire.

Eleventh Dynasty the legs became longer and slighter, the hips less powerful, the body and neck more slender. Works of this period of the Middle Kingdom are not to be compared with the best productions of the earlier centuries. The wall-paintings of Siût, of Bershch, of Beni Hasan, and of Assûan are not equal to those of Saqqara and Gizeh; nor are the most carefully executed statues

of that time worthy to rank with the *Sheikh el Beled* or the *cross-legged scribe*. Nevertheless, the seated statue of Mentûhotep I. discovered at Deir el Bahari

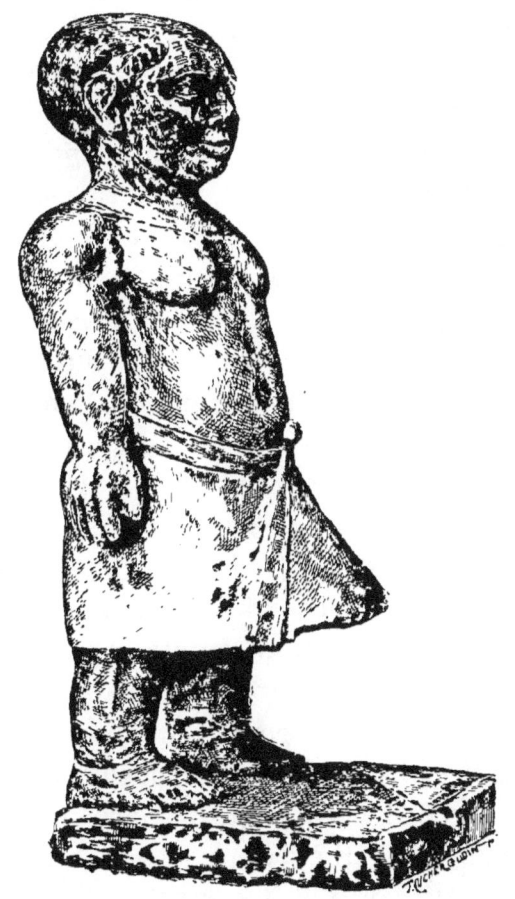

Fig. 212.—The dwarf Nemhotep, Old Kingdom.

in 1900 is a very vigorous and effective piece of work. Many of the royal statues of this period that we possess have been usurped by later sovereigns. Senûsert III., whose head and feet are in the Louvre, was appropriated by Amenhotep III., and the sphinx

at the Louvre and the colossi at Cairo by Rameses II. More than one museum possesses statues supposed to be of Rameses II. which on careful examination we are compelled to ascribe to the Pharaohs of the Thirteenth or Fourteenth Dynasty. Those statues of which there is no doubt, Sebekhotep III. of the Louvre, the Sebekemsaf of Cairo, and the colossi of the island of Argo, show dexterity of manipulation, but are wanting in vigour and originality, as though the sculptors had attempted to reduce them all to the same feeble and expressionless type.

The contrast is great when we turn from these poor puppets of the early Theban school to work of the Tanite school of the same period, the black granite sphinxes discovered by Mariette at Tanis in 1861. The body of the lion is powerful and compact, and is shorter than in sphinxes of the usual type. Instead of a head-dress of folded linen the head is covered with an ample mane that frames the face and encloses the lion's ears. Small eyes, an aquiline nose rounded at the base, high cheek-bones, the lower lip slightly protruding, a countenance so little in accord with what we are accustomed to find in Egypt that they were at one time supposed to be of Asiatic origin (fig. 213). M. Golenischeff, however, has shown that they were executed for Amenemhat III. of the Twelfth Dynasty, and with his features. Whatever the origin of the Tanite school that produced these specimens, it continued to exist long after the expulsion of the Hyksos invaders, since one of its works, the group of the two Niles of the North and of the South, bearing

SCULPTURE OF THE NEW EMPIRE.

trays laden with flowers and fish, was consecrated by Pisebkhanû of the Twenty-first Dynasty.

The first three dynasties of the New Kingdom have bequeathed us more monuments than all the others put together; bas-reliefs, paintings, statues of kings and of private persons, colossi, and sphinxes can be counted by hundreds between the Fourth Cataract

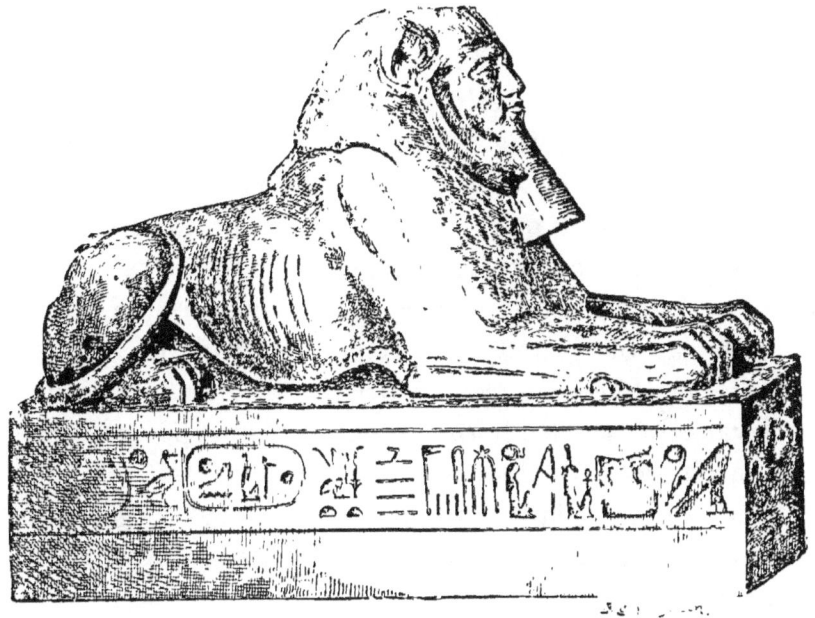

Fig. 213.—One of the Tanis sphinxes.

and the mouths of the Nile. The old sacerdotal cities, Memphis, Thebes, Abydos, are naturally the richest, and the ancient schools of Memphis and Tanis still preserved their traditions, but so great was the impetus given to art that even remote provincial towns could boast of producing *chefs-d'œuvre*. But it is to the Theban school, the royal city and workshops of Thebes, and the funerary workshops

of the western valley that most of the work of this period is due. The royal workshops at Karnak produced the official portraits of the Pharaohs. Amenhotep I. is at Turin, Thothmes I. and Thothmes III. are at the British Museum and at Turin, as well as at Cairo. The *favissa* at Karnak discovered by M. Legrain in 1903 contributed about eight hundred statues of the Theban school, of Pharaohs, and of eminent personages. The bas-reliefs in temples and tombs show a marked advance upon those of the earlier ages. The modelling is finer, the figures are more numerous and better grouped, the relief is higher, and the perspective is studied with more care and insight. The sculptured scenes of the terraces of Deir el Bahari and in the rock-tombs of Hûi, of Rekhmara, of Anna, of Khamha, and of many others at Thebes are surprisingly rich, brilliant, and varied. Feeling for the picturesque is aroused, and architectural details, the rise and fall of the ground, exotic plants, all factors hitherto neglected or only summarily indicated, are now introduced into the composition.

The cow found at Deir el Bahari by M. Naville is a fine piece of work; it reproduces all the characteristics of the kindly animal with marvellous fidelity, and also succeeds in imparting to the sacred symbol of the goddess Hathor a feeling of remoteness and mystery which is the result of real genius. Hathor is standing among the marsh plants, on her head is the solar disc, and under her protection are figures of Amenhotep II. in two positions, suckled by the sacred mother, and also leaning against her chest.

The taste for the colossal, somewhat modified since the construction of the great sphinx, now revived. Amenhotep III. was not satisfied with statues 20 or 30 feet in height, such as had contented his ancestors. Those erected by him in front of his funerary chapel on the west bank of the Nile at Thebes, one of which is the Memnon of the Greeks, are 50 feet high. They are monoliths carved in sandstone, and are as carefully worked as though they were of ordinary size. The avenues of sphinxes that stretch in front of the temples at Luxor and Karnak do not end some few feet from the entrance, they extend a long distance; in one avenue they are human-headed lions, in another they are kneeling rams. Akhenaten, the revolutionary successor of Amenhotep III., far from discouraging the progress of art, did his utmost to promote it. Never, perhaps, were Egyptian artists more unrestricted than by him at his new capital of Tell el Amarna. While throwing off the trammels of the ancient religion, art was able to expand, enriched by the foreign influences that for more than a generation had penetrated the court and country. It is probable that Akhenaten introduced artists from the neighbourhood. The school of Cusæ was mature as early as the Twelfth Dynasty. In the tomb chapels of Meir, 15 miles south of Tell el Amarna, are to be seen not only the naturalistic treatment of animal forms, but also of the human figure, and many of the peculiarities which we find reproduced under the Eighteenth Dynasty by the artists of Akhenaten and his court.*

* A. M. Blackman, *Archæological Survey, Egypt Exploration Fund*, 1911-12, p. 9 *et seq.*

Among the subjects treated on the bas-reliefs of Tell el Amarna are military reviews, chariot driving, festivals of the fellahîn, state receptions, the distribution of honours and rewards by the king, representations of palaces, villas, and gardens, and other subjects which differed from the traditional mode of treatment in so many points that the artists could follow their own ideas and natural genius without restraint. They did so with admirable results. The perspective of some of their bas-reliefs is almost entirely correct, and all of them express the movements of large numbers of people with astonishing success.

Admirable statues of the king and of members of his family have been found, many of them shattered, and others left unfinished in the sculptors' workshops. A very charming statuette of Akhenaten in painted limestone (fig. 214) was discovered at Tell el Amarna in 1912 by Borchhardt, and is now at Cairo. The monotheistic king is holding a table of offerings. The delicate features are those we are well acquainted with in other portraits of him both in the round and in bas-relief; the sensitive expression of the face is admirably rendered. The conventions are the same as in other royal statues; the pediment is there, and the full-face pose is unaltered.

The political and religious reaction that followed this reign arrested this development of art, and the Theban school was once more triumphant. The school of Tell el Amarna continued, however, at least as late as the Twenty-second Dynasty, and although it returned to the ancient religious conventions, the style of the school persisted to the

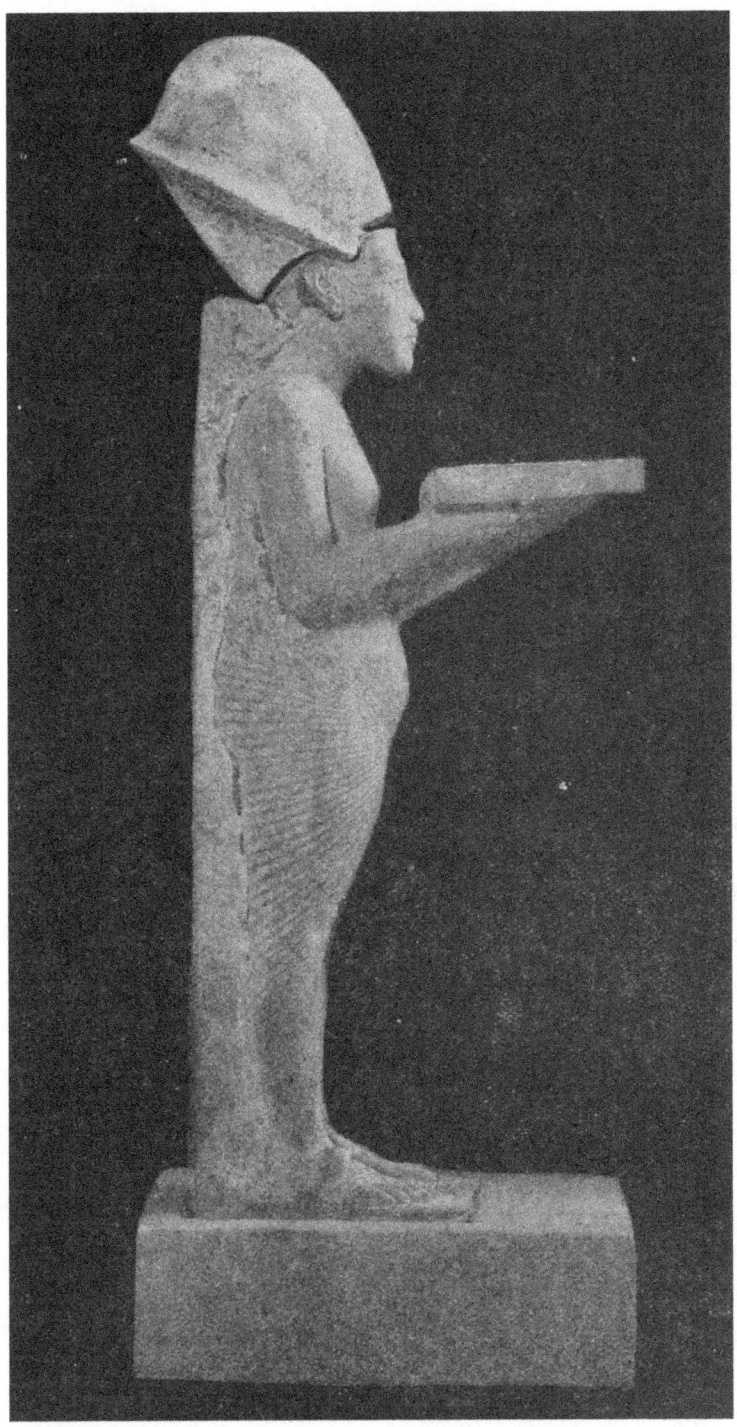

Fig. 214.—Statuette in painted limestone of Akhenaten.
Deutsch-Orient. Gesellschaft.

end.* Its influence, moreover, made itself felt under Horemheb, under Seti I., and even under Rameses II. If during more than a century Theban art remained free, graceful, and refined, that improvement was due to the school of Tell el Amarna. It would be difficult to find anything finer than the bas-reliefs of the temple of Abydos, or those of the tomb of Seti I. The head of the Pharaoh (fig. 215), which must necessarily be always very favourably presented, is a model of reserved and dignified beauty. Rameses II., represented as a warrior in the speos of Abû Simbel, is almost as admirable as Seti I., though very differently rendered. The action of the arm with which he brandishes his lance is somewhat angular, but the expression of courage and triumphant vigour that pervades the whole body, and the despairing and yet resigned attitude of the vanquished foe, completely atone for that defect. The group of Horemheb and the god Amon in the Turin Museum (fig. 216) is slightly heavy and ill-balanced. The fine colossi in red granite which Horemheb placed

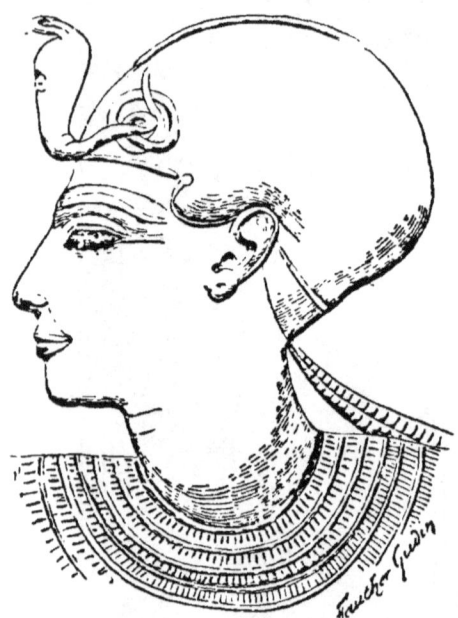

Fig. 215.—Head of Seti I., bas-relief.

* L. Borchhardt, *Mitt. Orient. Gesellschaft*, No. 50, Oct. 1912.

SCULPTURE OF THE NEW KINGDOM.

against the uprights of the inner door of his first pylon at Karnak, the statue of Khonsû which he placed in the sanctuary of the god, and the bas-reliefs on the wall of his speos at Gebel Silsileh, his own portrait and that of one of the ladies of his family now at Cairo, may be said to be faultless. The queen's face (fig. 217) is animated and intelligent; the eyes are large and somewhat prominent, and the mouth, though rather large, is well shaped. The head is carved in hard limestone, the creamy tint of which softens the satirical expression of her glance and smile. Horemheb is in black granite (fig. 218), and the sombre colour is unpleasing and depressing to the spectator. The face, which is a young one, is pervaded by a morbid air, which we find in other royal statues of the period. The nose is straight and delicate, the eyes are long, the lips are large and full,

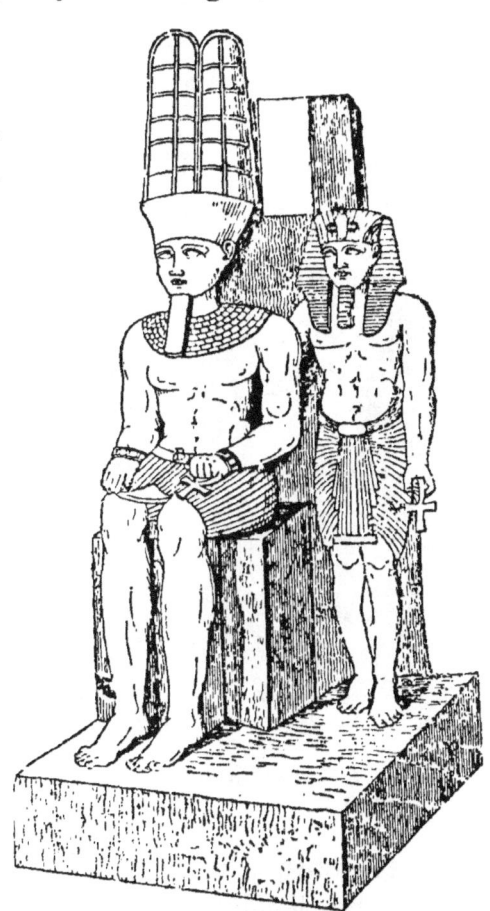

Fig. 216.—The god Amon and Horemheb.

slightly contracted at the corners, and strongly defined at the edges, the chin is barely covered by the false beard. Every detail is treated with as much skill as if the artist had to deal with a soft stone instead of with one that offers such resistance to the chisel. It is annoying that Egyptian artists never signed their work. The man to whom we owe the statue of Horemheb deserves to be remembered.

Fig. 217.—Head of a queen, Eighteenth Dynasty.

Like the Eighteenth Dynasty, the Nineteenth Dynasty erected colossi. Those of Rameses II. at Luxor measured from 25 to 35 feet in height, the colossal Rameses of the Ramesseum was 57 feet high, and that at Tanis about 65 feet. The colossi of Abû Simbel, although not of such gigantic size, present a formidable appearance on the river front.

At the present day it is almost a commonplace to say that the decadence of Egyptian art commenced under Rameses II., but nothing can be more untrue. It must be conceded that many of the statues and bas-reliefs executed during his reign are almost inconceivably rude and ugly, but they are chiefly to be found in provincial towns, where schools did not flourish and the artists had no ancient models to guide them. At Thebes, Memphis, Abydos, Tanis,

in localities in the Delta where the court habitually resided, and even at Abû Simbel and Bêt el Wally the sculptors of Rameses II. were in no way inferior to those of Seti I. and Horemheb. Decadence began after the reign of Merenptah. When civil war and foreign invasion had brought Egypt to the verge of ruin, art also suffered and rapidly declined. It is melancholy to watch the downward progress under the later Ramessides, in the well scenes of the royal tombs, in the reliefs in the temple of Khonsû, or on the columns of the hypostyle hall of Karnak. Carving in wood maintained its level for some time longer. The charming figurines of priests and of children in the Turin Museum date from the Twentieth Dynasty. The advent of Sheshonk and

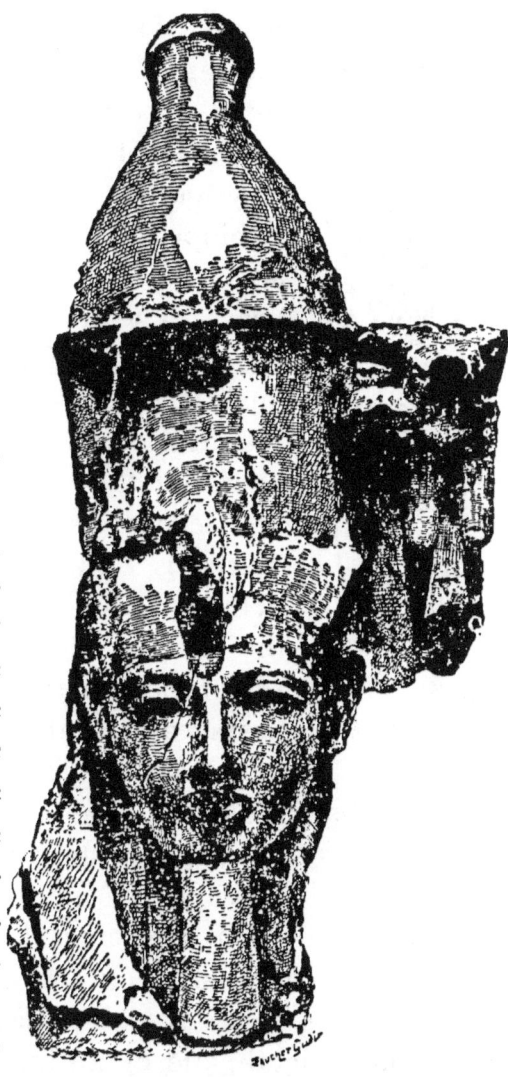

Fig. 218.—Head of Horemheb.

internal dissensions at length completed the ruin of Thebes, and of the school which had produced so many masterpieces. That the school of Tanis still persisted as late as the Twenty-first Dynasty is proved by the fine group of the two Niles now at Cairo, and the school of Tell el Amarna survived still longer. Towards the end of the Ethiopian Dynasty, Theban art revived after an interval of three hundred years. The statue of Queen Ameniritis (fig. 219) manifests some noteworthy qualities. The limbs are slender and rounded, the lines are delicate and pure, but the head, over-weighted with the head-dress usually worn by goddesses, is dull and lifeless. Psammetichus I., when victoriously seated on the throne, devoted himself to the restoration of the temples. Under his auspices the valley of the Nile became one vast studio of painting and sculpture, which owed its inspiration to the artists of the Delta. The carving of hieroglyphs attained remarkable precision, and fine statues and bas-reliefs were produced in large numbers. The Saïte school is characterised by a somewhat stiff elegance, by attention to detail, and by an incomparable facility in the working of stone. The Memphites preferred limestone, the Thebans chose red or grey granite, but the Saïtes by preference worked in basalt, breccia, or serpentine, and with these fine grained and almost

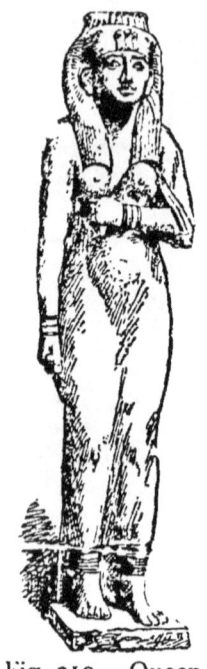

Fig. 219.—Queen Ameniritis.

homogeneous materials they obtained surprising results. They courted difficulty for the pleasure of overcoming it, and one finds distinguished artists spending year after year in chiselling the cover of a sarcophagus or carving statues out of the most stubborn materials. The statue of Taûrt (fig. 220), and the four pieces of the tomb of the scribe Psammetichus of the Thirtieth Dynasty in the Cairo Museum are the most remarkable pieces hitherto discovered of this class of work. Taûrt, the Greek Thûeris, was the goddess who protected pregnant women and presided over childbirth. This figure of the goddess was discovered at Thebes by fellahîn digging for *sebakh*, the nitrous manure that is found round the ruins of ancient buildings. She was standing in a chapel of white limestone dedicated to her by the priest Pabesa in the name of Queen Nitocris. This

Fig. 220.—The goddess Taûrt, Saïte work.

charming hippopotamus carved in green serpentine, with her disproportionate snout, her ample smile, rounded belly, pendant breasts, and shortened paws, is a fine example of difficulties overcome, the only merit I have any wish to ascribe to her. The Psammetichus group on the contrary has real artistic merit as well

as excellence of technique. It consists of four pieces of green basalt, a table of offerings, a statue of Osiris, a statue of Isis, and a Hathor cow against which Psammetichus is leaning (fig. 221). All four are somewhat artificial, but the faces of the divinities and of the deceased man are not wanting in sweetness. The cow is admirable. She is stretching her head over the man to protect him in the same manner as the cow of Deir el Bahari, and the little figure she is supporting groups well with her. Other less known pieces compare well with these. The Saïte style is easily recognised. It does not show the broad scholarly treatment of the first Memphite school, nor the grand

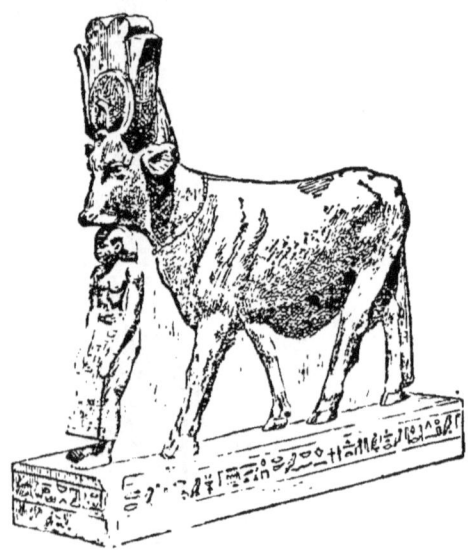

Fig. 221.—Hathor-cow in green basalt, Saïte work.

and sometimes rude manner of the second Theban school, the proportions of the body are more slender, and the limbs lose in vigour what they gain in elegance. A remarkable change in the attitude is also observable. Orientals assume attitudes which to us would be most fatiguing. They spend long hours kneeling or seated cross-legged in tailor fashion, or they squat like frogs with bent knees, only supported by the toes and ball of the foot on the

ground, or again they sit on the ground with their legs drawn up and arms crossed on their knees. The bas-reliefs show that these four attitudes were in use as early as the Old Kingdom, but the two last were not adopted for the early statuary. The early artists probably considered them ungraceful, and scarcely ever used them. The *cross-legged scribe* of the Louvre, and the *kneeling scribe* of Cairo, show how they availed themselves of the two first. The third attitude was neglected by the Theban sculptors, no doubt for the same reason. About the time of the Eighteenth Dynasty we find the fourth attitude coming into general use. It is possible that earlier it was not fashionable among the wealthier classes, who

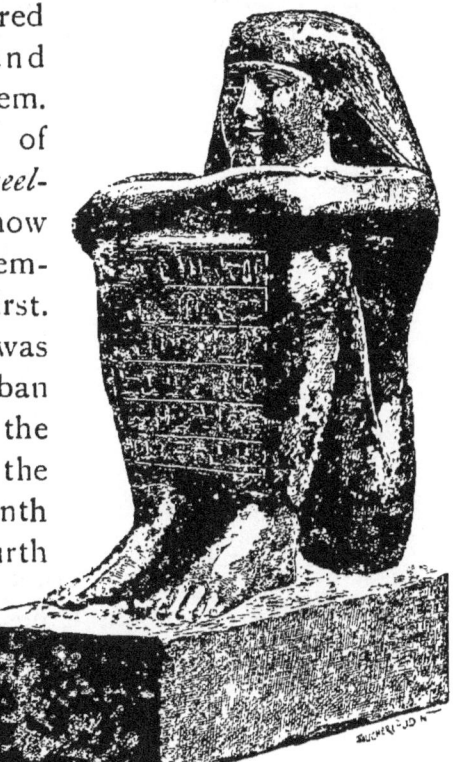

Fig. 222.—Squatting statue of Pedishashi, Saïte work.

alone were able to order statuary, and also it is probable that customers would not choose to appear in the form of a square package surmounted by a human head. The sculptors of the Saïte period had not the same objection as their predecessors to this position, and they contrived to arrange the limbs with some

grace, while they rendered the heads in a fashion that redeemed any defect of posture. That of Pedishashi (fig. 222) has an expression of youthfulness and intelligent kindliness such as we rarely meet with from an Egyptian chisel. Others again are brutal in their sincerity. The wrinkles on the forehead, the crows-feet at the corners of the eyes, the folds of the mouth, and the prominences on the head are marked with scrupulous fidelity on a small head of a scribe at the Louvre (fig. 223), and in another belonging to Prince Ibrahim at Cairo. The Saïte school divided into two parties. One attempted to model itself on the remote past, and endeavoured to revive the enfeebled art of their own times by adopting the methods of the ancient Memphite school. They

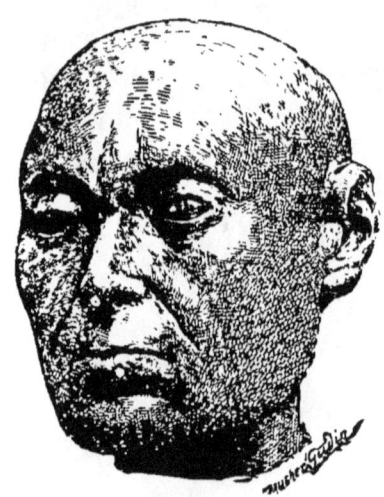

Fig. 223.—Head of a scribe, Saïte work.

succeeded so well that their work has been mistaken for some of the finest productions of the Fourth and Fifth Dynasties. The other fashion, without departing too obviously from tradition, elected to study from life, and approached more closely to nature than had ever been done previously. They might probably have carried the day, had not prolonged contact with the Greeks and the Macedonian conquest turned the art of Egypt into new channels.

The new departure progressed slowly. The

successors of Alexander were portrayed by the sculptors in the guise of Egyptians, and they were transformed into Pharaohs, as had happened in turns to the Hyksos and the Persians. The sculptures that can be assigned to the time of the early Ptolemies can scarcely be distinguished from those of the good Saïte period, and it is only rarely that one can detect imitation of Hellenic models: thus the colossus of Alexander II. at Cairo (fig. 224) has some flowing material as a head-dress, below which is a row of curls. Soon, however, the sight of Greek masterpieces determined the Egyptians of Alexandria, Memphis, and the great cities of the Delta to modify their methods of procedure. A mixed school was established that combined certain elements of the indigenous art with others borrowed from the foreign art. The Alexandrian Isis of the Cairo Museum still wears the attire of the Pharaonic Isis, but she has lost the slender form and stilted, unnatural bearing. There is a mutilated figure of a prince of Siût that might perhaps

Fig. 224.—Colossus of Alexander II.

pass for a poor Roman statue. The statue of a personage named Horus discovered in 1881 not far from the site of the tomb of Alexander is the most powerful example that we possess of this hybrid school (fig. 225). The head is a good piece of work, though perhaps somewhat dry in style. The thin straight nose, the eyes placed close together, the straight mouth pinched in at the corners, and the square chin all conduce to give an expression of harshness and obstinacy to the face. The hair is short, but not so cropped as to prevent its separating naturally into thick wavy locks. The body clothed in the chlamys is clumsy and not in accord with the head. One arm is hanging down, the other is bent and resting on the body, the feet are gone. All this statuary is the result of recent finds, and there is no doubt that systematic excavations at Alexandria would produce much more. The school that produced them gradually

Fig. 225. —Statue of Horus. Græco-Egyptian.

approached more and more nearly to the style of the Greek schools, and the stiffness, from which it never entirely freed itself, would scarcely be regarded as a defect at a time when certain sculptors employed in Rome prided themselves on their archaisms. I should not be surprised if the statues of priests and priestesses with which Hadrian decorated the Egyptian part of his villa on the Tiber might be attributed to this Alexandrian hybrid school.

The native schools outside the Delta, left to their own resources, gradually perished. And yet they were not without models, or even Greek artists. In the Thebaid, in the Fayûm, and at Assûan, I have bought or discovered statues and statuettes which are Hellenic in style and of correct and careful workmanship. One of them, bought at Koptos, appears to be a small replica of a Venus analogous to the Venus of Milo. But the provincial artists, from lack of knowledge and intelligence, failed to take advantage of the new ideas as the Alexandrians had done. When they endeavoured to give to their models the suppleness and plenitude of the Greek figures they only succeeded in losing the somewhat dry but masterly precision acquired by their predecessors. In place of the fine, delicate low relief, they adopted a relief deeply cut, but feebly rounded and modelled and wanting in vigour. The eyes smile foolishly, the slope of the nostril is exaggerated, the corners of the lips, the chin, and all parts of the face are contracted and seem to converge towards a central point placed in the ear. We have the work

of two schools each independent of the other. The least known flourished in Ethiopia at the court of the semi-barbarous kings who reigned at Meroë. A group sent from Naga in 1882 shows us to what this art had attained in the first century of our era (fig. 226). A divinity and a queen standing side by side are roughly carved out of a block of grey granite. The work is coarse and heavy, but it is not without energy and truth. The school that produced it, isolated among an uncivilised people, soon fell into barbarism and probably came to an end shortly after the age of the Antonines. Egyptian art survived somewhat longer under the ægis of the Roman domination. The Cæsars, no less astute than the Ptolemies, realised that they strengthened their dominion over the Nile valley by humouring the religious feelings of their Egyptian subjects. At enormous cost they caused the temples of the national gods to be rebuilt or restored according to the plans and ideas of the past. Thebes had been destroyed by a earthquake in the year 22 B.C. and it was now no more than a place of pilgrimage where devotees came at daybreak to listen to the voice of Memnon, but at Denderah and Ombos the decoration of the

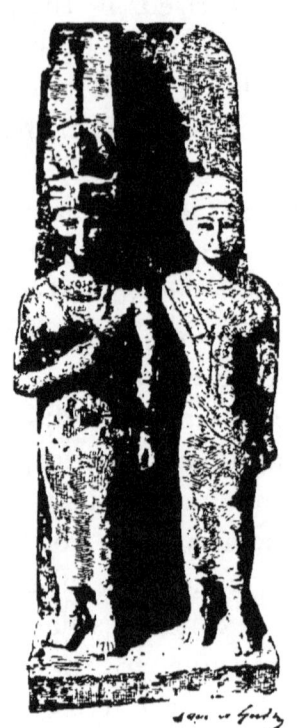

Fig. 226.—Group from Naga.

temples was completed by Tiberius and Claudius, Caligula worked at Koptos, and the Antonines at Philæ and Esnah. The workmen employed had sufficient knowledge to execute thousands of bas-reliefs according to the ancient rules. The work done by them is feeble, ungraceful, and absurd, inspired merely by routine, but nevertheless it is founded on ancient tradition, enfeebled and degenerate, but still living and capable of being invigorated with new life. The changes that occurred in the middle of the third century, the incursions of the barbarians, and the progress and triumph of Christianity led to the abandonment of the work and the dispersion of the workmen. With them died all that yet survived of the national art.

CHAPTER V.

THE INDUSTRIAL ARTS.

WE have briefly surveyed the fine arts; it now remains to turn our attention to the industrial arts.

Fig. 227.—Slate palettes, predynastic and First Dynasty. Ashmolean Museum, Oxford.

Love of luxury and of beauty very early invaded all classes of society. Living or dead, the Egyptian liked to load himself with jewellery and costly amulets, and to surround himself with elaborate furniture and

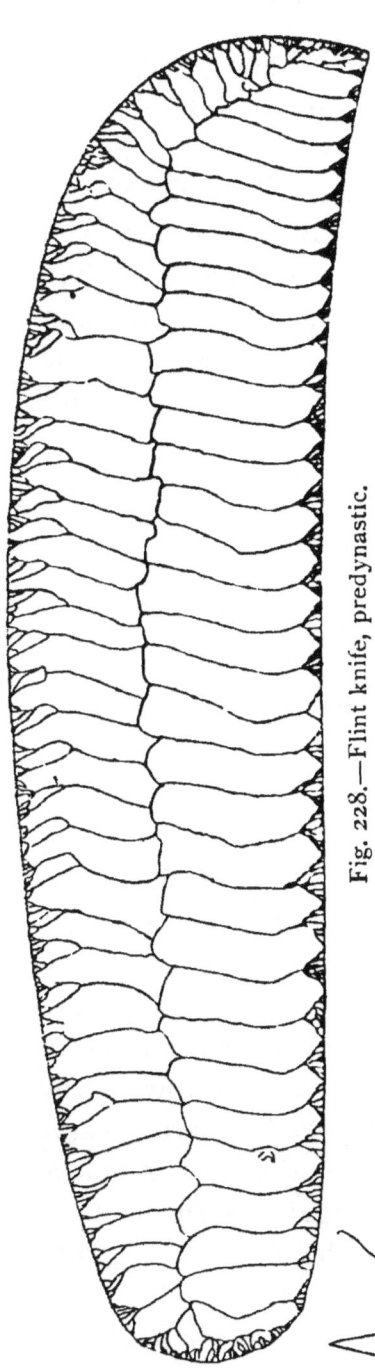

Fig. 228.—Flint knife, predynastic.

artistic household utensils. He desired that every object used by him should contribute to satisfy this taste by beauty of form, if not by richness of material; and pottery, stone, metal, and wood were all laid under contribution by him. whether they were the products of the country, or obtained from distant lands.

The Egyptian of the predynastic and earliest dynastic periods was laid in his grave surrounded by pottery jars filled with food, or with scented fat, while close to his hand was his slate palette (fig. 227) of many varied forms on which was rubbed the paint with which he coloured his eyes. Beads of agate, carnelian, brown and white quartz, steatite, calaite, and of glazed pottery, are found in abundance in the prehistoric graves, while beads of glazed stone, of turquoise,

amethyst, lapis lazuli, serpentine, hæmatite, obsidian, porphyry, silver, gold, and iron are found in somewhat later graves. The Egyptian of that period excelled in flint working, which he brought to the highest perfection (fig. 228). Knives with recurved tips were finished with unequalled dexterity. They were first ground to an even surface, and then flaked in two rows of perfect regularity, and the cutting edge finely serrated. Hoe blades and teeth

Fig. 229.—Flint teeth for sickles.

for sickles (fig. 229) were also made of flint, and tanged arrow-heads and spear-heads of the finest workmanship were manufactured. Copper was early introduced into Egypt and largely superseded the use of flint knives, the working of which deteriorated early in the dynastic period. The funerary outfit of the predynastic Egyptian included jewellery, ivory carvings, stone vases, and also a variety of amulets, some of which we meet with again in the historic period, such as the bull's head, the fly, the frog, and the serpent.

I.—STONE, POTTERY, AND GLASS.

It is impossible to visit a collection of Egyptian antiquities without being struck by the prodigious number of small objects in fine stone that have survived to the present day. At present we have found no diamonds, rubies, or sapphires, but with these exceptions the domain of the lapidary was almost as extended as at the present day; it comprised amethyst, emerald, garnet, aquamarine, rock-crystal, chrysoprase, the many varieties of onyx and agate, jasper, lapis lazuli, felspar, obsidian, granite, serpentine, and porphyry; fossiliferous substances such as amber and some kinds of turquoise; animal secretions such as coral, pearls, and mother-of-pearl; metallic oxides such as hæmatite, oriental turquoise, and malachite. Most of these substances were used for making beads of various shapes, round, square, oval, pear-shaped, lozenge-shaped, or of an elongated spindle form. Threaded and arranged in rows these beads were made into necklaces and they are found in myriads in the sand of the great cemeteries. The perfection with which they are cut and polished, and the precision with which they are drilled, do honour to those who made them. But the craftsmen accomplished more than this. With the saw, drill, point, and grindstone they worked the stones into a variety of different shapes, hearts, fingers, human limbs, cartouches, serpents, animals, and figures of divinities. All of these were amulets or charms, and they were probably valued less for the beauty of the work than for the supernatural virtues attributed to them by the

national religion. The girdle tie in red carnelian was the blood of Isis and washed away the sins of its possessor (fig. 230); the frog represented the goddess Hekt, guardian of mothers and newborn infants, and was emblematic of renewed birth (fig. 231); the little lotus-flower column in green felspar (fig. 232) typified the gift of eternal youth; the *uzat*, the mystic eye (fig. 233), when tied by a cord round the throat or the arm, was a protection against ghosts, snake bites, and against envious or angry words. These amulets were distributed throughout the ancient world, and many of them, especially those that represented the sacred beetle, were copied outside Egypt by the Phœnicians and Syrians, and in Greece, Asia Minor, Etruria, and Sardinia.

Fig. 230.— The girdle tie of Isis.

Fig. 231.—Frog amulet.

This insect was called *kheper* and it is supposed that its name was derived from the root *khepra*, "to become." By an obvious play on the words the beetle was made the emblem of terrestrial existence, and the successive developments of a man during his career in the world beyond. The amulet in the form of a scarab (fig. 234) is therefore a symbol of present or future duration, and to carry it was to obtain security against annihilation. These scarabs were made in all materials and of various sizes; some with the head of a sparrow-hawk, a ram, a man, or a bull. Some are as carefully carved on the underside as on the back, others are plain below, and there

Fig. 232.— Lotus column amulet.

are others that have almost lost the form of the beetle, and are called scaraboids. They are pierced lengthways with a hole through which a thin slip of wood was passed or a gold or silver wire by which they were suspended. The largest were regarded as taking the place of the heart. They were laid on the breasts of mummies, with wings outstretched; a prayer engraved on the flat side adjured the heart not to bear witness against its owner in the day of judgment. Various scenes of adoration were occasionally added to the formula. On the wing cases two seated Amons, on the shoulder the moon saluted by two cynocephali, and on the flat side the solar bark with a group below of the mummied Osiris between Isis and Nephthys, who are protecting him with outstretched wings. The small scarabs at first used as prophylactics finally became nothing more than ornaments, with no religious value. They were used as seals, as pendants or earrings, the bezel of a ring, or threaded to form a bracelet. The flat side is usually carved with various designs cut in the material without modelling of any kind; relief, properly so called, as employed in the cameo, was unknown among Egyptian lapidaries before the Greek period. The subjects have not yet been classified, nor has a complete collection been made. They include simple combinations of lines, spirals, and interlaced curves, without any special meaning; symbols to which the proprietor

Fig. 233.—Sacred eye or *uzat*.

Fig. 234.—Scarab.

attached some mysterious signification known only to himself; the names, parentage, and titles of some individual; royal cartouches of historical interest; good wishes, pious ejaculations, and magical formulæ. There are many scarabs in crystal and obsidian that date back as far as the Sixth Dynasty; others, roughly cut and uninscribed, in amethyst, emerald, and even in garnet, belong to the commencement of the first Theban empire. From the time of the Eighteenth Dynasty they can be counted by thousands, and the fineness and finish of the work vary according to the hardness of the stone.

This is the case with all the varieties of amulets. The hippopotamus heads, the *souls* or *Ba* birds, and the hearts that are picked up in numbers at Taûd, to the south of Thebes, are scarcely more than outlined, the amethyst and felspar of which they are made having proved almost impossible to work with the point. On the contrary, the girdle ties, squares, and head-rests that are carved out of red jasper, carnelian, and hæmatite are finished down to the smallest detail. Lapis lazuli is soft and friable, liable to break away at the edges, and it might be supposed that it would not lend itself to any minute work. Nevertheless, the Egyptians chiselled figures of goddesses out of it—Isis, Nephthys, Neith, Sekhet—which are marvellous examples of delicate carving. The modelling of the body is as boldly cut as if it were carved out of some material of no more than ordinary difficulty, and the features will bear examination with a magnifying-glass. Generally, however, a different method was adopted. The figure was subjected to a

breadth of treatment that sacrificed the details to the general effect. The projections and hollows of the face are accentuated, and the thickness of the neck, the curve of throat and shoulder, the slenderness of the waist, the hollows and roundness of the body, are exaggerated; the thigh and tibia are defined by a line that is almost sharp, the feet and hands are slightly enlarged. All this is the result of bold and judicious calculation. An exact mathematical reproduction of a model is, when applied to sculpture in miniature, not as happy as might be supposed. The head loses its character, the neck appears too slight, the bust is no more than a cylinder with irregular bumps on it, the feet and legs do not appear sufficiently solid to support the weight of the body, while the principal lines are lost in the complexity of the secondary ones.

By suppressing most of the accessory features and accentuating the important ones, the Egyptians escaped the danger of producing insignificant or meaningless work : the eye instinctively modifies any exaggeration, and supplies what is lacking. Owing to this skilful treatment, a minute figure of a divinity, barely $1\frac{1}{2}$ inches high, has almost the breadth and dignity of a colossus.

As early as the close of the predynastic period stone vases were worked in the hardest materials, such as breccia, syenite, quartz, crystal, and diorite, and great alabaster bowls were so finely worked as to be translucent. Stone vases intended for suspension were provided with handles carved out at the sides and pierced (fig. 235). Some of the finest of these

stone vessels belong to the later prehistoric and early dynastic times; they are found also in porphyry, slate, alabaster, diorite, basalt, and other fine stones in the temples of the Fourth and Fifth Dynasties, and the use of them in the softer materials of alabaster and serpentine continued into the Middle Kingdom. Revolving seal cylinders of steatite, gold, and ivory have been found at Thinis, and abundant examples of their use occur on the sealings of jars in the royal tombs at Abydos (fig. 236). They closely resemble

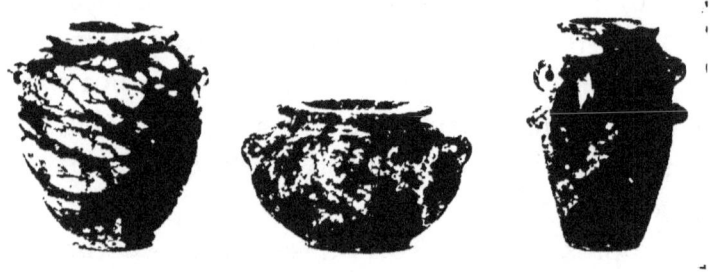

Fig. 235.—Stone vases, predynastic and First Dynasty. Ashmolean Museum, Oxford.

the cylinder seals of Babylonia. By the time of the Middle Kingdom they were superseded by scarabs, which were employed almost universally as seals during the later dynasties. Of stone were also the small funerary obelisks which come from the tombs of Saqqara, the bases of altars, the stelæ, and the tables of offerings. At the time of the Pyramids the favourite material for the tables of offering was alabaster or limestone, under the Theban kings, granite or red sandstone, and from the time of the Twenty-sixth Dynasty, basalt or limestone; but this

was not obligatory, and we find them at all periods in all kinds of stone.

Some of them were merely flat or slightly hollowed discs, others were rectangular, and carved on the upper face with loaves, vases, haunches of oxen and gazelle, birds, vegetables, and fruit. On the offering table of Sitû the libation, instead of being allowed to run off, was collected in a square basin divided into stages marking the height of the Nile in the Memphis

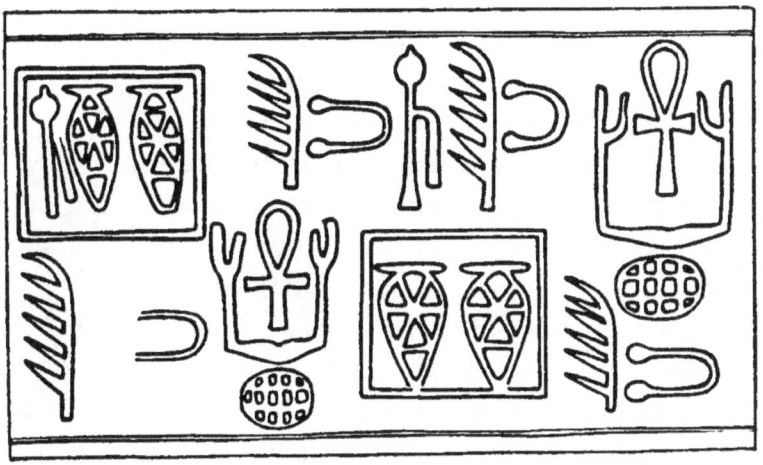

Fig. 236.—Impression of cylinder-seal, First Dynasty.

reservoirs at the different seasons—25 cubits in summer during the inundation, 23 in autumn and at the beginning of winter, 22 at the end of winter and in the spring. These unusual forms do not as a rule contribute to beauty, but one of the tables of offerings from Saqqara is a real masterpiece; it is in alabaster. Two lions standing side by side support a rectangular, slightly sloping table with a groove that carried off the libations into a vase placed between the tails of the animals.

The alabaster geese of Lisht are not without merit. They are cut in two lengthways, and are hollowed like a box. But as a rule the tables of offerings in painted limestone are poor in taste and workmanship, and so are the figures of offerings, the loaves, cakes, heads of oxen and gazelle, and the bunches of black grapes.

Fig. 237.—Perfume vase, alabaster.

They are not very numerous, and come chiefly from tombs of the Fifth and Twelfth Dynasties. The canopic jars, on the contrary, were always carved with great care. They are generally either of limestone or alabaster, but the heads that form the covers are often of painted wood. The canopic jars of Pepi I. are in alabaster, and so are those of the king who was buried in the southern pyramid of Lisht, as well as the human heads upon the lids. The carving of one of them is so finely executed that it can only be compared with that of the statue of Khafra.

Fig. 238.—Perfume vase, alabaster.

The earliest funerary statuettes yet found, those of the Eleventh Dynasty, are of alabaster, but from the time of the Thirteenth Dynasty they were also carved in limestone. The quality of the work is very unequal. Some of them are masterpieces, and are as faithful portraits of the deceased as any statue of ordinary proportions. Vases for perfume formed part of the outfit provided for temples and tombs. The nomenclature of these is very far from being fixed,

Fig. 239.—Perfume vase, alabaster.

and at present we can identify very few of the vases with the special names given them in the texts. The larger number are of alabaster, turned and polished. Some are heavy and ugly (fig. 237), while others possess an elegance and diversity of form that do credit to the inventive genius of the men who made them. They are spindle-shaped (fig. 238), or round, with a flat base and straight rim (fig. 239); they have no ornament, unless occasionally handles formed of two lotus buds, two lions' heads, or possibly a small female head projecting at the lower part of the neck (fig. 240). The smallest of these did not contain liquids, but pomades, medical unguents, or salves made with honey.

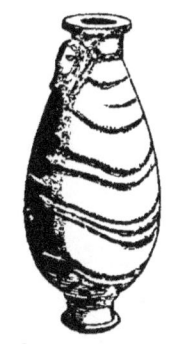

Fig. 240. — Perfume vase, alabaster.

One of the most usual type is a small round jar with a short cylindrical neck and flat rim (fig. 241). In these the Egyptians kept powdered charcoal or antimony, with which they blackened their eyes and eyebrows. This kohl-jar was perhaps the only article for the toilette that was in common use among all classes of society. Some of them were very fantastic in form, and we find many of them in the shape of men, plants, or animals. Among others, there are a full-blown lotus blossom, a sparrow-hawk, a hedgehog, a monkey

Fig. 241.—Kohl-jar.

clasping a column against his breast or climbing up a jar, a grotesque figure of the god Bes, a kneeling woman whose body contained the powder, or a young girl, nude, holding a wine-jar. The ingenuity of the

craftsmen when once exercised in this direction was unbounded, and they adapted everything to their purpose—granite, diorite, breccia, pink jade, alabaster,

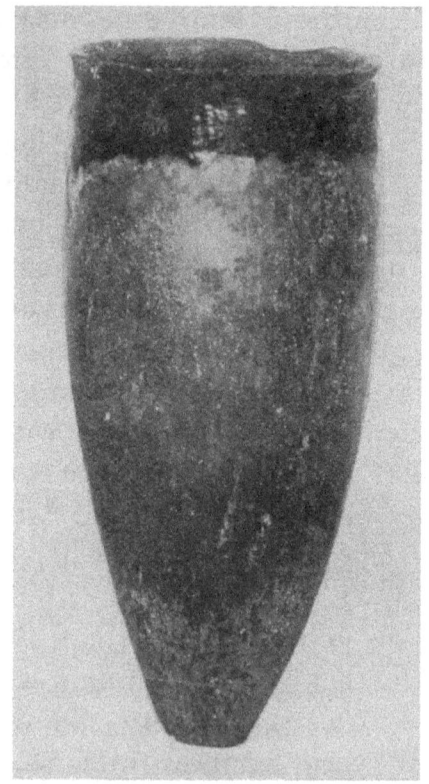

Fig. 242.—Black-topped pottery.

a soft limestone adapted for fine work, and a material even more easily worked, namely, pottery painted and glazed.

Although the art of modelling, decorating, and firing pottery was never carried to such perfection

in Egypt as it was in Greece, it was not for the want of the crude material. The valley of the Nile supplies a variety of fine ductile clays from which great results might have been obtained had it been carefully prepared, but in many cases the clay was

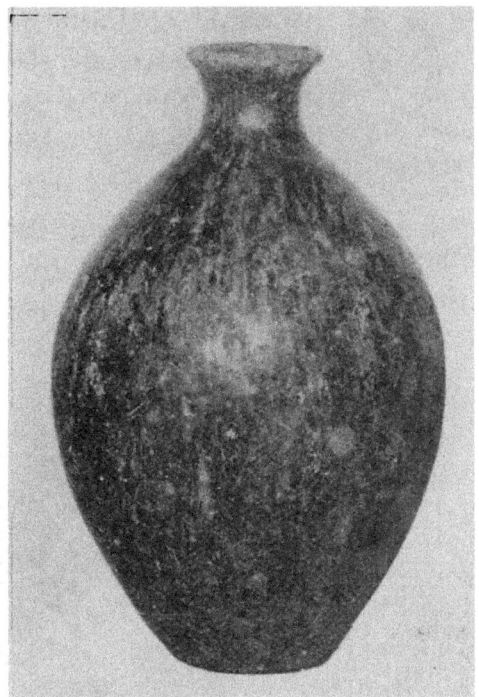

Fig. 243.—Red burnished pottery.

taken without selection from any place where the potter happened to be at the moment. Badly washed, badly kneaded, it was then fashioned with the hand or a primitive hand-worked wheel. The firing was very uncertain, some pieces were scarcely burnt at all and fall to pieces while in water, while others are as hard as a tile.

288 THE INDUSTRIAL ARTS.

Pottery is found in abundance in the graves of the predynastic period. There are rough, heavy jars of coarse red pottery weighing sometimes twenty or thirty pounds, each of which contained food offerings. Of the finer varieties there are several. A finely polished red pottery was shaped by hand before the invention of the potter's wheel. Washed with hæmatite and carefully burnished, a brilliant black was obtained on the upper part during the firing. Placed upside down in the kiln, the rim was covered by the charcoal, and the iron in the clay became deoxidised from red peroxide to black magnetic oxide, with a sub-crystalline surface (fig. 242). There is also a red burnished pottery (fig. 243) sometimes made in a variety of shapes in the form of fish (fig. 244) or birds, and red pottery painted with cross lines in white slip in imitation of basket-work (fig. 245), or with floral and other designs.

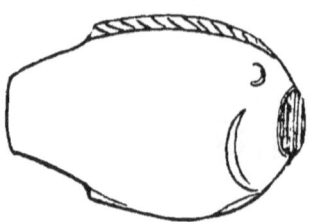

Fig. 244.—Pottery fish, predynastic.

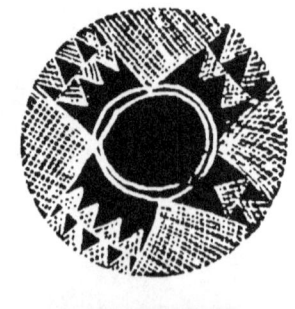

Fig. 245.—Red pottery with basket-work designs, predynastic.

The class of drab-coloured pottery painted with designs and figures in dull red is of peculiar interest as presenting us in a few instances with pictorial records of that remote time. Beside cordage designs, chequers, marbling in imitation

of stone vases (fig. 246), and spirals, many oared galleys with cabins, ensigns, and other details are rudely represented, and also figures of men, animals, and birds (fig. 247).

The black incised pottery found in many parts of the Mediterranean basin was also known in Egypt. Deep bowls made of a soft fat clay lightly baked, pricked with basketwork patterns and the punctures filled in with white clay (fig. 248), are found in predynastic graves, and again in various localities, and at later periods, at Medûm of the Third Dynasty, and at Kahûn of the Twelfth Dynasty.

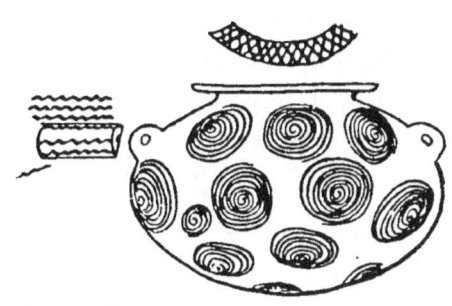

Fig. 246.—Vase painted to imitate mottled stone.

All tombs of the Old Kingdom contain pottery of a red or yellow ware, often mixed, like the bricks, with finely chopped straw or weeds. It consists mostly of large solid jars with oval bodies, short necks, and wide mouths without foot or handle. With them are found pipkins and pots in which to store the dead man's provisions, bowls of various depths, and flat plates. The surface is seldom

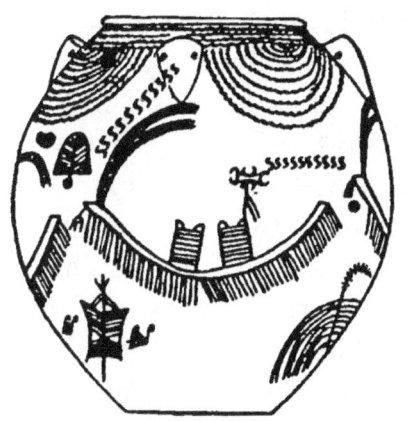

Fig. 247.—Decorated vase, predynastic.

19

smooth or glazed. It is generally washed over with a coating of white paint which flakes off at the slightest touch.

The town of Kahûn supplied domestic pottery of the Middle Kingdom. Ring-stands for water-jars, flower-vases with three separate openings or spouts to support and divide the flowers, and cylindrical vessels with a small hole at the base are among the most remarkable. Heavy dishes with deeply incised patterns are also found.

The Theban tombs of the great period of conquest have provided us with sufficient pottery to fill many museums, but unfortunately it is of little interest. There are the small funerary or *ûshabti* figures shaped by hand out of a lump of clay. A bit of the pottery pinched with the fingers formed the nose, while two dots and two short strips added after the firing supply eyes and arms. The better ones were shaped in terra-cotta moulds, many of which have been found. They were generally moulded in one piece, then carefully reworked, burnt, painted red, yellow, and white, and finally the hieroglyphs were added either with the point or the brush. Many of them are excellent in style and almost equal to those carved in limestone. The *ûshabti* figures of the scribe Hori, preserved in the Cairo Museum, are about 16 inches high, and they show what the

Fig. 248. Black incised pottery, predynastic.

Egyptians could have accomplished had they chosen to cultivate this branch of art.

The funerary cones were purely devotional objects which no skill could have succeeded in rendering beautiful. They are merely conical lumps of clay drawn out to a point at one end, and stamped at the broader end with a seal bearing the names, titles, and parentage of its possessor, the whole covered with a wash of whitish colour. They were, perhaps, intended to represent offerings of bread to secure an endless supply of food for the deceased.

Fig. 249.—Lenticular ampulla of Mykenæan type, Eighteenth Dynasty.

Many of the jars deposited in the tombs are painted in imitation of alabaster, granite, basalt, bronze, and even gold, and were probably cheap substitutes for the valuable vases lavished by the rich on their dead. Of the latter part of the Eighteenth Dynasty pottery is found of distinctly Mykenæan type, such as the lenticular ampullæ (fig. 249) and the false-necked vases (fig. 250). Among the vases intended to hold flowers and Nile water, some are covered with designs outlined in red

Fig. 250.—False-necked vase of Mykenæan type, Eighteenth Dynasty.

and black (fig. 251) circles and concentric lines (fig. 252), wavy lines, religious emblems (fig. 253), cross lines resembling fine meshed netting, garlands

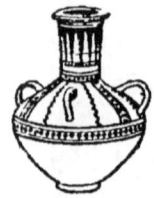

Fig. 251.

of flowers or of buds, or leafy stems carried down from the neck to the body of the vase, or rising from the body to the neck. The vases from the tomb of Sennetmû have a large collar on one side similar to the necklaces placed on mummies, painted with the brightest colours in imitation of natural flowers or of enamel. The canopic jars in pottery, rare during the Eighteenth Dynasty, became increasingly numerous as the wealth of Thebes diminished. The heads, more especially the human heads with which they are covered, are generally well carved. Modelled by hand, hollowed to lessen their weight, and then slowly baked, each was painted with the special colours peculiar to the genius whose head was represented by it. Towards the Twentieth Dynasty the custom was established of

Fig. 252.

Fig. 253.

depositing the bodies of sacred animals in these canopic vases. Those found near Ekhmîm contain jackals and hawks; those at Saqqara contain mummied snakes, rats, and eggs; while those at Abydos enclose the ibis. These last are by far the finest. The body of the vase is surrounded by the outstretched wings of the protecting goddess Khûit, while Horus and Thoth present the bandage and jar of unguents; the whole is painted blue and red on a white ground. Early in the

Greek period, when the poverty of the country had increased, pottery was used not only for canopic jars, but also for coffins. In the Isthmus of Suez, at Ahnas el Medineh, in the Fayûm at Assûan, and in Nubia there are entire cemeteries where one finds no other coffins than those made of pottery. Many resemble oblong boxes, rounded at both ends, and with a saddle-back cover. Some are of human form, but barbarous in style, the head surrounded by a sort of sausage that represents the ancient headdress, the features scooped out with the thumb, or perhaps some tool, while two small lumps placed haphazard on the breast indicate the corpse of a woman. But even in these closing years of Egyptian civilisation it is only the very roughest specimens that are left in their natural colours. Now, as formerly, they are almost invariably covered with paint, or with richly coloured glazes.

Glass was known to the Egyptians from the earliest period. Chemical analysis shows that the composition was almost identical with our own, but in addition to silica, lime, alumina, and soda, it contains a relatively considerable proportion of foreign substances, copper, oxide of iron, and oxide of manganese, which the Egyptians did not succeed in eliminating. Thus the glass is very rarely colourless. It possesses an indefinite tint that approximates to green or yellow. Some pieces of poor manufacture have completely rotted, and fall into fragments or into iridescent powder at the slightest touch. Others have not suffered so much from the action of time, but they are streaked and full of

bubbles. Others again, very few in number, are perfectly clear and homogeneous.

Uncoloured glass was not in favour as it is with us. Until the Roman period, whether opaque or transparent, glass was almost invariably coloured. This was effected by mixing metallic oxides with the ordinary ingredients—copper or cobalt for the blue, copperas for the greens, manganese for the violets and browns, iron for the yellows, lead or tin for white : one variety of red contains at least 30 per cent. of copper, and when exposed to damp becomes coated with verdigris. All this chemistry was empirical and purely instinctive. The workmen collected around them the necessary materials or received them from afar, and they then proceeded to use them, often without definite knowledge of the effect they were about to produce : many of their most harmonious combinations were the result of chance, and they could not reproduce them at will. In this way they sometimes produced very large pieces : classical authors speak of glass sarcophagi stelæ and columns made in one piece, but glass generally was only used for small objects, and more especially in imitation of precious stones.

Cheaply as these could be bought in the Egyptian markets, they were not accessible to all, and the glassblowers imitated emerald, jasper, lapis lazuli, and carnelian with such precision that we are often puzzled at the present day to distinguish the real from the false. The glass was run into stone moulds of the desired size and shape, beads, discs, rings, pendants for necklaces, narrow rods, and plaques

bearing figures of men or animals, gods and goddesses. Eyes and eyebrows for stone or bronze statues were made of glass, and so were bracelets for their wrists. Glass was used as an inlay for hieroglyphs, and entire figures, scenes, and inscriptions in glass were inlaid in wood, stone, or metal. The mummy-cases of Netemt are decorated this way, and so are the coffins of Iûiya and Tûiyû, the grandparents of Akhenaten.* They are entirely covered with gold leaf with the exception of the headdress and some details; the inscriptions and the principal part of the decoration are formed of these brilliantly coloured enamels, which contrast well with the gold background. The mummies of the Fayûm were covered with plaster or stucco on which the scenes and texts, which elsewhere were merely painted, were inlaid by means of adjusting the pieces of glass and then reworking them with the chisel, after the fashion of a bas-relief. Thus in the case of the goddess Maat the face, hands, and the feet are in turquoise blue, the headdress in very dark blue, the feather in alternate strips of blue and yellow, the robe is dark red. On the wooden naos from the neighbourhood of Daphnæ, and on a fragment of a coffin in the Turin Museum, the hieroglyphs of multi-coloured glass stand out directly on the dark wooden background, and the result of this arrangement is extraordinarily rich and brilliant.

Glass filigree, cut and engraved glass, soldered glass, and imitation of wood, straw, or cord, in glass

* T. M. Davis, *The Tomb of Iouiya and Touiyou.*

were all known to the Egyptians. At Cairo there is a square rod made of a number of strips of glass of varied colours fused together and forming the cartouche of one of the Amenemhats. The strips run through the whole length of the rod; wherever it may be cut, the section will show the same cartouche. Small glass objects are so numerous as to fill an entire case in the Cairo Museum. One represents a monkey on all fours smelling some large fruit lying on the ground, another is a portrait of a woman, full face, on a white or pale green background framed in red. Most of the plaques merely represent rosettes, stars, and flowers, either single or in a bouquet. One of the smallest represents an Apis bull, black and white, walking; the work is so delicate that it can well bear examination with a microscope. Most of these objects are not anterior to the first Saïte dynasty; but excavations at Thebes and at Tell el Amarna have proved that as early as the eighteenth century B.C. the taste for coloured glass had arisen, and in consequence it was commonly manufactured in Egypt. At Deir el Baharî, in the Valley of the Kings, at Gûrnet Murraî and at Sheikh abd el Gûrneh not only have amulets been found intended for the use of the dead, such as columns, hearts, mystic eyes, hippopotami standing on their hind legs, and pairs of ducks, in pottery of mixed colours, blue, red and yellow, but also vases of a type one has been accustomed to consider as Phœnician or Cypriote workmanship.

Here, for instance, is a small œnochoe of semi-opaque light blue glass (fig. 254) inscribed with the

name of Thothmes III., the ovals on the neck and the palms on the body of the vase traced in yellow. Here again is a lenticular ampulla 3¼ inches in height (fig. 255) in dark blue glass of admirable purity and intensity; over this is a bold, delicate pattern of fern-leaves in yellow. Two small handles of transparent light green are attached to the neck, and the rim is surrounded by a yellow fillet. An amphora of the same height is dark olive-green and semi-transparent (fig. 256); a band of blue and yellow chevrons confined within four yellow lines surrounds the body of the vase at the widest part. In the vault of Deir el Baharî by the side of the Princess Nesikhonsû there were goblets of similar workmanship; seven were of plain glass, light green, yellow, or blue, four in black spotted with white, and one was covered with a pattern of multi-coloured fern-leaves arranged in two rows (fig. 257). Thus the manufacture of glass was in full activity as early as the time of the great Theban dynasties. Heaps of scoriæ mixed with slag mark the site of their furnaces at Medinet Habû, Tell el Amarna, at the Ramesseum, at El Kab, and at the Tell of Eshmûneyn.

Fig. 254.—Parti-coloured glass vase, bearing names of Thothmes III.

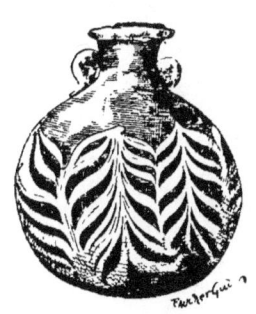

Fig. 255.—Parti-coloured lenticular glass vase.

From predynastic times the Egyptians enamelled stone. At least half of the scarabs, cylinders, and

amulets we admire in our museums are in limestone or schist covered with a coloured glaze. Ordinary clay, no doubt, did not appear to them suitable for

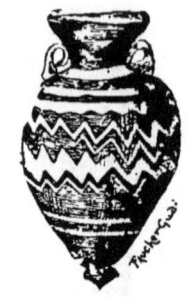

Fig. 256.—Parti-coloured glass vase.

this method of decoration. They replaced it by various kinds of frit, some white and sandy: another sort was brown and fine and was obtained by pulverising a special sort of limestone that abounds in the neighbourhood of Keneh, Luxor, and Assûan. A third sort was reddish and mixed with powdered sandstone and powdered brick. These various substances are known as Egyptian porcelain or Egyptian faïence, both terms being equally inaccurate. The earliest specimens of the so-called faïence were covered with

Fig. 257.—Parti-coloured glass goblets of Nesikhonsû.

an exceedingly thin coat of glaze except in the hollows of the hieroglyphs and figures where the vitreous substance accumulated and the brilliant colour stands out in vivid contrast to the somewhat

ENAMELLED STONE AND GLAZED WARE. 299

dull tone of the surrounding surface. Under the early dynasties, green was by far the most usual colour; but white, red, yellow, brown, violet, and blue were also used, and as early as the time of Menes glazing in two colours was understood. Blue predominated in the Theban manufactories from the early years of the Middle Kingdom. It is a soft brilliant blue much like that of lapis lazuli or turquoise. The Cairo Museum formerly possessed three hippopotami in this colour discovered at Drah abû'l Neggeh in the tomb of an Antef. One of these was lying down, the others standing in the marshes; on their bodies the potter has drawn in black ink sketches of reeds and lotus among which birds and butterflies are flying (fig. 258). It was his method of representing the animal among his natural surroundings.

Fig. 258.—Hippopotamus in blue glaze.

The blue is deep and brilliant in tone, and we must take a flight over twenty centuries to find its equal among the funerary statuettes from Deir el Baharî. The green reappears under the Saïte dynasties, but paler than it was in the earlier period. It predominated in Lower Egypt, at Memphis, Bubastis, and Saïs, but without entirely eliminating the blue. The other colours were only in common use during four or five centuries, from the time of Aahmes I. to the time of the Ramessides. It is

then, and then only, that the so-called *Respondants*, or ûshabti figures, in white or red glaze, rosettes and lotus flowers in yellow, red, and violet, and kohl-boxes in a mixture of colours abounded. The potters of the time of Amenhotep III. had a decided preference for shades of violet and grey. The olive-shaped amulets stamped with the names of this Pharaoh and the princesses of his family bear hieroglyphs of pale blue on a very delicate mauve background. The vase of Queen Tyi in the Cairo Museum is grey with a mixture of blue; round the neck there are bands of ornamentation and inscriptions in two colours.

Fig. 259.—Glazed ware, from Thebes.

These polychrome glazes attained their highest development under Akhenaten; at least, it is in the plain of Tell el Amarna that the finest and best specimens have been found—green, yellow, or violet rings, white or blue flowers, fish, lutes, figs, and bunches of grapes. There is a small figure of Horus with a red face and a blue body, and the bezil of a ring with the name of the king in violet on a light blue ground.

Fig. 260.—Glazed ware, from Thebes.

However small the space, the colours have been laid on with so sure a hand that they are never confused, but contrast vividly with each other. A vase for powdered antimony, chased and mounted on a pierced stand, is of a uniform reddish brown

(fig. 259); another, in the form of a mitred hawk, is blue with black spots, it belonged formerly to Aahmes I.; a third, carved in the form of a cheery little hedgehog, is of a variable green (fig. 260). The head of a Pharaoh in dead blue wears a striped linen headdress of dark blue. But, fine as these pieces are, the finest of the whole series is the statuette, now at Cairo, of Ptahmes, chief prophet of Amon. The hieroglyphs and the details of the mummy wrappings have been carved in relief on a white background of admirable uniformity, filled in with enamels; the face and hands are of turquoise blue, the headdress is yellow with violet stripes, the hieroglyphs and the vulture that spreads its wings over the breast are also violet. The whole figure is harmonious, delicate, and brilliant; no flaw mars the purity of the contour nor the sharpness of the lines. Glazed pottery was common at all times. The cups with a foot (fig. 261), the blue bowls decorated with mystic eyes lotus flowers fish (fig. 262), and palms, drawn in black ink, are usually of the Eighteenth, Nineteenth, and Twentieth Dynasties. The lenticular ampullæ, covered with a greenish glaze, and decorated with rows of beads or ovals on the neck, an elaborate necklace on the shoulders, and supplied by way of handles with two crouching monkeys, belong

Fig. 261.

Fig. 262.—Decoration of interior of small bowl, Eighteenth Dynasty.

almost, if not entirely, to the reigns of Apries (the Hophra of the Old Testament) and of Aahmes II. (fig. 263).

The Egyptians loved this ware, which was so cool to the touch, so pleasant to the eye, and so easily kept clean; they used it for the handles of sistra and of mirrors, for drinking-cups in the form of half-opened lotus buds, dishes, and plates. An immense piece of glazing is a sceptre 5 feet high with a separate head, made for Amenhotep II., and now in the South Kensington Museum. It appears that the Egyptians carried their preference for glazed pottery so far, in some instances, as to cover the walls of their palaces, temples, and tombs with it. Glazed tiles for fixing on walls were used during the Thinite period.

Fig. 263.—Lenticular vase, glazed ware, Saïte period.

As late as the nineteenth century one of the chambers of the step pyramid of Saqqara still retained its mural decoration of glazed ware (fig. 264). Up to three-quarters of its height it was faced with green tiles, oblong in shape, slightly convex in front, but flat at the back (fig. 265); a square projection pierced with a hole served to fix the tiles at the back by means of a flexible strip of wood passed horizontally through the whole row. The three rows of tiles that frame the lower part of

GLAZED TILES.

the doorway are inscribed with the titles of the Pharaoh Zeser of the Second or Third Dynasty. The hieroglyphs are in blue, red, green, and yellow on a tawny background. Of the Sixth Dynasty there is a yellow tile on which is the name and *Ka* name of Pepi I., and there are fragments of red and white

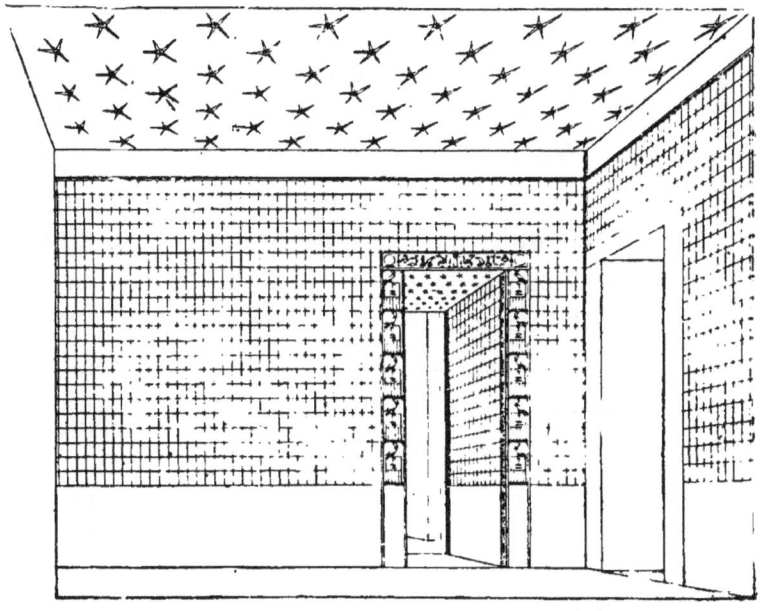

Fig. 264.—Chamber decorated with tiles in step pyramid of Saqqara.

tiles of Seti I. and of Sheshonk (Shishak), besides a green tile bearing the name of Rameses III.

In the palace of Tell el Amarna glazed tiles were used in abundance. The stone columns of the harem were covered with glazed and moulded tiles, ribbed to imitate bundles of reeds, and filled in with lotus buds and flowers all in glazed ware. The great hall of columns had a very beautiful dado. of green tiles

inlaid with white daisies and violet thistles. The limestone walls were inlaid with glazed ware and gleamed with great hieroglyph inscriptions of gorgeous colouring, while both in the temple and the palace stones were inlaid in other stones, white alabaster in red granite, or tesseræ of black granite in yellow quartzite.* This method of decoration was adopted to some extent by the successors of Akhenaten. At Tell el Yahûdîeh, Rameses III. employed much the same scheme for his temple.

Fig. 265.—Tile from step pyramid of Saqqara.

The main part of the building was limestone and alabaster, but the scenes, instead of being sculptured in the usual manner, were formed of a mosaic of stone tesseræ and glazed pottery in about equal proportions. The element most frequently introduced into the scheme of decoration was a circle, made of sandy frit coated with grey or blue glaze, on which was a cream-coloured rosette (fig. 266). Some of these rosettes

Fig. 266.—Tile inlay, Tell el Yahûdieh.

are surrounded by geometric designs (fig. 267) or spider-web patterns, and some represent open flowers, the central boss in relief, the petals and tracery inlaid. These circular plaques, which vary in size from three-eighths of an inch to 4 inches, were fixed to the wall with very fine cement. They were combined to form ordinary designs, such as scrolls, foliage, or parallel fillets such

Fig. 267.—Tile inlay, Tell el Yahûdieh.

* W. M. F. Petrie, *Tell el Amarna*.

as can be seen on the foot of an altar and the base of a column now in Cairo. The cartouches were usually made in one piece, and so were the figures; the details, either incised or moulded in the clay before baking, were afterwards covered with a paste of the desired colour. The lotus blossoms and leaves that decorated the base of the walls or the cornice were, on the contrary, formed of a variety of pieces. There every colour is separate, and made to fit into the surrounding pieces with great exactness (fig. 268).

Fig. 268.—Inlaid tiles, Tell el Yahûdieh.

The temple was pillaged at the beginning of the nineteenth century, and ever since the time of Champollion the Louvre has possessed figures of prisoners brought from there. All that was left was destroyed years ago by dealers in antiquities, and the débris dispersed. Some have found their way to the British Museum. Mariette recovered with great difficulty some of the most important fragments, including the name of Rameses III., which gives us the date of the building, some of the borders of lotus flowers and human-handed birds (fig. 269), and the heads of Asiatic and negro slaves (fig. 270). The destruction of this building is especially annoying,

Fig. 269.—Tile in relief, Tell el Yahûdieh.

because apparently the Egyptians did not build many of the same type. Rameses III. also decorated some part of his temple at Medinet Habû with inlaid enamels. The Boston Museum possesses a fine series of tiles that apparently came from there, and a doorway from Medinet Habû is now at Cairo. Glazed bricks and enamelled tiles are easily injured, and that would be a very serious drawback in the eyes of a people who regarded durability as being of the highest importance.

Fig. 270.—Tile in relief, Tell el Yahûdieh.

2.—IVORY, WOOD, LEATHER, AND TEXTILES.

Ivory, bone, and horn are somewhat rare in our museums, but this is no reason for supposing that they were not freely used by the Egyptians. Horn does not last well, certain insects are partial to it and destroy it very rapidly; bone and ivory soon lose their consistency and become friable. The elephant was known to the Egyptians from the earliest times, and it is possible that at a very remote period the animal existed in the Thebaid. As early as the Memphite dynasties the name of the island of Elephantine is written with the figure of an elephant. Before the time of Menes, ivory was freely used for combs and hairpins, decorated with figures of men, birds, or animals, and for spoons (fig. 271). Rudely carved tusks were also placed in the graves (fig. 272). Figures of men and women—the latter wrapped in long cloaks—inscribed plaques, cylinders, and tusks inscribed with

IVORY CARVINGS.

rows of animals, birds, and human figures (fig. 273) are also found of the earliest dynastic period.

During historical times ivory was imported into Egypt from the Upper Nile in the form of tusks, or half-tusks. It was generally left its natural colour, but occasionally

Fig. 271.—Ivory spoon, combs, and hairpins, predynastic. At Oxford.

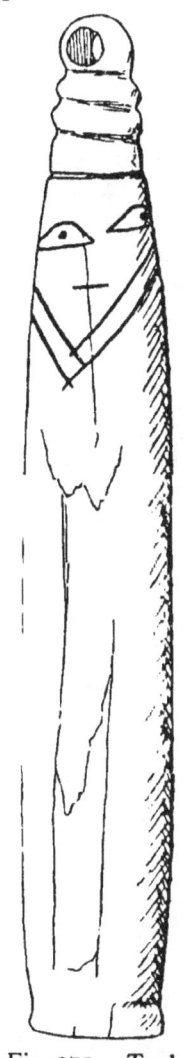

Fig. 272.—Tusk carved with human face.

it was stained green or red. It was in great request for inlaying furniture, chairs, beds, and coffers;

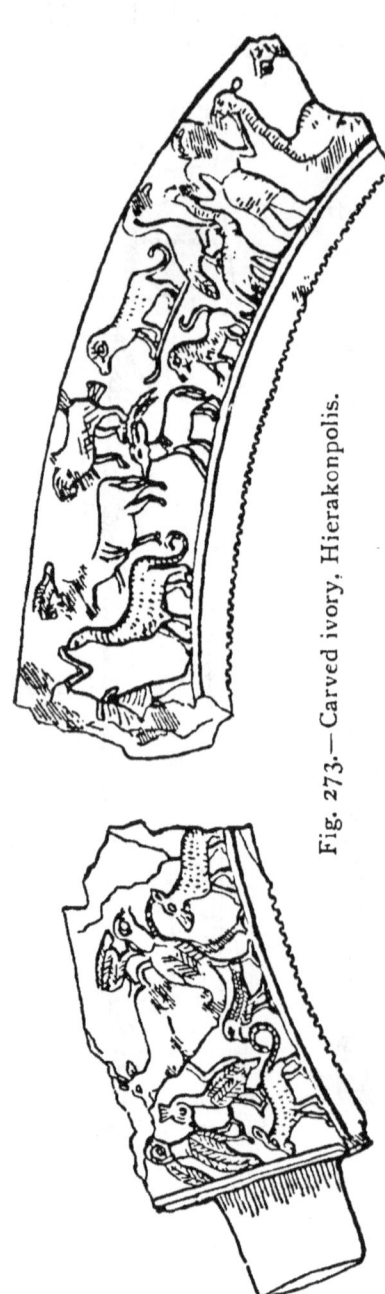

Fig. 273.—Carved ivory, Hierakonpolis.

combs, hairpins, toilette ornaments, and delicately wrought spoons (fig. 274) continued to be made of ivory, and so were dice, kohl-bottles made in the form of a hollow column surmounted by a capital, incense-burners shaped like a hand holding a bronze bowl in which perfume was burnt, and also boomerangs covered with outlines of divinities and fantastic animals. Some of these objects are fine works of art, as for instance a dagger handle at Cairo in form of a lion, or the carved ivory plaques on a box belonging to Tûaï, who lived at the end of the Seventeenth Dynasty. Of the Middle Kingdom there is an ivory gaming-board 6 inches long by 4 inches broad with playing pieces also carved in ivory. The board is shaped like an axeblade, and rests on four ivory bull's legs; below there is a small drawer of ivory and ebony

OBJECTS IN IVORY AND WOOD. 309

closed by an ivory bolt that works in copper staples. There are ten ivory playing pieces, five with dogs' heads and five with jackals' heads. The ivory of the board is backed with sycamore wood, and round the edges is an ebony veneer fixed with glue.*
Another object which also comes from the same excavations in the eastern valley of Deir el Baharî is a toilet box of cedar wood veneered with ebony and ivory. Below the lid there is a tray with partitions and a hollow to hold a mirror; below this again is a drawer fitted to hold eight alabaster vases of cosmetics; both lid and drawer are fitted with silver knobs. This was the property of Kemen, keeper of the kitchen department to Amenemhat IV. Engraved on the ivory plaque in front is a scene of Kemen offering vases to his sovereign.*

Some fine statuettes are carved in ivory. The seated figure of Khûfû found at Abydos is only 5 inches high, but it is of perfect and most delicate workmanship. There is a figurine dating from the Fifth Dynasty that has unfortunately been damaged, but which still bears traces of rose colour, and a miniature figure of Abi who died under the Thirteenth Dynasty. Abi is perched on the top of a lotus-flower column and gazes straight in front of him with a majestic air, which contrasts comically with his very prominent ears. The work is broad and spirited and will bear comparison with the ivories of the Renaissance.

Fig. 274. —Spoon.

* Lord Carnarvon, *Five Years' Exploration of Thebes*, 1913.

Egypt is not rich in trees, and most of those she possesses are useless to the sculptor. The two which are most abundant, the date-palm and the dôm-palm, are coarse and uneven in fibre. Some varieties of the sycamore and acacia are the only trees that provide wood suitable for carving. Wood was nevertheless a favourite material for cheap and rapid work, and at times it was chosen for important pieces such as *ka* statues. The statue of the *Sheikh el Beled* shows with what boldness and breadth wood could be treated. But the blocks and beams the Egyptian had at his disposal were seldom either broad or long enough to make a statue in one piece. The *Sheikh el Beled*, which is under life size, is carved in several pieces, joined with square pegs. The custom therefore arose of reducing the subject that was to be carved in wood to a size that could be rendered in one single piece, and under the Theban Dynasties the statues of early days have become statuettes. Art lost nothing by this reduction, and more than one of these small figures is comparable with the finest work of the Old Kingdom. The best of them all is perhaps one in the Turin Museum belonging to the Twentieth Dynasty. It represents a young girl whose only clothing is a narrow girdle round the waist. She is at that indefinite age when the undeveloped figure is almost

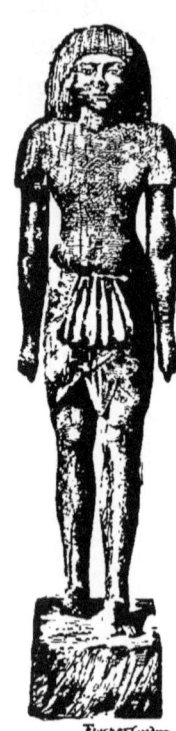

Fig. 275.—Wooden statuette of officer, Eighteenth Dynasty.

as much like that of a boy as of a girl. The expression of the face is roguish and pleasant, and the figure at a distance of thirty centuries is in fact a portrait of one of those graceful little maidens of Elephantine who without shame or immodesty walk unclothed in sight of strangers. The three small figures of men at Cairo are probably of the same date as the Turin figure. They are clothed in robes of state, as indeed they should be, for one of them, Hori, surnamed Ra, was a favourite of the Pharaoh. They are walking with calm and even pace, the bust thrown well forward and the head held high; their expression is knowing and somewhat furtive.

An officer (fig. 275) now retired to the Louvre is in the semi-military costume of the time of Amenhotep III., and his successors, a small wig, a tight-fitting vest, with short sleeves. A kilted skirt, stretched tightly over the hips and reaching scarcely half-way to the knees, has the free end plaited lengthways and puffed out in front by some artificial contrivance. Near him stands a priest (fig. 276) with a wig made of rows of small curls, wearing the long skirt that reached half-way down the legs, and spread out in front in a

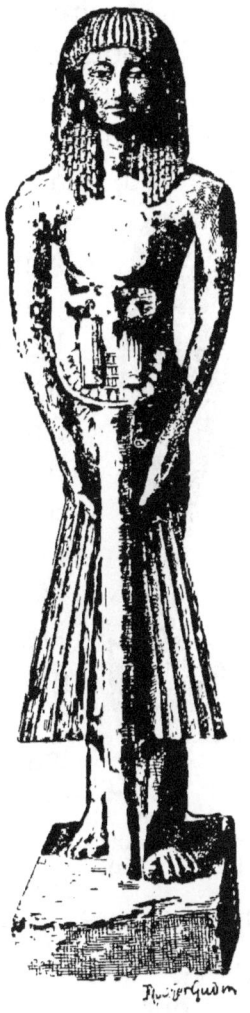

Fig. 276.—Wooden statuette of priest, Eighteenth Dynasty.

sort of plaited apron. With both hands he is holding a divine symbol, consisting of the head of a bull crowned with the solar disc, supported on a massive staff. Both officer and priest are painted a reddish brown with the exception of the hair, which is black, the corner of the eyes, which is white, and the sacred standard, which is yellow. Curiously enough their companion in a glass case, the little lady Naï, is also painted brown, and not yellow, the regular colour for women in Egypt (fig. 277). She is represented in a tight-fitting garment, trimmed down the front with white embroidery. Round her throat she is wearing a gold necklace of three rows, gold bracelets on her wrists, and on her head is a wig with tresses hanging over her shoulders. Her right arm is hanging down, and the hand grasped some object, now lost, probably a mirror; the left hand is holding a lotus bud. The figure is supple, the throat youthful and rounded, the expression of the broad smiling face is pleasant, though not entirely free from vulgarity. The headdress is heavy, but the bust is modelled with purity and grace of form; the dress defines the contour and without rendering them too visible the attitude is natural, and the movement by which the young lady presses the flowers to her breast is rendered with realistic skill. These are portraits, and as the originals were not people of exalted birth, they probably did not employ artists of the highest

Fig. 277.—Wooden statuette of the Lady Naï.

repute. They must have had recourse to unpretentious craftsmen, and the knowledge of composition and the dexterity of manipulation show the powerful influence exercised even on artisans by the great school of sculpture that still flourished at Thebes.

This influence is even more apparent when we study the small objects devoted to the toilet and those for household use.

Fig. 278.—Spoon, wood.

It would be no light task to attempt to describe the immense variety of knick-knacks on which the ingenious fancy of the artists was expended. The handles of mirrors are generally in the form of a lotus or papyrus stem, ending in a full-blown flower to which the disc of polished metal is affixed. Or they are sometimes formed of the figure of a girl either nude, or clad in a tight-fitting garment, bearing the disc on her head.

The tops of hairpins were formed of a coiled snake, of the head of a jackal, a dog, or a hawk, very similar to those of the archaic period. The stands intended to hold these pins are in the form of a tortoise or a hedgehog with holes pierced in a regular pattern on the carapace. Headrests which served instead of pillows for the head are decorated with scenes in sunk relief from the myths of Bes and Sekhet, and the forbidding countenance of Bes is carved on the lower side or the base. But the inventive genius of the craftsmen was more specially roused by the spoons for perfumes and the kohl-vases.

Fig. 279.— Spoon.

314　THE INDUSTRIAL ARTS.

In order to save their fingers, spoons were used for essences, pomades, and for the various dyes with which both men and women stained their cheeks and lips, their eyelids, nails, and the palms of their hands. The designs are generally derived from the flora and fauna of the Nile. A spoon in the Cairo Museum represents a fox in full flight, carrying off an enormous fish in his mouth, the body of the fish forming the bowl of the spoon (fig. 278). Another is a cartouche that rises out of an open lotus flower, or a lotus fruit placed on a bouquet of flowers (fig. 279), or a simple triangular bowl, flanked by two flower buds (fig. 280). The most elaborate spoons combine a human figure with these designs. A girl, nude except for a girdle round the hips, is swimming with her head well above water (fig. 281). Her extended arms support a duck, the body of which is hollowed out, while the two movable wings serve as a cover.

Fig. 280.—Spoon.

Not in ivory or wood, but very delicately modelled

Fig. 281.—Spoon, wood. At New York.

in glazed ware is another spoon found in 1913 in the Oxford excavations at Merawi. This dates from about the Twenty-sixth Dynasty. The figure of the swimming girl is almost identical with that just

described (fig. 281), but the arrangement of the hair is slightly different. It is brushed back close to the head and then arranged in a large knot behind; her outstretched arms support an oblong tray. The details of the tiny figure are perfectly rendered. The ears pierced for earrings, the slender hands and fingers, the fingers and toes all bear close examination.

At the Louvre there is also a girl (fig. 282) partly concealed among the lotus plants, from which she is gathering a bud. A bundle of stems, from which two full-blown flowers emerge, unite the handle to the bowl of the spoon, which in this case is reversed, the pointed end being attached to the handle. In another the girl is framed by two flowering stems, and is playing on a long-necked lute as she walks (fig. 283), or, again, the musician is standing on a boat (fig. 284), or her place is taken by a woman bearing offerings. Sometimes a slave is represented bending under the weight of an enormous sack.

Fig. 282.—Spoon.

Fig. 283.—Spoon.

The physiognomy and the age of each of these tiny persons are very clearly characterised. The girl gathering lotus is of good birth, as is indicated by the dressing of her hair and the pleated linen of her skirt. The young Theban ladies wore long garments, and she has only gathered up

her dress in order to avoid wetting it as she makes her way through the reeds. The two girls playing lutes are, on the contrary, of inferior birth. One is satisfied with a mere girdle round the hips, and the other has only a short petticoat carelessly arranged. The girl bearing offerings (fig. 285) wears the long pendant tress which was distinctive of childhood. She is one of the slim, slender girls we know so well among the fellahîn of to-day. Her lack of clothing therefore does not prove that she was not of gentle birth, for even the children of the nobles did not wear the garments of their sex before the period of adolescence. The slave (fig. 286), with his thick lips, his flat nose, his heavy animal jaw, his retreating forehead, and his conical head, is evidently a caricature of some foreign prisoner. The sullen demeanour with which he slouches along under his burden is admirably caught, and the angularities of his body, the shape of his head, and the disposition of the various parts all recall the general appearance of the grotesque terracotta figures of Asia Minor. The natural objects, such as leaves, flowers, or birds that are grouped round these principal figures, are skilfully and truthfully arranged.

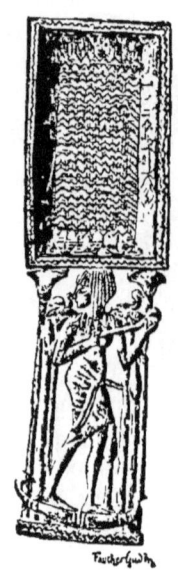

Fig. 284.— Spoon.

Fig. 285.—Spoon.

Thus in the case of the three ducks tied together by the legs, carried by the girl bearing offerings, two have resigned themselves to their fate, and are swinging with outstretched necks and open eyes, while the third has lifted up its head and is flapping its wings in protest. The two water-birds we see perched on the lotus plants listening to the lute are entirely at ease with their heads on their breasts. They know by experience that they need not disturb themselves for a song, and that they have nothing to fear from a girl who carries no alarming weapon. The sight of a bow and arrow would put them to flight. The Egyptians were thoroughly acquainted with the habits of wild creatures, and they delighted in representing them with exactitude. The habit of observing the minutest facts was instinctive with them, and in consequence even the smallest piece of work was certain to be characterised by a marvellous degree of realism.

The variety of furniture used in ancient Egypt was no greater than it is at the present day. The poor were contented with a few mats which they rolled up by day. Those who were somewhat better off possessed stools, low frame beds like the Nubian *angareb*, and some chests and boxes of various sizes to hold tools or linen. The nobles had chairs and divans in

Fig. 286.—Spoon.

addition, such as those found in the tomb of the parents of Queen Tyi. The art of the cabinet-maker had attained a very high degree of perfection early in the dynastic period. Boards were worked with the adze, mortised, glued, and fitted together, and fastened with pegs of hard wood, or with the thorns of the acacia, never with metal nails. They were then polished and ready to be painted. Chests generally stand on four straight feet, sometimes of considerable height. The cover is either flat or rounded according to a special curve which was popular with the Egyptians at all periods (fig. 287), or, very rarely, they were sloped to a ridge like the roofs of our houses (fig. 288). Generally the whole lid lifts off, but occasionally it turns on a peg inserted in one of the corners at the top, or it opens at the side on two wooden pivots (fig. 289). The panels are admirably adapted for decoration and are covered with paintings, or inlaid with ivory, silver, enamel plaques, or with valuable woods. It is possible that we are not in a position to judge of the skill possessed by the Egyptians in this branch of art, nor of the variety of shapes invented by them at various

Fig. 287.—Chest.

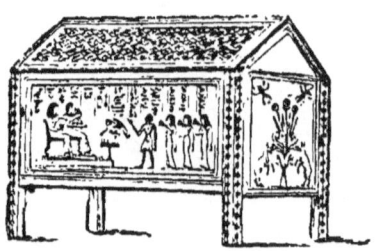

Fig. 288.—Chest.

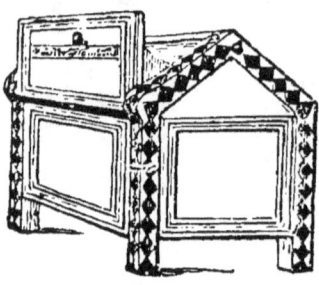

Fig. 289.—Chest.

WOODEN SARCOPHAGI.

periods, as most of their furniture that we possess has been found in tombs, and some of it may have been cheap imitation provided for the purpose, or of special design reserved for the use of mummies.

It was these mummies who were the most profitable customers of the cabinet-makers. Everywhere else man carried only a small number of objects with him into the next world, but in Egypt he was content with nothing less than a complete outfit. The coffin itself was a serious piece of work that employed a whole gang of workmen (fig. 290). The method

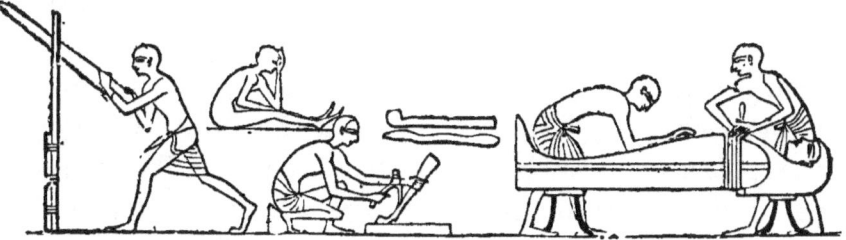

Fig. 290.—Construction of a mummy case, wall scene, Eighteenth Dynasty.

varied at different periods. At the time of the Memphite empire and the first Theban empire, the coffins are almost without exception huge rectangular chests of sycamore-wood, flat both at top and bottom, the various parts joined together with wooden pegs. The shape is not elegant, but the decoration is very interesting. The cover has no cornice, and the centre of it is occupied by a long band of hieroglyphs on the outside, sometimes written with ink or painted, sometimes carved in the wood and then filled in with a bluish paste. This inscription gives merely the name and titles of the deceased, occasionally followed

by a short formula of prayer on his behalf. The inside is covered on the surface with a thick coating of stucco, or it is whitewashed. On this the seventeenth chapter of the *Book of the Dead* is generally written with red and black ink in fine cursive hieroglyphs. The coffin itself consists of eight vertical planks, two at each side and at the ends, and three horizontal planks at the bottom. On the outside it is sometimes decorated with wide parallel lines of colour ending in intertwined lotus leaves, corresponding to the grooves on the stone sarcophagi. More often the coffin has two large open eyes, and two monumental doors on the left, and three doors on the right, precisely like those found in the rock-cut tombs of the period. The coffin is in fact the house of the deceased, and as such it was necessary that its walls should bear a summary of the prayers and pictures that covered the walls of the tomb. The formula and necessary representations were inscribed and shown on the inside, in about the same order in which we find them in the mastabas. Every side is divided into three registers and every register contains either a dedication in the name of the occupant or a picture of the objects belonging to him, or texts of the ritual recited for his benefit. When this was skilfully done on a background painted to look like fine wood, the whole effect was bold and harmonious. Only a small share of the work fell to the cabinet-maker, and the long boxes in which the earliest mummies were enclosed demanded little skill on his part. But this was not the case with coffins that were made as nearly as possible in the human form.

Of these we have two types. In the earliest of the two the coffin followed the lines of the mummies. The feet and legs are joined together throughout their length: the slight projection of the knees, the rounding of the calf, and the outline of the thighs and the trunk are summarily indicated, as though they were vaguely modelled under the wood. The head, the only living part of the inert body, is entirely disengaged. In this type the man was imprisoned in a sort of statue of himself, which was so well balanced that it could be stood up on end when desired.

In the second type the man appears to be lying down on his coffin; his statue carved in the round forms a cover for his body. On his head is his large curled wig, the breast is scarcely concealed by his vest of almost transparent white material, the petticoat with its symmetrical folds covers his legs, on his feet are elegant sandals, and his hands clasp various emblems, the *ankh*, the girdle tie, the *dad*, or in the case of the wife of Sennetmu at Cairo, a wreath of ivy.

This sort of mummiform casing is rare under the Memphites. Menkaûra, the Mycerinus of the Greeks, has, however, left us a noteworthy example. They were very common under the Eleventh Dynasty, but at that time they were often little more than the hollowed trunk of a tree, with a human head and feet roughly hewn out. The face is daubed with brilliant colours, yellow, red, and green; the hair and headdress are painted with black or blue stripes. A necklace is ostentatiously displayed at the breast;

the remainder is either covered with the gilded feathers of Isis and Nephthys, the two mourning goddesses, or plastered with a thick wash of uniform colour either yellow or white, on which is a scanty decoration of figures and bands of hieroglyphs

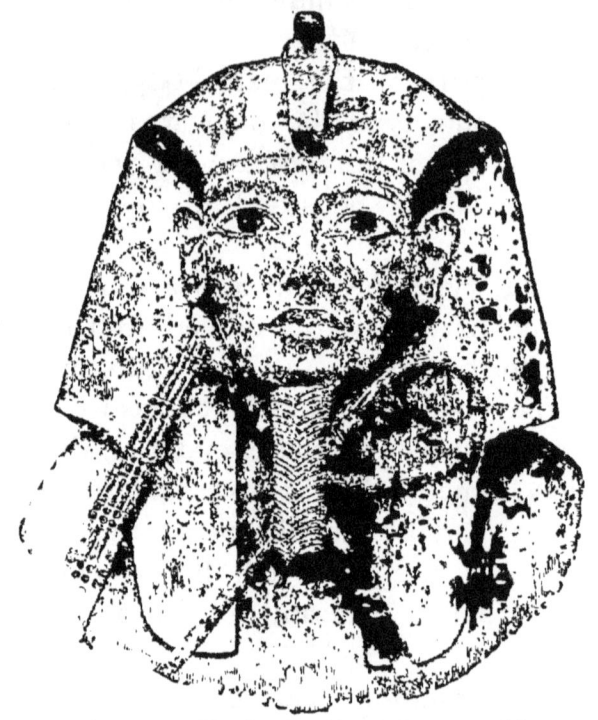

Fig. 291.—Mask of coffin of Rameses II., *tempo*, Twenty-first Dynasty.

painted black and blue. The most elaborate royal coffins of the Eighteenth Dynasty that I excavated at Deir el Baharî belong to this type, and are only distinguished by the finish of the work and by the extraordinary perfection with which the artist reproduced the features of the sovereign. The mask of Aahmes I., of Amenhotep I., and of Thothmes II.

are actual masterpieces of this species of work. The mask of Rameses II. shows no trace of painting except a black groove inserted to accentuate the eye. It is undoubtedly a portrait of the Pharaoh Herihor who restored the funerary furniture of his powerful predecessor, and is almost comparable to the best examples of contemporary statuary (fig. 291). Two coffins, those of Queen Aahmesnefertari and her daughter Aahhotep II., are of immense size and measure more than $10\frac{1}{2}$ feet in height. When standing upright (fig. 292) they might almost be mistaken for some of the caryatids in the court of Medinet Habû, though on a smaller scale. The body is represented swathed in bandages and only faintly suggests a human form. A network in relief, with each mesh standing out in blue on the yellow background, fits tightly to the neck and shoulders, and forms a kind of mantle, from which the hands emerge, and are crossed on the breast clasping the *ankh*, the sign of life. The head is a portrait, the face round and broad, the eyes wanting in intelligence, the expression mild and characterless. Above the heavy

Fig. 292.—Mummy-case of Queen Aahmesnefertari.

wig are the headdress and stiff feathers of Amon or Mût.

It may well be asked what motive the Egyptians could have had in manufacturing these extraordinary productions. Both queens were small women and their bodies were lost in such huge coffins. They had to be wedged in and padded with rags to prevent their rolling about and being injured. Apart from their size the coffins are characterised by the same simplicity as that which distinguishes all of that period, whether of royal or private personages. About the middle of the Nineteenth Dynasty there was a change of fashion: one single coffin soberly adorned was no longer sufficient; it was necessary to have two or three or even four inside one another, profusely decorated with paintings or inscriptions. At this time the outer casing was often a sarcophagus with short square posts or handles at the corners and a ridged or saddle-back lid painted in white on the lower side and covered with figures of the deceased in adoration before the gods of the Osirian group. When the coffin is shaped in human form, some of the former bareness of decoration is still retained: the face is coloured, there is a necklace spread on the breast, and a band of hieroglyphs extends to the feet. The rest is of a uniform colour, black, brown, or a dull yellow. The inner coffins are decorated to an almost extravagant degree. The face and hands are red, rose-coloured, or gilded. The jewellery is represented either by painting or by enamels inlaid in the wood, and there are scenes and texts in a variety of colours, the whole covered with the yellow

varnish already referred to. The contrast between the abundant ornamentation of this period, and the simplicity of the earlier work is very striking. It is to Thebes itself that we must look for an explanation. Private people as well as the Pharaohs of the period of conquest devoted their full energy of resources to the construction of their rock tombs. There the walls formed one vast picture, and the sarcophagus was a colossal block of finely worked granite or alabaster. It mattered little that the coffin in which the mummy reposed should be only slightly decorated. But the Egyptians of the decadence and their rulers could no longer draw on the wealth of Egypt and of surrounding countries as their predecessors had done. They were poor, and most of them had to renounce any attempt at constructing elaborate tombs. They devoted the money they had at command to providing themselves with fine coffins of sycamore-wood. The splendour of their mummy-cases is therefore only another proof added to those we already possess of their weakness and poverty.

When the Saïte Pharaohs succeeded in re-establishing the prosperity of the country, stone sarcophagi once more appeared, and the wooden coffin to some extent returned to the simplicity of the time of prosperity and fine art; but this revival was not of long duration, and the Macedonian conquest led to changes in funerary customs similar to those that followed the downfall of the Ramessides. The custom of employing double or treble coffins with excess of painting and crude gilding once more revived. The skill of the workpeople who prepared

the inhabitants of Ekhmîm for their last resting-place was even less than that of the funerary undertakers who lived under the obscure Ramessides of the Twentieth Dynasty, and in the matter of bad taste they were fully equal to them. A series of Græco-Roman examples from the Fayûm exhibits the stages

Fig. 293. – Panel portrait, Græco-Roman, at National Gallery.— *Hawara, Biahmu and Arsinoe*, W. M. F. Petrie.

by which portraiture in the flat then replaced the modelled mask, until towards the middle of the second century A.D. it became customary to bandage over the face of the mummy a panel portrait of the dead as he was in life (fig. 293).

The remainder of the funerary outfit involved as

much work for the cabinet-maker as the coffins themselves. Chests of different sizes were required to hold the garments of the deceased, and to contain the viscera, and for the *respondants*, the *ûshabti* figures; tables for his meals, chairs, stools, beds for the mummy; hearses to convey him to his tomb, and chariots both for war and for pleasure. The boxes that contained the canopic vases, the *ûshabti* figures, and the libation vases were divided into several compartments, sometimes guarded on the lid by a jackal, which also served as a handle. Each box was mounted on a small sledge, on which it could be drawn in the funeral procession.

Beds are not uncommon. Those that resemble the Nubian *angareb* are mere wooden frames, with coarse linen or crossed strips of leather stretched across them. The greater number are less than 5 feet in length; the sleeper, therefore, could never have stretched himself at full length, but must have curled himself up. The decorated bedsteads were of very much the same type as our own. Generally they were horizontal, but occasionally they sloped slightly from the head to the foot. They often stood some height from the ground, and were climbed into with the help of a stool or a set of portable steps. These details were only known to us by pictured wall paintings till 1884-5, when I discovered two complete beds, one at Thebes, in a tomb of the Thirteenth Dynasty, another at Ekhmîm, in the Græco-Roman necropolis. The sides of the later bed were formed of two lions, kindly animals, whose heads supported the top of the bed, and whose tails curved over the foot. Over this

bed there was a species of canopy, which was used at any rate during the funeral ceremonies. A similar canopy had already been found by Rhind, and presented by him to the Edinburgh Museum (fig. 294). It is in the form of a temple, with a rounded top, supported by graceful miniature columns of painted wood. A door guarded by two serpents was supposed to afford access to the interior. Three winged discs,

Fig. 294.—Carved and painted mummy canopy, Thirteenth Dynasty.

graduated in size, are ranged in the three superposed cornices over the doorway, and the structure is crowned by uræi drawn up in line. The canopy of the Thirteenth Dynasty bed is much less complicated. It is a sort of wooden balustrade carved and painted to resemble bundles of reeds, the *hotesu* pattern employed to decorate the upper part of temple walls. Above this there is the usual cornice. In the mummy couch of the Græco-Roman period (fig. 295) the side balustrade is replaced by crouching figures of the

goddess Maat, sculptured and painted, with her feather in her hand. At the head and foot stand Isis and Nephthys, waving their arms fringed with wings. The upper part is in open work, and three vultures hover over the mummy, and kneeling figures of Isis and Nephthys weep over it.

The sledges that conveyed the dead to their tombs were also provided with canopies, but totally different in appearance. The sledge canopy is also a naos, but with solid sides, similar to those found by me in

Fig. 295.—Mummy-couch with canopy, Græco-Roman.

1886 in the chamber of Sennetmû. When there were any openings they were square, and so arranged as to allow the head of the mummy to be seen. Wilkinson describes one of these canopies from paintings in a Theban tomb (fig. 296). In all cases the panels could be removed. When the mummy had been placed in the sledge, the panels were replaced and the curved roof, with its many-coloured cornice, was shut down, and the whole closed in.

Many of the chairs in the British Museum and the Louvre date back to the Eleventh Dynasty, and are

equal to some of later date. One of them (fig. 297) has retained its brilliance of colour to a remarkable extent.

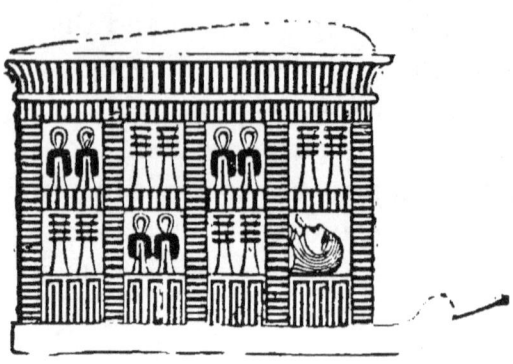

Fig. 296.—Mummy-sledge and canopy.

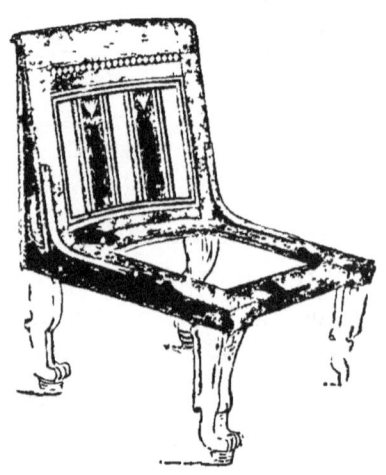

Fig. 297.—Inlaid chair, Eleventh Dynasty.

The frame, formerly filled in with a network of cords, stands on four lion's feet. The back is decorated with two flowers and a row of lozenges in marqueterie work of ebony and ivory on a red ground. Stools of similar workmanship (fig. 298), or folding stools with feet in form of the flattened heads of geese, are to be found in all museums. Pharaohs and functionaries of high rank sought for more elaborate designs, and their seats are at times very high. A painting of a royal chair shows the lower supports made of prisoners of war bound back to back (fig. 299). A step placed in front of the chair served also as a footstool. No complete example of this type of chair has yet been found. Arms were also provided for the chairs formed of leopards or of two running lions. From

CHAIRS. 331

the tomb of the parents of Queen Tyi, discovered by Mr. T. Davis in 1903, come three charming chairs. The carved lion's feet are very similar to those of the Eleventh Dynasty, but the chairs are provided with arms. The back and sides of one chair are of solid wood elaborately sculptured and gilded. In front of the arms are two small female heads, which balance the lion's feet below.

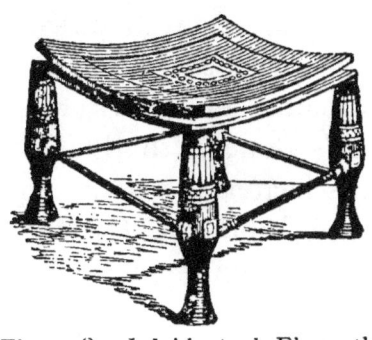

Fig. 298.—Inlaid stool, Eleventh Dynasty.

The sides of the two other chairs are carved in openwork designs.

The hardness of the seats was obviated by adding a stuffed cushion richly worked. There is no doubt that tapestry was known to the Egyptians. One of the reliefs at Beni Hasan (fig. 300) shows that it was made on a frame similar to that used by the weavers of Ekhmîm up to the present day. The loom is horizontal, although the Egyptian lack of perspective gives the impression of its being upright. It is composed of two slender cylinders, placed about 54 inches apart, and held in place by two large pegs driven into the ground about 54 inches from each other. The

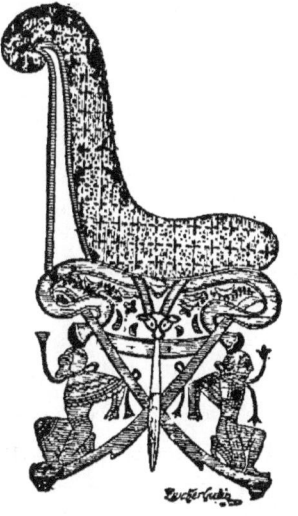

Fig. 299.—Royal chair of state, wall painting, Rameses III.

threads of the warp were firmly knotted, and then rolled round the upper cylinder until the proper tension was attained—cross sticks placed at intervals facilitated the insertion of the spindles filled with thread. The work was commenced at the bottom, as is done with the Gobelins tapestries. The tissue was beaten down and equalised by means of a coarse comb, and the finished work was wound upon the lower cylinder as it progressed. In this way both

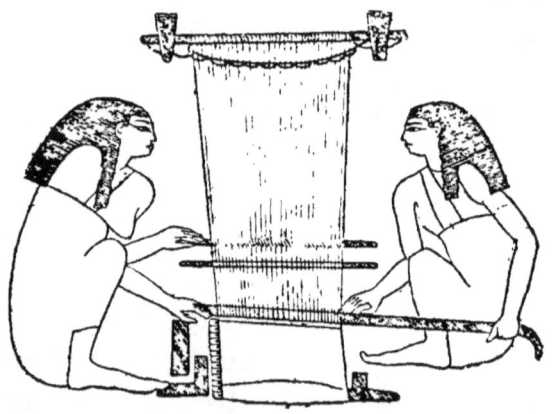

Fig. 300.—Women weaving, from wall scene in tomb of Khnûmhotep, Beni Hasan, Twelfth Dynasty.

tapestry and carpets were produced, one decorated with figures, the other with geometrical designs and zigzags and chequers (fig. 301), but at the same time a careful examination of the painted scenes has convinced me that the greater number of instances that have been thought to represent tapestry are in reality intended for leather, cut and painted. The leather industry flourished. There are few museums that do not possess at least one pair of sandals, or of those braces provided for mummies with pink and yellow

ends stamped with the figure of a god or of a Pharaoh, a hieroglyph text or a rosette, and sometimes with a combination of all four. These small objects are rarely of earlier date than the time of the high-priests of Amon or of the earlier Bubastites, and it is to this period that we must assign the cut leather canopy of the Cairo Museum. The catafalque that was placed over the mummy during its final journey to the tomb was often simplified, and consisted merely of a covering of some woven material or of

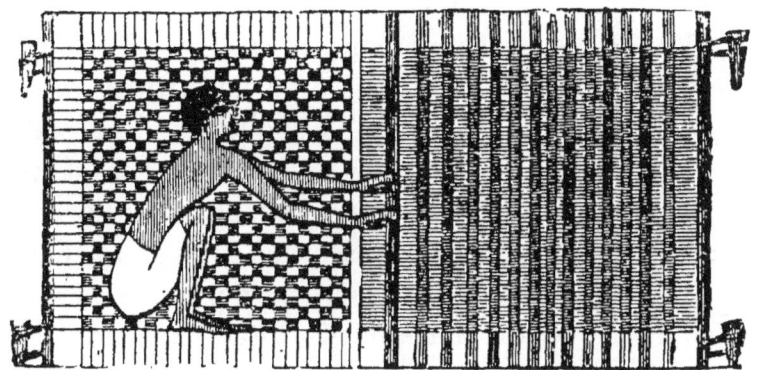

Fig. 301. Man weaving hangings or carpet, from Beni Hasan, Twelfth Dynasty.

pliable leather. This covering sometimes hung straight, and sometimes it was caught back, allowing the mummy to be seen. The canopy now at Cairo was made for the Princess Isiemkheb, daughter of the high-priest Masahirti, wife of the high-priest Menkheperra, and mother of the high-priest Pinotem II. The central portion, which formed the top, is longer than it is broad, and is divided into three sections of sky blue leather, now faded to pearl grey. The two side pieces are strewn with

yellow stars; on the central piece are vultures guarding the deceased with outstretched wings. The curtains that fill in the sides are in green and red chequer work. The two side curtains have each a border at the top. That on the right consists of scarabs with outstretched wings alternating with cartouches of Pinotem II., and a frieze above of lance heads. On the left the design is more complicated (fig. 302). In the centre is a tuft of lotus flanked by royal cartouches. Beyond on either side are gazelles kneeling on baskets, then two bunches of papyrus, and finally two scarabs similar to those on the other border; the frieze of lance heads again extends the whole length. The technique of the piece is very curious. The hieroglyphs and figures were cut out of large pieces of leather. Into the gaps thus made other pieces of leather of the desired colours were fitted, and the whole was strengthened and made good by a second piece of leather in white or pale yellow fastened behind it. Notwithstanding the difficulties that attended such a piece of work, the result obtained is very remarkable. The outline of the

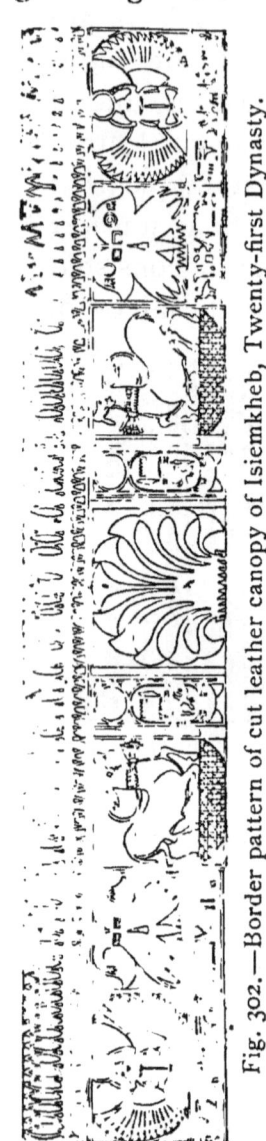

Fig. 302.—Border pattern of cut leather canopy of Isiemkheb, Twenty-first Dynasty.

gazelles, the scarabs, and the flowers is as clear and graceful as if it had been drawn with a brush on the wall or on a roll of papyrus, the choice of subjects is happy, and the colouring is both bright and harmonious. The craftsmen who planned and executed the work of the canopy of Isiemkheb were highly experienced in this form of decoration and

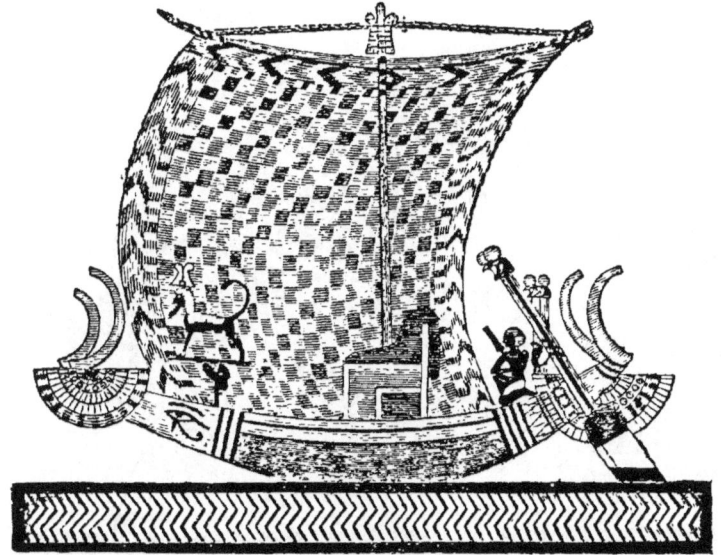

Fig. 303.—Bark with cut leather sail; wall painting in tomb of Rameses III.

the class of design required for it. I myself have no doubt that the cushions of chairs and of the royal divans and the sails of the funerary or sacred boats used for mummies or for statues of deities were frequently made of this leather work. There is a sail covered with chequer pattern and lateral rows of chevrons on one of the boats painted in the tomb of Rameses III. (fig. 303), and the chequers appear to be exactly similar to those on the canopy.

The vultures and fantastic birds on another sail painted in the same tomb (fig. 304) are no more strange or difficult to cut in leather than the vultures or gazelles of Isiemkheb.

The classical writers afford abundant testimony that the Egyptians of their time embroidered with rare skill. The two votive cuirasses presented by

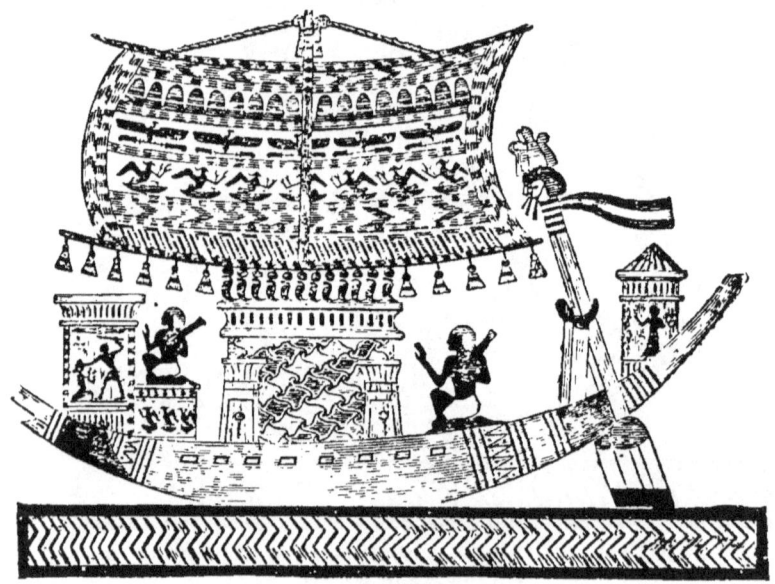

Fig. 304. Bark with cut leather; wall painting in tomb of Rameses III.

Amasis, one to the Lacedemonians, the other to the temple of Athena at Lindos, were of linen embroidered with figures of animals in gold thread and purple, each thread of which consisted of 365 separate strands. For earlier evidence we find from the Theban tombs that the garments of the Pharaohs had borders either woven or embroidered. The most simple of these consisted of one or more lines of a darker shade

parallel with the edge of the material. Elsewhere we find palmettos, or rows of discs and points, leaves, coils, or curves, and occasionally figures of men, divinities, or animals. On the garment of one of the Deir el Baharî princesses I found a royal cartouche embroidered in pale rose colour. In the tomb of Thothmes IV., discovered by Mr. Davis in 1903, were found some pieces of linen with a pattern of flowers and hieroglyphs worked or woven in most charming colouring.

The Egyptians of the best periods had a special esteem for materials in plain colours, especially white. They wove them with remarkable skill on a loom identical in all points with those employed for tapestry. The pieces of linen in which the hands and arms of Thothmes III. were wrapped are as delicate as the finest India muslin, and they deserved the name of *woven air* fully as much as did the gauzes of Cos : this is of course purely a matter of handicrafts into which art does not enter. The use of embroidery and tapestry only became general in Egypt towards the close of the Persian domination, and the commencement of the Greek period. Alexandria was partially populated by prosperous colonies of Phœnicians, Syrians, and Jews, who brought their native industries with them. Ptolemy attributes to the Alexandrians the invention of weaving with a variety of threads and producing the material now called brocade (polymita), and in the time of the earlier Cæsars it was a recognised fact that "the needle of Babylon was henceforth surpassed by the comb of the Nile." The materials thus made were not like

the ancient Egyptian tapestries, decorated almost exclusively with geometric designs, but, as the classical writers state, plants, animals, and even men were represented. Nothing now remains of the masterpieces which filled the palace of the Ptolemies, but fragments are frequently found that can be safely attributed to the later Roman period, such as the child with the goose described by Wilkinson, or the marine divinities purchased by me at Koptos. The numerous fragments of shrouds with elaborate patterns woven on the borders discovered in the Fayûm and near Ekhmîm are almost all of them from Coptic burials, and they belong rather to Byzantine than to Egyptian art.

3.—METAL.

Metals were divided by the Egyptians into two groups, separated from each other in Egyptian writings by the mention of various kinds of precious stones such as lapis lazuli or malachite. The noble metals were gold, electrum, and silver; the base metals were copper, iron, and lead, to which tin was added later.

— Iron was known as early as the predynastic period; some iron beads of that time proved on analysis to be of wrought iron. It is very rarely found, however, during the early dynasties, and in later times it was reserved for weapons of war, for tools intended for hard work such as chisels, sculptors' and masons' chisels, for axeheads and saws and the blades of adzes and knives. Lead was rarely used. It was occasionally employed as an inlay for the doors of temples, for coffers and other furniture, and it was

cast for small figures of divinities more especially of Osiris and Anubis. From the earliest prehistoric graves copper implements are found in small quantities, and its use rapidly increased and was almost universal up to the Sixth Dynasty, when it was gradually superseded by bronze. The vessels made of it are of hammered work and shaped on a core or mould. Accessories, such as spouts, were cast separately, and welded on with the help of a blowpipe. Rivets were also used to fasten one part of a metal vase to another. By the Sixth Dynasty bronze had come into use; casting also was far more freely employed.

It has often been affirmed that the Egyptians succeeded in tempering bronze so that it became as hard as iron or steel, and it is certainly the case that they were able to produce bronze of very different qualities by varying the constituents and their relative proportions. The greater number of the specimens examined up to the present contain copper and tin in the same proportions that are used to-day in the manufacture of bronze. The bronze analysed by Vauquelin in 1825 contained 84 per cent. of copper, 14 per cent. of tin, and 1 per cent. of iron and of other substances. A chisel brought to Europe by Wilkinson had only 5·9 per cent. of tin, 0·1 of iron, and 94 of copper. Fragments of statuettes and mirrors analysed more recently have rendered a sensible quantity of gold or silver and correspond with the bronzes of Corinth. Others have the colour and composition of brass. Many of the finest have a marvellous power of resisting the effects of damp, and

oxidise with difficulty. While still hot they were rubbed over with a resinous varnish which filled up the pores, and formed an unalterable patina. Each kind had its special use. The ordinary bronze was employed for weapons, and for the common amulets; alloys similar to brass were used for household utensils, the gold or silver bronzes for mirrors, valuable weapons, and fine statuettes. None of the tomb paintings that I have examined represent the manufacture of bronze, but that omission is supplied by an examination of the objects themselves.

Fig. 305. - Bronze jug.

Tools, weapons, rings, and cheap vases were partly hammered, partly cast whole in moulds of hard clay, or stone. Everything in the nature of a work of art was cast in one or more pieces according to circumstances, and the pieces were then adjusted, soldered together, and worked over with the burin. The method most generally in use was casting by means of a core. The core was made of sand or earth mixed with pounded charcoal, roughly formed in the same shape as the mould. This was placed inside the mould, and the metal with which it was coated was often so thin that it would have yielded to the slightest pressure if the core had not been left inside it.

Fig. 306.—Same jug seen from above.

The greater number of domestic utensils and small household implements were usually made of copper or bronze; they are to be found by thousands in our museums. In Egypt trade was not incompatible

BRONZES. 341

with art, and the coppersmith endeavoured to give
beauty of form and of ornament even to the humblest
of his productions. The stockpot in which the cook
of Rameses III. patiently allowed his most elaborate
dishes to simmer is provided with lion's feet. Here
is a pitcher that does not appear to differ in
any way from the modern pitcher (fig. 305),
but let us examine it more closely. The
handle is a papyrus flower, and the petals
drooping on their stem rest on the rim of the
jug (fig. 306). The handle of a knife or spoon
is almost always the curved neck of a duck or
a goose. The bowl of the spoon may be an
animal, such as a gazelle bound ready for
sacrifice (fig. 307), and on the handle of a
sabre a small jackal is seated. The upper half
of a pair of scissors at Cairo is formed of an
Asiatic captive, with arms bound behind his
back. A mirror is composed of a leaf, the
stalk forming the handle. One
box for perfumes is a fish, another
is a bird, and a third is a grotesque
deity. Vases for holy water
carried by priests and priestesses
to sprinkle the faithful, or the
ground over which processions
were about to pass, merit a

Fig. 307.—Lamp, Græco-Roman period.

special place of honour among connoisseurs. They
are pointed or ovoid at the lower end, and
decorated with designs in outline or relief. Sometimes there are figures of deities, each enclosed in
a separate framework, and sometimes scenes of

prayer or of lustration, and the work is generally extremely good.

Both copper and bronze were early employed for statuary. The statue of Pepi I. discovered by Quibell at Kom el Ahmar has already been mentioned. The technique is not the least interesting thing about it. Bust, legs, and arms were hammered out and fitted together most accurately; the hands, face, and feet were cast. We possess some pieces of the Eighteenth and Nineteenth Dynasties; the chased lion's head found with the jewels and weapons of Queen Aahhotep, the Harpocrates of Cairo that bears the names of Kames and of Aahmes I., and several figures of Amon in the same museum, said to come from Medinet Habû and Sheikh Abd el Gûrneh, are of that period. The most important pieces belong to the Twenty-second or Twenty-sixth Dynasty, while many are no earlier

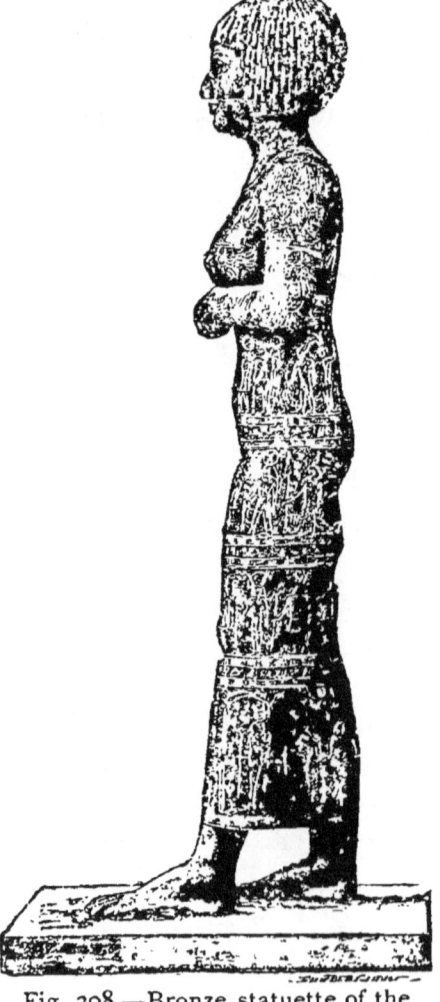

Fig 308.—Bronze statuette of the lady Takûshet.

than the beginning of the Ptolemaic period. A fragment from Tanis in the possession of Count Stroganeff formed part of a statue of King Petukhanu of the Twenty-first Dynasty. It must have been at least two-thirds of life-size, and is one of the largest pieces we possess. The portrait statuette of the lady Takûshet given by M. Démétrio to the museum at Athens, the four figures at the Louvre, and the kneeling genius at Cairo came originally from Bubastis, and probably date from the years that immediately preceded the accession of Psammetichus I. The lady Takûshet is standing, one foot advanced, the right arm pendent, the left arm folded below the breast (fig. 308). She wears a short robe embroidered with religious subjects, and she has bracelets on her arms and wrists. Her head is covered with a wig of short curls arranged in regular rows. The details of the dress and jewels are engraved in outline on the bronze inlaid with a line of silver wire. The face is a portrait and indicates

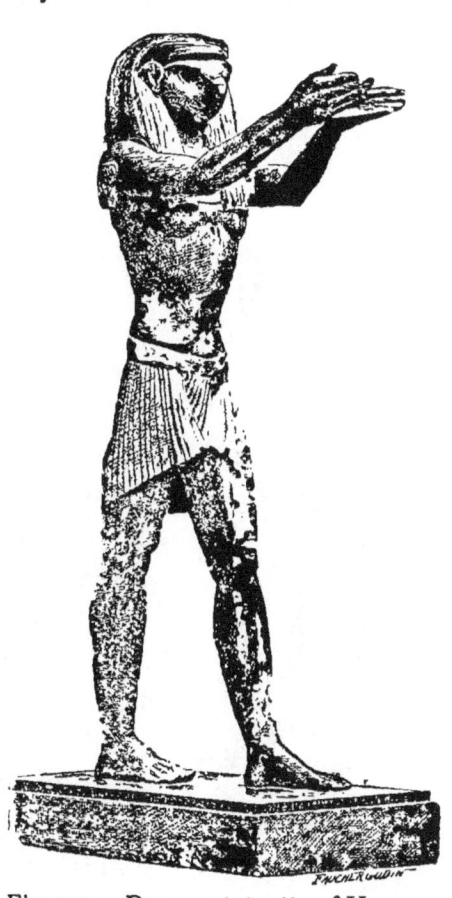

Fig. 309.—Bronze statuette of Horus.

a woman of mature age, while the body, following the traditions of the Egyptian school, is that of a girl, upright, firm, and supple. There is a large admixture of gold in the copper, and the soft lustre harmonises in the happiest manner with the rich ornamentation of the embroidery. The kneeling genius of Cairo, on the contrary, produces a rough and harsh effect. He is adoring the rising sun as was the bounden duty of the genii of Heliopolis; he is hawk-headed, his right arm is sharply raised, the left is folded on his breast. The whole style is dry and the impression of harshness is increased by the granulated surface of the skin, but the movement is correct and energetic, and the bird's head is adjusted to the human body with consummate skill.

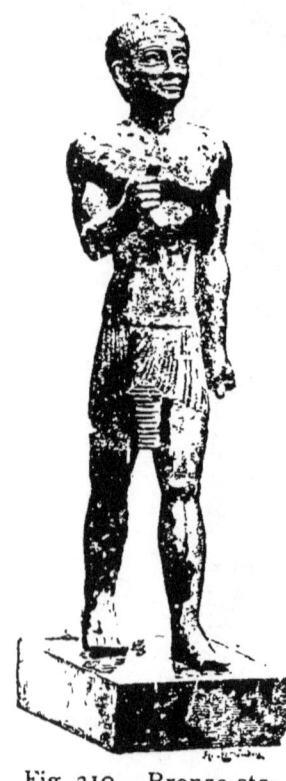

Fig. 310.—Bronze statuette of Mosû.

The same merits and demerits distinguish the Horus of the Louvre (fig. 309). Standing with outstretched arms, he is carefully pouring the contents of a libation vase over a king. Both vase and king have now disappeared. The other three figures are far better finished, especially one that bears the name of Mosû inscribed on the breast (fig. 310). Like Horus, he is standing with the left leg advanced, the left arm pendent, while the right hand once held the staff of

office. He is girdled with a striped waist-cloth, the end of which falls squarely in front. On the head is a wig formed of rows of small fine curls. The ear is large and round, the well-opened eyes were once inlaid with silver, which has been stolen by some native. The features bear a marked expression of pride and determination.

Of the numberless statuettes of Osiris, Isis, Nephthys, Horus, and Nefertûm that have been recovered from Saqqara, Bubastis, and other cities of the Delta, there is little to be said. Many, no doubt, are charming subjects for a glass case. The casting is faultless, and they are worked with great delicacy, but most of them are merely articles of commerce, made on the same pattern, and possibly cast in the same moulds, for centuries, for the edification of pilgrims and devotees. They are feeble and commonplace, and can no more be distinguished from each other than the figures or coloured pictures of saints sold by hundreds in Europe to-day. Figures of animals, rams, sphinxes, and more especially of lions, on the contrary, maintained their individuality. The Egyptians had a special predilection for the feline tribe; they represented the lion in all possible attitudes, chasing the antelope, attacking the huntsman, wounded and biting the wound, or in calm, disdainful repose. No nation has represented him with so intimate a knowledge of his habits, nor with such intensity of life. Several of the divinities, Shû, Anhûri, Bast, Sekhet, Tefnût, were of cat or lion form, and as their cult was specially popular in the Delta, scarcely a year passes without discoveries

being made at Bubastis, Tanis, Mendes, or some other less well-known town of large deposits of thousands of figures of these animals, or of human figures with lions' or cats' heads. Our museums are crowded with the cats of Bubastis or the lions of Tell es Saba.

The Horbeit lions may be reckoned among the masterpieces of Egyptian statuary. The name of Apries is inscribed on the largest of them (fig. 311).

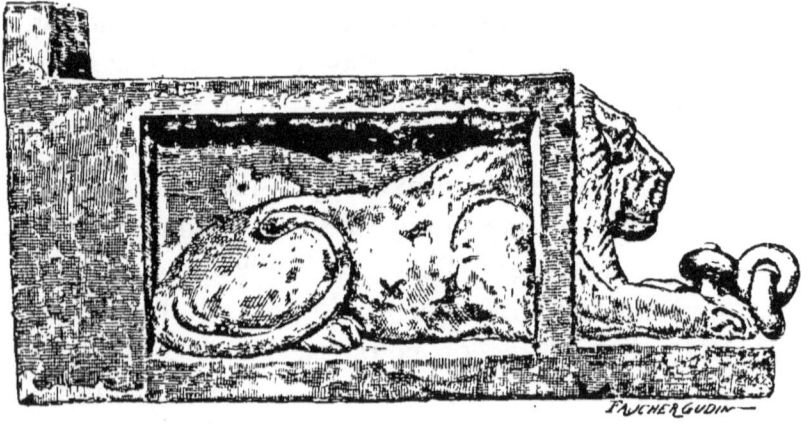

Fig. 311.—Bronze lion from Horbeit, Saïte period.

It formed part of the fastening of a temple door, and the back of the object was fixed with a wooden beam. The animal is caught in a trap, or is lying in a cage from which its head and forepaws protrude. The lines of the body are simple and full of power, and the expression of the face shows calm strength. In breadth of treatment and majestic demeanour it almost rivals the fine limestone lions of Amenhotep III.

The idea of overlaying stone or wood with gold

was familiar in Egypt before the time of Menes. Many of the earliest stone vases have handles and rim covered with gold-leaf, and limestone beads are also overlaid with it. The gold is often mixed with silver. When amalgamated to the extent of 20 per cent. it changes its name, and is called electrum. Electrum has a fine pale yellow colour, which becomes paler as the proportion of silver is increased, and at 60 per cent. it is almost white. Silver was brought from Asia in rings, sheets, and blocks of standard weight. Gold was also brought from Syria in rings and blocks, and from the Sûdan and from the Libyan Desert to the west of the Red Sea in nuggets and gold-dust. The processes of refining and smelting gold are represented on monuments of the early dynasties. On a bas-relief at Saqqara there is a record of the amount of gold entrusted to a craftsman for some piece of work, on another at Thebes the goldsmith is seated in front of his crucible holding his blowpipe to his lips to fan the flame, while his right hand grasps the pincers ready to seize the ingot (fig. 312).

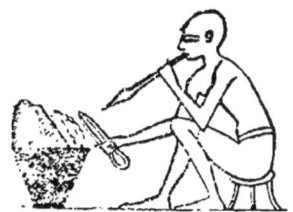

Fig. 312.—Gold worker.

The Egyptians struck neither coins nor medals, but with this exception they made the same use that we do of the precious metals. We gild the crosses and cupolas of our churches; they covered the doors of the temples with gold, as well as the lower part of the walls, certain bas-reliefs, pyramidions of obelisks, and even the obelisks themselves. The obelisks of

Queen Hatshepsût at Karnak were thickly coated with electrum. "They were beheld from the two banks of the Nile; both the lands of Egypt were illuminated by the splendour of their reflection when the sun rose between them as it rises on the horizon of heaven."

The sheets of gold employed for these obelisks were forged on an anvil with a hammer, but for smaller objects small pellets were beaten flat between two pieces of parchment. The Louvre possesses a perfect goldsmith's book, and the gold-leaf it contains is as fine as that used in Germany in the eighteenth century. It was applied to bronze by means of an ammoniacal mordant.

A wooden statuette that had to be gilded was first covered with a fine linen material or a thin coating of stucco, and then overlaid with gold or silver. Statues of Thoth, Horus, and Nefertûm in gilded wood existed as early as the time of Khûfû. The temple of Isis, "Mistress of the Pyramid," contained a dozen of these, and this chapel was by no means one of the largest in the Memphite necropolis. The Theban temples seem to have possessed some hundreds, at any rate under the conquering dynasties of the New Kingdom, and the Ptolemaic temples were no less well provided.

But bronze or gilded wood did not always content the Egyptian deities. They demanded solid gold, and it was unhesitatingly lavished upon them. The sovereigns both of the Ancient and the Middle Kingdoms dedicated statues cast or worked in the precious metals, while the Pharaohs of the Eighteenth and

Nineteenth Dynasties, who could draw almost at will on the treasures of Asia, surpassed all that had been done in this respect by their predecessors. Even during the decadent period we find feudal lords continuing the tradition of the past, and like Mentûemhat, prince of Thebes, they replaced the images of gold or silver carried off from Karnak by the generals of Ashurbânipal during the Assyrian invasions. The amount of precious metal thus devoted to the service of the supreme god must have been considerable. Numbers of small figures measured only an inch or two in height; others measured three or more cubits. Some were made entirely either of silver or gold, others are partly gold, partly silver; others, again, rival the Greek chrys-elephantine statuary, where the gold is combined with carved ivory, ebony, and precious stones. Bas-reliefs at Karnak, Medinet Habû, at Denderah and elsewhere, represent these statues, and show us what they were like, and so does the statuary in limestone or wood; the material may be different, but the style is the same. There is nothing more perishable than such work—the value of the materials foredooms it to destruction. All that survived the civil wars, foreign invasion, and the rapacity of the Pharaohs and Roman governors, fell a prey to the iconoclasm of the Christians. A few small figures in guise of amulets concealed in the mummies, a few statuettes once adored as domestic Lares, found among the ruins of houses, and some ex-votos lost in obscure corners of a temple, are all that have come to us of figures of divinities. An electrum statue of a youth

of the time of the Eighteenth Dynasty was found in a private tomb close to the valley temple of Hatshepsût at Deir el Baharî. It is 5¼ inches high. The figure is nude. In one hand the boy clasps a lotus bud with its long stem. The work is not highly finished, but the modelling is delicate and subtle.*

Fig. 313.—Gold cup of Tahûti, Eighteenth Dynasty.

This is not a religious piece. The figures of Ptah and Amon, belonging to Queen Aahhotep, another Amon at Cairo, and the silver vulture from Medinet Habû, are so far the only other pieces that can with certainty be attributed to the New Kingdom. The remainder belong to the Saïtic and Ptolemaic periods, and are only distinguished by perfection of workmanship.

The vessels of the temples and palaces have varied little better than the statuary. Early in the nineteenth century the Louvre acquired some flat-bottomed bowls or cups that had been presented by Thothmes III. to Tahûti, one of his generals, as a

Fig. 314.—Silver vase of Thmûis.

* Earl of Carnarvon, *Five Years' Explorations at Thebes*, 1912.

reward for valour. The silver cup is much mutilated; the gold cup is perfect, and of a very charming design (fig. 313). On the lateral side is a hieroglyph inscription; on the base a rosette is engraved, round which six fish are swimming; a border of lotus flowers united by a curved line surrounds the central design. The five vases of Thmûis, in the Cairo Museum, are of silver. They formed part of the temple property, and were concealed in a hiding-place from which they have only recently been removed. They date from the end of the Saïtic age or the beginning of the Ptolemaic period, but the workmanship is purely Egyptian. Of one, only the cover remains, with a handle consisting of two flowers on one stem. The others are perfect, and decorated in *repoussé* work with lotus lilies in bud and blossom (fig. 314). The form is simple and graceful, the ornamentation sober and delicate, the relief low. One, however, is surrounded by a row of ovoid bosses (fig. 315), with well-marked projections that somewhat alter the outline of the bowl.

Fig. 315.—Silver vase of Thmûis.

Fig. 316.—Ornamental vase in precious metal, from wall painting, Twentieth Dynasty.

In 1906 the Cairo Museum was enriched by a large number of gold and silver vessels, discovered with other treasures at Zagazig and elsewhere. Some of them date from the Nineteenth Dynasty, and bear

witness to the great skill of the gold-workers of that time. There are numerous flat silver cups, similar in form to that of General Tahûti, but far more elaborately decorated with *repoussé* work and with the point. Two gold jugs belonged to Queen Taûsert. One of these is covered all over the body with a series of bosses in *repoussé* work; round the neck four bands of floral designs are engraved, and immediately below the rim is a figure of an ox, with a hole through which is passed a ring for suspension. There is also a silver jug, with a gold handle in form of a goat. The animal is straining upwards, and its lips rest on the rim of the jug. The lower part of the jug is covered with rows of flowers in *repoussé* work.* The whole forms a real masterpiece.

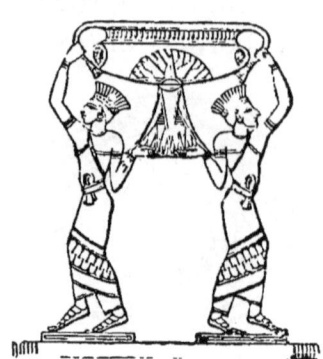

Fig. 317.—Crater of precious metal, wall painting, Eighteenth Dynasty.

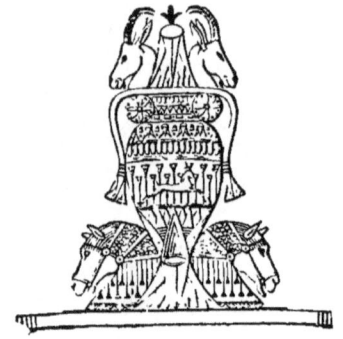

Fig. 318.—Hydria of precious metal, wall painting, Eighteenth Dynasty.

The Pharaohs had not our commercial resources, and could not circulate the gold and silver extorted from conquered nations in the form of coin. After deducting the share devoted to the gods they had no alternative but to melt the remainder into ingots or to convert their share of the booty into vessels of gold and silver or

* G. Maspero, *Guide to the Cairo Museum*, 1910, pp. 401 *et seq.*

GOLD AND SILVER WORK. 353

into jewellery. This was the case also with private persons, and from the time of Aahmes I. during at least six or eight centuries the taste for worked silver was indulged to an extravagant extent. All houses of any consequence contained not only what was required for the service of the table, dishes, ewers, cups, goblets, and baskets on which fantastic figures of animals were engraved and embossed (fig. 316), but they were also provided with large vases intended to be filled with flowers and displayed on gala days before invited guests. We have seen from the specimens we possess that some of them were of extraordinary richness, and also that some at least of the vases depicted on the monuments were copied from those in actual use, and we can turn to the wall paintings to show us the variety of forms in which they were fashioned. Here for instance is a crater with handles formed of two papyrus buds, and the foot of two full-blown blossoms; two Asiatics in sumptuous garments appear to be lifting it by exerting their full strength (fig. 317). Or again we find a kind of elongated hydria with a cover in the form of a lotus flanked by the heads of two gazelles (fig. 318); two horses' heads, bridled and caparisoned, are placed back to back at the foot. The body of the vase is divided into

Fig. 319. — Enamelled cruet, wall painting, Eighteenth Dynasty.

Fig. 320. — Enamelled cruet, wall painting, Eighteenth Dynasty.

23

horizontal zones of which the centre one represents a marsh, with an antelope careering at full speed. Two enamelled cruets are surmounted, one with the plumed head of an eagle (fig. 319), the other with the head of the god Bes between two serpents (fig. 320). A gold centrepiece (fig. 321) sent to Amenhotep III. by a viceroy of Ethiopia represents one of

Fig. 321.—Gold centrepiece of Amenhotep III., wall painting, Eighteenth Dynasty.

the most usual scenes of Egyptian conquest. A group of men and apes are gathering fruit in a grove of dôm-palms, two natives in striped waist-cloths, with a long feather stuck in their hair, are each of them leading a tame giraffe on a leash. Other men of the same tribe are kneeling on the ground and begging for mercy from the Egyptian soldiery, while negro prisoners laid flat on the ground are with difficulty raising their heads and shoulders. A cup with a shallow base and a high conical cover stands up among the trees.

Fig. 322.—Crater of precious metal, wall painting, Eighteenth Dynasty.

Evidently the workmen who carried out this design studied richness and effectiveness more than grace and beauty of design. It mattered little to them that the whole effect was heavy or in bad taste if only they could display their skill and the amount of

precious metal they had at their disposal. Other centrepieces of the same type are represented among the offerings made to Rameses II. at Abû Simbel. Here buffaloes instead of giraffes are wandering loose among the palms. These were costly toys similar to those collected by the Byzantine emperors of the ninth century in their palace at Magnaura, and which they exhibited on gala days to impress strangers. When the Pharaoh returned victorious from his distant campaigns these vases were carried in state in his triumphal processions, of which his unfortunate captives also formed part.

Fig. 323.—Crater of precious metal, wall painting, Eighteenth Dynasty.

Vases for ordinary use were of simpler form and less loaded with unnecessary ornament. The two leopards that serve as handles to a crater of the time of Thothmes III. (fig. 322) are not well proportioned and do not harmonise with the form of the crater. They are far from equal to the goat on the jug of Taûsert. The crater, however (fig. 323), and ewer (fig. 324) belonging to the same service are very happily conceived and have much beauty of form.

Fig. 324.—Ewer of precious metal, wall painting, Eighteenth Dynasty.

These gold and silver vases, engraved, hammered, and *repoussé*, and some of them bearing battle or sporting scenes arranged in zones were imitated in Phœnicia, and when exported into Asia Minor,

Greece, and Italy, introduced into those countries many other shapes and designs of Egyptian gold and silver work. The passion for precious metals went so far under the Ramessides that they were not content to employ them for the service of the table. Both Rameses II. and Rameses III. had thrones of gold, not merely overlaid, but of solid gold encrusted with precious stones. These were far too costly to last, and they disappeared on the first opportunity. Their artistic importance did not equal their intrinsic value, and we need not mourn their loss.

All orientals, whether men or women, are great lovers of jewellery, and the Egyptians were no exception to the rule. Not content with wearing it in profusion during their lifetime, they also loaded the arms, fingers, neck, ears, forehead, and ankles of their dead with ornaments. The quantity they deposited in the tombs was so great that even now, after thirty centuries of active search, mummies are still found from time to time that may be said to be sheathed in gold. Many of these gold ornaments were merely made for show on the day of the funeral, and the workmanship bears witness to the purpose for which they were intended. But in many cases the favourite jewellery of the deceased was buried with them and then the careful workmanship leaves nothing to be desired. As is only natural, a great number of rings and chains have survived to our time; the ring was not merely an ornament as it is with us, but an object of primary necessity; it was used for official sealing, and the seal held good in law. Thus every

Egyptian had his own ring that he carried with him in case of need. The ring of the poor man was merely of copper or silver, the ring of the rich was more or less elaborately chased and ornamented with reliefs. The movable bezel turned on a pivot, and was frequently set with an engraved stone bearing a device or emblem chosen by the owner, such as a scorpion (fig. 325), a lion, a sparrow-hawk, or a cynocephalous ape. For the Egyptian woman the chain was of as great importance as was the ring for her husband; it was her chief ornament. I have seen one in silver that measured 63 inches in length, while others are barely 2 or 2¼ inches long. They are made in every variety of pattern, in double or treble rows, with large or small links, solid and heavy, or as light and flexible as the finest Venetian chain. The poorest peasant could possess one as well as the ladies of the royal harem, but the woman must indeed have been poor whose dowry did not include something more. No list could give an adequate idea of the amount and variety of jewellery known to us. Berlin possesses the jewellery of an Ethiopian Candace, and the Louvre has that of Prince Psar, but the jewel room at Cairo possesses a wealth of gold, silver, and enamelled work which forms a complete history of Egyptian jewellery.

Fig. 325.—Signet-ring with bezel.

There are the four bracelets found on a piece of an arm of a woman in the tomb of King Zer, of the beginning of the First Dynasty, at Abydos. The bracelets are made of pure soft gold, turquoise, dark

purple lazuli, amethyst, and a kind of glaze or vitreous paste. One (fig. 326) is made of alternate plaques of gold and torquoise, the design being a house door surmounted by a hawk, the symbolic figure that

Fig. 326.

Fig. 327.

Fig. 328.

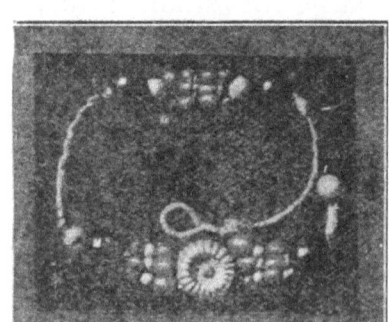
Fig. 329.

Bracelets, First Dynasty.

throughout historic times encloses the "Horus name" of the Pharaohs. The turquoise plaques show signs of re-threading, and the style of the carving indicates that they are somewhat earlier than the rest of the work. Two bracelets (figs. 327, 328) are formed of beads of various shapes finely cut and elaborately

JEWELLERY.

threaded. The fourth (fig. 329) has a gold flower of very beautiful workmanship.

The jewellery of the Old Kingdom is still very rare. There are necklaces formed of gold links copied from a shell the *cypræa*; a minute gold lion, and a fine wasp used as pendants, and some *repoussé* figures of animals in thin gold-leaf.*

Fig. 330.—Gold *cloisonne* pectoral, bearing cartouche of Senûsert III. Fron Dahshûr.

The treasure of Dahshûr consists of a mass of pectorals, rings, bracelets, necklaces, chains, pendants, and diadems that belonged to the wives of three of the Pharaohs of the Twelfth Dynasty. The pectorals of gold *cloisonné* work inlaid with vitreous paste or precious stones, which bear the cartouches of Senûsert II., Senûsert III. (fig. 330), and Amenemhat III.,

* G. Maspero, *Guide to the Cairo Museum*, 1910, p. 383.

exhibit marvellous precision of taste, lightness of touch, and dexterity of fine workmanship. There are two crowns. One is merely a delicate framework of gold threads united at six regular intervals by flowers with a carnelian centre and blue petals and sprinkled with tiny flowers also in red and blue. It could never have been worn; the weight of the flowers would have been too much for the delicate framework, and it must have been made expressly to be placed in a tomb. The second diadem has an alternative pattern of rosettes and lyres formed of gold, carnelian, lapis lazuli, red jasper, and felspar.

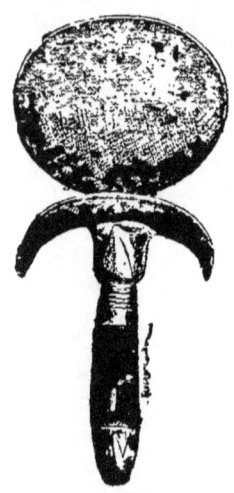

Fig. 331.—Mirror of Queen Aahhotep.

The ornaments of Queen Aahhotep are far more substantial, and were made for use by the living. Aahhotep was the wife of Kames, a king of the Seventeenth Dynasty, and she was probably the mother of Aahmes I., first king of the Eighteenth Dynasty. Her mummy had been stolen by one of the robber bands that infested the Theban necropolis towards the close of the Twentieth Dynasty. They buried the royal corpse till they had an opportunity of despoiling it unobserved. They were probably seized and executed before they were able to carry out their project. The secret of their hiding-place remained undiscovered until some Arab diggers hit on the spot in 1859. The equipment provided for this queen consisted almost entirely of women's gear, jewellery, and

weapons; there was a fan handle laminated with gold and a mirror of bronze-gilt with an ebony handle ending in a gold lotus flower (fig. 331).

The bracelets are of various types. Some were intended for anklets or to be placed on the upper part of the arm. These are plain gold circles either solid or hollow, edged with a species of filigree made of plaited gold wire. Others were intended for the wrist, and they are made of beads in gold, lapis lazuli,

Fig. 332.—Bracelet of Queen Aahhotep, bearing cartouche of Aahmes I.

carnelian, or in green felspar, threaded on strips of gold and arranged in squares, each divided diagonally in halves of different colours. Two gold plates on which the cartouche of Aahmes I. are lightly engraved with the point form the fastening, and are connected by means of a gold pin. A very beautiful hinged bracelet belonging to the same king (fig. 332) suggests to some extent the methods employed in the manufacture of *cloisonné* enamels. Aahmes is kneeling before the god Geb, and his acolytes the genii of Sopû and Khonû. The figures and hieroglyphs are

delicately worked with the burin on a gold plaque. The background is filled in with blue paste and lapis lazuli artistically carved. A bracelet of more complicated design, but of less fine workmanship, was placed on the wrist of the Queen (fig. 333). It is of solid gold and consists of three parallel bands set with turquoises. In front is a vulture with outspread wings; the feathers, rendered in green enamels, lapis lazuli, and carnelian are inserted in gold cloisons.

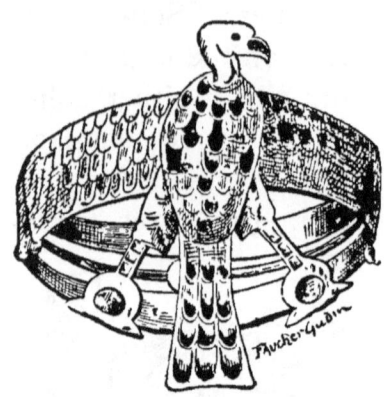

Fig. 333.—Bracelet of Queen Aahhotep.

The hair of the Queen was drawn through a massive gold crown, scarcely larger than a bracelet. On the oblong plaque fixed to the circlet is the name of Aahmes inlaid in blue paste, while a small sphinx at each end, appear to keep watch and ward over him (fig. 334). A thick flexible gold chain was twisted round the neck, finished at each end by the head of a goose which served to fasten the chain.

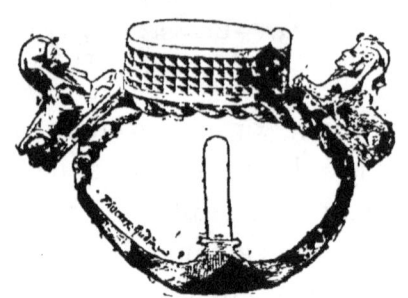

Fig. 334.—Diadem of Queen Aahhotep.

Attached as a pendant to this chain was a scarab with feet and body of solid gold, and thorax and wing-cases of blue vitreous paste striped with gold.

The decorations laid on the breast of the mummy

were completed by a large necklace of the kind known as the *ûsekh* (fig. 335). The fastening was

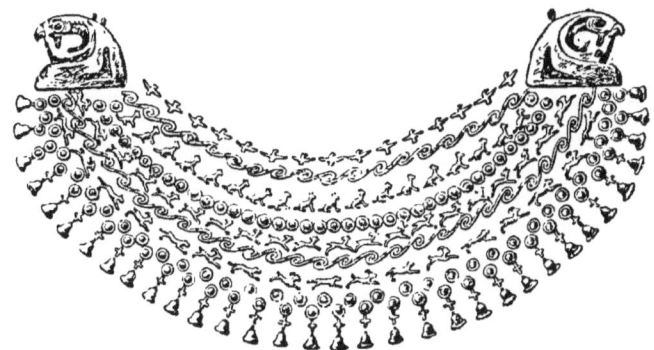

Fig. 335.—Gold *ûsekh* of Queen Aahhotep.

formed of two falcons' heads in gold, the details worked out in blue enamel. The rows of the necklace are composed of scrolls, of four-petalled flowers, of ante-

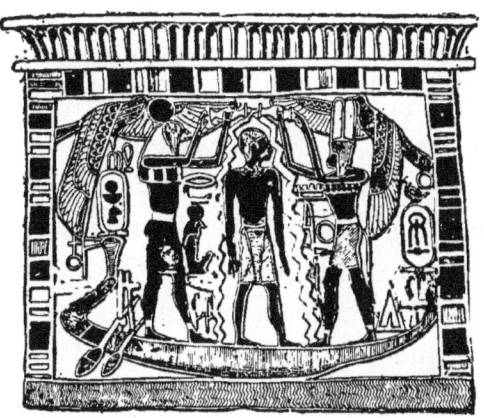

Fig. 336.—Pectoral of Queen Aahhotep, bearing cartouche of Aahmes I.

lopes pursued by tigers, of crouching jackals, winged uraei, falcons and vultures. All of these are in gold *repoussé* work, and were attached to the winding-

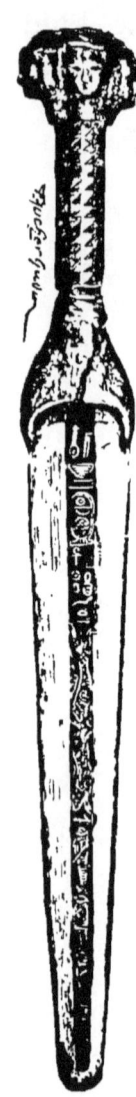

Fig. 337.—Poniard of Queen Aahhotep, bearing cartouche of Ahmes I.

sheet by a ring fixed to the back of each object. Below this, one of the square plaques to which the name of pectoral is given (fig. 336) was hung on the breast. In general appearance this resembles a naos. Aahmes is standing between Amon and Ra, who are pouring over his head and body the water intended for his purification. The figures are outlined in gold cloisons, once filled in with small stones and enamels, many of which have fallen out. The piece is somewhat heavy, and it is not easy to understand the use to which it was put. In order to do so we must recall the clothing worn by Egyptian women, a sort of tight dress of semi-transparent material that ended just above the waist, leaving the upper part of the body bare except for the narrow pair of braces that held up the garment. This bare space was covered with jewellery by the rich. The necklace half concealed the shoulders and neck, the pectoral filled in the space between the breasts, and the breasts themselves were frequently covered with two gold caps either painted or enamelled.

In addition to the jewellery, weapons and amulets were heaped up in confusion. There were large massive gold flies suspended on a fine gold chain, nine small axes, three in gold and six in silver, the head of a lion in gold of minutely detailed work, a

FUNERARY WEAPONS OF QUEEN AAHHOTEP.

sceptre in black wood decorated with gold spirals, two anklets, and two poniards. One of these (fig. 337) has a gold sheath; the wooden handle is decorated with triangles of carnelian, lapis lazuli, felspar, and gold; the knob is formed of four female heads in gold *repoussé* work; a bull's head in gold conceals the juncture of the handle and the blade. The edges of the blade are of solid gold, the central part of black bronze damascened in gold. On the upper face, below the prenomen of Aahmes, there is a lion chasing a bull opposite four huge grasshoppers, placed one behind another; on the lower face we find the name of Aahmes, followed by fifteen flowers opening one out of another and diminishing in size to the point. Several daggers discovered by Dr. Schliemann at Mycenæ are similarly decorated. The second dagger found with the Queen (fig. 338) is of a pattern not infrequently found at the present day in Persia and India. The blade is of yellowish bronze, very heavy, with a handle formed of a lenticular silver disc.

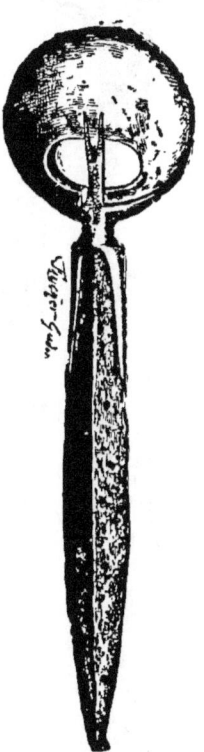

Fig. 338.— Poniard of Queen Aahhotep.

When in use the handle was held in the hollow of the hand, and the blade was passed between the index and the middle fingers. It may be asked what use a woman, and moreover a dead woman, could possibly have for so many weapons. The other world swarmed with

enemies against whom it was necessary to struggle unceasingly — there were Typhonian genii, serpents, gigantic scorpions, tortoises, monsters of every description. The daggers deposited in the coffin with the mummy helped the soul to protect itself, and as they could only be used in a fight at close quarters, projectiles were added, bows and arrows, boomerangs of hard wood, and a war axe. The handle of the axe is in cedar-wood covered with gold-leaf (fig. 339). The name and titles of Aahmes are inscribed on it in characters of lapis lazuli, carnelian, turquoise, and green felspar. The head is inserted in a notch in the wood and held in place by strips of gold bound round it. It is in black bronze and has been gilded; one of the two faces has lotus flowers in precious stones on gold; on the other face is Aahmes striking a prostrate barbarian, whom he is grasping by the hair; and below is Mont, the Theban war-god, in the likeness of an eagle-headed griffin. Two boats in gold and silver represent the barge on which the mummy crossed the river to reach its last resting-place, and in which the Queen would also navigate the waters of the West in the company of the gods. The silver boat was

Fig. 339.—Battle-axe of Queen Aahhotep.

DECADENCE OF JEWELLERS' ART. 367

mounted on a wooden chariot with four bronze wheels, but as it was in bad condition it was taken off its carriage and replaced by the boat made of gold (fig. 340). The hull is long and narrow, the prow and stern end in tufts of papyrus gracefully curved inwards. On the poop and at the prow are two raised platforms surrounded by a solid balustrade, to take the place of a quarter-deck. The pilot is standing on one of them, and the steersman in front of the other is working the wide oar that serves as a

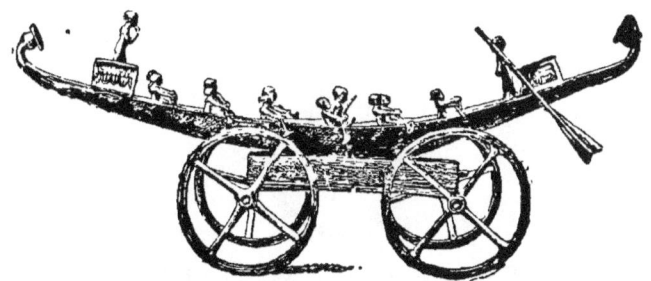

Fig. 340.—Funerary bark of Queen Aahhotep. The boat is gold, the men are silver.

rudder. Twelve oarsmen in solid silver are rowing under the orders of these two officers. In the centre Kames is seated holding the sceptre and axe.

All this provision was made for one single mummy, and I have only enumerated the most remarkable objects. The technique is irreproachable, and the good taste of the craftsman is as assured as the dexterity of his work. This high degree of perfection was not long maintained. Fashions changed, and jewellery became heavier in design. The ring of Rameses II. in the Louvre, with the pawing horse on

the bezel (fig. 341), the bracelet of Prince Psar (fig. 342), with griffins and lotus in *cloisonné* enamel, are less happy in design than the bracelet of Aahmes. The jewellers who made them were no less expert than the craftsmen of Queen Aahhotep, but their taste and inventive faculty were inferior. Rameses II. must either refrain from wearing his ring or be prepared to see his little horses damaged by the slightest blow. This decadence, already observable in the Nineteenth Dynasty, becomes more marked as we approach the Christian era. The ear-studs of Rameses IX. in the Cairo Museum are an inartistic

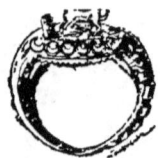

Fig. 341.—Ring of Rameses II.

medley of filigree work, small chains, and pendent uræi, such as no ear could have worn without the lobe being greatly enlarged and deformed. They were found attached to the wig on the head of the mummy.

The bracelets of the high-priest Pinotem III., found on the arms of the mummy, are mere circles of gold rounded and encrusted with coloured glass and carnelian, similar to those still made by the Sûdanese blacks. The settlement of Greeks in Egypt only very gradually modified the style of Egyptian gold work, although eventually Greek types were substituted for native art. The gold jewels

discovered at Saqqara in coffins of the Persian period are purely indigenous in style. The jewellery of an Ethiopian queen, purchased from Ferlini by the Berlin Museum, comprised, in addition to objects that might well be attributed to the Pharaonic period, others of a mixed style where Hellenic influence is easily recognisable. The treasures discovered at Zagazig in 1878, at Keneh in 1881, and at Damanhûr in 1882 are completely alien to Egyptian art and traditions ; here are hairpins surmounted by a figure

Fig. 342.—Bracelet of Prince Psar.

of Venus, waist-buckles, agraffes for the peplum, rings and bracelets set with cameos, and coffers flanked at the four corners with Ionic columns. The ancient models were, however, still held in honour in the country districts, and the village goldsmith followed with fair success the ancient traditions, while their servile fellow craftsmen of the cities copied Greek and Roman models.

In this rapid survey of the industrial arts there are only too many omissions. I have been forced to confine myself to quoting examples only from well-

known collections, but there is much to be learnt from those who have the leisure to visit our provincial museums, and also to examine the specimens that have passed by purchase into private hands. There is an immense variety of small objects which illustrate the industrial arts of ancient Egypt, and a methodical study of them has yet to be done. It is a task that holds out a promise of infinite pleasure and interest to the student who undertakes it.

INDEX.

AAHHOTEP 181, 342, 350, 360-7.
Aahhotep II. 323.
Aahmes I. 299, 301, 322, 342, 352, 360-7.
Aahmes II. 302.
Aahmesnefertari 323.
Aalû, fields of 198 (see ELYSIAN FIELDS).
Abacus 61, 63, 68, 133.
Abi 309.
Abû Gûrab 78.
Abû Roash 130, 159.
Abû Simbel 61, 96, 230, 260, 262, 263, 355.
Abûsîr 65, 68, 78, 107, 132, 163.
Abydos 1, 2, 3, 26, 28, 29, 171, 230, 255, 292, 309.
 art of 234, 262.
 fort of 32, 33.
 royal tombs of 3, 26, 282, 357.
Acacia 229, 248, 310, 318.
Adze 55, 338.
Agate 275, 277.
Agraffes 369.
Ahnas el Medineh 293.
Aï 16, 179.
Akhenaten 14, 16, 20, 179, 257, 258, 295.
Alabaster 7, 48, 53, 74, 76, 101, 189, 194, 243, 250, 281, 282, 283, 284, 286, 304, 309, 325.
Alexander, tomb of 270.
Alexander II., colossus of 269.
Alexandria 60, 269, 270, 271.
Altar 73, 80, 100, 125, 282, 305.
Alumina 293.
Amasis 336.
Amber 277.
Amenemhat II. 90.

Amenemhat III. 90, 168, 254, 359.
Amenemhat IV. 309.
Amenhotep I. 181, 182, 256, 322.
Amenhotep II. 61, 256, 302.
Amenhotep III. 61, 82, 92, 94, 121, 172, 206, 253, 257, 300, 311, 346, 354.
Ameni 174, 176.
Ameni Entef Amenemhet 125.
Ameniritis 264.
Amethyst 276, 277, 280, 358.
Amon 114, 119, 121, 123, 127, 260, 279, 280, 301, 342, 350, 364.
Amon Ra 113.
Amphora 42, 211, 297.
Amulets 55, 116, 118, 191, 274, 276, 277, 296, 298, 300, 340, 349, 364.
Andro-sphinx 105, 257.
Angareb, or Nubian bed 317, 327.
Angulated grooving 9, 31, 86, 148.
Anhûri 345.
Animal figures 201, 239, 257, 306, 336, 337, 345, 359.
 sacrifice 55, 88, 112, 113, 184.
 skins as shields 201.
Ankh amulet 321, 323.
Anklets 361, 365.
Anna 256.
Antef 299.
Antelope 202, 345, 354, 363.
Antimony 285, 300.
Antonines, the 272, 273.
Antoninus Pius 118.

INDEX.

Anubis 139, 188, 193, 339.
Anvil 348.
Ape 196, 225, 354 (see also CYNOCEPHALI).
Apis bull 172, 296.
Apopi (serpent) 188.
Apries (Hophra) 302, 346.
Aquamarine 277.
Arch 9, 59.
Archaic period 44, 130 (see PREDYNASTIC and THINITE PERIODS).
Archers 210, 216.
Architraves 53, 59, 63, 112, 175.
Argo, Island of 254.
Arrow-heads 276.
Art, decadence of 186, 263, 368.
 duality in 114.
 influence of court on 235, 263.
 schools 234, 255, 263, 264, 269, 271, 272.
Artists' models 195.
 palettes 195.
Ashmolean Museum, Oxford 44, 192, 193, 231, 233.
Ashurbânipal 349.
Asia Minor 278, 355.
Asiatics 109, 305, 341, 353.
Ass 196, 202.
Assûan 51, 82, 91, 173, 174, 252, 271, 293, 298.
 art school of 235, 271.
Assyria 349.
Astronomical figures 112, 187.
Athena 336.
Athens 343.
Ati 168.
Attitudes in statuary 239, 240, 245, 266, 267.
Atûm 123.
Axe 338, 364, 366, 367.
Axûm 123.

Ba, the soul 128, 280.
 transmigration of 188.
Babylonia 282.
Baityle 121.
Bakenrenf 189.

Bark, sacred 81, 91, 126 (see BOAT OF THE SUN).
Barrage 47.
Basalt 48, 163, 194, 222, 264, 266, 282.
Basket 353.
 work designs on pottery 289.
Bas-reliefs 40, 163, 219, 223, 225, 250, 255, 256, 258, 260, 261, 264, 267, 271, 273, 347, 349.
Bast 193, 345.
Bath 11, 25.
Beads 275, 277, 294, 338, 347, 358, 361.
Beams laid in brickwork 6, 7.
Bed 307, 317, 327, 328.
Bedouîn 48, 119.
Begig 123.
Beit el Wally 98, 230.
Belief in rewards and punishments 178, 179.
Benben stone 121.
Beni Hasan 66, 96, 173, 174, 176, 179, 191, 203, 252, 331.
Berlin 357, 369.
Bersheh 172, 173, 252.
Bes 61, 65, 285, 313, 354.
Biographies on tombs 179, 180.
Birds with human arms 109, 305.
Birket el Karûn 45.
Block houses 38.
Blow pipe 339, 347.
Boat 191, 212, 289, 315, 335, 366.
 of the sun 80, 126, 183, 187.
Bone 306.
Book of the Dead 169, 181, 189, 197, 230, 320.
Book of Knowing that which is in the Underworld 197.
Book of Opening of the Mouth 189.
Boomerangs 308, 366.
Boston 148, 243, 244, 306.
Bracelet 279, 295, 343, 357, 358, 359, 361, 362, 368, 369.
Braces 332, 364.

INDEX. 373

Breccia 48, 264, 281, 286
Bricks,—
 burnt 4.
 concave courses of 34, 104.
 glazed 5, 302 *et seq.*, 306.
 made with straw 131.
 marked with royal name 4.
 moulds for 3, 4.
 sizes of 4, 131.
 unburnt 3, 104, 131, 169.
Bridge 41, 42.
British Museum 256, 305, 329.
Bronze 122, 221, 223, 244, 245, 291, 339, 340, 342, 348, 361, 365.
 gilded 361, 366.
Brush, artist's 195, 196, 200, 219, 228, 290.
Bubastis 2, 60, 105, 299, 343, 345, 346.
Bubastites 93, 333.
Buffaloes 355.
Builders of Great Pyramid 148, 248.
Bull 276, 308, 365 (see APIS).
Burin 362.
Byzantine emperors 355.

Cabinet-making 318, 319, 327 *et seq.*
Cæsars (Græco-Roman period) 5, 66, 81, 107, 116, 198, 237, 271, 326, 327, 328, 337.
Cairo Museum 5, 123, 125, 199, 221, 222, 227, 233, 236, 242, 243, 244, 248, 250, 254, 256, 258, 261, 264, 265, 269, 289, 296, 299, 300, 301, 305, 306, 308, 311, 314, 321, 333, 341, 342, 343, 344, 350, 351, 357, 368.
Calaite 275.
Caligula 273.
Cameo 369.
Canaanite cities 38.
Canal 8, 41, 44, 51, 212.
Candace 357.
Canopic jars 191, 284, 292, 327.

Canopy 328, 329, 333, 335.
Capitals 51, 60, 65 *et seq.* (see also COLUMNS).
Caricature 196.
Carnelian 275, 278, 280, 294, 360, 361, 362, 365, 366, 368
Carpets 332.
Cartouches 55, 56, 68, 107, 280, 296, 297, 305, 314, 334, 337.
Casting 339, 340, 342, 345.
Cats 197, 345, 346.
Causeway, of temples 73, 76, 78, 100, 163.
Cedar-wood 309, 366.
Ceilings 2, 19, 108, 110, 166, 187.
Cella 83.
Cellars 42, 104.
Chains 356, 357, 359, 362, 364, 368.
Chairs 307, 317, 327, 329, 330, 331.
Chariot 113, 209, 258, 327, 367.
Chests 317, 318, 327.
Chisel 221, 222, 242, 338.
Chlamys 270.
Christianity 273, 349, 368.
Chrysoprase 277.
Cinnabar 228.
Claudius 273.
Cloisonné enamels 359, 361, 362, 364, 368.
Cobalt 294.
Coffers 307, 338, 369.
Coffins 173, 181, 191, 193, 292, 293, 319, 321 *et seq.*, 325, 369.
Coins 347, 352.
Colossi 96, 120, 121, 237, 254, 255, 257, 260, 262, 269.
Colours employed in painting, 201, 228.
 for flesh tints, 229, 230, 236, 312.
 for glass 294, 296, 297.
 for glaze 299, 300, 301.
 for ivory 307.
Columns 10, 53, 54, 60, 66, 70, 71, 107, 109, 163, 294.

Columns, campaniform or bell-shaped 63, 64, 86.
 Hathor-head 69, 70, 97.
 lotus-bud 66, 86, 92.
 palm-leaf 68, 78.
Combs 306, 308.
Composition, in art 194, 199, 205 et seq., 256.
Conception of earth and sky 108.
 of future life 128, 129, 181.
Constellations 111, 187.
Contra Latopolis 69.
Conventions of drawing 203 et seq.
Copper 42, 163, 223, 276, 294, 309, 338, 339, 340, 342, 344, 357.
 gilt 123.
 sulphate of 228.
Copperas 294.
Copts 338 (see also CHRISTIANITY).
Coral 277.
Corbelled vaulting 59, 103, 161, 170.
Cordage designs 288, 295.
Corinth, bronzes of, 339.
Corvée 248.
Counterforts 36.
Covering walls 32, 36, 37.
Cow 102, 256, 266.
Craters 353, 355.
Crio-sphinx 106.
Crocodile 196, 216.
Crowns 44, 360, 362.
Cruets 354.
Crypts 88, 97.
Crys-elephantine statuary 349.
Crystal 280, 281.
Cuirass 336.
Cuneiform tablets 24.
Cups, of precious metal 350, 352, 353, 354.
Cusæ, art of 257.
Cushions 331, 335.
Cynocephali 122, 188, 191, 357.
Cypriote type of vase 296.

Dad amulet 321.
Dado 109, 303.
Dagger 308, 365.
Dahshûr 81, 130, 132, 168, 359.
Damanhûr 369.
Dancing 141, 203, 206.
Daphnæ 43, 295.
Darkness of temples 87.
Decani 111.
Deceased, name and titles of 139, 143, 175, 291, 319.
Decoration of temples and tombs 77, 78, 80, 107, 112 et seq., 137, 166, 177, 187, 199, 213.
 of the golden collar 78.
Deir el Baharî 53, 69, 80, 98 et seq., 171, 206, 253, 256, 296, 297, 299, 309, 322, 337, 350.
Deir el Gebrawî 230.
Delta, art of 234, 263, 264, 269, 271, 345.
Denderah 61, 65, 69, 72, 105, 111, 118, 172, 272.
 art school of 234.
Derr 98.
Dice 308.
Diorite 48, 75, 189, 194, 222, 244, 250, 281, 282, 286.
Divans 317, 335.
Divine descent of Pharaohs 237, 241.
Dogs 196, 202, 313.
Doors, false 132, 136, 141, 143, 166.
 on sides of coffins 320.
Double or Ka 128, 129, 136, 139, 143, 166, 181, 186, 187, 241.
Dovetails 56.
Drah Abûl, Neggeh 171, 299.
Drain of hammered copper 163.
Drawing 186, 194, 202, 204.
Drill 221, 242, 277.
Ducks 296, 314, 317, 341.
Dwarf 241, 250, 251
Dyke 45.
 stone 47.

INDEX. 375

Eagle 354, 366.
Earrings 279, 315.
Earstuds 368.
Earthquake 94, 162, 272.
Ebony 246, 308, 309, 330, 349, 361.
Edfû 64, 65, 72, 105, 111, 118.
Edinburgh Museum 328.
Eggs, mummied 292.
Ekhmîm 234, 292, 326, 327, 331, 338.
El Hibeh 2, 40.
El Kab 2, 28, 29, 33, 34, 63, 84, 105, 230, 297.
Electrum 338, 347, 348, 349.
Elephant 306.
Elephantine 82, 83, 173, 306.
Elysian fields 186, 187, 191, 198.
Embalming 128, 143, 191.
Embroidery 336.
Emerald 48, 277, 280, 294.
Enamel 245, 248, 295, 301, 306, 318, 357, 362 (see also GLAZE and CLOISONNÉ).
Eshmûneyn 297.
Esneh 111, 168, 273.
Eternal house 129, 136, 191, 240.
Ethiopia 123, 168, 272, 264, 354, 357, 369.
Etruria 278.
Ewers 353, 355.
Exorcisms 167.
Eyes, inlaid 245, 248, 295, 345.
 mystic 278, 301.
 on sides of coffin 320.

Falcon 363.
False doors 132, 136, 141, 143, 166.
 necked vases 291.
Fan 361.
Fayûm 123, 293, 295, 326, 338.
Feast days 136.
Felspar 277, 278, 280, 360, 361, 366.

Feudalism 173, 191, 349.
Filigree 295, 361, 368.
Fingers as amulets 277.
Fireplace 13, 23.
Fish 288, 301, 314, 341, 351
Flint working 276.
Flooring of cylindrical pots 26.
Flowers 303, 304, 314, 316, 337, 353, 359, 360, 363, 365.
Fly, amulet 276, 364.
Fortnight 136, 187.
Fortress 2, 28 et seq.
Foundation 5, 6, 30, 54, 79.
 animal sacrificed for 55, 56.
 deposits 55.
Fox 314.
Frit 298, 304.
Frog 276, 278.
Funerary barge 141, 190, 335, 366.
 ceremonies 177, 187.
 cones 190, 291.
 feast 205, 211.
 furniture 189, 274, 307, 314, 317, 318.
 offerings 136, 139, 189, 190.
 procession 174, 177.
 ritual 169, 174, 181.
 temples 68, 98, 101, 257.
 workshop 256.

Gaming board 141, 308.
Garden 13, 15, 16, 25.
Garnet 277, 280.
Gazelle 141, 178, 190, 202, 203, 206, 217, 283, 284, 334, 341, 353.
Geb 361.
Gebel Abû Fedah 51.
Gebel Barkal 61.
Gebel Sheikh Herîda 51.
Gebel Silsileh 96, 261.
Gebeleyn 40.
Genii 112, 183, 344, 361, 366.
Genius, the kneeling 343, 344.
Gerf Hossein 98.
Giraffe 354, 355.
Girdle tie, amulet 278, 280, 321.

INDEX.

Gizeh 53, 60, 102, 131, 165, 237, 252.
 granite temple of 73, 102 (see KHAFRA).
Glass 293 et seq., 368.
 imitation of precious stones, 294.
 inlay 295.
Glazed pottery 190, 193, 275, 286, 293, 301, 302, 304.
 stone 275, 297.
 tiles 303 et seq., 306.
Glazes for inlay 21, 304, 358.
Goat 202, 352, 355.
Gold 141, 276, 279, 291, 295, 312, 338 et seq., 346, 347, 348, 349, 351, 355 et seq.
 leaf 347, 348, 359, 366.
Goose 189, 203, 284, 320, 338, 341, 362.
Graffiti 73.
Granary 2, 11, 14, 42, 104, 141.
Granite 53, 79, 98, 101, 120, 122, 161, 162, 164, 189, 194, 222, 227, 264, 272, 277, 286, 325.
 black 48, 189, 223, 254, 261, 304.
 red 48, 60, 74, 189, 243, 260, 264, 304.
Grasshoppers 365.
Graves, predynastic 129.
 of the middle classes 191.
 of the poor 191, 192.
Græco-Egyptian art 270, 271.
Greece 278, 356, 368, 369
Greek period 199, 268, 279, 293 (see also PTOLEMAIC PERIOD).
Greyhound 202.
Gûrneh 67.
Gurnet Murraî 296.

Hadrian 271.
Hæmatite 276, 277, 280.
Hairpins 300, 308, 313, 369.
Half-months, feast of 136 (see FORTNIGHT).
Hammer 348.

Harhotep 181.
Harpocrates 342.
Hathor 63, 97, 100, 102, 193, 244, 256, 266.
 head columns 69, 70, 97.
Hatshepsût 49, 55, 91, 98, 100, 122, 127, 182, 348, 350.
Hawara 168.
Hawk 241, 292, 301, 313, 344, 357.
Headrest 189, 280, 313.
Heart, amulet 277, 296.
 scarab 279.
Hearth 13.
Hedgehog 285, 301.
Hekalli 168.
Heliopolis 2, 33, 39, 121, 122, 344.
Hellenic influence 269, 271, 368, 369.
Hemispeos 98 et seq.
Hepzefa 174.
Herihor 182, 323.
Hermopolis 234.
Herodotus 45, 105.
Hesi 236.
Hierakonpolis 200, 217, 233.
Hieroglyphs 77, 78, 110, 112, 116, 123, 136, 186, 196, 208, 236, 264, 290, 295, 298, 300, 301, 304, 319, 322, 324, 333, 334, 337, 351, 361.
Hippopotamus 216, 265, 280, 296, 299.
Hittites 38, 211, 214.
Holy of Holies 85 (see SANCTUARY).
Hophra (Apries) 302.
Horbeit 346.
Horemheb 179, 205, 206, 211, 230, 260, 261, 262, 263.
Hori 290.
Hori Ra 311.
Horn 306.
Horse 178, 209, 353, 367, 368.
Horus 113, 123, 292, 300, 344, 345, 348.
 name, on plaque 358.
 Servants of 72.

INDEX. 377

Horus, statue of one 270.
Hotesu pattern 328.
Houses, façades of 17, 18.
 foundations of 5, 6.
 models of 27.
 plans of 9, 22 et seq.
 primitive 3.
 stories of 6, 7, 9, 11, 16, 18.
Human figure 202, 204, 231, 239, 257, 289, 292, 306, 307, 337.
 limbs as amulets 277.
Human-handed birds 109, 305.
Hûnefer 198.
Hunting scenes 201, 217.
Hydria 353.
Hyksos 254, 269.
Hypostyle halls 85, 88, 90, 92, 97, 101, 103, 106, 111, 119, 187, 263.

Ibis 292.
Illahûn 168.
Incantations 167.
Incense 113, 143.
 burners 308.
Incised patterns in pottery 289.
India 365.
Inlay 21, 295, 304, 318, 343, 345.
Iron 108, 221, 222, 223, 276, 294.
Irrigation 42, 44, 45.
Isiemkheb 206.
 canopy of 333 et seq.
Isis 113, 266, 269, 278, 279, 280, 322, 329, 345, 348.
Isthmus of Suez 293.
Italy 356.
Iûiya and Tûiyû, parents of Tyi 295.
Ivy 321.

Jack, for lifting 56.
Jackal 191, 292, 309, 313, 327, 341.
Jade, pink 286.
Jar stoppers 43.

Jasper 280, 294, 360.
Jewellery 274, 276, 353, 356 et seq.
 Egyptian love of 274, 356.
Jugs 340, 352, 355.

Ka (double) 128, 129, 136, 139, 143, 166, 181, 186, 187, 241.
 chamber 136, 138.
 statues 143, 144, 187, 190, 241, 243, 310.
Kadesh 38, 118, 211, 214.
Kahûn 1, 10, 289, 290.
Kalaat Addah 96.
Kalabsheh 62.
Kames 342, 360, 367.
Karnak 9, 53, 54, 58, 60, 61, 62, 65, 90 et seq., 105, 110, 118, 124, 220, 225, 256, 257, 261, 263.
Kasr es Said 172.
Kemen, toilet box of 309.
Keneh 298, 369.
Khafra (Khephren) 73, 76, 78, 107, 162, 237, 243, 284.
 temple of 73 et seq. (see also GRANITE TEMPLE OF GIZEH).
Khamha 256.
Khasekhemui, statue of 233.
Kheops (see KHÛFÛ).
Khephren (see KHAFRA).
Kheti 179.
Kheti, the 118, 213 (see HITTITES).
Khnûm 173.
Khnûmhotep 174, 176, 179, 203.
Khonsû 113, 114, 127, 261.
 temple of 67, 85, 263.
Khû 128.
Khûfû 148, 243, 309, 348.
Khûit 292.
King as mediator 112.
 as priest 119 et seq.
 of divine descent 119, 237, 241.

INDEX.

Knives, bronze 338.
 flint 276.
Kohl 285, 300, 308, 313.
Kom el Ahmar 2, 33, 244, 342
Kom Ombo 1, 9, 35.
Koptos 26, 273, 338.
Kosheish 45
Kummeh 35..

Labyrinth 66.
Lacedemonians 336.
Lake Moeris 45, 46.
 of temple 91.
Lamps 25, 341.
Lance-head decoration 334.
Lapis lazuli 228, 276, 277, 280, 294, 338, 358, 360, 361, 365, 366.
Lead 294, 338.
Leather 327, 332, 334.
 cut and painted 332.
Lenticular ampulla 291, 297, 301.
Leopard 202.
Libation 283.
 vases 327, 341, 344.
Libyan desert 347.
Limestone 7, 21, 48, 50, 52, 53, 72, 79, 100, 101, 120, 131, 163, 164, 166, 189, 195, 196, 221, 225, 227, 233, 236, 243, 250, 258, 261, 265, 282, 284, 286, 298, 304, 346, 347, 349.
Linen 327, 336, 337.
Lintels 53.
Lion 196, 202, 225, 283, 285, 308, 327, 330, 342, 345, 357, 359, 364, 365.
Lions' feet for furniture 330, 331, 341.
Lisht 107, 168, 284.
Loaves, feast of 136.
Loggia 23.
Loom 331, 337.
Loop of cord on column 69.
Lotus 9, 65, 109, 133, 206, 285, 299, 300, 301, 302, 303, 305, 312, 313, 314, 315, 319, 334, 350, 351, 353, 361, 366, 368 (see also COLUMNS).
 flower column amulets 278, 296, 309.
Louvre 242, 245, 250, 253, 254, 268, 305, 315, 330, 343, 347, 357, 367.
Luminous, the 128, 129.
Lute 206, 300, 315, 316, 317.
Luxor 54, 60, 65, 94, 105, 120, 122, 124, 125, 227, 257, 262, 298.
Lyres 360.

Maat 295, 329.
Mace heads 118, 233.
Macedonian conquest 325.
Magic formulæ 139, 280.
 powers of sphinx, obelisk, etc. 116, 121, 193, 237 (see also AMULETS).
Malachite 277, 338.
Manfalût 168.
Manganese 294.
Marqueterie 330.
Masahirti 333.
Massarah 50.
Mastaba 27, 130 *et seq.*, 134, 171, 172, 173.
Mastabat el Faraûn 167.
Masts in front of temples 52, 86, 120.
Matting, coloured 27.
Medamot 64, 66, 72.
Medinet Habû 9, 39 *et seq.*, 60, 61, 65, 66, 104, 119, 182, 209, 220, 223, 225, 297, 306, 323, 342, 349, 350.
Medûm 72, 130, 235, 289.
Meir 230, 257.
Memnon 120, 257, 272.
Memphis 1, 39, 45, 53, 60, 105, 130, 172, 178, 189, 255, 269, 283, 299.
 art of 234 *et seq.*, 243, 252, 255, 262, 264, 266, 268, 269.
Mendes 346.

INDEX. 379

Menes 52, 72, 168, 299, 306, 347.
Menkaûhor 250.
Menkaûra 77, 162, 241, 243, 244, 321.
Menkhepperra 333.
Mentû 114.
Mentûemhat 349.
Mentûhotep I. 253.
Mentûhotep II. 101, 171.
Merawi, Nubia 314.
Merenptah 263.
Merenra 165, 166.
Merlon 31.
Meroë 169, 272.
Mesheikh 84.
Metals 338.
Migdol (Magadilû) 38, 39.
Min, feast of, 136.
Mines 42, 48.
Minieh 173.
Mirror 302, 309, 312, 313, 339, 340, 341.
Models 225, 226.
Mokattam mountains 161.
Moeris 45 *et seq.*
Monkey 285, 296, 301.
Monoliths 60, 257.
Monotheism 258.
Mont 366.
Months, feast of 136.
Mortar 56, 131.
Mosû 344.
Mother-of-pearl 277.
Moulds 190, 290, 340.
Mourners 190, 239, 241.
Mulkaf 13, 28.
Mummy 143, 163, 164, 170, 174, 187, 190, 191, 198, 279, 295, 319, 325, 329, 335, 349, 356, 360, 366, 367.
 couches 328 *et seq.*
 of animals 292.
Musical instruments 190, 196 (see also LUTE).
Musicians 141.
Mût 114.
Mycenæ 365.

Mycenæan type of pottery 291.
Mycerinus (see MENKAÛRA) 162, 321.
Mystic eye amulet 278, 301.

Naga 272.
Nagada 172.
Naï 312.
Naos 69, 74, 125, 126, 295, 329, 364.
Napata 169.
Necklace 277, 292, 294, 302, 312, 321, 359, 363, 364.
Nectenebo 70.
Nefer-ar-ka-ra 163.
Neferhotep 179.
Nefert 236.
Nefertari 97.
Nefertûm 345, 348.
Negroes 109, 305, 354.
Neith 280.
Nekheb 110.
Nemhotep 250.
Nephthys 279, 280, 322, 329, 345.
Netemt 295.
Nesikhonsû 297.
Ne-ûser-ra 78, 80, 163, 243.
New York 197.
Niche in tombs 129, 132 (see also FALSE DOOR).
Niles 109, 254, 264.
Nilometer, table of offerings as, 283.
Nitocris 265.
Nome 110.
 goddess 244.
Nubia 53, 80, 96, 130, 293, 314.
Nubian bed 317, 327.
Nûrri 169.

Oared galley 289.
Obelisk 79, 82, 91, 120, 121, 122, 123, 347, 348.
 magic power of 121.
Obsidian 276, 277, 280.
Ochre 201, 228.

380 INDEX.

Œnochœ 296.
Offerings for the dead 100, 112, 125, 138, 166, 189, 288, 291.
Ombos 34, 43, 105, 111, 272
On (Heliopolis) 113.
Oracles 126, 127.
Orders of architecture 72.
Orientation, of body 129, 165.
 of mastabas 131.
Osirian cycle 186, 324.
Osiride figures 61, 77, 97, 123, 216.
Osiris 28, 61, 63, 88, 113, 139, 167, 193, 266, 279, 339, 345.
Ostraca 43, 197.
Oval 297 (see CARTOUCHE).
Ox 51, 202, 205, 283, 284, 352.
Oxford 44, 231, 233, 250, 314.
Oxide of iron 293.
 of manganese 293.

Pabesa 265.
Pahûrnefer 243.
Painting 194 *et seq.*, 228 *et seq.*, 255.
 on pavements 20, 21, 22, 108.
 on walls 12, 21.
Pakhet 49, 96.
Palestine 121.
Palettes 129, 233, 275.
 painters 195, 228.
 scribes 189.
Palm 192, 301, 354.
 columns 68, 78.
Palmettos 337.
Papyri 101, 184, 191, 195, 198, 199.
Papyrus 65, 109, 216, 230, 249, 313, 341, 353.
 columns 163 (see CAMPANIFORM COLUMNS).
Paris 243 (see LOUVRE).
Pearl 277.
Pectoral 359, 364.
Pedishashi 268.
Pennants 86.
Pepi I. 166, 244, 284, 303, 342.

Pepi II. 166, 168.
Peplum 369.
Perfume 82, 145, 187, 313, 341.
Peristyle 97, 98, 123.
Persia 365.
Persian period 127, 199, 269, 369.
Perspective 201, 202, 203, 208, 210, 233, 258.
Petamenoph 189.
Petûkhanû 343.
Philæ 43, 65, 69, 70, 94, 111, 118, 273.
Phœnicia 278, 355.
Phœnician vase, type of 296
Piankhi 41.
Pig 188, 221, 222.
Pigments 201, 228.
Pillars 20, 60, 61, 62, 98, 174.
Pinotem 199.
Pinotem II. 333, 334.
Pinotem III. 368.
Pisebkhanû 255.
Pithom 2, 43.
Place d'armes 32, 33.
Plan of tomb of Rameses IV. 184.
Planets 111.
Plants emblematic of union of North and South 109.
Point, the 226, 277, 290, 361.
Polygonal columns 78, 101, 174.
Porphyry 48, 276, 277, 282.
Portcullis 153, 161, 162, 164.
Portico 14, 25, 28, 133, 134, 174.
Portrait masks on coffins 322, 323.
 panels on coffins 326.
Postern gate 32, 33.
Potter's wheel 287, 288.
Pottery 129, 132, 189, 275, 286 *et seq.*
 black incised 289.
 glazed 286, 287.
 painted 293.
Precious stones 349, 356, 359, 366.

INDEX. 381

Predynastic period 34, 129, 130, 275, 276, 281, 282, 288, 289, 297, 338.
 tomb of Hierakonpolis 200.
Priest 113, 136, 139, 166, 187, 265, 311.
 High 333, 368.
Primitive huts 3 (see PRE-DYNASTIC and THINITE PERIODS).
 temples 52.
Pronaos 88.
Psammetichus I. 264, 343.
 the scribe 265, 266.
Psar, prince 357, 368.
Ptah 193, 350.
Ptahhotep 27, 135, 216.
Ptahmes 301.
Ptolemaic period 66, 69, 81, 88, 93, 94, 107, 112, 116, 127, 225, 237, 268, 272, 338, 343, 348, 350, 351.
 art of the 268.
Punt, land of 127.
Purpose of wall paintings 141.
Pylons 14, 17, 20, 82, 86, 93, 103, 104, 107, 112, 120, 122, 169, 213, 216, 231.
Pyramid 154 *et seq.*, 101, 170, 171, 222, 302.
 period 282.
 temples 72, 73, 78.
 texts 187, 189.
Pyramidion 122, 172, 347.

Qodshû (Kadesh) 118.
Quarries 42, 48, 49, 50.
 turned into chapels 49.
Quarrying, methods of 50, 122.
Quartz 275, 281.
Quartzite, yellow 304.
Quay, of valley temples 73, 74.

Ra 364.
Ra Harmakhis 123.
Raemka 247.
Rahotep 235.

Ram 225, 278, 345.
 kneeling as sphinx 105, 257.
Rameses I. 93.
Rameses II. 93, 94, 97, 103, 118, 227, 254, 260, 262, 355, 356, 367, 368.
Rameses III. 39, 40, 119, 121, 220, 221, 223, 254, 260, 304, 305, 306, 323, 335, 341, 356.
 tomb of 185, 186, 187, 210.
Rameses IV. tomb of 184.
Rameses IX. 368.
Ramesseum 54, 57, 65, 111, 182, 262, 297.
Ramesside period 5, 30, 182, 192, 263, 299, 325, 326, 356.
Ramps 73, 76, 78, 98, 101.
 for building 56.
Ranefer 243, 245.
Rats 196, 292.
Red Sea 48, 347.
Reed brush 195, 196, 200, 219, 290.
 pen 199, 201, 228.
Registers, superposed 115, 116, 215, 217, 230.
Rekhmara 212, 256.
Relative proportions of human figures 141, 206.
Repoussé work 351, 352, 355, 359, 365.
Respondants 300, 327 (see USHABTIÛ).
Reversed capital 65.
Rings 193, 279, 294, 300, 340, 356, 357, 359, 367, 368, 369.
Ritual of embalment 181.
 of funerals 187.
 of opening of the mouth 181.
Riveting 339.
Rock crystal 277.
Rock temples 95 *et seq.*
 tombs 169, 173 *et seq.*, 189, 256, 325.
Roman period 116, 168, 272, 349 (see also CÆSARS).
Roofs 2, 11, 12, 13, 26, 27, 28, 59, 112, 129.

382 INDEX.

Rosettes 300, 304, 333, 351, 360.
Royal tombs, Abydos 3, 26, 282.

Sacred animals 292.
 barks 81, 91, 126.
 beetles 278 (see SCARAB).
 eye 278, 301.
Sacrificial animals 80, 112, 113, 189.
Sahûra 163.
Saïs 33.
 art of 264, 265, 267, 268 *et seq.*
Saïte period 296, 299, 325, 350, 351.
Sakkieh 21.
Sân 33.
Sanctuary 77, 81, 85, 87, 88, 89, 96, 97, 98, 100, 103, 106, 120, 125, 127, 176, 177.
Sandstone 48, 50, 53, 82, 101, 120, 194, 227, 257, 282.
Saqqara 27, 60, 130, 131, 164, 169, 216, 230, 247, 252, 283, 292, 302, 345, 347, 369.
Sarcophagus 161, 163, 165, 181, 185, 188, 189, 265, 294, 319.
Sardinia 278.
Saw 277, 338.
Scarab 278, 279, 297, 335, 362.
 used as seal 279.
Scented fat 275.
Sceptre 302, 365, 367.
Schist 76, 233, 298.
Scissors 341.
Scorpion 357, 366.
Scribe 265, 268, 290, 311.
 cross-legged 242, 243, 245, 247, 253, 267.
 kneeling 243, 248, 267.
Sculptor's models 224, 225.
 sketch 219, 220.
 trial piece 223.
 workshop 258.
Sculpture 107, 163, 186, 194, 218 *et seq.*, 231 *et seq.*, 258.

Seal cylinders 153, 282.
 rings 356, 357.
 scarabs 282.
Sealings of jars 282.
Sebakh 25, 265.
Sebekemsaf 227, 254.
Sebekhotep III. 254.
Sekenenra 181.
Sekhemka 243.
Sekhet 280, 313, 345.
Semneh 28, 35, 36, 58.
Seneferû 72, 107, 168.
Sennetmû 292, 321, 329.
Senûit 206.
Senusert I. 35, 90, 168.
Senusert II. 168, 359.
Senusert III. 253, 359.
Serdab 77, 143, 144, 165, 176, 189, 190, 243.
Serpent 183, 188, 278, 328, 354, 366.
 amulet 276.
Serpentine 194, 221, 222, 264, 265, 276, 277, 282.
Set 113.
Seti I. 56, 93, 94, 102, 118, 221, 260, 263, 303.
 tomb of 185, 186, 187, 220, 260.
Sharona 84.
Sheikh abd el Gûrneh 296, 342.
Sheikh el Beled 243, 247, 248, 253, 310.
Sheikh Said 172.
Shell 359.
Shepseskaf 244.
Sheshonk (Shishak) 41, 263, 303.
Shrine 101, 119.
Shû 345.
Sickle teeth 276.
Silica 293.
Silsilis 50, 51.
Silver 276, 279, 309, 318, 338 *et seq.*, 347, 349, 350, 351, 353, 355, 357.
 inlay for eyes 345.
Sinai 80, 119.
Sistrum 69, 113, 302.

INDEX. 383

Sitû 283.
Siût 132, 173, 174, 251, 269.
Slate 233, 250, 275, 282.
 triads of Menkaûra 243, 244.
Slaves 48, 212, 250, 305, 315, 316.
Sledge 327, 329.
Sleeping bench 21 (see also BED).
Sleeping chamber 13, 21, 25.
Smelting 347.
Snakes 167, 292, 313.
Soda 293.
Solar bark 187 (see SUN).
 disc 312.
Sothis 136.
Soul (Ba) 128, 129, 178, 180, 181, 183, 188, 280.
South Kensington Museum 302.
Sow 188.
Sparrow hawk 191, 278, 285, 357.
Speos 96 *et seq.*
 Artemidos 49, 96.
Sphinx 74, 100, 104, 105, 121, 253, 254, 255, 345, 362.
 avenues of 82, 257.
 magic powers of 121, 237.
 the Great 74, 162, 237.
Spinning 141.
Spoon 306, 308, 314 *et seq.*, 341.
Square as amulet 280.
Squaring lines 219, 224, 225.
Stables 42, 104.
Stairs 12, 17, 24, 28, 31, 34, 79, 81, 85, 86, 102, 173.
Stars on ceilings 78, 110, 187, 334.
Statues 76, 77, 120, 121, 124, 163, 227, 231 *et seq.*, 255, 258, 264, 265, 272, 335, 346, 348.
 from favissa at Karnak 124, 256.
 in false door 137.
 Ka statues 143, 144, 187, 189, 190, 241, 243, 310.
 moving oracles 126, 127.
 usurpation of 253.

Statuettes 258, 301, 310, 339, 340, 343, 348, 349, 311.
Steatite 275.
Steel 222.
Stela 77, 133, 139, 141, 143, 177, 179, 198, 282.
 of Bakhtan 127.
 upright stones 73, 121.
Stone 104, 275, 277, 282, 325, 346.
 blocks 53.
 inlay 304.
 quarrying of 50.
 transporting of 51.
 vases 276, 281, 282, 295, 347.
Stools 327, 330.
Store chambers 76, 82.
 house 43.
Stories of houses 6, 7, 9, 11, 12, 16, 18.
Sûdan 347, 368.
Sun, boats of the 80, 126, 183, 187.
 identity of deceased with 186.
 journey of the 114, 183, 187, 188.
 temple of the 78.
Sun-dried brick 131 (see CRUDE BRICK).
Superposition in drawing 208.
 of registers 115, 116, 215, 217, 230.
Sycamore-wood 56, 230, 310, 319, 325.
Syene 91 (see ASSÛAN).
Syenite 91, 164, 222, 281.
Syria 121, 278, 347.

Table 327.
 of offerings 124, 133, 189, 258, 266, 282, 283, 284.
Taharka 60, 93.
Tahûti, cups of 350 *et seq.*
Takûshet 343.
Tanis 2, 53, 121, 225, 254, 262, 343, 346.
 art of 254, 255, 262, 264.

INDEX.

Tank 10, 24, 28.
Tapestry 332, 337, 338.
Taskmasters 48.
Taûd 280.
Taûrt (Thûeris) 265.
Taûsert 55, 352, 355.
Taxes 42.
Tefnût 345.
Tell el Amarna 1, 14, 16, 22, 178, 257, 296, 297.
 art of 257, 258, 260, 264.
 palace of 20 et seq., 303.
Tell el Yahûdîeh 304.
Tell es Saba 346.
Temple 7, 72 et seq.
 as image of the world 107.
 ceremonies 81, 112, 113, 119 et seq.
 levels of 87.
 store-houses 43.
 terraced 99, 100.
Tenons in statuary 242.
Tesseræ 304.
Teti 165, 166.
Thebaid 271, 306.
Thebes 1, 105, 106, 173, 189, 230, 255, 257, 265, 272, 296, 325, 327, 347, 348, 349.
 art of 234, 252, 255, 256, 258, 260, 262, 264, 266.
 necropolis of 169, 172, 178, 192.
 town walls of 33, 40.
Thinis 282.
Thinite period 148, 231, 275, 282, 303, 307.
 graves of 129.
 jewellery of 357.
 towns of 1, 13.
Thmûis, vases of 351.
Thoth 113, 292, 348.
 feast of 136.
Thothmes I. 90, 182, 256.
Thothmes II. 91, 182, 322.
Thothmes III. 49, 65, 67, 91, 102, 110, 182, 256, 297.
Thothmes IV. 230, 337.
Ti 134, 144.

Tiberius 273.
Tiger 363.
Tin 294, 338, 339.
Toilet-box 309.
Tomb, chamber 142, 145, 146, 161, 162, 165, 170, 171, 178, 183, 189, 190.
 chapel 136, 174, 175, 178.
 of Rameses III. 185, 186, 187.
 of Rameses IV. 184.
 of Seti I. 186, 187, 220.
Tombs 129.
 excavated 169, 172 et seq.
 of the kings 181 et seq.
Tortoise 313.
Torus 58.
Towns, plan of 7.
Transmigration 188.
Transport of stone 51, 122.
Trees, varieties in Egypt 310.
Trenches for common graves 192.
Tûaï 308.
Turah 50, 51.
Turin 126, 184, 196, 256, 260, 263, 295, 310, 311.
Turquoise 275, 277, 357, 358, 362, 366.
Tusks, carved 306.
Tyi 300, 318, 331.

Uaga, feast of 136.
Uazit 110.
Una 179.
Unas 164, 165, 166, 186, 187.
Uræi 68, 115, 226, 241, 244, 328, 363, 368.
Usekh necklace 363.
Ûshabtiû 190, 191, 290, 300, 327.
Usurpation of statues 253.
Uzat 278 (see also MYSTIC EYE).

Valley temples 73, 100, 107, 162, 163, 244.
 of the tombs of the kings 182, 296.

INDEX.

Varnish 229, 324-5, 346.
Vases 189, 284, 289, 292, 296, 300, 340, 341, 344, 347, 351, 355;
 for flowers 290, 291, 353.
 stone 276, 281, 347.
Vaulting 59, 174.
Venus 271, 369.
Vessels with cabins 201.
Vignettes 198, 199.
Vitreous paste 358, 359, 362.
Vultures 229, 301, 329, 334, 336, 350, 362, 363.

Wady es Sabûa 98
Wady Genneh 47.
Wady Gerraweh 47.
Wady Hammamat 48.
Wall scenes 112 et seq., 141, 200, 201.
Walls 56 et seq., 104, 105, 218.
 covered with gold 347.
 covering 32, 36, 37.
 decorated with glazed tiles 302, 303.
Wasp 359.

Water channel in street 7.
 cisterns 48.
 of youth and life 114.
Waters of the West 366 (see ELYSIAN FIELDS).
Wattle and daub 2, 3, 52.
Weapons in graves 129, 361, 364, 365.
Weaving 141, 332, 336, 337.
Wells 20, 25.
Windows 3, 10, 12, 28, 58, 86.
Wine 42, 43, 206.
Winged disc 328.
Woman's face, in glass 296.
Wood 125, 194, 195, 248, 250, 275, 284, 295, 310, 318, 321, 346, 349, 365.
 carving 263, 310, 311.
 gilded 347.
Wooden panel of Hesi 236.

Zagazig 351, 369.
Zarû 41.
Zer 357.
Zeser 168, 303.
Zodiac, signs of the 112.
Zowyet el Aryan 159.

www.ingramcontent.com/pod-product-compliance
Lightning Source LLC
Chambersburg PA
CBHW031418150426
43191CB00006B/320